MW00636749

The Ceramics Studio Guide

The Ceramics Studio Guide
What Potters Should Know

JEFF ZAMEK

Foreword by Steven Branfman

Schiffer Publishing Ltd

4880 Lower Valley Road • Atglen, PA 19310

Geneva Public Library District

Other Schiffer Books on Related Subjects:

Wood-Fired Ceramics: 100 Contemporary Artists, Amedeo Salamoni, Foreword by Jack Troy,
ISBN 978-0-7643-4533-3

Vessels: A Conversation in Porcelain and Poetry, Porcelain by Jennifer McCurdy, Poetry by Wendy Mulhern,
ISBN 978-0-7643-5313-0

Master Your Craft: Strategies for Designing, Making, and Selling Artisan Work, Tien Chiu, Foreword by Christopher H. Amundsen, Executive Director, American Craft Council,
ISBN 978-0-7643-5145-7

Copyright © 2019 by Jeff Zamek

Library of Congress Control Number: 2018937208

All rights reserved. No part of this work may be reproduced or used in any form or by any means—graphic, electronic, or mechanical, including photocopying or information storage and retrieval systems—without written permission from the publisher.

The scanning, uploading, and distribution of this book or any part thereof via the Internet or any other means without the permission of the publisher is illegal and punishable by law. Please purchase only authorized editions and do not participate in or encourage the electronic piracy of copyrighted materials.

"Schiffer," "Schiffer Publishing, Ltd.," and the pen and inkwell logo are registered trademarks of Schiffer Publishing, Ltd.

Designed by Jack Chappell
Cover design by Brenda McCallum
Technical editor: Jim Fineman
Front cover image: Trae Von Morrison

Type set in Zurich/Futura/Times
ISBN: 978-0-7643-5648-3
Printed in China

Published by Schiffer Publishing, Ltd.
4880 Lower Valley Road
Atglen, PA 19310
Phone: (610) 593-1777; Fax: (610) 593-2002
E-mail: Info@schifferbooks.com
Web: www.schifferbooks.com

For our complete selection of fine books on this and related subjects, please visit our website at www.schifferbooks.com. You may also write for a free catalog.

Schiffer Publishing's titles are available at special discounts for bulk purchases for sales promotions or premiums. Special editions, including personalized covers, corporate imprints, and excerpts, can be created in large quantities for special needs. For more information, contact the publisher.

We are always looking for people to write books on new and related subjects. If you have an idea for a book, please contact us at proposals@schifferbooks.com.

"IT IS NECESSARY FOR US TO LEARN FROM OTHERS' MISTAKES. YOU WILL NOT LIVE LONG ENOUGH TO MAKE THEM ALL YOURSELF."

—HYMAN G. RICKOVER

CONTENTS

Foreword by Steven Branfman ... 8

Acknowledgments .. 9

Introduction .. 10

Part 1: Clays ... 12

1. Heating Ceramic Materials ... 12

2. Changing Raw Materials ... 17

3. Ever-Variable Clay .. 24

4. Fireclays .. 29

5. How to Interpret a Typical Data Sheet: Ball Clays 38

6. Dense-Packing and Filter-Pressing Moist Clay 47

7. Mass Production of Premixed Clays ... 55

8. Soluble Salts in Clay ... 62

9. Choosing the Right Clay .. 67

10. Clay Body Formulas .. 71

Part 2: Raw Materials .. 80

11. Talc Substitutes .. 80

12. No More Albany Slip, No More Barnard/Blackbird 84

13. The History of G-200 Feldspar .. 91

14. Another Choice in Feldspars ... 96

15. A Substitute for Gerstley Borate .. 102

16. Old and New Cornwall Stone .. 107

17. Changes in Fired Materials .. 110

18. Choosing the Right Glaze and Adjusting Glazes 118

19. Liner Glazes .. 128

20. The White Spots of Maiolica Ware ... 136

21. Mixing Glaze Colors ... 143

22. Using Decorative Engobes .. 147
23. Clay Body and Glaze Defects .. 149
24. Diagnosing Glaze Blisters 162
25. A Problem with Cobalt? ... 168
26. Developing Color and Opacity in a Raku Glaze 173
27. Glaze Description / Glaze Notation 177
28. Base Glazes ... 181

Part 3: Protect Yourself—Physically and Economically 185
29. Pottery Studio Air Quality ... 185
30. Functional Pottery Sets ... 190
31. Hand Injuries in Potters .. 195
32. Selling Pots ... 199
33. Cupcakes and Pottery .. 214

Conclusion .. 220

Glaze Formulas .. 222
Notes ... 225
Glossary .. 232
References .. 238
About the Author ... 240

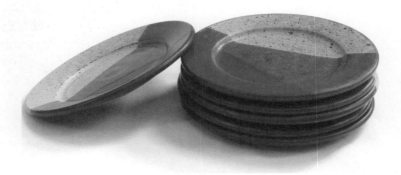

FOREWORD

I must start my preface with an admission: Jeff Zamek is my dear friend, and I am a big fan of his books. Okay, two admissions.

The Ceramics Studio Guide is a new and unique contribution to the bibliography of books available to both the student and seasoned clay worker. Zamek has taken inventory of his vast experience as a clay artist, technical expert, and businessperson; selected the key ingredients; and combined them into proper percentages. The result is a ceramic culinary delight.

I admitted up front that Jeff is a dear friend. Our friendship stems from our connection through clay and has grown over many years as we've gotten to know each other. Jeff is the consummate professional. His knowledge of ceramic science as it pertains to our craft is unparalleled. His skill as a ceramic detective is nothing short of remarkable. And his problem-solving capability is magic. But it is his calm style and nonsensational approach to the serious health, safety, and technical issues that we, as clay people, face every day in our studios that sets him apart from others in our field who teach and advise.

Regardless of the depth of our knowledge and how well we encounter and navigate through the technical side of our craft, the bottom line, if we are going to get positive results, is being able to apply our knowledge in a practical way. This too is where Jeff excels as a teacher and consultant. His previous books, *Safety in the Ceramics Studio* and *What Every Potter Should Know*, are examples of how Jeff is able to present complicated concepts in an understandable, comprehensible, and functional way. *The Ceramics Studio Guide* follows suit. It is logically organized and clearly presented. He has chosen topics of interest and concern to all of us working in clay. His drawings, charts, and photos are crisp and illustrative of the text that they accompany.

In addition to being my friend, Jeff has been my go-to person for ceramic problem solving for as long as I've known him. He has extricated me from both serious and less critical debacles on many occasions. Each and every time he has, I've learned more and I've never had to go to him twice for the same problem. That's the sign of a good teacher.

So hunker yourself down and use *The Ceramics Studio Guide* to expand and increase your knowledge base; to get to the bottom of current questions and uncertainty, snags, and complications that you may be having; and to avoid problems that might otherwise be in your future. You'll be happy that you have this book. I've been a clay artist for over forty years, and I'm delighted to have it at my disposal.

Steven Branfman
The Potters Shop & School
Needham, Massachusetts

ACKNOWLEDGMENTS

Thank you, Schiffer Publishing, for getting my book into print. My editor, Sandra Korinchak, kindly and immediately made me realize I didn't know anything useful about editing. My first thought was, "What does an editor know about pottery?" After several suggestions about chapter placement, endnotes, and captions, I realized a lack of pottery knowledge was not a factor in her ability to produce a readable book. Sandra made the book better than my preliminary efforts, while greatly helping the reader understand the content.

Thank you to my technical editor, Jim Fineman, who has edited my past books and articles. I first met Jim as a client many years ago, as he is a professional potter practicing his craft every day in his North Carolina studio. At some point I sent Jim an article destined for *Ceramics Monthly* magazine. His response was humbling and informative as he diplomatically mentioned there were several punctuation and spelling errors. I was not familiar with comma placement or when to stop a run-on sentence. In my defense, I was sick the day this information was covered in grade school.

While I was grateful for his critique, the thought came to me of how many other articles I had blindly sent publishers, articles that were not thoroughly proofread on a technical level. After that realization, Jim kindly took on the task of reviewing my work *before* publication. Along with his expert knowledge of how to spell words correctly is the exceptional and rare quality of being the ultimate reader to whom my articles and books are directed: the potter. Working with clay, glazes, and kiln firings every day allows Jim to see if the information I am writing about works on a practical level in the studio.

I could not have attempted compiling the information and writing the book without the help and support of my wife Lauren, my son Ben, and my daughter Maya, as I borrowed time away from them.

Thank you to Trae Von Morrison, who has freely given of his technical support on the photography of pottery, including the cover photo.

My students and clients over the past 45 years have yielded valuable information, which I've included in this book. Their practical everyday experiences have given me a body of knowledge in ceramics that I feel a responsibility to pass on. After listening to their stories of clay body and glaze defects or kiln firing errors I've concluded that it's always easier and less expensive to learn from others' mistakes.

INTRODUCTION

Many people pass over a book's introduction and go directly to the text. I urge readers to take a few minutes to understand how this book is presented.

Imagine yourself as a potter just starting out. In the past, you would be taken on as an apprentice to a master potter who got his training as an apprentice himself. Depending on the potter, you might start out only digging and then mixing clay. After you mastered this boring but essential task, the next assignment might be mixing glazes. Eventually, a further step would be to make a simple form on the wheel. At each stage you would be shown what to do and how to do it, and then execute the task exactly as required. As we know, making pottery involves many steps, with each requiring a unique skill set. At any point in the process, a mistake could result in a failed pot, which was the reason for instilling small steps building to larger tasks dictated by the master potter's specifications.

Under ideal conditions, a beginning or advanced student would be guided at every step in the pottery-making practice. Mistakes and bad habits would be caught as they occurred, and corrected. Having a potter with proven experience in your studio, imparting his or her knowledge of "trade secrets," would make you a proficient potter and, just as importantly, would stop the number of costly mistakes that beginning and some advanced students encounter. Unfortunately, such learning situations are rare to nonexistent today.

The Ceramic Studio Guide represents an extension of bits and pieces of ceramics information first covered in my book *What Every Potter Should Know*. Working with clays, glazes, and kilns requires many small but vital pieces of information that, once acquired, allow whole areas of knowledge to fall into place.

I have divided the book into three parts, with Part 1 ("Clays") discussing raw materials, the building blocks for any glaze or clay body formula. If you know the characteristics of each raw material and how it reacts with other raw materials at different temperature ranges and kiln atmospheres, that is a useful tool in your ceramics knowledge base. For example, ten to twelve raw materials are used in various amounts and ratios in most glaze formulas, oftentimes fewer. Additionally, clay body formulas can contain ball clay, stoneware clay, fireclay, feldspar, flint, and grog in various combinations depending on the forming method, color, and firing conditions. What does this mean in terms of educating yourself as a potter? While there are many raw materials, there are relatively few that are used consistently in the majority of glazes and clay body formulas. This fact is a reachable goal in that it represents a limited amount of materials to understand for anyone wanting to study this topic.

Part 2 ("Raw Materials") is a presentation of glazes, which will give potters an understanding of how to develop their own palette of textures and colors. At some point, potters will encounter a defect in the forming, glazing, or firing of their work. I have included clay body and glaze defects, causes, and corrections. If you can diagnose a defect accurately, it is the first step in enacting a correction. Glaze notation is especially important because it is a system to standardize the language of describing a glaze. Once you know it, you can accurately compare glaze formulas. By using a standardized method of glaze description, you will understand how describing a glaze by its popular name such as John's Blue or Randy's Red can lead to inaccuracy.

Part 3 ("Protect Yourself—Physically and Economically") contains topics ranging from safely considerations in the pottery studio to earning a living as a potter. The economics of selling pottery is a subject often overlooked in ceramics arts programs for several reasons, one of which is that the teaching professors never had to earn their living selling pottery. However, in recent years one or two courses in business have found their way into such institutions. People with business expertise who become potters do better statistically than potters without business experience. I have covered a diverse range of information that appeals to potters of varying levels of expertise. Mainly the chapter contents are generated by my own experience as a professional potter, my teaching experience, consulting clients, and questions frequently asked during my lectures and workshops.

During my years of teaching, the most valuable experiences for students occurred when I was able to catch their mistakes in forming, glazing, and firing. Often a brief mention of adding

bentonite to their glaze—which prevented it from settling—or the suggestion to constantly sponge water out of the thrown form when working on the potter's wheel saved hours and days of trial and error on their part. This reduction of wasted time enabled them to advance their own creative ideas at a faster pace. Pottery in the broad perspective is made up of little pieces of information that, once known, allow the potter greater freedom of expression. Even though there are many such pieces, once you know them they are not easily forgotten. How many bisque pots have to blow up in the kiln before you learn not to turn the heat up faster than the clay's mechanical and chemical water can safely be released from the ware?

While it is important to know how to correct mistakes in all aspects of pottery, the pursuit of developing good pots cannot be limited to correcting technical errors or concentrating on technique alone. Some of the best pots I have encountered had multiple technical errors, such as dripping glazes, badly thrown shapes, and kiln-firing mishaps, but somehow spoke to me in a way that was magic. Conversely, I have seen pots that were technical triumphs of form with perfect glaze and firing results, but in the end they remained lifeless and void of feeling. In fact, the potters' skill in these visible areas only further underscored their lack of aesthetic convictions, relying on only one aspect of making pottery. To me, making pottery is the nearest thing to magic as I can think of; you start with nothing and then have something.

I hope the reader gains some knowledge of pottery, but more importantly every potter must pursue his or her own vision. Frequently the most insightful growth occurs between making one pot and another. It is this undefined middle ground that often leads to future development. Inspiration often comes from going into the studio every day and making pottery, with one pot leading to another, not a sudden "golden moment." Eventually, technique falls into the background, and technical ability is just a tool to an end. I often tell my students, "I can teach you the technical ABCs of making pottery, but it is up to you to write either a phone book or poetry."

PART 1 - CLAYS

1. HEATING CERAMIC MATERIALS

One of the small mysteries regarding ceramic materials is the central issue of how they melt. As potters, we all know the negative results of making a pot without firing the ware. The pot would lack durability and break easily, and most importantly, once in contact with water it would again slake down into a plastic mass. While every potter knows that it is important to fire a clay body or glaze, what is not apparent is how much heat work and temperature ceramic materials require to function properly. This is determined by several factors, some obvious and some subtle, but all critical in the total process of firing pots or sculpture. All aspects of heat transfer and its subsequent reactions with ceramic materials must be understood to consistently obtain successful firing results in pottery kilns. The firing process represents the greatest area of miscalculation when making ceramic objects. In part this is caused by the many factors taking place in the kiln that affect clay and glaze materials.

Heat is a form of energy produced by the movement of molecules, capable of transmission through *convection*, *conduction*, or *radiation*. Temperature is the intensity of heat or cold upon objects or atmosphere. Many clay body and glaze defects can be directly related to faults in the kiln's heating and cooling cycle. Incorrectly firing the kiln can result in a cascade of clay body and glaze defects. It makes no sense to invest the time and energy required to fabricate a ceramic object successfully and then cause it to fail in the firing. As most potters have learned, making pots is just one part of the ceramics process. Firing the pots involves another set of skills that have to be mastered. While there is always some wisdom to be gained from firing the same kiln, it can be limiting. In order to obtain a thorough and diverse knowledge of kiln firing, the potter should try to fire as many different kilns as possible rather than just one. Craft centers and college ceramics departments offer the best locations for this experience. When several potters work in one location firing different types of kilns, they can learn by observation and experience from their successes and failures. While there are many differences between firing a kiln fueled by wood or gas compared to electricity, the same methods of heat transfer are always present.

Methods of Heat Transfer

Conduction

Conduction is the transfer of heat through solids. When the kiln is being fired, kiln shelves gather and then release heat during and after the firing. The heat is transferred directly through the solid kiln shelf, posts, and other pots on the shelf. When the heat source, whether it be electricity, gas, wood, coal, or any hydrocarbon-based fuel, is turned off, the overall kiln temperature drops but the shelves and other kiln furniture act as a thermal reserve, which still transfers its depleting heat to the pottery resting on the shelf. Some materials transfer conduction heat more efficiently than others. Anyone who has mistakenly picked up the end of a hard brick exposed to high heat has experienced burning conduction heating firsthand. There is still a great amount of heat stored within the hard brick, which takes a while to dissipate. Conversely, picking up a soft brick, which is formed with air pockets throughout the structure, will not transfer heat readily and can be handled at the opposite end if one end is extremely hot.

Convection

Convection is the process by which heat is transferred through the movement of air. This method of heat transfer can be felt when opening a hot oven. Air molecules are heated from the heat source and then move about the kiln, heating the interior of the kiln, shelves, and pots.

Radiation

When heat is transferred through the kiln by energy waves, it is called radiation. When a kiln is heated, the greater the thermal mass in the kiln from bricks, shelves, posts, and pots, the greater the radiant heat that is transferred to every object in the kiln. After the heat source is turned off, radiant heat is still affecting all the objects in the kiln.

Melting Characteristics of Ceramic Materials

Ceramic materials react or melt under specific conditions. In practice, several circumstances are taking place during any kiln firing, causing vitrification, or glass formation. The absolute or end-point temperature is the most commonly thought-of factor causing clay and glazes to melt. The higher the firing temperature for any given ceramic material, the greater degree of melting that takes place in the clay body or glaze. Fluxing materials contained in clay and glaze materials react with alumina and silica in clay and glazes to bring about vitrification. However, there are other factors that contribute to melting that may not be so apparent to potters firing their kilns.

The particle size of ceramic materials can also affect the melting characteristics of glazes and clay body formulas. Materials with smaller particle sizes have greater melting potential than larger sizes of any ceramic material. Small particle sizes expose greater surface areas to heat. Anyone who has used flint 325 fine mesh (silica) in glazes and then substituted silica sand 60 coarse mesh can observe the difference a larger-particle silica will bring about in a fired glaze.[1] The larger particle size 60 mesh flint will not combine with other glaze materials and go into a melt. However, the 325 mesh flint will combine with other materials, forming a glaze.

The kiln atmosphere can greatly influence the melting and color characteristics of clays and glazes. Depending on the heating source, a kiln can be fired in oxidation, neutral, or reduction atmospheres. An electric kiln produces an oxidation kiln atmosphere due to the ratio of air being higher than fuel. In reduction kiln atmospheres the ratio of fuel to air is higher, producing carbon. At high temperatures, carbon mixes with oxygen in the kiln to form carbon dioxide. After the oxygen is consumed, carbon monoxide remains, which pulls away oxygen from the metallic oxides in the glaze and clay body. This colorless and odorless gas is oxygen hungry, and when it is in the presence of easily reduced metallic coloring oxides found in clays and glazes it draws an oxygen molecule from them, changing their color and melting characteristics. Other oxides such as alumina, barium, silica, magnesium, potassium, and sodium found in clay and glaze formulas are not so easily reduced and need higher temperatures than pottery kilns can economically achieve.

Various eutectics (combinations of two or more materials, which cause melting at the lowest possible temperature)[2] can be formed when different oxides are brought together in glazes. The most common example is the combination of lead and silica: when the mixture is heated it produces a lower melting point than lead or silica melted separately. A strong eutectic can develop when two or more glazes are overlapped on a pot, combining their individual oxide components. The mixture of glazes can cause blistering, pinholes, or glaze running off vertical surfaces and pooling excessively in horizontal areas.

Melting can also occur due to the specific metallic coloring oxides used in glazes, and their amount. For example, iron oxide can be a strong flux in a glaze if used in high percentages. On the opposite end of the spectrum is chrome oxide, a refractory or heat-resistant oxide. High percentages of chrome oxide can dry the surface texture of the fired glaze. To varying degrees, other metallic coloring oxides can be classified as contributing a refractory or flux component to clay bodies or glazes.

The clay body on which a glaze forms can also influence the melting characteristics of the glaze. A clay body that is absorbent when fired can leach out fluxing oxides in the vitrifying glaze during the firing. A dry surface texture, glaze opacity, or both can result when some portion of the flux oxides in the glaze are leached into the clay body surface. In porcelain, with dense vitreous-clay surfaces, the glaze is more likely to exhibit its original texture and opacity. Depending on the clay body and glaze combination, in some instances the glaze can slide down vertical surfaces due to the underlying highly vitreous clay surface. Whether a glaze is sprayed, dipped, or brushed on the ceramic surface, the actual thickness of the glaze can play an important part in its ability to melt. While some glazes can be applied thickly and some thinly—depending on the actual glaze formula—as a general rule, the thinner the glaze layer, the greater degree of melting. A thick glaze application can need more heat work (the time it takes to arrive at the maturing temperature of the glaze) to cause complete vitrification of the entire glaze layer.

The heating and cooling cycle employed in a kiln firing can affect how clay and glaze materials melt. Aside from a longer heating cycle resulting in greater melting action of clay and glaze materials, a kiln can be programmed to hold at a specific temperature for a period of time. Holding at temperature can result in increased melting as the materials are given more heat work, resulting in greater vitrification or glass formation. If the potter chooses to hold at the maturing temperature of the glaze, there is always the possibility of boiling off lower constituent glaze oxides, resulting in glaze blisters, running, or clay body bloating. The safe approach is not to hold the glaze at temperature but to fire to the glaze-maturing temperature over a longer period of time. There is also the option of downfiring the kiln, which delays the cooling cycle of the kiln.

Heat Work in the Kiln

For the purposes of describing how ceramic materials react to progressive temperature increases, we can say that a clay body contains flint, feldspar, and clay(s). The first stages of change in the clay body occur with the removal of mechanical or free water, which is accomplished from 212°F to 392°F, followed by the removal of chemically combined water, which takes place from 842°F to 1112°F. At 1063°F, quartz or flint in the clay body expands (and shrinks when cooling in the 842°F–1112°F range). In the 572°F–1292°F temperature range, organic matter in the clay is oxidized and removed.

If the kiln is not fired in a complete oxidation atmosphere, carbon can cause bloating in the clay body at higher temperatures. At 1796°F, metakaolin, an intermediate product formed when kaolin is heated, changes to spinel, which ejects silica. From 1922°F to 2012°F, spinel changes to mullite, along with the melting of feldspar in the clay body. At this point the vitrified clay body starts to react with silica ejected in spinel/mullite formation. At 2195°F, the clay body porosity decreases sharply. From 2012°F to 2282°F, any silica or quartz in the clay body starts to change to cristobalite. If high amounts of cristobalite are formed in the clay body at this point, it can cause cooling cracks in the 392°F temperature range. Cristobalite cracking in clay bodies is often encountered when a kiln stalls or takes an exceptionally long time after c/8 (2280°F)[2] to reach its final firing temperature.[3]

It is helpful to know the exact technical changes associated with ceramic materials subjected to increasing temperatures; such reactions take time whether they are occurring in clay bodies or glazes. Often the most overlooked or unrecognized factor when firing any type of ceramics is the amount of heat work required to reach the end-point temperature. In nontechnical terms, the first high temperature that the pot or sculpture is exposed to occurs in the bisque firing, which prepares the clay for the future glaze firing. A fast bisque firing can result in a clay body crack or, in some instances, an explosive burst in the clay, causing other nearby pots to fracture or explode. This is caused by water in the clay heated into steam. Clay contains mechanical water and chemical water; both have to be driven off slowly. The general rule for bisque firing follows that slow is better than fast, and when in doubt a slow bisque firing can do no harm. A common fallacy is believing that a pot has dried thoroughly because it was kept in the studio for years before bisque firing. In fact the pot is still "wet," since it has assumed the moisture only in the studio atmosphere. Additionally, the pot has chemical water, which has to be slowly driven off in the kiln. For most functional pottery forms (cups, bowls, pitchers, covered jars, bottles, etc.) that are dry to the touch when placed in the bisque kiln, a 12- to 14-hour total firing time is recommended.

Slower bisque-firing times are required if the pots are thicker than ½" or taller than 14". Longer bisque-firing times are essential if plates, tiles, wide-based forms, or thicker forms are fired. A common firing mistake takes place when a potter falls into the habit of firing functional pottery with a "safe" bisque-firing cycle and then tries to fire plates or large sculptural pieces with the same cycle. The plates or larger pieces often crack or blow up, throwing small shards throughout the kiln. Larger or thicker pieces need slower temperature increases to safely release their mechanical and chemical water. A fast bisque firing can also trap organic material in the clay even if the clay is fired to the appropriate pyrometric cone. Organic material, which is primarily but not exclusively found in ball clays, earthenware clays, fireclays, and stoneware clays, needs time to completely burn off or oxidize in the bisque kiln. If there is still carbon in the bisque pottery at higher temperatures, it can volatize as a gas, which is then trapped in the dense clay body, causing bloating or black coring.

Potters by experience and intuition know that if they try to fire a kiln load of pots in 1 hour, the clay body and glaze will look much different as compared to the kiln reaching temperature over a much longer period of time. As stated, ceramic materials need time in the firing process to achieve their vitreous qualities. When glaze-firing stoneware pottery, most clay bodies and glazes will mature successfully if there is a temperature increase of 75°F to 80°F per hour from c/06 (1828°F) until the end of the firing. Why is the characteristic of vitrification or glass formation so important in clay bodies and glazes? In clay bodies the formation of some glass within the clay body makes the fired clay harder, more durable, and less likely to absorb liquid. If fired incorrectly, a clay body can be porous and leak liquid when filled. The porosity of fired clay can sometimes be observed when vases are filled with water, and the next day a dark water stain is observed on furniture.

It is also important to note that a clay body when fast-fired has not achieved its maximum degree of strength. Often this fact is not recognized because the fired clay might look dense and have a ring when hit, but the real question is, Has it reached its maximum fired strength? Fast-fired functional pottery often breaks or cracks under normal daily use in serving or cleaning. However, if a clay body is overfired and develops too much glass, it can slump, bloat, shrink excessively, stick to the kiln shelf, or warp. Going a step further, if a kiln can be fired to increasingly higher temperatures, any clay body can be eventually transformed into a glaze. By using the right clay body formula, the appropriate end-point temperature, and the correct time to temperature, a clay body can achieve strength and durability, all of which increase its functional life. A dense clay body with a compatible glaze formula also allows for a stable glaze fit.

An immature permeable clay body can also cause delayed crazing (a fine network of lines) in the fired glaze. It can sometimes reveal itself days or months after the piece is removed from the kiln. It is critical to note that the fired glaze can never be considered as a "sealant" to contain liquids. The glaze functions only for aesthetic considerations and to achieve a smooth surface for ease of cleaning. By firing the glaze kiln too fast, it can look intact and perfect, but the potter does not realize that the underlying clay body is still porous and can leak. The potter is often under the false impression that just because the glaze was fired to the correct temperature or cone, it has achieved an acceptable amount of heat work. A fast kiln firing can affect glazes in several visible ways, resulting in a dry, rough, or dull surface texture; immediate glaze crazing; pinholes; blisters; a muted or dull glaze color; and a less durable glaze surface. Fast firing can also cause increased solubility in a glaze, which can reveal itself as staining on plates or functional pots due to the weak acids found in certain foods. A "soft" glaze surface might look perfect, but it can be easily scratched and dulled by exposure to abrasive cleaners or alkaline dishwasher liquids. In floor tiles a less durable glaze surface will wear and scar due to the inherent abrasive qualities of dirt. In glazed outdoor ceramic sculpture, the installation might be subject to acid rain effects due to an immature, partly soluble glaze.

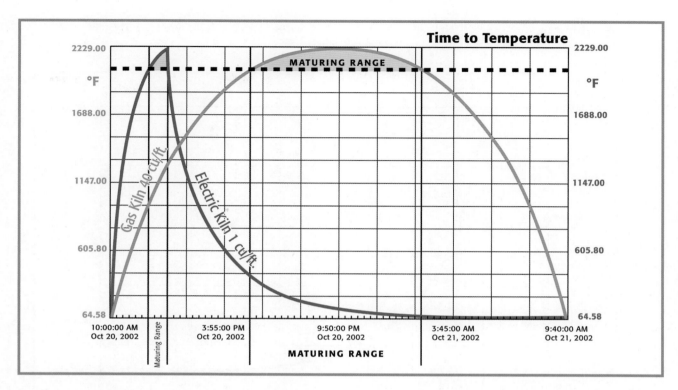

Larger gas kilns (red line) due to increased thermal mass, produce longer times in the glaze and clay body maturing range than smaller electric kilns (blue line).

Gas vs. Electric Kiln Firing to 2229°F

As the heating-and-cooling chart shows, both kilns were fired to 2229°F. The electric kiln (blue line) stayed in the glaze-maturing range (yellow section) for a shorter time as compared to the gas kiln (red line), which remained in the maturing range (yellow section) for a longer time. The 40 cu. ft. gas kiln, having a greater thermal mass in bricks, posts, shelves, and pots, increases and decreases temperature at a slower rate than the smaller 1 cu. ft. electric kiln. The longer time spent in the clay body and glaze-maturing range, the greater increase in glass formation in both clay body and glaze. Ceramic materials used by potters in clay bodies and glazes respond favorably to slow heat increases and decreases.

Fast-Firing Kiln to 2220°F

The graph represents a kiln firing of 2 hours and 40 minutes to 2222°F. The kiln has been fired to the correct temperature for the glaze, but the time to temperature and subsequent cooling are reflected in the downward "spike" of the heating-and-cooling curve. Ceramic materials need to reach their maturing temperatures

but, significantly, need the appropriate amount of time to facilitate adequate vitrification.

Slow-Firing Kiln to 2217°F

The graph represents a kiln firing of 11 hours and 5 minutes to 2217°F. The kiln has been fired to the correct temperature over a long-enough time to promote increased glass formation in the clay body, resulting in a lower absorption rate than the faster firing to c/6 (see fast-firing kiln to c/6 graph).

Comparison of Cone 6 Glaze in Fast and Slow Kiln Firings

Identical glazes have been fired to c/6 (2232°F). The top glaze has been fired in a fast kiln firing; the bottom glaze has been fired over a longer time to cone 6. The satin matte, semiopaque fired glaze is almost identical in both the fast and slow firings. However, most significantly, the absorption rate of the clay in the fast-fired glaze is 1.40%, as compared to the absorption rate of the clay in the slow-fired glaze of 0.22%. Potters are often

Fast-firing to 2220°F, demonstrating that the kiln reached the correct temperature but did not stay in the maturing range long enough for sufficient clay body and glaze maturation.

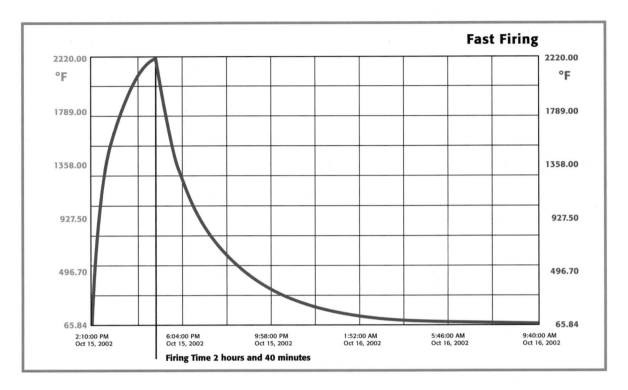

Slow firing cycle (2217°F)

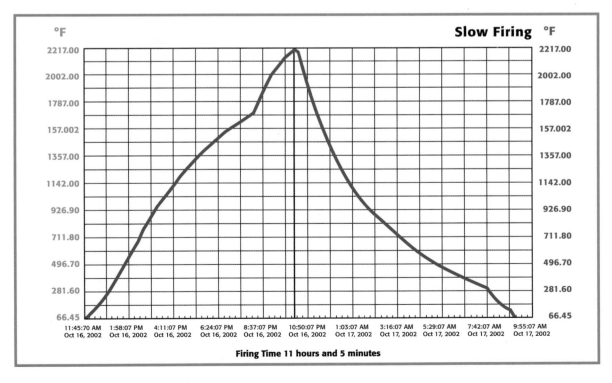

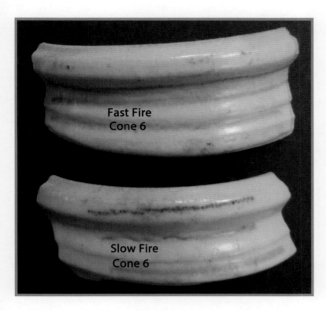

The same glaze fired to Cone 6 (2232°F) in fast and slow firing cycles.

slower temperature increases to obtain their maturity and strength. Often a false economic decision, cutting fuel costs results in costly technical defects with the finished pottery. The economic factors for potential fuel savings in fast-firing kilns are irrelevant when compared to the time and labor lost in flawed ceramic pieces produced by this process. Only by understanding the characteristics of heat work on ceramic materials can the potter hope to get an accurate picture of where to cut costs. In fact the actual cost of equipment, raw materials, and supplies is not significant when compared to a potter's time and labor, which are the two most significant factors in any ceramics operation. A more effective use of cost-cutting procedures should center on how to reduce unnecessary steps in the production of pottery. It cannot be stated enough that the incremental cost of fuel (gas, electric, oil, wood, etc.) by firing a longer time to the clay body and glaze-maturing temperature is not a key factor in increasing the cost of production.

misled by a good glaze result but do not fully realize that the underlying clay body can have a significantly high absorption rate that can result in delayed crazing in the glaze, less durable pottery, and functional pottery that might leak liquids.

2. CHANGING RAW MATERIALS

Economic Factors in Fast Bisque and Glaze Firings

To a greater or lesser extent, economic factors are important when creating ceramic objects. Whether potters are amateurs or professionals, economics play some component in their ability to pursue their individual projects. Whatever the level of experience, a thorough understanding of ceramic materials and their reactions under increasing temperatures is essential. An often-overlooked factor is the heat work or time it takes to arrive at the end-point temperature in order to have a successful ceramic piece come out of the kiln. The defects from fast firing are often not apparent as to their true causes. For example, a fast-fired glaze and clay body can appear intact and stable; however, in time and when subjected to moisture in the atmosphere and normal cleaning, a glaze surface can craze. In this case the actual cause of delayed crazing can be due to an absorbent clay body, which has not reached its maturity even though it was fired to the correct temperature. The fast firing did not give the clay body enough time to vitrify to a point where the glaze was in a stable configuration upon cooling in the kiln.

The most frequent reason given for the fast firing of bisque or glaze kilns is the savings in fuel that will result. While such an efficiency measure might seem logical, it does not take into account that ceramic materials found in clay body and glaze formulas need

Before listing some of the potential problems involving the inconsistency of raw materials, the first question to ask is why individual potters suffer more than industrial users of clay and glaze materials. In the diverse world of ceramics there is a constant material inconsistency that affects all aspects of manufacturing ceramic products produced by professional potters, industry, and hobbyists. The only consistent thing about raw materials used in ceramics is their inconsistency in quality, causing subsequent variations in performance.

With this in mind, let's look at the economic facts of working with raw materials. Specifically, the process of making pottery starts with assembling raw materials either for clay body or glaze formulas. The best formulas are no better than the quality of the raw materials they contain. If there is a failure in the raw materials, the resulting pottery does not have a chance of being successful. Not only will potters lose the actual pot, they will lose the time it took to create and glaze the pot, plus the valuable kiln space it occupied during the bisque and glaze firings.

Clays and other raw materials used by potters and industry start as geologic deposits that can be processed to little or considerable degree depending on *industry* requirements. Industrial users of ceramic materials, which operate with larger volumes than individual potters, can dictate to the mine or processing plant specific quality-control parameters for a raw material or clay because they buy millions of pounds per year. They also have staffs of technical specialists to oversee and correct defects caused by raw-material failures. Their on-site quality-control equipment is also specialized to monitor and correct raw-material variations during production.

This is in sharp contrast to individual potters or small pottery-producing companies, which are undercapitalized, not having the resources or technical organization to monitor raw materials. Individual potters do not generate the ordering capacity to be able

to specify raw-material parameters to suppliers, resulting in a situation where they are forced to use what is available and often not designed for their needs. Potters can incorporate "guaranteed quality-controlled" materials used in industry in their clay body and glaze formulas. In some instances, marginal-quality materials are required due to their unique qualities not found in highly processed materials. However, while imparting unique qualities to the ware, marginal-quality-controlled materials can produce increased amounts of clay body and glaze defects.

Mass-produced functional pottery has several technical advantages over limited-production, one-of-a-kind handmade pottery. Aside from the economics of scale and lower unit costs achieved when machines make thousands of pieces a day, large commercial operations have the resources to set standards and monitor the incoming raw materials. High-quality, consistent raw materials specified by the manufacturer ensure a product uniform in size, shape, and color. Individual potters or small pottery-producing operations are often not aware of a raw-material variability until it is revealed in a defective pot. At that point they are coming to the quality-control stage too late in the production cycle.

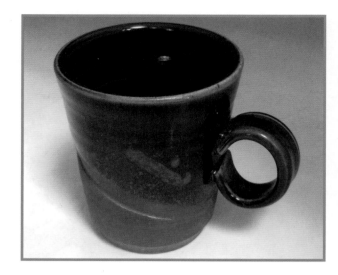

⌃ Handmade cup (individual pottery). Sold for $14.50 at craft show. Higher defect rates.

⌄ White paper containing kaolin, contributing opacity.

⌃ Mass-produced cup (ceramic industry). Sold for $2.99 at many retail stores. Lower defect rates.

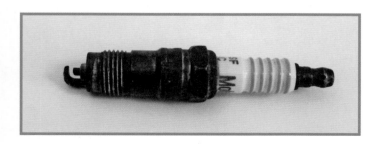

⌃ Ceramic tips of spark plugs are made from refractory, high-quality, white kaolin clay.

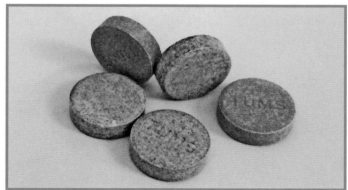

⌃ Calcium carbonate is the principal ingredient found in antacid tablets.

Supply and demand plays an important part in large commercial ceramic operations. If you are a large-quantity user of EPK (Edgar plastic kaolin) and need millions of pounds per year to, say, make spark plugs (which, in fact, does happen), you could then go to the mines and say: "I need a white, easily pressed, high-temperature, clean-burning clay. It also has to be guaranteed to have these properties in every batch to ensure quality control over the entire production run every year." At this point, the management of the mine looks at your large order and agrees on specifications for the clay you want, then sets a price. Everything is fine, the kaolin is delivered to the plant, and spark plugs are produced with no spit outs, iron specks, or other defects, which conceivably can be caused by a substandard material. Kaolins used in the manufacturing of paper are also "guaranteed"; kaolin added during the manufacturing process produces a white, opaque paper that keeps ink from bleeding.

Individual potters do benefit from knowing about this particular situation—meaning one bag of clay being identical to the next, year after year—and use EPK with consistent results. Other virtually guaranteed raw materials are Custer feldspar, nepheline syenite, spodumene, Superpax, tin, titanium dioxide, whiting, dolomite, flint, calcined kaolin, Kona F-4 feldspar, wollastonite, talc, magnesium carbonate, calcined alumina, bone ash, Pyrotrol, soda ash, and lithium carbonate, to name a few. Potters can take advantage of a situation that has been developed by the large players in the supply-and-demand market and obtain consistent results by using quality-controlled raw materials whenever possible in clay body and glaze formulas.

Another quality-controlled raw material commonly used by industry is whiting (calcium carbonate). After processing it is pressed into a popular antacid tablet and sold over the counter. Calcium carbonate is also found in chalk, pharmaceutical products, paints, adhesives, vitamins, and sealants. The demand for calcium carbonate generated by large industries "guarantees" a steady uniform supply for potters. Whiting supplies calcium to glaze formulas, acting as a flux. It is also used in some low-fire, white-clay body formulas to control crazing and promote glaze fit.

Altered, Discontinued, and Substitute Raw Materials

Occasionally, a large industry changes the specifications for products they manufacture, which can result in alterations in the raw materials used to make that product. At some point the potter suddenly finds that a favorite clay body or glaze melts or bloats when using what is thought to be the same raw material. It is then necessary to backtrack and determine if a material has shifted in particle size or chemical composition, or if a substitution has been made without the potter's knowledge. Most insidiously, a raw material used in the clay body can change in the natural deposit, causing an inconsistent result. Raw-material variations can be most detrimental to production in that they are often not discovered

until the pottery comes out of the kiln. At this point a raw-material change that started at the mine or processing plant fully reveals itself, and it's too late for any meaningful correction to take place.

Researching the current state of a raw material used in a clay body or glaze formula will also play an important part in lowering the defect rate at every stage of forming, glazing, and firing. Asking fellow potters or ceramics suppliers about a specific raw material is highly recommended, since they might have current information that can prevent future defects caused by the material. Keep in mind that some ceramics suppliers are not aware of such changes or are purchasing raw materials without checking the chemical-analysis sheet that is periodically published for each material. In fact, such record keeping by suppliers can be time consuming and expensive. The documentation effort required on every raw-material shipment would be hard to justify compared to the relatively low price being charged for raw materials. Ceramics suppliers can offer data sheets on raw materials, and they should be requested by potters at every purchase. They contain the raw-material properties, chemical analysis, and fired properties. Data sheets can then be compared to previous purchases, and any irregularities can be noted. Unfortunately, even after studying the full range of raw-material data—which essentially indicates past performance—most likely at some point a defect will occur in the ware, directly related to the material.

When a raw material is dropped from a manufacturer's production requirements, it is most likely for economic reasons and not because of a geologic shortage or change in the material. With increasing frequency, large US producers are subcontracting the manufacturing of their products to foreign countries that have lower labor rates and production costs. In such instances, foreign materials will be used in the product. The domestic raw-material supply still exists in the mine; it's just not profitable to produce it for only a few potters or ship it to foreign factories. At some point, potters will

Glaze blisters caused by volatilized material in fireclay, exiting as a gas at high temperatures.

⚫ Sharp-edged cooling crack caused by high levels of silica in fireclay changing into cristobalite, causing an inversion in the 1063°F range.

eventually exhaust the supply of the material in their studio or, as a stopgap measure, will buy it from other potters. Eventually they will have to find a substitute that will produce the same effect in their clays and glazes. This scenario has become an increasingly common event that many raw-materials potters have come to depend on. Over the past thirty years, Buckingham feldspar, Kingman feldspar, Oxford feldspar, Albany slip, Michigan slip, Gerstley borate, and many other raw materials, though still in the ground, are no longer available to the small market of potters.

Unfortunately, there is a downside when large industries employ raw materials that are also used by potters. It occurs when the industry changes specifications for the material. Suddenly, a favorite clay body melts or bloats. Something in the raw material that the potter would consider a major defect might not be considered a flaw by a larger user; thus it's allowed into the mine's batch. An example of a good clay for industry that is sometimes a bad clay for potters is A. P. Green Missouri fireclay. Used mostly in the brick and steel industries, it is perfect for their products, but watch out for those specks of iron and manganese; they might ruin your best casserole. Why doesn't the mine remove the "impurities" before it ships the clay? Well, those impurities don't matter to the large industrial users. What are a few large specks in a brick? They aren't considered a defect, so why spend money adjusting or refining clay that is acceptable to 99.9% of the market? Potters will always have a certain amount of difficulty using Hawthorn Bond fireclay, Okmulgee red clay, Kentucky ball clay (OM 4), and other such variable-quality clays. The probability is high that over a given period of time there will be some "shift" in the quality of these clays, which will cause defects for potters.

Individual potters cannot order enough kaolin or other types of "guaranteed" clays to demand a specific level of quality control from the mines or processing plants. They are forced to accept the raw materials as is, which in many instances means particle-size variations, chemical-composition deviations, and tramp material contamination. Inconsistent raw materials and the potter's inability to change this fact are recurrent areas contributing to the

loss of product. While ceramics suppliers as a general policy have limited liability on the clay they sell, it is the potters who suffer the greater loss. A supplier will replace "bad" clay, but potters will not be compensated for their time and labor in producing the defective pots. The potter will also not be compensated for the damage to shelves or other kiln furniture caused by a defective clay or raw material. In many instances the potters must prove that the defect originated in the clay and not in their forming or firing procedures. Regardless, at some point an inconsistent material will cause damage to a whole load of pots, causing a major financial loss for the potters who depend on successful firings for their income.

Now that we know that potters are on the tail end of the raw-material economy, we should realize it's not likely that potters ever wag this dog. Instead, the best course of action is to pick and choose carefully, using "guaranteed" clays and glaze materials whenever possible. Trouble-free glazes and clay bodies can be formulated if potters learn to use their supply-and-demand strengths rather than being discouraged by choosing raw materials blindly. A little knowledge in these areas will produce better results in the pottery.

Raw-Material Characteristics

Particle Size

While clays can range in particle size from 0.1 to 100 microns, an important aspect of any clay or raw material is the particle-size distribution within the material, which reveals what percentages of the particles are fine, medium, or coarse. Particle sizes can be charted out on a graph, giving a "fingerprint" of any individual material or clay. At some point in the mining or processing stages, the particle-size distribution of a clay or raw material can shift or change radically. While such variables are infrequent, the results when they do occur can considerably alter the finished ware. Defects caused by particle-size changes are very hard to discover in the raw materials. Keep in mind that clays and raw materials all look like fine powders, and it is impossible to determine particle size with the naked eye. For example, if a ball clay is used as part of a clay body formula and a shipment comes through with a higher percentage of "fine" particles, excessive shrinkage or cracking can occur in the drying or firing stages due to the extra water required for plasticity.

Raw materials used in glaze formulas are another area where particle size is critical in determining how a glaze applies and how it eventually fires on the ware. If a raw material comes through with a higher percentage of coarse particles, it can cause the glaze to settle in the glaze bucket. Clear, transparent glazes can also appear semiopaque or white due to high percentages of large-particle materials that have not gone into a complete melt. For example, whiting (calcium carbonate) acts as a secondary flux in

high-temperature glazes. Whiting is a generic name for a raw material that is produced in several different mesh sizes, some of which can alter the fired glaze and all of which look deceptively identical in the raw state.

A raw material with a smaller particle size can cause increased melting in a glaze due to the greater surface area of the material coming into contact with the heat work of the kiln. When ordering raw materials, always specify the exact mesh size every time to ensure consistent results.

⌄ Particle-size affect on glaze.
An example of a glaze that is too fluid, running on vertical surfaces. Nepheline syenite 400x mesh is the primary flux in this glaze. Its finer particle size has produced a greater degree of melting in the glaze.

⌄ Raw materials can be inconsistent. Just because the name on the bag stays the same, it is not guaranteed that the raw material is the same in every bag.

⌄ Larger-particle-size whiting used in clear glaze, causing opacity in glaze due to incomplete melting of the whiting.

⌄ Particle-size affect on glaze.
The same glaze formula with a larger-mesh nepheline syenite 270x does not run on vertical surfaces.

Chemical Composition

The chemical composition of any ceramic raw material or clay can influence its handling characteristics, forming qualities, fired texture, and color. Higher-than-normal amounts of silica or fine-grained quartz (silica) found in clay can also cause quartz inversion cracking in clay bodies when heated and cooled too fast in the 1063°F region. In clay bodies fired over c/8 (2280°F), any quartz present in the clay body starts to change to cristobalite. If enough cristobalite develops, it can go through a cristobalite inversion and cause cracking if cooled too fast in the 392°F region.[1] All these events can be magnified because the chemical composition of a clay has changed, sometimes from one bag of clay to the next.

Factors that can radically change a glaze are associated with the loss on ignition of raw materials. Chemical water plays the largest part, with carbon and sulfates contributing to lesser percentages of loss on ignition. Excessive shrinkage of high mechanical or chemical-water concentrations found in raw materials such as Gerstley borate, borax, and colemanite can cause the raw glaze to fly off the pot and onto kiln shelves during the first part of the firing. In such instances, after the firing a "halo" of glaze debris is often found around the base of the pot. Such a violent reaction is more likely to happen if the kiln is heated too fast from 212°F to 1100°F.

In slip-casting clay bodies, sulfate and soluble salts found in clays are a factor, which can greatly influence the amount of deflocculant (a suitable soluble electrolyte such as sodium silicate, an alkali, added to the clay water structure, causing greater fluidity in the slip) required to achieve the proper flow rate or viscosity in a casting slip. Over time, excessive sulfate growth in slip-casting bodies neutralizes the deflocculant, yielding a jellylike casting slip that cannot be poured into molds. In throwing and handbuilding, a clay body's soluble salts can interfere with the glaze and also leave a residue of white crystals on unglazed areas of the fired ware.

⌃ Chemical composition of clay.
Higher levels of fine-particle silica found in clays can cause quartz or cristobalite inversions in the heating or cooling stages during the firing cycle. This inconsistency in the raw material can result in sharp-edged cracks in the fired ware.

⌃ Chemical composition of clay.
Clays can have fluctuating levels of soluble salts, which can migrate to the surface during forming, drying, or firing stages, leaving a white crystal powder.

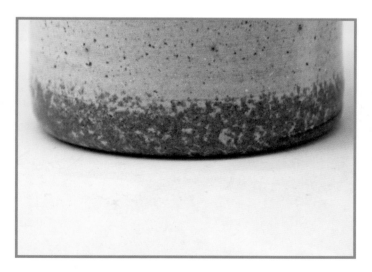

⌃ Chemical composition of clay.
The chemical composition of clays can change from one shipment to the next. Fireclays can contain nodules of chalcopyrite ($CuFeS_2$) and erubescite 3 ($2CuSFe_2S_3$); both release copper, which can cause green specks in the clay body.

Crude Color

Each clay, whether an individual deposit or blend, has a characteristic crude color, which can be tan, off-white, white, buff, brown, etc. If a new batch of clay suddenly changes in crude color, it could be indicative of a mistaken shipment resulting in a different brand of clay. Any time a raw material has to rebagged, there is the possibility of error. It is always best to buy full bags (50 or 100 lbs.) of clays and raw materials that are commonly used in clay body and glaze formulas. While this might seem like it can lead to a large raw-material inventory, keep in mind that typically ten to twelve of the same raw materials are found in over 80% of glaze formulas.

Crude clay color can also come from naturally occurring metallic oxides such as iron in several different forms, resulting in various crude colors. Unlike organic materials in clays, metallic oxides will influence the fired clay body color. In clay bodies and glazes, whenever a raw material changes color it should be investigated before committing to using the material.

Organic Level

Crude color can also indicate high levels of organic materials in the clay. In some instances it does not affect the fired clay, but if organic materials are not volatilized out completely during

the firing, they can cause black coring or bloating. The organic level of clays can fluctuate depending on the specific clay pit or mine from which the clay is taken. While minor changes in organic materials are not generally severe, a problem can occur when a clay comes through with a higher-than-normal level of organic material. For this load of clay, a normal firing cycle in the kiln cannot oxidize or clean all the organic material in the 662°F–1292°F temperature range. This circumstance can lead to bloating, black coring, or both, conditions that are closely

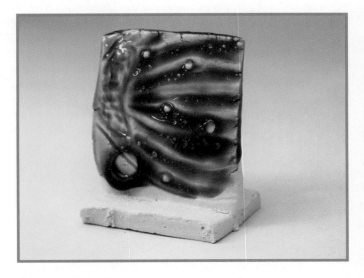

⌃ Organic level.
One type of blister in the glaze is formed when carbonaceous material in the clay body is not completely driven off during the first stages of the bisque firing. The carbonaceous material remaining in the clay body then turns into a gas, which is released into the glaze during the subsequent glaze firing.

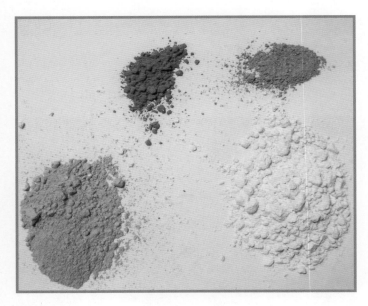

⌃ Crude color.
Many raw metallic coloring oxides or stains (top samples) do not look like their fired color when introduced into clay bodies or glazes. Clays, feldspars, talcs, flint, whiting, dolomite, magnesium carbonate, and other ceramic raw materials (bottom samples) are white, off-white, or tan in raw color, and their raw color can sometimes differ from the fired color.

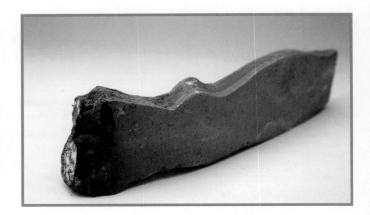

⌃ Organic level.
If excess oxygen in not present in the first stages of the bisque firing, organic material in the clay is trapped, which can cause bloating in the fired clay. If the clay body contains iron and there is a lack of oxygen in the kiln, CO is formed with carbon present in the clay to produce black coring.

related. If an oxidation atmosphere is not present to remove carbonaceous materials in the clay, glass formation can trap gases, causing bloat or bubble within the clay body. If an oxidation atmosphere is not present and the clay body contains iron, carbon in the clay can react with the lack of oxygen to form CO, which reduces the iron to a strong fluxing agent. The reaction can cause a black core in the clay body. High levels of organic material trapped in the clay body can also cause the glaze to blister; the material turns to gas, which is then released into the molten glaze. In the case of ceramic raw materials, knowledge is power. The more that is known about possible irregularities in the material going into a product, the more control measures can be developed to counter the possible variable qualities inherent in the material. Potters suffer, since they do not have the economic resources to demand better-quality clays. They also suffer because they cannot incorporate the economies of scale, with its subsequent lower unit cost, for their pots. Potters essentially want a low-cost, marginal grade, inconsistent material (clay) to somehow produce a uniformly high-quality pottery product. They are also under economic pressure to compete against commercial mass-produced pottery. This unrealistic economic situation cannot be met, and it often leads to frustration and failure. The only defense against such economic "facts of life" is to know the materials thoroughly and to be always on guard for irregularities with every shipment.

3. EVER-VARIABLE CLAY

Whether you are a professional potter or a six-year-old sitting in summer camp, the moist clay in your hands is a more complex amalgamation of ingredients than you might realize. While low-temperature, white-clay bodies might contain only talc and ball clay, most clay bodies contain various mixtures of clay(s), flint, feldspar, talc, grog, and other raw materials. The individual raw materials are combined in different amounts and ratios to form a *clay body* formula. The clay body formula should reflect the forming process (handbuilding, wheel, slip casting, ram press, or jiggering), firing temperature (c/06, c/6, and c/9 are common), fired color (white, tan, brown, etc.) kiln atmosphere (oxidation, neutral, reduction), and special effects such as salt, soda, or wood firing. Each characteristic will determine the amount and type of raw materials that will be used in the clay body.

While change is evident in every aspect of ceramics, whether in the forming or firing, it is important to understand where it is most likely to occur, which is in the clay. Understanding clay and how it is mined is the first step in learning how to cope with and adjust to this dynamic material. Clay is formed by a series of geological events and is eventually mined from the ground, marketed, and sold with the implication of its being a uniform product. Unfortunately, clay is not a consistent commodity; in fact, it is always changing, sometimes with no ill result to the potter, but sometimes with drastic reactions that can cause any number of defects.

Potters must always think of their clay as subject to change at any time. When variations in chemical composition, particle size, organic content, or fired color occur, it should not be totally unexpected; it is in the nature of the material. The type of clay mined and its processing can greatly influence its performance. The sequence that clay goes through, from its first discovery in the earth to its eventual use by the potter, is an important aspect in understanding this unique material.

Clay-Mining Operations

In a typical clay-mining operation, test holes are first drilled in a geologically likely place, which will indicate the estimated reserves of a particular type of clay deposit. A specific block or area of clay is defined, and the overburden or topsoil is removed, exposing the underlying seams of clay. A few deposits in Kentucky are fortunate in that the overburden can be screened to remove sand or gravel, which can then be sold to construction and landscaping contractors for economic benefit. Most deposits have overburden stockpiled for later use in reclaiming of the mine. One clay deposit can cover approximately 20 acres and produce 4,000,000 tons of clay. Most clay companies have less than twenty end-point clays, which they blend for market-grade clay. It is not unusual for a clay-mining company to have dozens of different blended grades of clay and over one hundred years of reserve, depending on geological conditions at each site. Blending of individual deposits ensures a prolonged life for the mine and improves the quality control of the blended-clay product.

In some instances, groundwater has to be pumped out of the excavation site to facilitate the removal of the raw clay. The clay is then trucked to a storage shed for drying and processing. Once

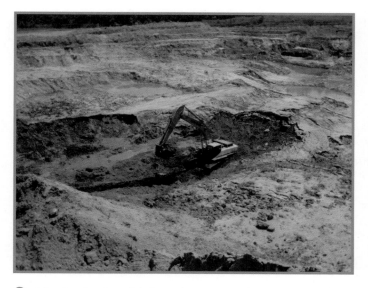

After the clay deposit is located, scrapers and tractors are used to remove the overburden.

the clay reaches the shed, it can be processed for sale in the forms of shredded (large clay chunks), air floated (fine particles separated form larger particles), or slurried clay (clay blended with water). Another operation air-floats the clay to ensure a standard particle-size distribution within the batch, which is an important factor in casting-slip formulas. Clays from different sites are then blended to ensure uniform product and properties. Diverse quality-control procedures are carried out during the processing stages to monitor physical properties, particle-size distribution, chemical analysis, and fired properties. Specific operations and procedures for mining clay may vary according to the mine site.[1]

Same Name—Different Clay

Clay mining is a large mechanized industry supplying diverse manufacturing operations with the raw materials needed to produce many products. Economic factors, standardization of product, and

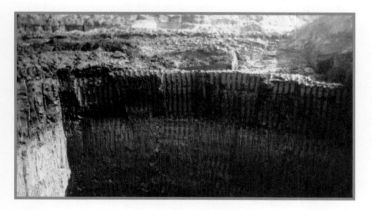

Typical "clay cut" showing overburden; dark gravel from the overburden.

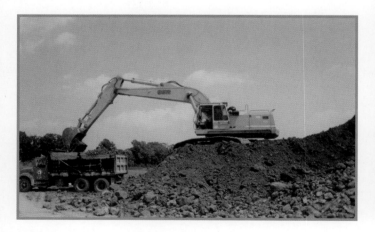

Excavator placing clay in a truck.

the demands of the marketplace dictate the blending of clays from different sites to form a reliable uniform product. While the blending/mining process meets the demands of large industrial users, it frequently reduces the "unique" qualities of a clay drawn from a single pit or deposit. Individual ball clay deposits can be limited in quantity as to consistent mineralogy, chemistry, and physical properties. The mine has to ensure a reliable long-term product, and it is more efficient to blend several different clay deposits to achieve a standardized mixture of clay for sale now and in the future. For potters there is a trade-off in the quality controls and uniformity that benefit industry: the loss of the subtle clay characteristics and distinctive "feel" of a single-pit unblended clay. Potters represent less than one-tenth of 1% of the raw-material market for mines, and they could not theoretically exhaust a single clay deposit site; it would not be economically viable for the mine to set up their operation for potters. It is important to know that clay mines are geared to supply their largest markets and not their smallest.

An example of single-deposit clay was Kentucky Tennessee Clay Company's Old Mine #4 ball clay, which was originally taken from one clay pit. Now Old Mine #4 clay is a blend of several clays to approximate the original clay deposit; however, potters have noticed a significant change in the clay over the years from its original unique characteristics. The Old Mine #4 name on the clay bag stays the same, but the clay has changed. While the mine is trying to keep the clay uniform—which is required for mechanized production practices—potters are looking for a clay that has some "character" and offers distinctive handling and firing qualities to their handmade objects. In one sense the mining companies' clay-harvesting practices and the potters' requirements for distinctive clay are at odds. Unfortunately for potters, ball clays from various mines are now blended as a standard industry practice.

After the air-floating process, clay is packaged in 50 lb. bags and 2000 lb. bulk sacks ready for shipment.

The Clay Is Always Changing

There are several factors that can change a clay body; some take place subtly over years, and some are more dramatic and can occur immediately with the first bag of clay opened. In any ceramics activity, the more information the potter can access, the better able they are to interpret and solve problems with clays and other ceramic raw materials. The actual raw materials that compose clay bodies are always changing in mechanical-water content, chemical-water content, organic content, pH level, particle size, mineral content, and tramp material (contaminants found in the clay deposit or inadvertently added in the mining or processing stages).

Other variables can occur when a higher iron content in a particular clay results in a darker fired color. A shift in the silica content of a clay can adversely influence a future glaze fit. Sometimes a change will occur in a single bag of clay, causing a clay body or glaze defect. Occasionally, a clay alters over a period of months or years, causing a shift in a clay body color or texture. While the clay mine and the ceramics supplier strive for consistency—and for the most part succeed—a few small changes in clays can add up to a big change for the entire formula.

Think of one or more of the raw materials that form a clay body formula as a train. We imagine that the train is stopped at the station; for example, Jake's Clay Body is what we buy because it always produces the same handling qualities and fired color. The shrinkage and absorption rates are always the same, and the name on the box is always the same. It implies that the clay is unchanged from batch to batch or from one year to the next. The reality of Jake's Clay is that of a moving train; sometimes the train moves slowly and the changes are not significant or noticed, but now and then the train moves fast, resulting in Jake's Clay cracking upon cooling in the kiln, shrinking excessively in drying, or producing a different fired color. In fact Jake's Clay is always moving and changing and will always do so in the future. The real question is this: How much will the clay mutate, and will it be significant to us as potters?

There are many reasons for a clay body to fluctuate, some of which involve a predetermined adjustment by the potter who mixes their own clay or the ceramics supplier who mixes and sells moist clay. For example, if a raw material used in a clay body is out of stock or has gone out of production, a substitution can cause unforeseen variations. Such substitutions are only as accurate as the technical knowledge and testing performed on the clay. A clay body can also fluctuate due to inaccurate weighing-out of the dry materials or incorrect mixing procedures by the individual potter or clay-mixing staff. Preventing this type of negligence depends on the expertise of the ceramics supplier or potter who is mixing the clay.

Clay bodies can be altered due to variations in individual raw materials. Whenever a change occurs, it always has the potential to alter the clay body's shrinkage, absorption, handling qualities, drying characteristics, and fired color. In some instances more than one change is taking place, unknown to the person mixing the clay. Since one or more types of clay (fireclays, stoneware clays, ball clays, kaolins, earthenware clays, bentonites) make up

the major ingredient in a clay body formula, it is most important to know their individual qualities and their interactions with each other. The following is a list of several factors within clays that can shift, causing alterations in handling, firing characteristics, or both. It is important to note that a change or shift in clay composition can occur in each component in the clay.

What's in Clay

Mechanical Water

Mechanical water in clay is composed of the moisture content in the raw clay (average 1%–4%) plus any water added to obtain a plastic workable mass of clay (average 25%) for forming operations. Ceramics suppliers package their premixed moist clays in plastic bags in 50 lb. increments. Once the moist clay is taken out of the plastic bag, it begins to stiffen due to water loss. Actually, the moist clay has been losing water since it was first mixed due to the semipermeable quality of the plastic bag. Whether sealed in plastic or out of the bag, at some point the clay cannot be formed into a plastic mass due to mechanical water loss. However, there is still mechanical water trapped in the clay. The next step in a clay body's shrinkage occurs at the "leather hard" stage, which is characterized by the clay being cold and damp to the touch and nonplastic. At some point the clay becomes bone dry—which is not an entirely accurate phase—but the clay changes color, and all visible water is absent. At this stage the clay is at its most fragile. A common misconception is that if we let the "bone dry" clay dry for months or years in our studio, it will become drier. Unfortunately, the clay assumes only the moisture content of the studio, which means there is still mechanical water trapped within the so-called dry clay. Mechanical water is removed in the bisque-heating cycle by 212°F. If the clay is heated too fast in the first stages of bisque firing, mechanical water turns to steam, which expands and can cause the pot to crack or in extreme cases blow up. This is commonly known as the "shrapnel effect," which can also induce adjoining pots to blow up or crack. It is always best to fire the bisque kiln slowly to allow the protracted release of mechanical water.

Chemical Water

Chemical water is part of the hidden structure contained within the clay body. Clay is theoretically composed of one part alumina, two parts silica, and two parts chemical water, which can be stated as Al_2O_3 2 SiO_2 2 H_2O. If the chemical-water component of clay is released at too fast a rate, it can also cause the pots to crack in the first stages of the bisque firing. As a general guideline for most functional pottery (1"–14" tall and 1"–8" wide, with a thickness of ¼"–⅜"), the kiln should be fired slowly between 212°F and 1200°F.

On average, a 10- to 12-hour total firing time in an electric kiln is not unusual for a bisque to cone 06 (1828°F). Thicker or larger pots/sculpture will require a longer time to temperature to remove any mechanical and chemical water in the clay structure. The slow increase in temperature will give the larger ceramic forms enough time to release water at a safe rate. When heated, the clay body is releasing water, which results in an average shrinkage rate of 4% to 6% from the leather-hard consistency to the fired-bisque stage. As with removing mechanical water, chemical water is driven off between 842°F and 1112°F, which approximates dull-red visible heat in the kiln.

Organic Content

Clays contain organic material, which is formed by the breakdown of plant life, twigs, and roots during the clay's formation process in the earth. Each type of clay contains different levels of organic material, which can also fluctuate from one part of the clay deposit to the next. Another reason for a long-duration clean (oxidation atmosphere) bisque firing up to 1200°F is to completely remove any carbon caused by the clay's organic content. If carbon is not removed, it can be sealed in the vitrified clay body. As the carbon turns into a gas at higher temperatures, it can cause pinholes or blisters in the glaze surface or bloating in the clay body. The level of carbonaceous materials in a clay body can fluctuate from one batch to the next. A successful bisque-firing cycle, which has produced clean bisque pots in the past, might not continue to remove all the organic material in the clay if the new load of clay comes through with a higher-than-normal organic level.

pH Levels

The pH level in clays refers to the alkalinity or acidity of the clay. The pH level could vary as much as 0.5 within the same batch of clay or other raw materials used in clay body formulas such as feldspars or flint. Most clays are slightly acidic, usually 4.5 to 6.5, with 7.0 being neutral and above 7.0 being alkaline. Acidic clays and raw materials cause the moist clay body to bind together, exhibiting greater plasticity and improved forming characteristics. When being thrown on the wheel, the clay will stand up more firmly between pulls. In throwing and handbuilding, clay body flocculation (aggregation of clay particles, caused by acidic conditions in the moist state) is a very beneficial quality. The moist clay "knits" together and does not deform under pressure when throwing or handbuilding.

The opposite effect occurs when alkaline clay or raw materials are used in a clay body. They promote thixotropy, a condition in which the moist clay becomes softer when pressure is exerted on it. The clay body under high pH alkaline levels is "rubbery" and "sticky" when thrown on the wheel or used in handbuilding operations.[2] After pulling up a moist clay form on the wheel, potters find a great amount of slurry clay in their hands. Alkalis in clays or raw materials used in clay bodies cause clay particles to repel each other, resulting in minimal clay adhesion. The negative handling qualities of high-alkaline raw materials are most noticeable in porcelain clay bodies. In other types of clay bodies such as stoneware, raku, salt/soda (sodium carbonate vapor firing), earthenware, and casting slips, soluble alkalis can also cause thixotropy. In slip-casting clay bodies, a variation in pH levels (acidity/alkalinity) from the water source or raw materials can affect the deflocculation or dispersion of particles in the slip. In many instances, each new batch of slip has to be recalculated for the correct levels of water and deflocculant to achieve consistent casting requirements.

Alkaline materials used in clay bodies can break down or become soluble at different rates depending on the specific material, the pH level of the clay-mixing water, the combination of other ceramic raw materials in the clay body formula, or combinations of these. It is important to think of combinations of clay and water as dynamic reaction systems that can cause the moist clay to behave differently at various times and under different storage conditions. For example, a moist clay body can slowly depart from a flocculated (tight) to partially deflocculated (rubbery) state over a period of time in storage, due to the breakdown of alkaline materials within the clay body. While not generally considered as a variable in moist-clay production, the pH level of the water used to mix the clay can alter the handling and forming qualities of the moist clay by increasing the release of soluble alkaline materials in the clay body.

Particle Size

Clays are composed of microscopic platelet structures that uniquely interact with water on many levels to form a plastic mass. While all dry clay looks like fine powder, there can be quite a difference in the size of each platelet contained within that powder. Platelet size and the distribution of sizes within a given clay depend on the type of clay and, in some instances, on how the clay was processed. Fireclays will have a larger platelet size than ball clays. Particle-size distribution within a specific type of clay (e.g., ball clays, fireclay, earthenware clay, stoneware clays) can be critical in determining the clay's handling qualities. The particle-size distribution reflects the range of platelet sizes in a particular clay. For example, if there are too many small platelets in a clay, excessive warping and shrinkage can occur. A high percentage of small platelets will have a greater surface area, requiring more water to achieve plasticity. The moist clay can also have a "gummy" or "rubberlike" feel in forming operations. Drying cracks can develop where a handle or an applied piece of clay meets the body of the pot. This type of crack is caused when water evaporates from between the body of the pot and the clay applied to the pot, resulting in dry clay platelets separating.

The rate of failure for any moist clay depends on several factors. Even the best quality-controlled raw materials are sometimes inconsistent in terms of particle size, chemical composition, and organic content. For example, fireclays are noteworthy in terms of their inconsistency. As a group of clays they illustrate the inconsistency that is found in other clays, but fortunately to much lesser degrees.

Fireclays can constitute 15% to 30% of the clay component in many stoneware clay body formulas. Fireclays by definition are coarse and refractory and can contain large nodules (2–3 mm) of manganese dioxide and iron. Large nodules of manganese in clay can produce black "spit outs" or depressions in the fired clay's surface caused by the decomposition of gas when manganese is heated. Iron oxide particles, being fluxes, tend to produce brown, smooth, irregular-shaped blotches on the clay's surface. Both conditions are visible when the large-particle metallic oxides contained in fireclays are fired in reduction kiln atmospheres. The size of the manganese and iron nodules and the amount of reduction are the determining factors in acceptable brown and black specking or brown and black irregular concave and convex defects in the fired clay. Such defects can disrupt a smooth surface on functional pottery, making it unsanitary. It is important to note that iron and manganese specking can be an aesthetically desirable feature in the fired clay when particle sizes are small and do not compromise the functional pottery's surface.

Fireclays can also contain coal, lignite, sand, high levels of free silica, and other impurities, all of which can drastically fluctuate from one bag of clay to the next. If your moist clay contains a bad batch of fireclay, a whole kiln load of pots can be ruined. The mine does not care about this kind of defect in the fireclay. The large industry that uses the fireclay finds it perfectly acceptable for their use, and the ceramics supplier may not be aware of the defect when they mix their clay formulas. Any or all of these conditions can at some point cause a failure in the clay body.

Mineral Content

The mineral content of any clay can change radically depending on the type of clay (e.g., ball clay, stoneware clay, kaolins, earthenware clay, bentonites, and fireclays). For example, ball clays typically contain 75% kaolinite, 20% free silica, and 5% trace elements. Free silica (not bound up with the clay particle) in ball clay can average from 15% to 30%; it is in the form of silica crystals floating around the clay particles. High levels of silica in the clay body in any form can cause heating and cooling cracks. Free silica is also very refractory, which can increase the maturing range of a clay body, causing glaze fit problems and high absorption rates in the fired clay body.

Loss on Ignition (LOI)

LOI is defined as the loss in weight of clay when it is heated under specific conditions. The loss on ignition is stated as a percentage of the clay's dry weight.[3] In ball clays, chemical water is the largest component in loss on ignition, followed by organic materials, which are carbon. Any sulfate found in the clay is the smallest part of the total percentage in the LOI component.

Tramp Material (Contaminants)

Tramp materials are found not only in clays; they accompany other raw materials used in clay body and glaze formulas. Tramp contaminants are more likely to be found in clays and raw materials not used by large industries, or, if used, their particular contamination is not relevant to the industries' specifications for the material. Fireclays are commonly utilized in the metal-casting industry, where their contamination by sand, manganese, and iron is not a factor.

Some other variable-quality materials, due to their mineral content, are Gerstley borate, plastic vitrox, wood ash, volcanic ash, Barnard Black Bird clay, various slip clays, and local clays. While there is nothing inherently flawed about these materials, they do contain tramp components. Many metallic coloring oxides also carry trace amounts of contaminants, which can subtly affect clay body and glaze colors. For example, copper oxide, a colorant in glazes, can contain trace amounts of iron, lead, calcium, sodium, and other heavy metals.

As the name implies, tramp material hitches a ride with some clays and raw materials commonly used in a clay body or glaze. In some instances it is the cause of a defect but can also enhance the aesthetic or functional quality of the fired ceramic piece. Contamination found in clays can range from coal, lignite, and other organic materials to, surprisingly, metal nuts, bolts, and cigarettes, but this last category speaks more to poor quality control and packaging at the mine. A common contamination is found in Gerstley borate, a popular glaze material. Gerstley borate contains ulexite ($Na_2O\ 2CaO\ 5B_2O_3\ 16H_2O$) with small amounts of colemanite ($2CaO\ 3B_2O_3\ 5H_2O$) and probertite ($Na_2O\ 2CaO\ 5B_2O_3\ 10\ H_2O$), along with gangue (pronounced "gang"). Gangue is composed of bentonitic clay and other insoluble or "tramp" materials. The bentonitic clay gangue typically contains calcium and silica; in addition, there are small amounts of sandstone and basalt, which are revealed as brown/black "pepper" specks in the off-white raw Gerstley borate powder. The gangue component in Gerstley borate aids in glaze application because it allows the glaze to dry evenly and fast on the ceramic surface. Glazes that contain ulexite and colemanite are not to be confused with Gerstley borate but can give similar glaze results; however, they can cause glaze application problems due to their lack of impurities.

It is possible to formulate a clay body or glaze that is based only on pure oxides of silica, alumina, iron, calcium, magnesium, potassium, and sodium, but it will not exhibit the same handling or fired qualities as the mined raw material containing the identical percentages of the pure oxides. For example, using equal parts of calcium carbonate and magnesium carbonate in a glaze formula in place of the naturally occurring ore dolomite ($CaCO_3\ MgCO_3$) will not produce the same fired-glaze result. Ceramic materials formed by nature, along with their trace contaminants, fire to a greater homogeneous melt as compared with straight oxide substitutions. The occurrence of tramp or organic material associated with clays often increases their plasticity and handling characteristics along with contributing visual uniqueness that would not be evident in clays that were theoretically "pure." However, there are certain limitations as to the type, size, shape, and

amount of tramp material that will cause problems when an "out of spec" clay is used as part of a clay body formula.

After learning about the many ways that clays can and do change, the potter must first accept another truth: nothing remains static in ceramics. In fact, other aspects of such a dynamic system often contribute to the exciting qualities of color and texture found in clay and glazes. Not all change is bad, but shifts in a clay's chemical composition, organic content, particle size, or other characteristics do in fact have to be adjusted if they contribute to a functional or aesthetic defect that the potter does not desire. In practical terms, if you are a production potter who depends on consistent clay body and glaze results to fulfill retail and wholesale orders, it is best to use clay body and glaze formulas based on so called "guaranteed" raw materials that do not change significantly from one batch to the next.

4. FIRECLAYS

Pottery and Industrial Applications for Fireclays

Fireclays are used in diverse ceramic products such as floor and wall tiles, functional pottery, and sculptures. They are also used in many high-fire clay body formulas. Knowing how they are mined and processed will help the potter to better understand their strengths and inherent defects. There are relatively few fireclays in the Unites States compared with ball clays or kaolins, and substitutions within the fireclay group are limited. Fireclays are the most problematical of all types of clays used in clay body formulas. Their high incidence of producing defects and the limited choice of substitutes require an understanding of this material's limitations and benefits.

The amount and type of fireclay in a clay body formula depend in part on the cost of bringing the fireclay to the point of manufacture, whether it is a ceramics supplier or individual potter. The cost of shipping fireclay or any clay is often as expensive as the cost of the material. This consideration is apparent when ceramics suppliers stock raw clay and use clays in their moist-clay-body formulas in part on the basis of the lowest shipping cost. It is unusual for West Coast ceramics suppliers to use midwestern fireclays in their stock clay body formulas when West Coast fireclays are available and offer lower transportation costs. However, some large West Coast suppliers can make the capital investment to also stock midwestern fireclays as part of their inventory. East Coast ceramics suppliers are also reluctant to carry West Coast–mined clays for the same economic reasons.

Fireclays are refractory clays with relatively coarse particle size and low shrinkage that are mainly employed as a component in medium-temperature (2232°F, cone 6) to high-temperature (2300°F, cone 9) clay body formulas. However, they can be used in low-fire (1828°F, cone 06) clay body formulas, contributing a coarse particle size and "tooth" to the forming qualities of the moist clay. Fireclays can constitute 5% to 30% of a clay body, depending on the firing temperature, forming method, fired color, and intended function. However, in sculpture and tile clay body formulas they can exceed 30%. Fireclays in any temperature range of clay body formula decrease dry and fired shrinkage, offer a diverse particle-size clay, and decrease dry and fired warping. Significantly, they enable the clay body to withstand high-temperature pyroplastic deformation, which can result in the clay body slumping, bloating, or fusing to the kiln shelf.

As their name implies, fireclays are primarily associated with fire or heat. While the refractory nature of the clay becomes evident when used, fireclays can also contribute particle-size variation to a clay body, which enhances its forming characteristics. Why is it important to know about fireclays? As a type of clay they offer the potter the most cause for concern when used as part of a clay body formula, and thus deserve vigilant inspection and care when introduced into a clay body formula. While other components of the clay body have their own potential for producing imperfections in the forming, drying, glazing, or firing stages, fireclays are statistically more likely to be the origin of faults in comparison to ball clays, stoneware clays, bentonites, earthenware clays, feldspars, flint, talc, or any of the other raw materials that can compose low-, medium-, or high-temperature clay body formulas. Understanding the characteristics of each fireclay and how it's mined and processed can offer valuable information on which one to use in any ceramic project.

Origin of Fireclays

The geologic formation of fireclays depended on rock from the earth's crust weathering by wind, rain, heat, abrasion, freezing, and changes in temperature. The raw materials were transported

Representative raw fireclay after processing and formed into fired bar at c/9 (2300°F).

to acidic waters containing roots and vegetation, resulting in finely divided minerals containing silicates of alumina along with other materials. After the Sturtian and Marinoan glaciations of the Cryogenian period (800 to 600 million years ago), the meltwaters receded, leaving sediment and silt ground by the diminished glaciers. Streams moved the remaining fine-particle material to other locations, resulting in different types of fireclay depending on the local geology. Almost all fireclays are formed by their movement along streams, eventually forming into beds. Clays of this type contain impurities gathered on their travels, which can contribute to their plastic qualities, fired color, particle size, organic content, and refractory nature.

Consequently, the American Ceramic Society defines fireclay as "sedimentary clay of low flux content," which enables them to withstand high temperatures before deforming. Generally, fireclays can have a pyrometric cone equivalent (PCE) from cone 31 (3022°F) to cone 36 (3268°F). The pyrometric cone equivalent is a classification of the softening point of a material; in this case, fireclay. The fireclay is shaped into a "cone" and placed in a cone holder with a series of known Orton pyrometric cones close to the temperature where the fireclay is projected to soften. The cone holder is placed in a specially designed furnace, and the temperature is raised on a schedule until the fireclay cone bends over and the tip touches the cone holder. At this point the sample is removed and the cone in question is matched with the "standard" cone and given a PCE value.

Typical Fireclay-Mining Operations

Christy Minerals offers an example of one type of clay-mining operation. The mine is located approximately 50 miles west of St. Louis, Missouri. They use selective open-pit excavation to extract Hawthorn Bond fireclay. The top layer of overburden is taken away and the clay seam is exposed. After carefully removing the clay, it is stockpiled and weathered for 12 to 18 months, causing it to break down. The natural freeze/thaw conditions plus rain and sun hydrate and dehydrate the clay platelets, ultimately improving consistency and plasticity. The clay is then transported to the plant, where it is dried and placed in a covered shed until it is ground to the appropriate mesh size. There are several grinding methods depending on the desired grain size and distribution of the product. Then the material is tested for particle-size distribution and placed in packaging ranging from 50 and 100 lb. paper bags to larger 3500 lb. super sacks.

Roller Mill, Air-Floating, and Hammer Mill Systems of Clay-Processing Equipment

Raw clay is rarely taken from the mine site without some form of processing. Over 99% of clays are destined for use by industry and the commercial sector of the economy. Clays for commercial applications require a degree of uniformity and quality control, but not necessarily the same kind of processing that potters require. Two machines used in the preparation of raw clay are the roller mill and the hammer mill.

In a typical roller mill operation, some of the free moisture is removed from the clay as it is fed between a ring and a series of rolls that spin around the inner diameter of the ring, where it is ground and dried. It is then thrown between the ring and rolls by plows. A stream of air lifts the finer clay particles up to a whizzer (fan blades); the faster the blades spin, the finer the clay particles need to be to pass through the whizzer. Once through the whizzer the clay/air stream goes to a cyclone collector, where the clay is separated from air during the air-floating process. The clay then goes to a packer, where it is bagged and ready for shipment. Greenstripe is an example of a roller-milled, air-floated fireclay.

Crushed clay 2" and smaller enters the hammer mill from above. High-rpm hammers rotate and pulverize the clay, which is pushed through screens at the bottom. Screen size determines the mesh size of the clay and the size of possible contaminants that are processed with the clay. Hawthorn Bond is an example of a hammer-milled fireclay.

Contaminants Found in Fireclays

Fireclays are the weakest link in any of the clays that can compose clay body formulas. There are several geologic and economic

Reclaimed clay mine with overburden replaced.

Mining clay for movement to processing plant.

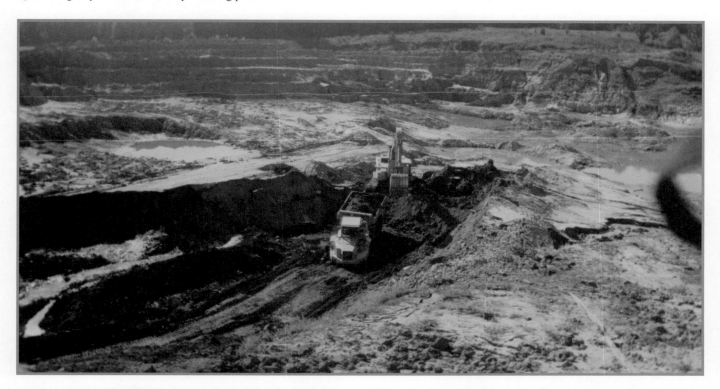

Clay pit showing exposed clay with overburden on top.

reasons for the presence and continued existence of contaminants found in this necessary but troublesome clay. Unfortunately, there is a downside for potters when they use raw materials specified for industrial requirements. Something that industry would not consider a defect can produce flaws for the potter; thus it's allowed in the mine's production batch sold to large commercial customers. The process of mining and processing fireclays does not lend itself to consistency when used by potters.

Fireclays can contain carbonaceous materials such as lignite, peat, coal, and other associated tramp materials. They can also have variable particle sizes of silica, iron, and manganese. At the mine site, even with careful excavation, some of these impurities can find their way into the seams of fireclay. On a technical level, all of these "bad" qualities can be refined out of the clay. However, on an economic level, intense processing is not required since the majority of fireclay users—steel mills, casting foundries, and brick manufacturers—use the clay with minimal processing, since it works well in their processes and products. Since potters represent less than one-tenth of 1% of the raw-material market in the United States, it does not make sense for mines or raw-material processors to refine a product for such a small market share or, conversely, to spend money improving a material that is perfectly acceptable for the majority of customers.

Lime, Iron, Manganese, and Copper in Fireclays

The major—but not only—contaminants found in some types of fireclays are lime and iron. With iron, the size of the particle is critical, since potters want aesthetically random small, brown specks (½ to 1 mm in diameter) in the fired clay body. However, large nodules of iron (4 to 6 mm in diameter) in the fired body can cause outsized brown blemishes on pottery surfaces. Fireclays can also contain lumps of manganese, which can cause brown/black concave or convex defects in fired-clay surfaces. In functional pottery these disruptions can be difficult to clean and may trap food or liquid, causing unsanitary conditions. The same but more pronounced defect occurs when manganese decomposes between 1112°F and 1976°F in a reduction kiln atmosphere; the manganese nodules are unaffected by reduction but melt in irregular "spit out" patterns on the clay body's surface.

Clay Platelet Size Distribution

The platelet size of clay is best observed on a microscopic level, as opposed to the process of screening clay, which removes comparatively outsized coarse clumps of clay and large-sized contaminants from a given amount of clay. Platelet size distribution simply means how many small, medium, or large platelets are in a given amount of clay. The distribution of platelet sizes also affects the texture or

"tooth" of the moist clay during forming operations. The size of the platelets, their direction in relation to each other, and the colloidal water adhesion forces that bind them together also play a part in determining the handling characteristics of the moist clay. Platelet size distribution can influence plastic qualities, shrinkage rate, forming potential, and drying characteristics. A greater percentage of larger platelets will result in a fireclay that is less plastic, with decreased ability to bend when moist. It will shrink less and dry faster than a fireclay with a higher percentage of small platelets. Fireclays having a finer platelet size will shrink more and have greater plasticity when moist. They will take longer to dry and require more-extensive water films around the increased amount of platelets in the fireclay to achieve plasticity. However, most clay body formulas contain other types of clays, feldspars, flint, and grog, which can be mitigating factors to the abovementioned fireclay platelet-size characteristics.

Screen Size

The mesh size of the processing screen is a factor in determining the amount of contaminants that are allowed to pass through with the fireclay. A 20 mesh screen can allow greater quantities of "tramp" material or contaminants (twigs, stones, coal, or processing debris such as bolts, wire, and metal parts) to enter the bag of clay that the potter will eventually encounter, compared to fireclay passing through a 50 mesh screen. Air-floated fireclays, such as Greenstripe 200 mesh fireclay, which is naturally finer than clays such as Hawthorn Bond, offer lower defect rates from contaminants but also change the "clay body feel" when moist. The greater the percentage of fine-mesh fireclay used in a clay body formula results in less "tooth" and an increased "gummy" feel to the moist clay. Such clay bodies do not stand up on the wheel, and they feel overly soft. They can take on more water in forming operations and deform more easily due to each small clay platelet being surrounded by water. While these are subjective terms for each potter, there is a recognizable difference when a coarse fireclay such as Hawthorn Bond 35 mesh is used in place of the finer Greenstripe 200 mesh as a component in a clay body formula.

As with any screening procedure, whether it's a 35 mesh or 200 mesh fireclay, there is some residual material that gets through the screen. Clay is not a round or symmetrical material but has an aspect ratio 1:10, making one dimension larger than the other. In some cases, depending on how the clay particle hits the screen, it may pass through or be retained and removed. The screening process is not 100% efficient, since there will always be some material that is allowed through a production screen that if screened again could be removed. In most instances the material is not screened again and is simply packaged for shipping. Unfortunately, potters require a greater degree of quality control for their fireclays than processors are offering. As in any economic profit motive activity, some fireclay processors are more in tune with serving the larger market than the smaller pottery production market.

The Roller Mill Process

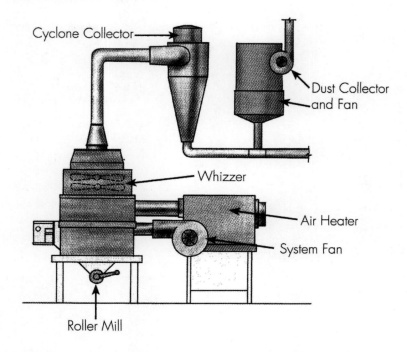

Roller mill for processing, drying, and separating particle sizes of clay.

The Hammer Mill Process

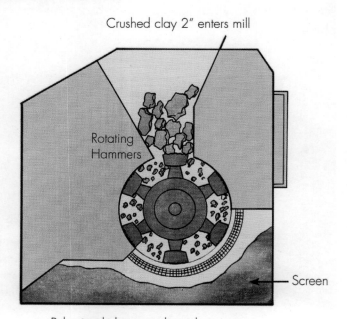

A hammer mill crushes the clay, reducing its size depending on the screen size used in the operation.

⏶ Large (2–3 mm) particles of manganese forming concave defects (white boxes) in a reduction-fired c/9 (2300°F) clay body.

⏷ Lime pop caused by expansion of lime in the fireclay component of the clay body.

⏶ Iron specking from fireclay component in a c/9 brown (2300°F) reduction clay body. While some iron specking can be desirable in a clay body, giving depth and contrast to glazes, specking that is too large or frequent can be visually and functionally undesirable.

⏶ Large (2–3 mm) particles of manganese forming concave defects in a reduction-fired c/9 (2300°F) clay body.

⏷ Green contaminants in fireclay. The chemical composition of fireclays can change from one shipment to the next. Fireclays can contain nodules of chalcopyrite ($CuFeS_2$) and erubescite 3 ($2CuSFe_2S_3$), releasing copper, which can cause green specks in the fired clay body.

Silica in Fireclay

Aside from tramp material, there can be large silica particles associated with coarse (35, 40, and 50 mesh) fireclays, which can also cause defects in a clay body. Fireclay, by the preference of potters for coarse material with tooth or grit, will by design have coarse particles of silica. Both the fine and coarse particles of silica have the potential to form cristobalite as the clay body is heated past cone 8 (2280°F). Often, excessive cristobalite buildup in the clay body is due to the kiln stalling or taking an excessively long time to reach temperature past cone 8.

Particles of silica in fireclay that convert to cristobalite will produce a larger expansion/contraction, thus exerting a greater pressure on the body. However, all aluminosilicate materials such as talc, feldspars, and other clays will contain some level of free silica, which can also be subject to the same transformation to cristobalite and the eventual cooling inversion. If considerable amounts are present in the clay body, an inversion of high to low cristobalite takes place around 392°F, which can cause a pinging noise in the pots as they cool in the kiln.[1] Seemingly intact functional

pottery with a buildup of cristobalite can also crack later when heated in a hot kitchen oven, due to cristobalite inversion in a similar cooling range. Cracks can occur anywhere on the pot and have a sharp edge, almost like the pottery has been hit by a hammer.

Lime, Gypsum, and Coal in Fireclays

Lime nodules or gypsum formed alongside seams of fireclay or in pockets contained in the clay seam can range from pebble to fist size and can result in a clay body defect called *lime pop*. After the clay body has been fired, lime expands when in contact with moisture in the air, causing a half-moon-shaped crack on the clay body surface. On occasion, fireclays can contain high levels of alkali fluxes, which can result in lower melting temperatures. Fireclays mined near the coal fields of Pennsylvania and Illinois are laid down next to seams of coal and lignite (an intermediate carbon-based material between peat and bituminous coal). Such contamination if not removed by a clean-firing oxidation kiln atmosphere can cause black coring/bloating in clay bodies or blistering in glazes, due to incomplete combustion of carbonaceous material in the fireclay exiting as a gas through the glaze layer.

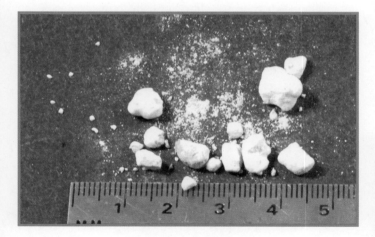

Raw fireclay nodules caught on a 30 mesh screen.

Contaminants found in raw fireclay can cause defects in the forming and firing stages. Particles can range in size from 2 to 6 mm.

Potters find themselves in a difficult economic situation. In a perfect world they could dictate the exact specifications of the materials required in their craft. However, the extra processing of clays and other raw materials would generate a higher cost, which would be prohibitive. With custom processing of raw materials, potters could easily pay dollars per pound for moist clay, as compared to the cents per pound currently being charged by ceramics suppliers. The economics of raw-material supply and the inability to pay higher prices for superior quality translates into potters making careful choices of existing materials or suffering the results of questionable-quality raw materials and clays.

Limited Liability

Individual potters cannot order large-enough quantities of clays or raw materials to demand a specific level of quality control from the mines or processing plants. They are forced to accept materials as is, which in many instances means particle-size variations, chemical-composition deviations, and tramp material contamination. Inconsistent raw materials and the potter's inability to change this fact are recurrent areas contributing to the loss of product. While ceramics suppliers, as a general policy, have limited liability on the clay they sell, it is the potters who also suffer a loss because their profit margins are tight. It is not unusual for a potter to lose an entire kiln load of pottery due to a raw material causing a defect. A ceramics supplier will replace "bad" clay, but the potters will not be compensated for their time and labor in producing the defective pots caused by substandard clay. As a general rule, the potter will not be remunerated for the damage to the kiln, kiln shelves, adjacent pottery in the kiln, or kiln furniture caused by a

Sharp-edged cooling crack in ware, caused by cristobalite inversion in the kiln or oven. Larger part of crack (right side) is where the crack started to form.

defective clay or raw material. In many instances the potters must prove and document that the defect originated in the raw material and not in their forming or firing procedures.

⬆ Lime pop crack. The crack is often half-moon shaped and can be peeled away, revealing a conical hole with a black or white speck at the bottom.

⬇ Glaze blisters. Sharp-edged crater glaze blistering caused by carbonaceous material in the fireclay exiting the clay body as a gas at high temperature.

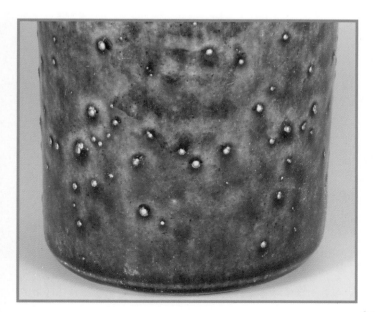

Discontinued Fireclays

Some discontinued materials do live on in ceramics supply houses' inventories or individual potters' storage bins, but they are not currently being mined. Before developing any clay body or glaze formula, always inquire if the material is still in production. In some instances, potters have used a clay, feldspar, or other ceramic raw material found in their studio, only to discover when it is time to reorder that the material is no longer in production. It is highly unusual once a fireclay is removed from production for it to be brought back on the market. A little research will save much time and effort. Some fireclays that are no longer in production are P.B.X. fireclay, North American fireclay, and Pine Lake fireclay. Green Ribbon fireclay and G.S. Blend fireclays were blended by Laguna Clay Company from Lincoln 60 and Irish Hill Cream fireclays when Greenstripe fireclay was temporarily unavailable.

Alternative Strategies for Problem Fireclays

For medium- to high-temperature clay body formulas (cone 6 and above 2232°F), the total lack of a fireclay component can affect the drying qualities, handling characteristics, fired color, and fired maturity. Keep in mind that porcelain clay body formulas traditionally do not contain fireclays when high temperature, whiteness, and translucency are desired, but in a great percentage of high-temperature stoneware clay body formulas, fireclays are a viable component of the formula.

Finer-Mesh Fireclays / Splitting Fireclays

Fireclays with comparatively large (28, 35, or 40 mesh) sizes can have periodic runs of irregular contaminants. This happens when rips in the screen occur or by operator error, allowing large particles to enter the clay batch. Simply stated, the larger the contaminant size, the greater the chance of it causing a problem in the forming, drying, and firing stages. Using a finer-mesh fireclay is one option that can diminish the problem, but the moist clay can lack "tooth" or stand-up ability in forming operations. If a coarse-mesh fireclay is used, splitting the total fireclay requirement 50/50 with another fireclay of similar or finer mesh can often reduce the risk of a bad batch of fireclay disrupting the clay body.

Screened Fireclay

One of the major problems when using fireclays is the lack of adequate processing at the mine. Several ceramics supply companies have taken it upon themselves to screen the fireclay. The additional cost is more than worth the potential failure of the clay body. Sheffield Pottery Inc. (US Route 7, PO Box 399, Sheffield, MA 01257; 423-229-7700; www.sheffield-pottery. com) is a ceramics supply that can screen fireclays or any other material used by potters. Typically, a fireclay is passed through a 30 mesh screen to remove contaminants, though they do offer other mesh-screening sizes. Additionally, the clay can be moved through a tube containing a powerful rare earth magnet, which removes ferrous iron contaminants. The clay will still produce an iron spot pattern when fired, but large particles of iron will not be present. Both systems bring an added degree of processing necessary for clays used by potters.

Fireclays Commonly Used by Potters

Geologically, the clay deposits are still present, but due to the changing industry demands, any clay can be discontinued because of economic reasons. Potters often assume that a material is still in production because they have such containers in their studios. However, many potters realizing this illusion still choose to use their remaining stocks of discontinued material. When their supplies are exhausted, they will either have to find other sources or eventually locate workable substitutes. Before committing to any raw material or clay, contact the supplier to ensure that their product is still in production.

While raw materials change, in most instances the change does not alter the final result. However, on rare occasions a significant change can alter the final result. These are some currently available fireclays.

Lincoln fireclay: Gladding McBean (www.gladdingmcbean. com). Technical data sheets are available. The Gladding McBean plant in Lincoln, California, has been in operation since 1875, and the Lincoln Clay Products plant, a division of Gladding, has been in operation since 1898. The mine produces Lincoln 60, 8, and 9 fireclays, which are hammer milled. The sedimentary clays are formed from erosion of the Sierra Mountains in California and are open-pit selectively mined. Scrapers peel off the overburden soil, exposing seams of clay 2 to 5 ft. thick. It is then processed and shipped in 50 and 100 lb. bags and bulk packaging having a range from 20 to 34 mesh. All the Lincoln fireclays have excellent drying properties, with minimum cracking and warping.

Lincoln 60 fireclay: Lincoln 60 fireclay fires to a buff/cream

Clay-screening hopper used to remove contaminants in clays. The clay is fed through the top, passes through a screen, and is deposited in a hopper below.

color and is frequently used in pottery production. Its name is derived from the one to six layers of clay that form the deposit. Over 30,000 tons per year are shipped to pottery manufacturers and ceramics suppliers. It is hammer milled and has coarse iron specks. PCE 28–29.

Lincoln 8 fireclay: Lincoln 8 fireclay has a higher percentage of iron than Lincoln Fireclay 60 and fires to an orange color. It has good plasticity and excellent strength. PCE 28–29.

Lincoln 9 fireclay: Lincoln 9 fireclay fires to a buff/cream color and has granules of siderite (iron carbonate and iron sulfate). It has a low iron content and exhibits good plasticity and excellent strength. PCE 30–31.

IMCO 400: IMCO 400 is Lincoln 60 fireclay mined by Gladding McBean. It is then roller milled and air floated by Industrial Minerals Company (www.clayimco.com). Technical data sheets are available. Industrial Minerals Company sells 400 to 500 tons per year each of IMCO 400, IMCO 800, Howard clay, and Irish Hill Cream clay. IMCO 400 has greater strength and fires to a buff/cream lighter color than IMCO 800, both of which are mined in layers.

IMCO 800: IMCO 800 is a smoother fireclay than IMCO 400 and has a yellow fired color. It is roller milled and air floated by Industrial Minerals Company. It is a finer-ground fireclay than

Lincoln 8, cutting down on the size of contaminants and iron specking. Technical data sheets are available.

Howard clay: Howard clay is a roller-milled, air-floated fireclay mined by Industrial Minerals Company. Technical data sheets are available. It has a lighter fired color than IMCO 400 or IMCO 800.

Irish Hill Cream: Irish Hill Cream is a roller-milled, air-floated fireclay mined by Industrial Minerals Company. Technical data sheets are available. It has good green strength and is not as refractory as Howard clay but is darker in its fired color.

Greenstripe: Greenstripe is a very plastic, 200 mesh air-floated, comparatively high-shrinkage, excellent green-strength fireclay mined in Northern California by Ione Minerals (www.ioneminerals.com). Technical data sheets are available. Fireclays have been mined in the Ione basin on and off since the mid-1800s. The Ione basin is about 20 miles long and 1 to 4 miles wide, lying along the western Sierra Nevada foothills.[2] The company has eight mine sites totaling over 21,000 acres, where it solar dries and processes its fireclays and kaolins. The plant has been in continuous operation since the early 1950s. Greenstripe fires to a light buff color. PCE 31–32.

Hawthorn Bond fireclay: Hawthorn Bond fireclay is a hammer-milled sedimentary fireclay that is ground to 20, 35, 40, and 50 mesh sizes. It is mined by Christy Minerals LLC (www.christyco.com). Technical data sheets are available. Christy Minerals sells 80% of its production of fireclays to the pottery market and the art clay industry, which manufactures architectural ceramics. Missouri fireclays such as Hawthorn Bond and A. P. Green, due to their harder granular structure, take longer to absorb water in the clay-mixing process than do West Coast fireclays. This characteristic can result in clay bodies with a Missouri fireclay component becoming stiffer after the initial mixing process as water is eventually absorbed into each clay platelet. Missouri fireclays can also be associated with seams of lime and gypsum, which can have nodules from ¼" to 4" in diameter, causing lime pop in the bisque and fired ware if not screened properly in the processing stage. The fireclay can also have nodules of silica disrupting a clay body surface. PCE 31–32.

A. P. Green Missouri Fireclay was purchased by ANR Refractories and now encompasses North American Refractories, A. P. Green, and Harbison Walker Refractories (www.anhrefractories.com). Technical data sheets are available. A. P. Green fireclay is a plastic, 20 mesh clay located in the same geological deposit as Hawthorn Bond fireclay. However, A. P. Green fireclay is processed for the brick and refractory industries. The pottery market for this clay is minimal, resulting in the lack of appropriate processing for potters. Contaminants that are acceptable for the manufacture of brick and other refractory products are definitely not suitable in pottery manufacture. Quality control over the years has been unreliable. One large ceramics supplier uses the fireclay in special orders but not stock clay body formulas. It is shipped in 50 lb. bags. PCE 31–32.

5. HOW TO INTERPRET A TYPICAL DATA SHEET: BALL CLAYS

Ball clays contribute plasticity to clay body formulas. They are frequently used in clay bodies designed for functional pottery and sculpture. The percentage of ball clay found in any given formula depends in part on the forming method, whether it is wheel thrown, slip cast, ram pressed, or jiggered. Clay bodies and glazes are composed of raw materials, each having specific characteristics. Ceramics suppliers and raw-material processors periodically produce data sheets on the materials they sell; the information contained can be vital in developing a clay body or glaze. In addition to the product name, code, or both, data sheets reveal particle size, raw and fired color, shrinkage, absorption, pH content, and other vital parameters of the material. It is useful to think of a data sheet as a "snapshot" of a constantly variable raw material. However, since over 99.9% of raw materials used by potters are employed in industry, it only makes economic sense that mines and processors hold to strict quality-control standards to ensure market satisfaction. The typical data sheet for ball clay illustrates one method of obtaining information on this common raw material.

A typical clay deposit found at Old Hickory Clay Company requires the removal of 25 to 80 ft. of overburden before the layers of clay are exposed. Deposits average 20 acres, with layers of clay approximately 18 to 40 ft. thick. The Old Hickory deposits comprise thirteen active mines between Kentucky and Tennessee. The normal deposit consists of three grades of clay, with the highly organic on top, the purest in the middle, and the most silicious at the bottom.[1]

History of Ball Clays

It is said that ball clays were first named in Devon, England, after the practice of rolling the clay out of the mine in 30 to 35 lb. balls. Major ball clay deposits are located in California, Mississippi, Tennessee, Texas, the United Kingdom, Southeast Asia, and central Europe. Ball clays evolved from the chemical degradation and weathering of granite, causing feldspars in the granite to form into large kaolin plates. Streams carried the kaolin into ponds that contained 99% pure kaolin. Small pieces of kaolin that did not settle in the ponds were washed downstream, where they joined with organic matter. Kaolin and organic matter settled in areas of water with low flow rates. Fine-particle silica sands were also mixed in, forming what we now call ball clay. This explains why ball clays are 70%–80% clay particles, 10%–20% free silica, and organic matter contaminants, combined with other trace minerals. Aside from containing some kaolinite, ball clays can also have varying amounts—depending on the deposit—of free silica and

the oxides of potassium, sodium, calcium, and magnesium. Ball clays fire to a white or cream color and have a vitrification range of 2012°F to 2192°F. The most widely accepted theory on Tennessee and Kentucky ball clays is that they formed approximately 40–50 million years ago in the Eocene Epoch, when the region was tropical in climate and swampy.

Today "end-point"—or clay mined from a single pit—is blended and air floated to ensure a consistent, reliable product. Ball clays can be characterized in different ways, but their general description can be stated in one word: plastic. Their small platelet or particle size imparts great plasticity in the moist state. Ball clays require large amounts of water to achieve plasticity; however, both plasticity and water can result in significant amounts of dry shrinkage, fired shrinkage, and warping. In varying degrees, ball clays can also contain elevated amounts of carbonaceous matter that further aid plasticity but can lead to subsequent burnout (black core: carbonaceous matter is trapped in the clay body when vitrification begins, causing carbon deposits in the clay body) problems in the firing stages. Such characteristics prohibit ball clays from being used as the sole clay component in clay body formulas.

Common Ball Clays Used by Potters in Clay Body and Glaze Formulas

Listed are some of the ball clays most widely used by potters. There are variations in particle-size distribution, organic content, and chemical makeup, along with other variables throughout this group. However, each clay has a typical data sheet that can offer information on its eventual use in clay bodies and glazes. As the information will reveal, not all ball clays are the same. When substituting one for another, try to match as many characteristics as possible to ensure a successful result. While at first glance the amount of detail in the data sheet can appear overwhelming, patterns and comparisons can be identified. Data sheets are another language for describing clays, but the potter should always combine this analysis with practical experience when using the ceramic material. For example, Thomas ball clay, mined by Old Hickory Clay Company, can be substituted on a one-for-one basis with Kentucky Old Mine #4 ball clay, mined by Kentucky Tennessee Clay Company. Both are close in several important raw-material parameters. Most significantly, they have been interchanged successfully in clay body and glaze formulas under many temperature ranges and kiln atmosphere conditions.

Kentucky Old Mine #4	Foundry Hill Cream	Champion
Kentucky Stone	M&D	Bell Dark
Tennessee #1 SGP	KT1-4	C&C
Tennessee #5	KTS-2	Black Charm
Tennessee #9	XX Sagger	Kentucky Special
Tennessee #10	Zamek	Kentucky Old Mine #5

What Is a Typical Data Sheet? (Selections of Fine and Coarse Ball Clays)

A typical data sheet listing ball clays will indicate which clays have finer or coarser particle-size distributions. The particle-size distribution (particle size % less than) of a clay tells what percentage of the particles are fine, medium or coarse. Particle-size percentages can be charted on a graph, giving a "fingerprint" for each ball clay. The distribution can be complex, since all clays have particles as large as 100 microns and as small as 0.1 microns (1 micron = 1/24,500 of an inch). The number of particles in each range determines the overall fineness or coarseness of the clay. Particle size is critical in determining the optimum ball clay for a particular forming operation, and it also serves for comparing different ball clays. Other properties on the typical data sheet that indicate fine, medium, or coarse particle sizes are under these headings: Dry MOR (modulus of rupture), Wet Sieve Residue, Water of Plasticity, Linear Drying Shrinkage, Filtration, Specific Surface Area, CEC/MBI, and Median Particle Diameter, all of which give clues to the relative fineness and coarseness of the ball clays. A typical data sheet can be obtained either from a ceramics supplier or the company that mines the clay.[2]

Why are there so many methods of measuring the fineness or coarseness of ball clay? As instrumentation technology has improved, new ways to measure plasticity have evolved. Ceramic engineers tend to stick with whatever test they had confidence in and experience with during their training. Even the most scientific of technical people in ceramics might look at only one or two different tests before choosing a ball clay for a ceramic project. The water-of-plasticity measurement was probably the first test developed because it requires no instrumentation other than a balance and a measured water container. Later, other more complicated and expensive tests for plasticity were developed. Nevertheless, the important points are to choose tests that are applicable to the forming

process and to compare clays only by using that method. Do not compare the same test results from two different clay companies, since each might use distinctive test procedures that can make comparisons impossible.

Fine Ball Clays

Finer-sized ball clays have greater plasticity and increased dry or green strength, which make them suitable for plastic-forming operations such as throwing and handbuilding. In operations where surface decoration or handling of the unfired pot is encountered, fine-particle-size ball clay will increase the clay body's dry strength. However, finer clays can tighten a clay body structure, causing an exothermic (heat-releasing) reaction, preventing the oxidation of organic matter when heated in the 572°F–932°F range.[3]

When fine-particle-size ball clays are used in a casting-slip formula, they can cause the slip in the mold to take an excessively long time to build up a wall thickness. The fine-particle-size clay delays the absorption of water by the plaster, causing a slower turnaround and refilling time. Casting-slip formulas containing high percentages of fine-particle ball clays will take excessive amounts of deflocculant to achieve a liquid state. Fine-particle ball clays in a casting slip will also cause the cast piece to take a longer time to "firm" or handle when it is eventually released from the mold.

Coarse Ball Clays

Ball clays containing coarser particle sizes are less plastic and are better suited for casting-slip clay formulas. Coarser ball clays allow water to "wick" through the liquid clay into the mold, building up an acceptable clay thickness in the cast piece. Coarse-particle-size ball clays also allow the clay body to "firm" quickly or develop durability after draining out the excess slip from the mold. Coarser ball clays will contribute to greater durability and firmness in a cast piece when it is removed from the mold. In actual practice, what is needed is a ratio of good casting properties balanced with acceptable green or dry strength that will be desirable in handling and decorating the piece once it is removed from the mold. By experimenting with various ball clays, the appropriate particle-size distribution of one or more clays should result in a workable casting slip.

Coarse ball clays can also be used in clay bodies that do not require the degree of plasticity needed in throwing operations. Ball clay of larger particle size can be used in handbuilding, coil, ram press, or dry press in forming clay bodies. Coarse ball clays still fall into the ball clay group and not the larger platelet-sized stoneware or fireclay classifications and should not be considered as a substitute for either clay group.

What the Numbers Mean

The typical data sheet has four general classifications of each ball clay: **Raw Properties, Particle Size, Chemical Analysis,** and **Fired Properties**. Within each section there are further detailed classifications. For example, under the Raw Properties section, each ball clay is evaluated for Crude Color, Dry MOR, Wet Sieve Residue +200, Water of Plasticity, Linear Drying Shrinkage, Soluble Sulfates, Filtration, Specific Surface Area, CEC/MBI, and pH Characteristics.

The numbers and percentages can be used to compare specific characteristics of each ball clay. Generally, a 10% or less difference between one ball clay and another will not be significant. Such a difference can be due to testing errors or the wide production parameters of the final product, such as pottery clay bodies as opposed to ceramic components for a jet engine. A difference in any category that is more than 10% would be significant and could be used as a basis of comparison. For example, Taylor Blend's Dry MOR is 519, while Thomas Dry MOR is 510; the difference is less than 10% and is thus insignificant, as opposed to S-4's Dry MOR of 500 compared with TB-1 Dry MOR of 580, resulting in a difference greater than 10%.

Uses of Ball Clays

Ball Clays Used in Handbuilding, Sculpture, Ram-Press, and Dry-Press Operations

Ball clays are commonly included in clay body formulas to increase plastic qualities in the forming operation. Clay bodies can also contain fireclays, stoneware clays, earthenware clays, bentonite, feldspars, flint, talc, and other ceramic materials, each serving a distinct purpose in terms of handling properties, firing temperature, fired color, and glaze fit. However, the percentage of ball clay that is used is directly related to the forming process. Handbuilding or sculpture bodies will generally contain little or no ball clay, compared to throwing clay bodies, where greater degrees of plasticity are essential. However, it has proved useful to have some ball clay in handbuilding and sculpture bodies to physically span the spaces between medium- and large-platelet clays such as stoneware and fireclays found in the formulas. The amount and type of ball clay will depend on factors such as the forming method (coil, slab, or pinch), clay body fired color, and the clay bodies' fired shrinkage and absorption rates. The goal is to use enough ball clay for the required degree of plasticity, and no more.

In handbuilding and sculpture bodies the composition of other ceramic materials in the formula will also determine the percentage of ball clay needed. If plastic stoneware clays are used in the formula with bentonite (a very plastic clay), the percentage of ball clay needed for plasticity might be less than in clay bodies containing high percentages of fireclay, talc, flint, wollastonite, and feldspar, which are relatively nonplastic. The amount of ball clay used in handbuilding or sculpture bodies can range from 1% to 15%, with greater amounts contributing to possible excessive shrinkage in the drying stage, fired shrinkage, and warping during the drying or firing stages. High amounts of ball clay in the clay body formula can cause cracking where thin and thick sections meet. Thinner sections will dry and shrink faster than thicker areas, causing unequal shrinkage and stress cracks. High levels of ball clay can cause the moist clay to become "sticky" and thixotropic, deforming under pressure in the forming process. The moist clay can exhibit a gelatin-like quality, making it difficult to shape. Low levels of ball clay can result in the clay body being "short" or nonplastic. In handbuilding, a slab of moist clay can crack on its edges when rolled into sheet. Cracking can also occur when the nonplastic clay is rolled into coils.

Clay bodies intended for ram-press or dry-press operations (where the clay is compressed hydraulically between molds) do not require significant percentages of ball clay. In such methods the greater pressure brought into contact with the clay decreases the need for plasticity.

Ball Clays in Throwing Clay Bodies

Ball clay adds much-needed plasticity to throwing clay bodies. The amount and type of ball clay can vary depending on other clays in the formula, such as fireclays or stoneware clays. It can also depend on other materials in the formula, such as feldspar, flint, talc, or grog. The percentage of ball clay in throwing bodies can be as low as 5% or as high as 30%. In higher percentages, ball clay can result in the moist body taking on water too fast in throwing operations. Excessive amounts of ball clay can also cause thixotropy or deformation under pressure as the potter's fingers manipulate the form. The moist clay body can also sag or sink when formed, resulting in the inability to pull tall forms on the wheel. Excessive amounts of ball clay can result in warping in the drying stages and high shrinkage rates in the dry and fired clay body formula. Too much ball clay in the throwing clay body can also cause handles to crack off in the drying stage due to unequal rates of shrinkage. Low levels of ball clay can result in the moist clay not forming or holding a curve when thrown on the wheel. Cracking can also occur after a curve is placed in the form. Areas of high stress such as lips or edges of the thrown form can crack due to lack of plasticity in the clay body.

Ball Clays in Glaze Formulas

In glaze formulas, ball clays supply silica and alumina, which can affect raw glaze fit, glaze maturation temperature, glaze opacity, and glaze surface texture. Ball clays or other small "plate" structure clays such as bentonites help glaze materials stay in suspension. However, in some formulas that require a clay component, ball clays can cause a clear glaze to fire semiopaque or cloudy because of their higher amounts of iron and manganese as compared with kaolins, which do not have as high levels of metallic coloring oxides. However, in opaque or colored glaze formulas the metallic oxide concentrations in ball clays will not generally be apparent in the fired glaze.

Ball Clays in Casting Slips

Most casting-slip formulas have a minimum of 35% and a maximum of 50% ball clay. As stated, ball clays of coarser particle size are best suited for slip casting because they allow a thicker wall section to build in the mold. They are also easier to deflocculate because there is less clay surface area to wet. Coarser clays also have fewer particles to break apart from each other. Many formulas for throwing clay bodies can be used for slip casting with the substitution of coarse ball clay and the addition of the correct amount of deflocculant. Ball clays in casting slips contribute green strength and plasticity in the pouring and drying stages. Green strength is the property that allows the piece to resist mechanical shock. Plasticity is required in the casting process from the moment the body begins to shrink until it reaches the bone-dry stage. Some would argue that plasticity remains even in the dry state and allows the piece to flex a little as opposed to breaking.

A typical casting slip is made by adding 200 grams (g) of dry clay body formula (which can contain ball clays and any one or a combination of feldspars, flint, talc, other clays, metallic coloring oxides, or stains) to 100 g of water with the correct amount of deflocculant. The type and amount of deflocculant will depend in part on the choice of raw materials used in the casting slip. For example, the deflocculant Darvan #7 can be used in amounts of 0.2% to 0.8%, on the basis of the dry weight of the clay body.[4] The slip will have a specific gravity of about 1.75 g per milliliter (ml).

Typical Data Sheet

Old Hickory Clay Company's typical data sheet will serve as an example on how to read and understand the properties of each type of ball clay they mine.

Ball Clay Grade: The identifying name of each ball clay: FC-340, M-23, S-4, Taylor Blend, TB-1, and Thomas.

Raw Properties: Crude Color is the raw, unfired color of the clay. The crude color is in no way indicative of the color of the fired clay body. It is important only to manufacturers who use unfired clay in adhesives, paints, and pastes. The crude color represents the clay's mineralogy and iron staining, along with minor levels of contaminants. Iron and titania are found in ball clays and do affect crude and fired color. High levels of carbon found in ball clays can yield a darker crude color and, if not removed, can cause black coring and bloating. An oxidation atmosphere and slow kiln firing during the 662°F–700°F range is essential to completely remove carbon from the ball clay.[5] Once this is accomplished the natural fired color of the ball clay will be present.

Dry MOR (50% clay / 50% flint) (psi): The Modulus of Rupture tests require a mixture of 50% clay and 50% flint that is formed into a bar and allowed to dry, and a weight is then pressed against the bar until breakage occurs. The readings, expressed in pounds per square inch, represent the relative dry strengths of individual ball clays. What does the MOR reading mean to the total clay body formula? It cannot be judged as a single factor in the total clay body. However, when replacing one ball clay with another, similar mechanical strength would be one factor in making a reliable substitution. The more handling and decorating that takes place with the clay body, the higher MOR it will need to withstand mechanical shock. As the clay dries to the bone-dry state, it's at the weakest point and is easily damaged in any forming operation. Thinner pieces will require a higher MOR from their clays to help resist breakage and chipping. Keep in mind that the total combination of clays contained in a clay body formula regarding mineralogy, particle-size distribution, contaminant content, and particle-packing efficiency should be the true judge of the clay body's mechanical strength. Each clay company might measure MOR differently, which can result in a false comparison in test results. However, MOR readings between different clays *within* the *same* company (identical testing procedures) can offer an accurate basis of comparison.

For example, TB-1 ball clay with an MOR of 580 psi will have a higher green strength (mechanical strength of clay when it is dry and before firing) than M-23, which has an MOR of 500 psi. Generally, 10% or lower differences between MOR readings are not significant, while 20% or higher readings can be meaningful. In some instances a clay with low MOR reading in the 50/50 test can give a high MOR reading when tested in the total clay body formula. The different test readings are due to just the right particle-size distribution, which makes the clay stronger by plugging gaps in the body. However, often a clay that is strong in the 50/50 test will be strong in the clay body formula.

Wet Sieve Residue + 200 Mesh Residue (wt. %): Represents the amount of ball clay that will be caught on a +200 mesh screen. The opening in a 200 mesh screen is 2.9 thousandths of an inch wide. This is expressed as 74 microns (one micron = one thousandth of a millimeter), while a 400 mesh screen has openings of 38 microns. In this test the amount of ball clay passing through a 200 mesh screen will give an idea of the fineness or coarseness when compared with other ball clays. The material that does not pass through the screen is mostly silica sand and coarse lignite (carbonaceous) particles. A "clean" ball clay would have very little or no +200 residue on the screen. Some ball clays have higher than 10% +200 residue on the screen, but typically most range from 0.10% to approximately 1.0% on the screen. A carbon content test will indicate the amount of carbon that needs to be burned out of the clay, but a high +200 mesh residue could also mean high amounts of silica.

Example: M-23 is a ball clay leaving 0.12% residue on a +200 mesh screen. TB-1 is a coarser ball clay leaving 0.40% on a +200 mesh screen. The coarseness of TB-1 could be due to a higher level of a large-particle carbonaceous material, coarse-particle silica left on the screen, or both, as compared with M-23.

Water of Plasticity (%): The percentage of water added to a dry ball clay in order to form it into a plastic mass. A higher percentage of water of plasticity in a ball clay means there are higher amounts of clays of finer particle size. The finer the particle size, the more surface area that needs to be wetted per pound of clay. The CEC/MBI, Water of Plasticity, and the Specific Surface Area are the three tests giving a measure of the fineness or coarseness of the ball clay in relation to other ball clays. Ball clays have between 30% water of plasticity for coarse clays and 40% water of plasticity for very small-particle clays.

Example: TB-1 has a water of plasticity of 39%, which is a finer particle size and greater plasticity than Thomas's water of plasticity of 34%.

Linear Drying Shrinkage (%): This is the measurement of the linear amount of shrinkage occurring in a bar of clay that goes from a plastic mass to a dried bar having less than 1% moisture. This type of shrinkage is a function of the clay's platelet size or particle-size distribution, indicating how many small-, medium-, and large-sized clay platelets are in the clay. It also determines how efficiently the clay platelets pack together as water evaporates while allowing the clay's platelet sizes to pack together again when drying. High dry-shrinkage rates suggest more plasticity in clay where the finer clays fill the gaps between nonplastic materials and other clays in the clay body formula. Finer clays shrink more due mostly to the increased amount of water needed to wet all of the fine platelets in order to achieve plasticity.

TB-1, having a dry-shrinkage rate of 7.6%, has greater plasticity than FC-340, having a dry-shrinkage rate of 6.4%. One factor in retarding shrinkage in ball clays is high amounts of coarse silica. Generally, dry-shrinkage in a typical ball clay is between 5% and 9%.

Soluble Sulfates (parts per million [ppm]): This measurement shows the amount of natural sulfates that can be dissolved by water that is added to the slip or plastic mass. The soluble-sulfates test will not measure plasticity. However, the quantity of soluble

Old Hickory Clay Company—Typical Data Sheet

Tennessee Ball Clays

Ball Clay Grade Raw Properties	FC-340	M-23	S-4	Taylor Blend	TB-1	Thomas
Crude Color	Tan-Lt. Gray	Lt. Gray	Lt. Brown	Lt. Gray	Lt. Gray	Brown
Dry MOR [50% clay / 50% flint] (psi)	540	500	500	519	580	510
Wet Sieve Residue +200 Mesh Residue (wt. %)	0.55	0.12	0.24	0.35	0.40	0.31
Water of Plasticity (%)	34	38	37	38	39	34
Linear Drying Shrinkage (%)	6.4	6.8	6.8	7.5	7.6	6.8
Soluble Sulfates (ppm)	545	229	250	190	220	190
Filtration (ml)	29	26	30	24	24	27
Specific Surface Area (m²/g)	16.2	18.5	17.9	20.2	20.2	18.1
CEC/MBI (meq/100 ml)	9.0	11.0	9.6	11.0	11.0	10.5
pH	5.4	5.5	5.1	5.4	5.3	5.3

Particle Size (% finer than)

5 micron	80	84	84	85	87	85
1 micron	51	63	56	68	66	66
0.5 micron	39	53	45	58	55	56
Median Diameter	0.98	0.48	0.65	0.31	0.41	0.38

Chemical Analysis (%)

SiO_2	62.04	58.70	57.60	60.00	56.55	59.40
Al_2O_3	24.10	27.70	28.10	26.40	28.68	26.50
Fe_2O_3	1.01	1.00	1.06	1.06	1.10	1.02
TiO_2	1.27	1.50	1.40	1.70	1.66	1.60
CaO	.05	.02	.02	.04	.13	.06
MgO	.30	.20	.22	.22	.63	.20
Na_2O	.11	.08	11	.08	.05	.08
K_2O	1.18	.60	.89	.52	.54	.40
LOI*	9.94	9.90	10.60	9.98	10.65	10.74

Fired Properties (%)

Linear Shrinkage/Absorption						
Cone 04	4.3/16.0	6.3/15.4	4.9/18.0	6.1/16.8	6.3/16.4	5.7/15.7
Cone 3	5.9/10.7	7.5/10.0	6.6/11.5	6.9/11.0	7.2/10.0	6.6/10.6
Cone 11	7.8/3.6	8.8/4.5	8.9/3.5	8.7/3.5	9.2/2.8	8.1/3.6
PCE	30–31	31–32	32	31	31	31

* Loss on ignition

sulfates present will determine the amount of deflocculants, flocculants, and antiscumming additives that might be required in the clay body formula. Ball clays generally fall into three categories of dissolved sulfur, with low sulfate having less than 300 ppm, medium sulfate having 300 to 600 ppm, and high sulfate clays having above 600 ppm. In most clays the higher the amount of sulfur in the clay, the wider the range of variation there will be in the sulfate levels of that clay. High levels of soluble sulfates in a clay body can migrate, causing a white "snowflake" scumming effect on the clay body surface. Barium carbonate (0.25% to 2%, based on the dry weight of the clay body) can be added to clay body formulas and will turn the sulfate radical from a soluble form to a precipitated solid, which will remove the scumming effect on the clay body surface.

Example: FC-340 has a higher level of soluble sulfate's 545 ppm than TB-1, having only 220 ppm.

Filtration (ml): The Filtration and the Specific Surface Area tests were developed primarily for the sanitary ware industries. They measure the amount of water that can be drawn through a standard-thickness cake of clay; the equipment used is a Baroid filter press. Coarser-particle clays do not pack as efficiently as finer clays and subsequently leave wider cracks, voids, and capillaries for water to run through. Clays that are ideal for slip casting will allow approximately 30 ml of water to pass through the cake in a set time. Finer-particle-size clays, more suited for plastic-forming operations such as throwing and handbuilding clay body formulas, will allow only 15 ml of water through the cake in the same amount of time. The higher the milliliter reading, the coarser the clay.

Example: For example, S-4 clay, having a filtration of 30 ml, is coarser than TB-1, having a filtration of 24 ml.

Specific Surface Area (m^2/g): Another test that will offer an indication of a ball clay's fineness or coarseness. Finer ball clays will have more surface area per pound (high surface area numbers) due to greater exposed surface area from their particles being smaller. The higher the surface area, the finer the clay. Surface area can be compared to an ice cube in that it takes a while to cool down and melt due to the limited surface area exposed to the air. Crush that ice cube into small pieces, which reveals much more surface area, and it will melt faster. Finer-particle clays expose more surface area and have greater plasticity than coarser-particle clays. The Specific Surface Area test gives a result that reads "m (meter) squared per g (gram)" or as square feet of area per pound. The actual test measures the amount of gas required to completely coat the clay particle in the sample chamber; the more surface area, the more gas needed. Finer ball clays have surface areas in the range of 20–24 m^2/g, whereas coarser ball clays will have surface areas of approximately 15–18 m^2/g. Taylor Blend, with a specific surface area of 20.2, is finer than FC-340, with a specific surface area of 16.2.

CEC/MBI [CEC = cation exchange capacity; MBI = methylene blue index] (milliequivalent [meq] / 100 ml): A test to measure the fineness or coarseness of ball clay. The test was first utilized for clays used in the paper, tile, and sanitary ware industries. The ball clay is mixed into a low solid slurry (a slip that has a low amount of solids and high amount of water, containing 10 g of clay to 100 g of water, giving a specific gravity of about 1.1 g/ml), and then a liquid called methylene blue is added to the mixture that totally coats the surfaces of the ball clay (methylene blue has a chemical attraction to the clay surface). When excess methylene blue appears in the test water, all surfaces of the clay are coated. Finer ball clays have higher CEC/MBI numbers due to the increased amount of methylene blue required to coat a greater number of small clay particles. Conversely, coarser ball clays have lower CEC/MBI numbers that required less methylene blue for a complete coating. CEC/MBI numbers in ball clays range from 8 to as high as 12.

Example: M-23 has a CEC/MBI of 11.0, which is a finer particle size than S-4, having a CEC/MBI of 9.6.

pH: The pH test is a measure of the ball clay's acidity or alkalinity. The higher the number, the more alkaline the clay; conversely, the lower the number, the more acid the clay. Ball clays average from 5.0 to 6.5, which means that they are almost all on the acid side. The alkaline or acid nature of ball clay is important only if it is used in a casting slip; then it can be determined what type and how much deflocculant is required to adjust the viscosity of the slip. Under actual mixing conditions the slip would be adjusted to a target viscosity without ever knowing what the pH level of the ball clay was.

Example: Taylor Blend has a pH of 5.4, indicating a greater alkaline content than S-4, which has a pH of 5.1.

Particle Size (% less than): A sedigraph is the most sensitive and comprehensive instrument used to compare particle-size differences between ball clays. It uses X-rays that pass through a clay slurry and land on a receptor. The number of X-rays that hit the receptor and how many are reflected elsewhere are then calculated into a formula to determine the clay particle-size distribution in microns (one-millionth of a meter). The test results give a percent finer than figures for a continuous range of particles from extremely large (100 microns) to extremely fine (0.2 microns). Imagine a mixture of basketballs, soccer balls, softballs, golf balls, and marbles suspended in water. A sedigraph test result would determine the number of each size of object in the total mixture, giving a "fingerprint" of the clay, which would be different for each ball clay tested. The sedigraph is a very expensive piece of equipment and is not affordable to many ceramic producers.

Examples:
5 Micron
FC-340 has 80% of its particles finer than 5 microns, while TB-1 has 87% of its particles finer than 5 microns, which indicates more smaller particles in the "finer than 5 micron" ranges.

1 Micron
At the 1-micron level, FC-340 has 51% of its particles finer than 1 micron, while TB-1 has 66% finer than 1 micron.

0.5 Micron

At the 0.5-micron range, FC-340 has 39% of its particles finer than 0.5 microns, while TB-1 has 55% finer than 0.5 microns.

From the 5, 1, and 0.5 micron ranges, it can be determined that TB-1 is a finer, more plastic ball clay than FC-340.

Median Diameter: This is an approximation of the average particle size of the clay. The smaller the median, the finer the clay. The median particle-size number will give a "snapshot" of which ball clays have greater amounts of finer-sized particles than others.

Example: TB-1 has a smaller median micron size of 0.41 than FC-340, with a median micron size of 0.98, indicating TB-1 is a smaller particle-size ball clay.

Chemical Analysis (%): Several different methods are used to obtain a chemical analysis of ball clays. Old Hickory Clay Company uses an X-ray fluorescence test that dissolves the clay sample in acid. A flame is introduced, which is then pierced by X-rays. Most ball clays will have approximately 60% silica and 30% alumina. The testing procedure requires a large amount of an acid/clay solution with a clay that is exactly 60% silica and 30% alumina, and is run with this solution each time an unknown clay is tested. By comparing a known solution with the unknown test solution, the exact amount of silica and alumina in the test clay can be determined.

The chemical analysis of any ball clay does not give an indication of plasticity. It can reveal several other important characteristics such as fired color, the amount of silica tied up with the clay, and the amounts of free silica in the clay. However, any single oxide percent should not be used to evaluate a clay. For example, the fired color of a ball clay will depend in part on the percentages of both Fe_2O3 (iron) and TiO_2 (titania) in the clay and not just one oxide.[6]

SiO_2: The total silica content of the clay is measured. The amount listed can be slightly inaccurate due to the fact that it combines silica, which is part of the clay particle, with free silica, which can be found separate and alongside the clay particle. Clays can behave differently depending on the varying amounts of free silica and clay content. Higher levels of SiO_2 (silica) indicate relatively higher free-silica content and subsequently lower clay content. Silica is found in the clay particle, but there is also substantial free silica traveling along with the clay. Free silica can range from 10% to 30% in ball clays.

In clay bodies fired to 2% absorption or less, substituting a ball clay with higher free-silica content for a ball clay with lower free-silica content will increase the amount of fired absorption due to free silica being such a refractory (heat-resistant) material. Ball clays having silica tied up with the clay particle will enter a melt to a greater degree, causing increased vitrification and a lower fired absorption in the clay body. In clay body formulas where the water absorption is higher than 2%, such a substitution restriction is not relevant. In general, ball clays with higher amounts of total silica content will have a larger component of free silica in them than lower silica ball clays having less free silica. As a rule, try not to substitute a 68% silica clay for a 58% silica clay, since this kind of substitution can yield changes in shrinkage, water absorption, and thermal expansion.

Using this replacement guideline, Taylor Blend, with a SiO_2 of 60.00%, would be a good substitute for Thomas ball clay, with a SiO_2 of 59.40%.

Example: Taylor Blend Substitution for Thomas Ball

Al_2O_3: The alumina content contributes to the refractory or heat-resistant quality of the clay. High Al_2O_3 (alumina) levels indicate a higher clay content since alumina is almost entirely part of the clay particle.

Taylor Blend, with an Al_2O_3 content of 26.40%, has a similar Al_2O_3 content as Thomas, with an Al_2O_3 of 26.50%.

Fe_2O_3: The iron content of ball clay contributes to the fired color and acts as a flux, causing greater vitrification as the clay is fired at increasing temperatures.

M-23, with an iron content of 1.00%, has less iron than TB-1, with 1.10%, suggesting that the fired color might be lighter.

TiO_2: The titania content also contributes to the fired color in ball clays. Crude, unrefined titania found in ball clays can impart a yellow/white color to the fired clay.

FC-340, with 1.27% titania, will have a lighter fired color than Taylor Blend, with 1.70% titania.

CaO: Calcium is a minor percentage of ball clay but does aid in vitrification.

Not a great amount of information can be inferred from the relative percentage of calcium oxide found in ball clays.

M-23, with a CaO of 0.02, has an identical CaO content as S-4.

MgO: Magnesium is also found in ball clay in minor percentages and does not aid in vitrification or affect fired color. No usable comparisons can be made from the magnesium percentages in ball clays.

S-4, with 0.22% MgO, and Taylor Blend, with 0.22% MgO, have identical magnesium percentages.

Na_2O: Sodium oxide is a strong melting-flux component of ball clay and does affect the amount of glass formation in the fired clay.

S-4, with 0.11% Na_2O, has a greater amount of sodium oxide than TB-1, with 0.05% sodium oxide. This does not necessarily indicate that S-4 will have a greater amount of glass formation, since vitrification also depends on other oxides in the chemical makeup of the clay.

K_2O: Potassium acts much the same way sodium does; it is a strong flux component in ball clays.

FC-340 has a greater amount of potassium, 1.18%, than Thomas, with 0.40% potassium. This does not necessarily indicate

that FC-340 will have a greater amount of glass formation, since vitrification also depends on other oxides in the chemical makeup of the clay.

LOI: Loss on ignition is composed primarily of the loss of chemical water trapped in the clay platelet structure. The only other minor contributions to LOI are the organic content—which burns out—and any carbonates that give off CO_2 during heating. Commonly, a higher shrinkage rate is found with clays having higher LOI. This means that clay has a higher percentage of clay particles and less free silica. The clay will impart shrinkage, but the free silica will not.

The LOI test is run in stages. First, the clay must be dried for an hour or more at 212°F to drive off the physical water. Once the clay reaches a stable weight, the physical water is considered totally removed. However, chemical water will not break away from the clay particle at this point. A known amount of dry clay is placed in a porcelain or alumina crucible and fired. The firing cycle is raised until 1832°F is reached, and is kept there for 30 minutes, after which the chemical water is driven off. Then the clay is weighed again, and the loss on ignition is determined (original dry weight minus after-firing weight divided by original dry weight times 100 = LOI).

Every clay particle has a water molecule attached to it. The water is attached chemically and will not be removed by simply drying the clay to 212°F, which would remove mechanical water or physical water as a vapor. A deceptive concept is that individual clay particles will have physical water molecules between them in clusters of clay particles. This kind of water that is not attached chemically will be liberated when it vaporizes at 212°F.

Surprisingly, the loss on ignition in ball clays is usually at least 90% from chemical water and only 10% from organic content. This can be deceptive in that higher alumina / higher clay content clays will have a higher LOI due to more chemical water, but it looks like they have more organic matter. One example, EPK (Edgar plastic kaolin), has a 13.5% LOI, but only 0.2% is lost through organic matter while 13.3% is from chemical water being liberated from the clay particle.

Example: FC-340, with LOI 9.94%, is almost identical to M-23, with LOI 9.90%, which, if other parameters are factored in, might make for a workable substitution.

Fired Properties (%) Linear Shrinkage: Linear shrinkage occurs while firing an already dry bar of 50% clay and 50% flint to a specific pyrometric cone value. Linear shrinkage is added to the fired shrinkage to determine the total shrinkage rate for the clay. For example, at c/04 (1945°F), FC-340 has a linear shrinkage of 8.6% and a fired shrinkage of 4.7%, resulting in a total shrinkage of 13.3%.[7] Keep in mind that different linear shrinkage rates for the same ball clay are possible depending on the specific forming method used to make the clay object. Old Hickory Clay Company provides fired shrinkage rates at c/04, c/3 (2106°F), and c/11 (2361°F). As the clay is fired higher, a greater amount of glass formation takes place, causing increased shrinkage.

Example: FC-340 shrinks less at c/04, c/3, and c/11 (4.3%, 5.9%, 7.8%) than TB-1 (6.3%, 7.2%, 9.2%), indicating a poor match for a possible substitution.

Absorption: The percentage of water absorption is a measure of the amount of pores that are left in the clay body after it has been fired. The results are the percent of water that is soaked in by the body. (A 100 g fired clay bar that soaks up 9 g of water during the ASTM [America Society for Testing and Materials] **Water Absorption Test C 373-72** is said to have a 9.0% water absorption value.)[8] As the clay bar is fired to higher temperatures, there is more glass development in the clay, which closes the pores and lowers the water absorption percentage.

Example: TB-1, with absorption percentages at c/04, c/3, and c/11 (16.4%, 10.2%, 2.8%), is less absorbent than Taylor Blend, with absorption percentages of (16.8%, 11.0%, 3.5%).

PCE: Pyrometric cone equivalent determines the temperature needed in pyrometric cones to melt or deform a bar of clay. The higher the PCE, the longer the clay will keep its structure before melting and deforming. Ball clays as a group are very resistant to heat, and at c/10 (2345°F) will show no indication of deforming. Most ball clays will not deform or melt until they have reached PCEs of 28 (2946°F) or 32 (3103°F).

Example: Taylor Blend, with a PCE of 31 (3022°F), is slightly less refractory (less heat resistant) than S-4, with a PCE of 32.

What Typical Data Sheets Mean for Your Work

It is important to think of the typical data sheet as several "snapshots" of a ball clay's plasticity relative to other ball clays mined by same company. The information contained in one company's data sheet in most instances cannot be used for comparison with other companies' clays. Testing methods and procedures can vary depending on the company doing the testing. In practical application, when using the typical data sheet, only one or two parameters for the ball clay's plasticity would be considered. The choice of which test measurements to appraise would be the preference of the evaluator. As stated, different tests for plasticity have slowly evolved over the years and have found their way into the typical data sheet analysis.

The typical data sheet reveals the raw, unfired color of a ball clay. However, the fired color can vary considerably depending on the chemical composition of the clay, kiln atmosphere in which the clay is fired, end-point temperature, kiln heating-and-cooling cycle, and other materials used in the clay or glaze formula. A typical data sheet also supplies the soluble-sulfate component of a ball clay, which can determine the appropriate deflocculant and the total amount used in the casting-slip formula. The Dry MOR (modulus of rupture) can be useful in determining the relative dry strength of each ball clay. The shrinkage and

absorption percentages can be most informative in determining if one ball clay can be substituted for another in a clay body formula. However, consideration must be paid to the total amounts of other ceramic raw materials in a clay body or glaze formula, which can influence the handling or fired results.

It is not necessary—or, in some instances, practical—for potters to evaluate every piece of information listed in the typical data sheet. However, the more information known about each ball clay, the greater the chance for a successful result in any ceramic project. Industry uses the information contained in a typical data sheet with the goal of producing a uniform, consistent, reliable product, whether it is a toilet bowl or missile heat shield. Potters can use the information to obtain similar reliable results with their pots or ceramic sculpture. Having gained a greater knowledge of a particular ball clay, the potter can also alter the result to realize an aesthetic goal.

6. DENSE-PACKING AND FILTER-PRESSING MOIST CLAY

The question of how to make clay more plastic and workable has been discussed since clay was first discovered to be a useful medium for forming functional pottery, ceremonial objects, and sculpture. While every period and culture have developed their own means to achieve this end, several clay-mixing systems are now being rediscovered to achieve greater plasticity in clay bodies.[1]

The dense-pack/filter-press method of clay mixing has been widely used in industry. Dry clay and water are mixed together, creating a slurry; the liquid mixture is then pumped into a series of canvas bags that look like pages of a book. Excess water is wicked away, after which the clay is placed into a pug mill for continued mixing and the removal of air from the batch.

This type of mixing-and-blending procedure has significantly improved clay body plasticity as compared to other methods of clay mixing. It allows each clay platelet to be completely surrounded by water, as compared to other clay-mixing methods, which result in many dry platelets not in contact with water. While other clay-mixing methods are currently in use by ceramics suppliers and individual potters, the system of dense packing and filter pressing has produced technically improved clay bodies. However, it should be noted that filter-pressing clay is a time-consuming and relatively expensive procedure as opposed to placing dry clay in a mixing machine, adding water, and running the clay through a pug mill.

Every potter has suffered the negative effects of "short" or nonplastic clay, no matter the forming method used. The clay does not hold curves well and splits during the forming process. Nonplastic clay is most noticeable when rolling out a slab and the edges begin to crack. While some clay body formulas are inherently more plastic

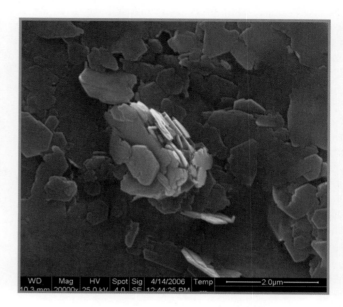

Sheets of kaolin platelets under 20,000x magnification.
Image courtesy of Matt and Dave's Clays

than others—and the term "plasticity" is extremely subjective—at some point the clay just does not bend or perform its assigned task.

Clay Platelets

Why is clay plastic when wet? Why does the shape of clay influence its plastic properties? Clay under a microscope looks like a hexagonal plate having a ratio of roughly one part thickness to ten parts surface area. The diameter of kaolin, a refractory, low-iron, white-firing clay, can range from 1 to 100 microns (1 micron equals a millionth of a meter; the diameter of a human hair is 80 to 100 microns). Other types of clays such as fireclays, ball clays, earthenware clays, stoneware clays, and bentonites all have different-sized platelets, with bentonites having the smallest platelet size. (If the platelets in 2.6 g of bentonite were placed edge to edge, they would cover approximately 6000 sq. ft.; 100 lbs. would cover 2400 acres.)[2]

The Dense-Pack Clay Body

Imagine a room filled with basketballs, each one representing a large clay platelet. When the room is filled there are always spaces between the basketballs. Then fill those spaces with softballs (a medium-sized clay platelet). When those spaces are filled, place tennis balls in the room (small-sized clay platelets) and then golf balls (very small clay platelets) in the remaining spaces. There

will always be some empty space, which water can fill to make the clay body plastic. For throwing clay bodies and handbuilding clay body formulas, additions of small-platelet clays (ball clays, bentonites), medium-platelet clays (stoneware clays), and large-platelet clays (fireclays) contribute to superior forming qualities, as opposed to clay body formulas relying on one or two types of clay. Platelet-size variation on a mechanical level results in a "tight" interlocking moist clay.

In addition to different types of clays, other materials contribute to the total performance of a clay body. In high-temperature formulas above cone 6 (2232°F), feldspar and flint act in conjunction to control vitrification temperature, density, and absorption.[3] On a microscopic level, feldspars and flint are larger in comparison to the clay particles that pack around them. Grog, silica sand, and other fillers can also be used, which are of different shapes and in some instances many times larger than the clay component. For example, silica sand and other fillers are of different shapes and in some instances 40 times larger than the clay component.

Grog, molochite (a calcined china clay), and silica sand all are produced with varying mesh sizes. To further maximize particle-size variation and physical interlocking, several mesh sizes can be used in the clay body formula. The larger the number, the finer particle size of the material. Numbers below 100 mesh indicate a fine powder, which can decrease clay body plasticity. For example, a 48/ to fine-mesh-size grog can be used in throwing bodies, while a larger-mesh grog, 20/48 mesh or a 20/30 mesh material, would be suitable for sculpture bodies. Silica sand is also produced in various mesh sizes. However, some sands are round in shape and will not add "tooth" or stand-up ability to the moist clay in the forming operations. Sharp sand, having an angular irregular shape, is better suited in the clay body, since its surfaces interconnect more efficiently with the adjoining raw materials and clays.

Under magnification, feldspars and quartz (silica) are giant grains in the multi-platelike structure of the clay body. However, many small clay platelets are able to control the movement of relatively few large grains of materials found in fillers.[4] Although these materials do not improve plasticity, they contribute workability to the clay body.[5] The selection of clays, especially their particle-size distribution, and the total amount of clay used in the clay body are important factors in dense-packing clay body formulas. Dense-packing of clays contributes to an internal structure of the clay body characterized by more powerful bonding between the clay particles, making it stronger.

Surprisingly, aging of the clay and its moisture content are not as critical in determining plasticity as dense-packing of the clay platelets.[6] The actual water content of the clay body will determine if it will be hard or soft, but does not influence its performance. Some potters have a preference for softer or harder clay, but this is a personal consideration that allows them to achieve a particular goal when making a form. In many instances, potters blame a very soft clay (high water content) for warping, or hard clay (low water content) for cracking, when the actual cause is whether the clay body has achieved a dense-packing configuration or not.[7] If the clay body contains only one clay, such as Grolleg kaolin (found in porcelain clay body formulas), the uniform-sized

Dense-packed clay body. Large, medium, and small clay platelets. *Images courtesy of Matt and Dave's Clays*

Less dense-packed clay body. Only one size of platelet clay with greater water films. *Images courtesy of Matt and Dave's Clays*

clay platelets leave a lot of empty space that is filled with water, causing the "floppy" feeling. When working porcelain on the wheel, potters frequently report that it slumps or falls back on itself. This is in contrast to stoneware clay body formulas, which usually rely on several clays, each having a different platelet size, so there are fewer empty spaces between the plates to be filled with water, resulting in a clay body less likely to slump during handbuilding and throwing operations.

However, introducing ever-smaller particles into the clay body can cause the moist clay to become too stiff for handbuilding or wheel throwing due to less room for water in the clay body

Dense packing of the clay body formula increases the workability of the clay. Traditional porcelain clay body formulas (left, Porcelain) are less workable than (middle) Matt and Dave's Clays Porcelain for the People. Stoneware clay body formulas having a greater particle-size variation (right, Stoneware) have greater workability. As green packing density increases, workability increases up to a point and then decreases due to too little water in the clay mix, causing a stiff clay body (extreme right side of graph, Industrial Bodies). Workability can also decrease if too much water is used in the mix (extreme left black box, Grolleg Porcelain Bodies). *Image courtesy of Matt and Dave's Clays*

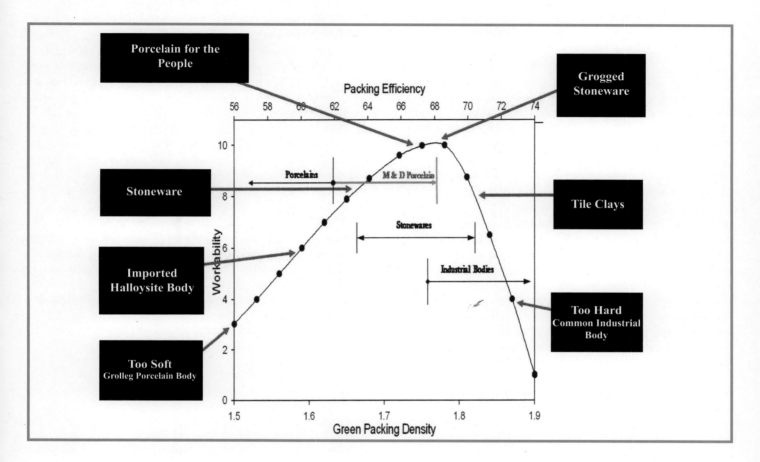

structure. The overly packed moist clay is almost unbendable but is suitable for ram pressing or jiggering, which apply greater force to form moist clay.

Diversity in clay platelet size creates increased contact between platelets and enhanced electrostatic attraction of clay platelets. The faces of the platelets attract each other like the positive and negative poles of a magnet draw together. Additionally, the attraction effect of water clinging to the individual clay platelets serves to increase plasticity. Greater clay surface areas of different sizes are used by both reactions.

Traditionally, porcelain clay body formulas are composed of 50% of a single kaolin, 25% flint, and 25% feldspar and do not handle well, resulting in a "flaccid" condition and "rubbery" feel in forming operations. This is due to a low clay content and the similar platelet size found in its kaolin. Using only one type of

kaolin limits the particle-size distribution and creates a less than dense pack condition. Using a plastic kaolin such as Grolleg, EPK, or Tile #6 in conjunction with other kaolins such as Velvacast, Kingsley, or Helmer can improve overall plasticity as compared to stoneware clay body formulas, which can contain approximately 80% of clays of various particle sizes.

Dense-packing of clay bodies depends on three conditions: the clay platelet sizes used and their subsequent surface areas, the particle-size distribution of a clay(s), and the morphology or shape and aspect ratio of the particles introduced into the clay body. Dense-packing and mixing the clay as a liquid slip (slurry mixing) increases green strength, making cracking less likely when leather hard or bone dry. It also minimizes packing voids in the clay body, resulting in less warping in the drying and firing stages.

Clay-Mixing Procedures: Plastic Mixing and Slurry Mixing

The Plastic-Mixing Procedure

Traditionally, clay body formulas mixed by commercial ceramics suppliers and individual potters involve weighing out the dry materials—which might be mixed in random order—then adding 21% to 25% water to achieve a plastic moist clay. However, the moisture content differential between soft and hard clay can be as little as 3% to 5%. The clay body can then be sent through a de-airing pug mill, which further mixes and compresses the clay while removing excess air. This has proven to be a low-cost, high-volume method. The mixing operation is usually performed by bread dough mixers, Muller-type roller mixers in which the clay is kneaded but not crushed by the wheels, or ribbon-mixing machines and pug mills. While economical and labor saving, plastic mixing does not produce optimum plasticity. It also does not promote green or fired strength in a clay body.

When the clay becomes plastic after the addition of water, there are clumps of feldspar, quartz, and clay. These clumps cause inconsistency in performance, inducing many forms of body failure such as bloating, warping, and slumping in the fired clay. Over time, water does wick through the entire mass of clay, increasing its plasticity, but the normalization of water does nothing to disperse the agglomerates. Many potters have experienced this type of delayed plasticity when they first mix their clay and roll a small coil around their finger and it cracks. The same-diameter coil of moist "aged" clay rolled around the finger a few days later does not crack due to increased moisture saturation of the clay body, with a water film surrounding a greater number of clay platelets.

Plastic clay mixing can cause several defects, one of which is marbling, which produces darker or lighter discoloration in the moist or fired clay body. Marbling is due to incomplete blending in the mixer. Where colored clays are used in the clay body and are marbled, they can cause areas of varying fired colors. If a low-temperature, darker-colored clay is added for clay body color in a high-temperature clay body, it can cause overfluxed areas due to its lower melting point. When feldspar or other raw-material particles are not distributed equally, they can stick together, yielding highly concentrated areas of flux in the clay body that can cause bloating or bubbles in the fired clay. The formation of feldspar clusters due to agglomeration (clumping) of feldspar particles can be stopped by the addition of clay to the mixing process, which coats the feldspar (see "The Slurry-Mixing Procedure").

The Slurry-Mixing Procedure

The slurry-mixing process uses excess water, a specific sequence of adding materials, and high-shear blending to ensure a thorough mix in the clay/water structure. This combination assures that each clay platelet is surrounded by a water film, resulting in greater clay body plasticity. The process begins with water and bentonite, an extremely plastic, small-platelet clay that is added to increase plasticity. However, bentonite expands when in contact with water. Therefore, it should be thoroughly mixed in water for at least 24 hours to ensure its complete dispersion. In high-shear mixing operations, bentonite can be added first to ensure hydration of the particles. The process then requires that 20% of the clay component be added to the water, resulting in a dilute clay/water soup. The suspension encapsulates and disperses the feldspar, which is added next, preventing it from clumping, which would result in overfluxed areas in the fired clay body. Flint is then added, followed by the remaining 80% of clay.

While the slurry-mixing procedure is time consuming and labor intensive, it does produce greater plasticity, increased green strength, and homogeneity in the moist clay, one result being lower loss rates when moving green pots. The process also reduces failures caused by potter's wheel torque, where the moist clay is twisted by the rotation of the wheel, and the pot can unwind and warp in the drying or firing process. Slurry mixing also enables sturdier attachments to the moist clay, such as spouts, handles, and knobs.[8]

Filter-Pressing Clay

Since slurry mixing introduces excess water into the process, the next step removes it while leaving enough to achieve a plastic clay body. Water removal can be accomplished in several ways. In the private studio, a container of absorbent material such as plaster can wick out the excess water. In industry, it is accomplished by a filter press, where the slurry is piped between a series of fabric-coated plates, and pump pressure forces out excess water through the fabric, leaving the plastic clay behind. The resulting sheets of clay are then fed into a pug mill for compressing and de-airing. Significantly, dense-packing clay, slurry mixing, and filter pressing combine to make stronger and more-plastic clay bodies than the plastic-mixing process. This has been proven by using the same clay body formula and processing it by using the plastic mix method versus the slurry mix, filter press method, which resulted in a significant improvement in the handling qualities of the moist clay body.

Dense-packing and filter pressing makes the clay more workable. For example, porcelain clay bodies can be used on the wheel and for handbuilding operations, while filter pressing of the clay enhances wider firing ranges due to the consistent distribution of feldspar throughout the clay mix.

⊙ Ribbon-type clay mixer capable of mixing 3000 lb. batches of moist clay. Ribbon and Muller clay mixers are the most common machines used in producing clay for potters. *Image courtesy of Sheffield Pottery*

⊙ The slurry clay is pumped into plates, which retain the material while excess water drains. The slurry mixing of clays and other raw materials uses excess water and the fast blending action of the impeller, resulting in the thorough wetting of the clay platelets and yielding greater plasticity in the clay body.

⊙ The clay is then ready for the pug mill.

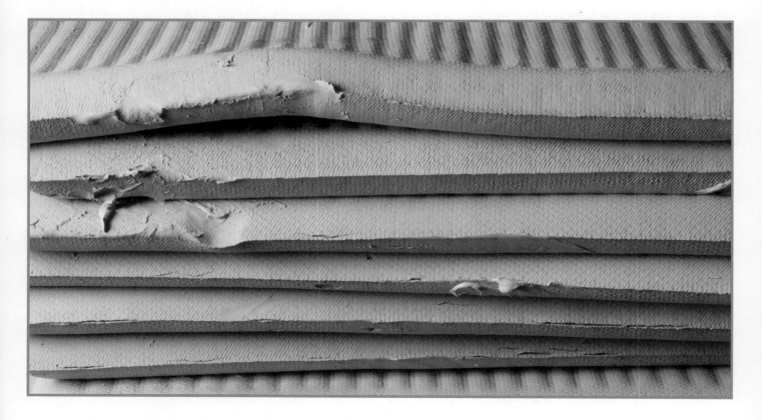

⊙ Moist clay extruded from the pug mill.

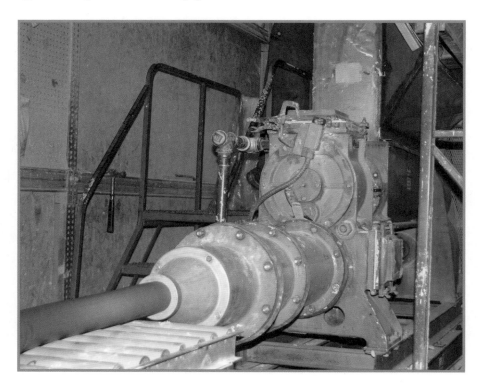

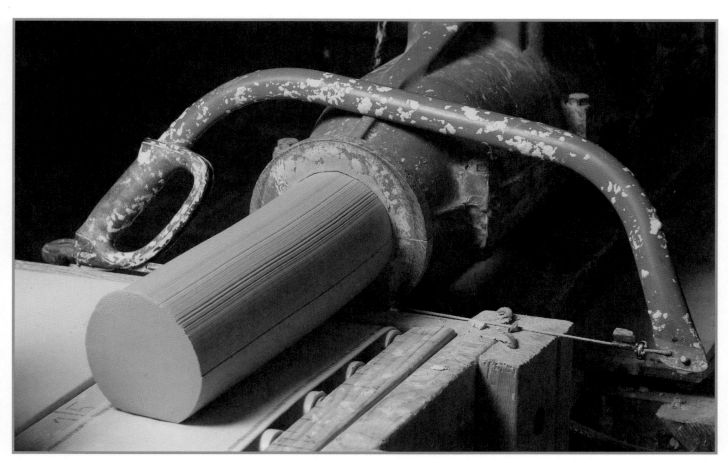

Comparison of Cross Sections of Fired-Clay
Filter Pressing vs. Plastic Mixing

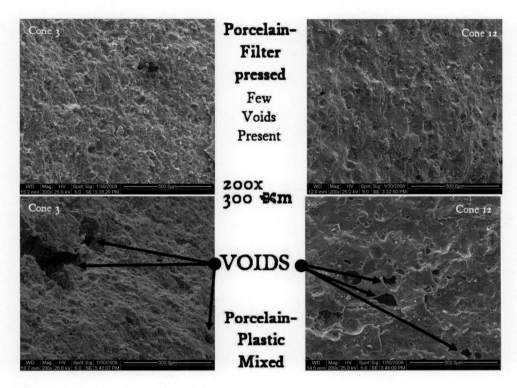

Comparison of the same porcelain clay body mixed by using the filter press method, fired at cone 3 (2106°F) and cone 12 (2383°F), showing fewer voids in the fired clay body (top images) as compared to the plastic-mixing clay method, resulting in more voids and a weakened fired clay body (bottom images). Fewer voids in the dense-packed, filter-pressed clay yield a stronger, more durable clay when fired. 200x magnification of porcelain clay bodies. *Images courtesy of Matt and Dave's Clays*

The Economics of Clay Mixing

The cost of labor, raw materials, and production time required to mix the clay body all play a part in determining why the plastic-mixing process is so popular with ceramics suppliers and individual potters who mix their own clay. The efficiency and low operating costs are accepted industry standards. For professional potters who mix their own clay, saving time in any part of the pottery production operation is critical in keeping costs low. The plastic-mixing method allows them to produce large quantities of moist clay faster than would be possible with slurry mixing and filter pressing. Almost all industrial clay-manufacturing operations utilize the slurry mix and filter press operations. They find that the improved quality of the clay body drastically reduces the losses they face in manufacturing.

The extra expense generated in dense-packing clay body formulas requires ordering, inventorying, and mixing an increased number of clays to enhance platelet-size variation. It also demands greater time to produce a slurry mix and to filter press a clay body. For ceramics suppliers, such steps necessitate higher pricing, increasing the cost of a typical porcelain clay body by as much as 25%. Short cuts taken by most ceramics suppliers are something that artists must consider carefully. The composition and mixing used by those companies do produce low-cost clays. However, low-cost clays come with many potential problems that are corrected in filter press mixing. Although the cost of filter press clays is higher, the success of one's work in the studio and kiln is the most valuable asset a maker can have. Potters as a group are very sensitive to the cost of their materials, especially premixed clays, since this is one of their largest expenditures. However, the cost of raw materials is small compared to the expenditure of time and labor required to make the pottery. This fact is still not widely recognized, and, as a result, ceramics suppliers who make premixed clays are reluctant to incur additional expenses to change their mixing operations.

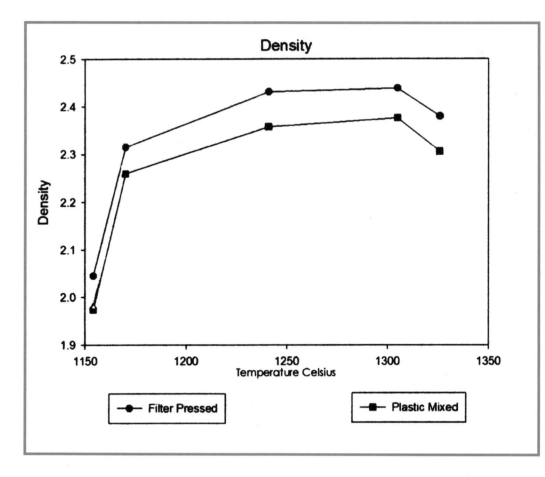

Comparison of increased density of filter-pressed clays vs. the plastic mix procedure at various temperature ranges. *Image courtesy of Matt and Dave's Clays*

Comparison of plastic mix ½" diameter coils of moist clay (top) compared to identical-dimension coils slurry mixed and filter pressed (bottom). Cracks in newly made plastic mix clay body caused by incomplete water penetration to the entire mix. Slurry mixing and filter pressing surrounds more clay platelets with water, causing less cracking in forming operations.

As for individual potters mixing their own clay body, once aware of the benefits of dense-packing, slurry mixing, and filter pressing, it's an open question as to whether they will take advantage of this technical improvement in clay plasticity and strength. The extra cost and time and the additional equipment have to be balanced against an improved clay body. It does seem that a percentage of potters are satisfied with their moist clay no matter how it is mixed, and they do not have the time or money to consider an alternative. However, potters who realize that the cost of clay is only a fraction of their production costs may turn to dense-packing, slurry mixing, and filter press mixing to reduce defects and possibly expand aesthetic choices. The greater appeal of this method might be found in college ceramics programs or craft centers, where economic considerations are not as critical, and there is more time to investigate different aspects of clay mixing.

7. MASS PRODUCTION OF PREMIXED CLAYS

Purchasing premixed moist clay from a ceramics supplier can offer many choices in terms of firing range, kiln atmosphere, forming characteristics, and fired color. By offering a wide range of moist clays, the ceramics supplier is hoping for a satisfied customer who will be buying more clay in the future and possibly other supplies and equipment. A supplier can place a great amount of effort in the planning and testing of a premixed clay before it is ready for sale. However, many stock clay body formulas were originally an individual potter's clay body that the supplier is now mass producing, one hopes with the potter's consent. Sometimes if a clay body works well for one person and is formulated correctly, all is well, and many potters use it with good results. The formula gains popularity and stays in the catalog. Whether a clay body formula comes into existence by this method or is developed in-house and tested before committing to full production, there are several market, economic, and technical matters that have to be considered.

Market Demand Factors

Ceramics suppliers can conduct an informal survey of potters just by asking what kind of pottery or sculpture they are producing at various temperatures in what kiln atmospheres. They can then devise clay bodies to suit the needs of their customers. If the ceramics supplier's market contains a great many schools, an inexpensive, low-temperature clay body that fits a wide range of commercial glazes might be required. This type of clay body can be composed of relatively low-cost ball clays and fillers such as talc to meet the competitive bid structure of many school districts. If potters are making functional stoneware pottery, a midrange- to high-temperature white or brown clay body suitable for wheel or handbuilding might satisfy the market. Higher-priced clays such as fireclays or stoneware clays that are designed for salt, soda, raku, or wood firing might require specialized raw materials designed to enhance the effects of fast firing or vapor kiln atmospheres. Production runs will vary, depending on the specific clay body. It is always more efficient and profitable to produce a long run of a clay formula as opposed to having to clean machinery between new formulas.

A major consideration for adding a new moist clay to the catalog is not duplicating an existing clay body. There is no economic sense in copying a clay that customers are already buying. An exception is when a competing supplier has a popular moist clay, and the competition must be met to hold or increase market share. While new moist clay formulas do come about, most ceramics suppliers have a vested interest in keeping their existing formulas, since potters generally stay with a clay that is producing consistently good results.

National or local advertising through magazines, catalogs, or websites is frequently accompanied by color images of the different clay bodies, along with their recommended firing temperatures and color in reduction and oxidation kiln atmospheres. A short description of the clay body and its potential uses is also listed along with pricing at various amounts plus delivery charges. Since the transportation costs of moist clay to the potter can be significant, most potters order from local or regional sources, either through the ceramics supplier who mixes clay or their distributors. In the past few years, professional potters' testimonials have been used to promote sales.

Moist-Clay Name and Description

Moist clay is usually named or numbered depending on the history of the ceramics supply company's method for clay body designations. However, each clay body does have a catalog number for easy and accurate ordering and tracking. When choosing the name or number, it is often a matter of personal preference. Some clays are named after the person who developed the formula, such as Pete's Supreme, or it can be a purely generic and numerically descriptive designation such as White Stoneware with Grog #3333.

Technical Factors—Clay Body Performance

A clay body formula must be all things to everyone and still have a specific character that the potter can recognize and want to purchase again. After all, why buy one over another if they all are the same? The clay body must have good handling and firing qualities for a wide range of potters with varying degrees of skill, which is often a difficult balance to achieve. Clay bodies could be formulated that would be "cutting edge" in performance, but such extremes would not make them profitable to produce, since only a few skilled potters could enjoy the results.

One of the most common customer complaints is the moist clay's consistency. One potter might find the clay too hard, while another states the same clay is too soft. Often the difference between hard and soft clay is a 5% to 6% variation in the amount of water used to mix a specific batch. Ceramics supply companies have instituted several quality-control measures to ensure consistent moisture content in each batch. One device is the penetrometer, a needlelike instrument that when pushed into moist clay registers its resistance. With soft clay, the needle sinks in; harder clay with less water in the batch presents greater resistance to the needle, all of which is quantified by numbers on the device.

Ceramics suppliers also keep accurate tallies on the amount of dry material and water used when mixing clay. Interestingly, the water content can change considerably from one clay formula

to another, ranging from 18% to 30%. Clay bodies for throwing that contain high amounts of ball clays will require more water to achieve plasticity than sculpture bodies containing grog and larger-platelet clays such as stoneware or fireclays.

The water content can also vary with the same formula from batch to batch. Most clays are air floated and have a small amount of moisture in them from the mines. The moisture content from one lot to another can make a slight difference in the final water content added to the mix. A quart of water added to or subtracted from a 1000 lb. batch of clay can make a significant difference in handling qualities of the plastic clay. Most commercially produced moist clays range from 19%—very stiff clay—to 30% moisture content, resulting in a very soft clay body. Potters requiring a specific consistency can send a carefully wrapped sample of moist clay to ensure the correct moisture content in the larger batch mixed at the ceramics supplier.

In order to track the many variable clay-mixing factors, a well-trained, highly experienced crew is essential. One major ceramics suppler states, "It takes a year to fully instruct a clay-mixing operator and five years to train a pug mill operator." Paying minimum-wage workers to mix clay can produce poor quality control. Also, low pay can mean high turnover rates in personnel, all of which affect moist-clay consistency. In the long run, it pays to invest in a fully trained staff that can work with the variable nature of the material and mixing factors.

Aside from the careful monitoring of the water content for each clay body, many ceramics suppliers place problem clays such as fireclay through a 30 to 100 mesh screen. They also use rare earth magnet iron filters to reduce unwanted iron specking in the clays. The clay-mixing water is also tested, since hard water containing calcium or magnesium minerals can flocculate or harden the moist clay. Soft water with sodium mineral deposits can deflocculate the clay, causing a soft, easily deformed plastic mass when subjected to forming methods.

Firing Range

As a general rule, a single clay formula cannot do everything, and that's why there are so many different premixed clays available. Adequately formulated clay bodies should have a firing range of three pyrometric cones. For example, if a clay is rated as c/9 it should function at cone 8, 9, and 10, without deformation and excessive shrinkage. Be on guard if a moist clay has a wide firing range, since it might not be dense and vitreous over its entire range. While high-temperature stoneware clay bodies can be used for low-temperature pit firing or raku firing due to their open, porous structure at low temperature, clays can deform and melt if fired to high temperature. Most ceramics suppliers offer a range of clays at c/06 (1828°F), c/6 (2232°F), and c/9 (2300°F).

Ceramics suppliers list the shrinkage and absorption rates for each moist clay they sell. The percentages are useful in comparing one clay with another, but there can be a plus or minus of 1% or greater difference in how much the clay will shrink or absorb moisture in your own kiln. The published numbers should be compared only with other clays listed in the catalog in a very general way. Comparing these numbers is even more imprecise, since the size of the test kiln and the firing time to temperature are variables that can make comparisons meaningless. To arrive at precise shrinkage and absorption rates, fire the moist clay in your own production kiln, since small test kilns have different firing and cooling rates than larger kilns.

Forming Method

Clay bodies are formulated for throwing, handbuilding, jiggering, ram pressing, or slip casting. Each requires a different ratio of plastic to nonplastic materials in addition to fluxes and fillers. Various clay types such as fireclay, stoneware clay, earthenware, kaolin, ball clay, or bentonite are frequently combined to impart specific characteristics to the clay body. Throwing bodies require the most plasticity, which is derived primarily from ball clays, bentonite, and other plastic clays. Handbuilding, jiggering, and ram press bodies have greater percentages of nonplastic clays such as fireclay, kaolins, and stoneware clays and higher percentages of nonplastic materials such as flint, feldspar, and pyrophyllite. It is not unusual to use a throwing body for handbuilding in some ceramic projects. However, the larger or thicker the handbuilt piece, the more specialized the clay body requirement. Casting slips are a world unto themselves and are much more sensitive to the exact ratios of water, clay, filler, flux, and deflocculant.

Kiln Atmosphere

Whether the moist clay is fired in an oxidation atmosphere (excess air-to-fuel ratio in combustion), neutral atmosphere (equal amounts of air and fuel), or reduction atmosphere (excess fuel-to-air ratios), the clay body formula will have to be compatible with the firing kiln's atmosphere. Generally, clay bodies designed for reduction kiln atmospheres can also be fired in neutral or oxidation due to possibly high amounts of iron oxide or iron-bearing clays in the clay body not being overfluxed by the neutral or oxidation atmosphere. However, depending on the specific formula, the clay bodies might not look the same. Conversely, clay bodies designed for oxidation atmospheres can possibly be overfluxed in reduction kiln atmospheres due to their high iron content. Ceramics suppliers should indicate the atmosphere recommendations for each clay body they sell.

Clay bodies can also be developed for wood, salt, soda, or raku firing. The wood kiln presents several elements not found in other types of atmospheres. Stoking can create intermittent oxidation, neutral, and reduction kiln atmospheres, all of which can create random flashing on the exposed clay surface. At temperatures above 2300°F, wood ash begins to flux into an alkaline glaze, altering unglazed and previously glazed clay surfaces. The

clay body must accommodate such wide ranges of atmosphere and variations in wood ash deposits.

In salt and soda firing, a sodium vapor atmosphere is introduced into the kiln and reacts with alumina and silica in the exposed clay body surfaces, creating a sodium/alumina/silicate glaze. The clay body must be formulated to develop an "orange peel" or gloss surface. In some instances, random flashing of the surface is desired, and the clay body should accommodate this reaction.

Raku clay bodies must be able to withstand wide ranges of heating and cooling either in an oxidation or reduction carbon-trap atmosphere, all within a short period of time. Additionally, the clay body must accommodate a broad range of fast-fired glazes.

Fired Color

Ceramics suppliers try to offer a wide range of clay body colors in different temperature ranges. Dark brown, brown, light tan, and cream are often the easiest and least expensive colors to produce since they depend to varying degrees on iron-bearing clays. Porcelain or white stoneware clay body formulas that require imported or domestic kaolins and are more difficult to develop average a few cents more per pound than ball clays or stoneware clays. Black, green, or blue clay body formulas require a higher level of expense depending on the coloring oxides or stains used.

Moist Clays' Stability in Storage

Many ceramics suppliers ship their moist clay in two 25 lb. 3 mil plastic bags, which are enclosed in a cardboard box. The bags are sealed either with a twist tie, a rubber band, or a cost-cutting twist of the plastic bag as it is placed in the box. The name of the manufacturer and clay name or catalog number are usually stamped on the box. Since the plastic bags are permeable, the average shelf life of the moist clay is four to six months before it becomes harder. Some ceramics suppliers use a thinner 2 mil bag because it seals more effectively than a thicker bag, but it leaves the moist clay more prone to air infiltration.

Moist clays in the plastic bag can become harder or softer due to the breakdown of soluble materials such as nepheline syenite, which can make the moist clay softer with age. Conversely, some frits and VeeGum T can have the opposite effect, causing the moist clay to become harder in the plastic bag. The pH content of the clay-mixing water—whether acidic or alkaline—can also intensify the effects of raw-material solubility, creating harder or softer clay in the bag. Generally, clay bodies containing high percentages of ball clays remain softer longer in the plastic bags, since a greater percentage of water film surrounds each clay platelet. Coarser clays with less surface area require less water for plasticity and dry out somewhat faster in the bag.

Raw-Material Substitutions

Periodically, a ceramics supplier will have to reformulate a clay body due to one or more of its raw materials being discontinued. In some instances the ceramics supplier does not have the mechanism for notifying each customer. Many will note a change of raw material on their websites or when a customer calls to reorder, and ceramics suppliers who wholesale their clay send letters to their distributors. If a substitution is successful, the customer's moist clay will have the same handling, glaze fit, and firing characteristics as the original clay body formula.

Economic Factors

Some ceramics suppliers mix and sell their own moist clays. Others buy moist clay at wholesale and sell it to their retail customers. Raw-material costs have increased, primarily due to increases in transportation. The machinery used to dig and process clay runs on diesel and gas fuel. Carriers have instituted fuel surcharges, as have material suppliers and mines. At some point these costs have to be passed on and factored in to the retail pricing of the moist clay.

While ceramics suppliers try to use domestic clays and raw materials whenever possible, there are some materials that have to be imported, such as spodumene, Grolleg, and English China clay. The same domestic transportation fuel surcharges apply getting the materials from the point of entry into the United States to the ceramics supplier's mixing facility. The materials are also affected by currency fluctuations. Imported clays and raw materials also tie up the importers' capital, since shipments can take months to reach the United States.

The average profit margin on ceramics suppliers' moist clay is 30% to 35%, which does not allow for inefficiency in the ordering, mixing, and shipping. Other items such as tools, pottery wheels, kilns, and related goods have higher profit margins and contribute more income than moist-clay sales. The retail price of the moist clay is also a central factor as it compares to the competition. Many potters consider the price of moist clay in their purchasing decisions. They are reluctant to pay a few cents more per pound, thinking they are saving money while not realizing it is the quality of the clay and the expertise to mix it that is most important. Why save pennies on a pound of poorly mixed clay and lose dollars in pottery sales due to defects in the clay? Yet, many potters fall into this trap only to discover that cheap clay can turn out to be very expensive when it fails in the forming or firing process.

However, ceramics suppliers have to be aware of pricing their moist clay in relation to the competition, since many potters still shop only by price and do not factor in the actual quality of the moist clay. A supplier's large stock of dry and moist clays makes

for efficient customer service but carries a cost that cannot be directly passed on to the customer. For ceramics suppliers the economics of making moist clay or buying it from a distributor are major factors, in that the correct choice will keep the business viable.

Aside from low costs for raw-material shipping, ceramics suppliers are looking for clay body formulas that are easy to produce and have the widest appeal. A long production run of a single clay body formula is the ideal situation for a supplier, preferably followed by a formula of the same temperature range in a similar color. Any deviation such as a different temperature range or fired color can slow down production, since more time is needed to clean equipment between runs. Nylon, fiberglass, and paper fibers and additives can achieve unique results in a clay body but can also increase clean-outs of mixers and pug mills, all of which mean increased labor costs and higher moist-clay pricing. The same production considerations apply to the use of coloring oxides or stains in the clay body. If the machines are not cleaned properly, the next batch is contaminated. A small amount of iron oxide or iron-bearing clay can contaminate a batch of white clay, which is often unnoticed until the clay is fired.

Cost vs. Performance

As in any production situation, there is always the balance between creating exceptional performance in a clay body—low shrinkage, good handling properties, correct glaze fit—and little or no deformation in firing. However, does the cost to bring these qualities and value-added features justify the higher price that must be charged? For example, different particle-size clays and raw materials can be used in a clay body to densely pack the moist clay, resulting in better handling qualities. The best clay body formulas have small, medium, and large structures, either in the form of clays or raw materials, but that might mean adding two or more ball clays or multiple fireclays of different particle sizes, all of which results in higher costs.

Filter pressing, a labor-intensive and slow process, can also be employed. The clay is slaked down with water, and the resulting slip is run through an absorbent leaflike structure to remove excess water. This method thoroughly surrounds each clay platelet with a water film, increasing its plastic properties, which adds cost to the final moist clay. Will there be enough potters willing to purchase a clay body engineered and processed to such a degree? Such production questions have to be calculated by the ceramics supplier and balanced with what the market will buy.

Raw-Material Availability

Rising fuel prices can yield transportation charges equal to or exceeding the actual cost of the raw materials, making it uneconomical to use distinctive clays from a distant location to achieve unique handling or firing qualities in a clay body. There is always a risk that only a few potters will choose to buy such a specialized formula. Ceramics suppliers tend to choose raw materials that will remain in production for reasonably long periods. However, there is no guarantee of perpetual raw-material availability in clay body production.

For example, NYTAL HR 100 talc was discontinued in January 2009. The talc was mined in New York State and was used in low-fire white clay body formulas for years. For some East Coast ceramics suppliers, the freight cost to substitute Texas talc has substantially increased their cost. Recently G-200 feldspar and Cornwall stone have not been discontinued but have gone through several alterations based on new sources for these commonly used raw materials in clay body and glaze formulas. Specifically, when using either it is best to test any new stocks before committing to full-scale use. Consequently, suppliers have passed on the increase to their customers. At some point any given raw material may be discontinued, which might affect overall pricing to the moist clay.

Raw-Material Quality

Clays are mined and refined to the specifications of larger industry standards, which might not ensure their problem-free use by potters. The percentage of defects based on the million of pounds of moist clay produced is exceptionally low. However, even one defect has a disproportional effect because of the time and labor lost.

Very few ceramics suppliers will take the additional steps of refining clays further to ensure better-quality moist clays for their customers. A few do screen their clay, but this extra step adds to the cost due to the equipment, labor, and time involved. Some segments of the market are willing to pay the extra cost for improved-quality moist clay, since the screened clays run a few cents more per pound.

Aside from screening, ceramics suppliers are reluctant to use additives such as Epsom salts, bentonite, nylon fibers, fiberglass fibers, paper pulp, or Additive A in their stock clay body formulas due to the limited number of potters willing to pay for the added costs of the materials and machinery cleaning and the time required to fit the special clay body into the production cycle.

Typical Clay Cycle from Mine to Potter

The clay deposit site is excavated, overburden soil is removed, and then test cores are drilled to determine the extent of the deposit.

The clay can then be extracted for drying and processing, depending on type and potential use, after which it is bagged and shipped to industrial users and ceramics suppliers. The dry clay is weighed and combined with other raw materials, and water is added while it is in the clay mixer. The moist clay is then placed into a de-airing pug mill and extruded for packaging and eventual use.

The Future of Moist Clay from Ceramics Suppliers

There will always be a percentage of potters who purchase premixed clay from ceramics suppliers, due in part to the convenience and time-saving benefits. Additionally, the supplier has the equipment and personnel to make consistently accurate clay formulas. Premixed moist clays have become more sophisticated over the years, and this trend will continue. Many potters have developed their own clay body formulas, which are mixed at the ceramics suppliers' facilities.

However, the trend since the 1980s indicates fewer potters pursuing the craft as a profession and a leveling off of people using moist clay at the hobby level. A more troubling development is the elimination of ceramics programs in schools due to possible health concerns. School administrators who traditionally purchased moist clay from ceramics suppliers are now often fearful of potential litigation concerning clay dust in the art room environment.

It is anticipated that the current trend in mine closures will continue as more industrial users of clay move to foreign countries that have lower labor costs and fewer safety regulations. This will result in fewer domestic clays that can be used in clay body formulas. Those with knowledge will be fine, but ceramics suppliers that mix old formulas without ongoing research will have problems with the diminished selection.

Clay refined and bagged for shipment.

● Clay mixer at a ceramics supply company.

Recommendations for Choosing a Clay Body

Stock clay bodies sold by ceramics suppliers are generally problem free, but it is impossible to devise a formula that will suit every potter's requirements. It is possible with some experimenting to find a clay body that will work well for your requirements. However, no ceramics supplier has a perfect track record of selling defect-free clay, though some have better quality-control procedures than others. Potters should first investigate their local suppliers who have the lowest incidence of defective clay. In part, this information can be obtained by asking other potters what their experience has been with a given supplier. Ceramics is a small world, and a few phone calls will return big dividends in useful information. Always find out how the supplier handles their eventual customer complaints; do not expect to be treated differently from other potters who have experienced unfair services. When you find a reputable supplier of moist clay, do not price shop; remaining a loyal customer is the best insurance of a favorable resolution to future problems.

Many potential problems can be avoided just by using the appropriate clay for your individual situation. The catalog, staff at the ceramics supply company, and other potters are good sources with which to evaluate a clay choice. Most suppliers offer several

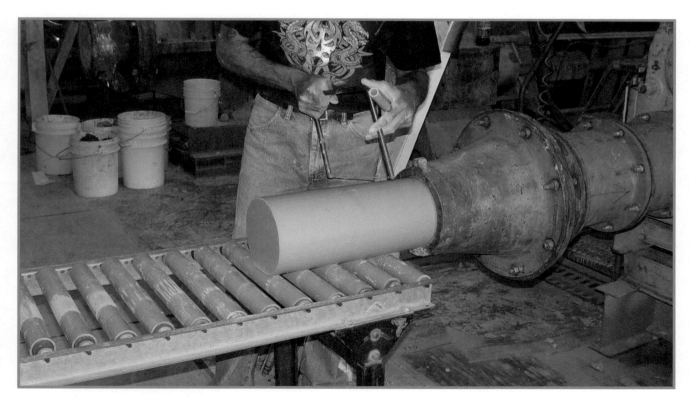

▲ Moist clay exiting a pug mill.

Boxed moist clay ready for use by the potter.

Finished pottery.

moist clays in a particular firing range and fired color. Start by ordering small samples of each and test them as to their handling properties, glaze interaction, and fired results to see which one suits your needs. Keep in mind that some clay bodies are listed in the catalog as having a long firing range. For example, a stoneware clay body might have a firing range from cone 6 (2232°F) to cone 9 (2300°F). Do not expect this clay body to be mature and vitreous over the entire temperature range. Be sure to test the clay in your production kiln at the temperature you will be using, and note the shrinkage, absorption, and glaze fit.

Most ceramics suppliers have a minimum order requirement for private formulas. Keep in mind that the potter who submits a private formula assumes a higher degree of risk. If a fault occurs in the forming, drying, or firing, the potter should be prepared to prove that the clay body was mixed incorrectly and not due to an error in formulation. When ordering, be specific about the mesh size of the raw materials required. For example, specify flint 200 mesh or nepheline syenite 270 mesh, since both materials are processed in various mesh sizes, which can alter the clay body's forming and firing qualities. When possible, specify virgin grog and the mesh size instead of reprocessed grog, since it may contain contaminants that can produce a range of defects. To ensure the correct moisture content, send along a moist-clay sample with any mixing instructions.

The question of how much clay to order at one time is important. Ordering small amounts can be expensive since the price per pound is higher than in larger amounts. Ordering too much clay at a time can result in the clay becoming harder in the semipermeable plastic bags.

Probably the most difficult procedure to carry out consistently is reordering a new batch of clay *before* the old batch is exhausted. When a new shipment arrives, open several bags and test the clay before committing the entire batch to a kiln load. If a defect is noticed, stop using the clay and call the supplier with the date and batch code. In some instances you will be required to send a fired sample of the defect. As a general policy, suppliers have limited liability, which means they will only replace the clay and not compensate for damage caused by the clay or any time and labor lost. This policy applies only if the defect originated with the clay or mixing procedure. Keep careful records of clay shipments and be prepared to describe the problem accurately, which is critical in achieving a favorable outcome.

The price of moist clay is insignificant compared to the quality control used to mix the clay. However, many suppliers will offer a price break if you choose not to package the clay in a box. One supplier offers a reduction of 1 cent per pound. Another will buy back clay boxes and offer 25 cents for each on the next purchase. Policies vary depending on the supplier. If you choose to have clay shipped without boxes, inspect each plastic bag upon delivery for any holes. Additionally, make sure the bags can be stored in your studio without ripping.

Whether an individual or a ceramics supplier mixes the clay, the primary concern is the use of raw materials that are not mined, refined, or blended for the needs of the potter. The variable nature of the materials and their wide parameters for a successful result are remarkable. Ceramics suppliers who mix clay are dedicated to providing a reliable product, and in most instances they succeed. Economic factors such as high shipping costs, retail price limitations on moist clay, and diminishing sources of raw materials are at odds with a substantial improvement. Informed consumers can help ceramics suppliers produce consistent-quality moist clays by offering accurate critical feedback on every batch they buy.

8. SOLUBLE SALTS IN CLAY

Most potters have experienced the effects of soluble-salt migration in a clay body, which can occur in the drying, bisque-firing, or glaze-firing stages. Scumming—the industry term—presents itself as efflorescence, or white crystal powder forming on the surface of the clay. It can be observed on random parts of the clay body surface but is most often seen on edges or high points, which dry faster than other parts. Faster drying increases the "wicking" action, bringing soluble salts to the surface of the clay with the evaporating water. Textured surfaces or the ridges on cup handles can reveal a hard, discolored crust on the fired ware. The same outcome is present with slip-casting formulas that are overdeflocculated with sodium compounds such as sodium silicate, soda ash, Darvan #811, or Darvan #7 (sodium polyelectrolyte), all of which are soluble.

In the bone-dry or bisque state, fingerprints can disturb the soluble-salt deposit on the clay surface, causing a noticeable flashing or discoloration on the fired clay. High concentrations of soluble salts on bisque clay surfaces can result in fused areas that retard absorption, resulting in uneven glaze deposits. Soluble-salt migration can also disrupt the covering glaze surface. Essentially, it can create a mechanical disruption of the clay body / glaze interface, which can result in the glaze crawling (the fired glaze rolls back, revealing the clay body) or a series of small glaze blisters (sharp-edged, craterlike holes in the fired glaze) due to the fluxing action of the soluble salt on the clay body.[1] The relatively low melting point of soluble salts can prevent the release of organic material in the clay, resulting in carbon trapping at higher temperatures. The melting action of soluble salts on the clay surface can also fuse pottery to kiln shelves.

Glaze pinholes (a round-edged hole exposing the clay body) can also occur due to soluble-salt deposits on the underlying clay body surface. What makes the problem more difficult to solve is its intermittent nature. Any given clay body formula can produce a defect-free batch of clay many times and not the next. This is due to the specific level of soluble salts found in one or more of the clays used in the body. In most instances, soluble-salt deposits on the clay body surface do not come from water used in the clay-mixing process—provided the water does not originate from a static source that through evaporation can concentrate salts found in the water.[2]

Glaze Defects Caused by Soluble Salts

Red earthenware tile with soluble-salt deposits on the surface and high areas.

Stoneware balls with soluble-salt discoloration fluxing the iron content of the clay.

⌃ Earthenware flower pot with soluble-salt deposit on lower half.

⌃ Glaze pinholes: round edge.

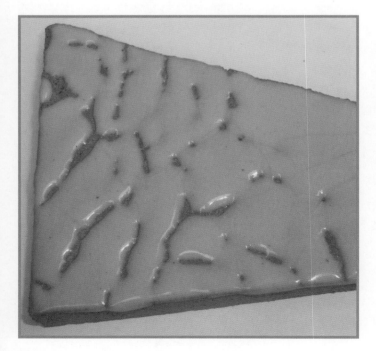

⌃ Glaze crawling: glaze contracts, exposing clay.

⌃ Glaze blister: sharp edge.

Where Soluble Salts Are Found

In clay mining, the overburden (the layer above the clay seam) and any possible water source nearby can contain organic material, which when decomposed can produce soluble salts. The overburden and underlying clay seam can vary in the amount of soluble salts, depending on location and topography. One marker for possible soluble material is the presence of calcite or gypsum, often observed as crystals in the soil. If the overburden is composed of permeable materials such as sand or loose gravel, the rate of soluble material leaching into the clay seam increases. A high pH (acidic) level in the overburden can also intensify the transmission of soluble materials into the underlying clay seam.

The permeability of the clay seam also plays a part in overburden leaching. Some types of clays are more permeable to leaching from the overburden, causing the top sections of the clay seam to become unsuitable for mining. Additionally, the clay itself can contain high levels of alkalis and alkali earths such as calcium, magnesium, sodium, potassium, and iron sulfates, which can be found at low levels in most clays.[3] As in the overburden, a high pH level in the clay can also bring more soluble-phase ions into the system.

Clay Mining

The most widely used method of clay mining involves drilling test holes through the overburden to reveal the contours and depth of the underlying clay seams. The overburden can be from 6 to 14 ft. in depth, with the clay seams ranging from 5 to 20 ft. in thickness. The actual seams can contain different strata of clays for possible use, depending on market requirements. At this point an economic factor comes into play: if too much overburden has to be removed, the cost of mining the clay and replacing the overburden decreases or eliminates the profit. The cost of clay recovery is also dependent on the energy required in man-hours, equipment, and fuel costs. Or, if the seam of clay is too thin, too inconsistent, or both, mining the clay is unprofitable. An exception occurs when the small seam is highly valued by the end-point user who is willing to pay a premium price for its extraction and processing. Essentially, the clay company is looking for a large deposit of uniform-quality clay that can be excavated with minimum costs.

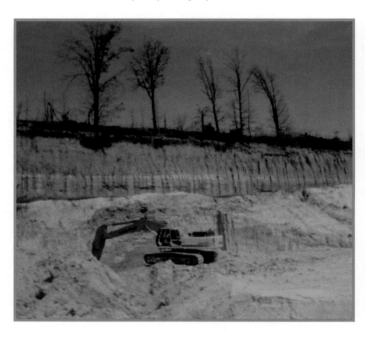

Clay-mining operation, showing overburden and clay deposit. *Photo credit, Old Hickory Clay Company*

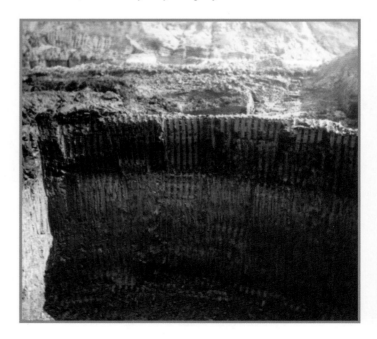

Excavated clay pit, revealing different layers of clay. *Photo credit, Old Hickory Clay Company*

Types of Clays with Soluble Salts

Bentonite clays can have high levels of soluble salts, but since their use in clay body formulas to increase plasticity is generally limited to 2% or less, their visible soluble effects on the surface of the clay body are less prominent.[4] Most ball clays and kaolins have relatively low concentrations of soluble salts but, depending on the specific levels of soluble material in the clay deposit, can exhibit various shades of discoloration. High-content iron-bearing clays that contain lime, such as Redart, can periodically cause soluble deposits on the surface of the clay. Other high-iron or organic-bearing clays such as C-Red and Lizella clays tend to be higher in sulfate content and seem to generate intermittent excess soluble salts when used in a clay body formula. Iron sulfates of marcasite and pyrite can also be found along with lime in some high-iron-content clays. The disassociation of iron sulfides gives rise to sulfate in free radical form, which can cause salt migration to the surface of the ceramic form.

Soluble sulfur in clays similar to Goldart stoneware can give off a sulfur smell during firing from 600°F to 1200°F, when the kiln is relatively cold and moisture from the clay saturates the atmosphere and condenses on the ware.[5] It can also leave a yellow efflorescence on the bisque-fired clay surface. Generally, this deposit does not seem to interfere with the fired glaze.

Soluble-salt migration is found in common red building bricks. For economic reasons, low-grade shales (containing clay, quartz, mica, organic mater, and ferric oxides) are the most widely used clays in the brick industry and can contain high levels of soluble salts. This effect is most noticeable after a rainstorm. As the surface water evaporates from the brick, it draws out or "wicks" soluble salts from the interior to the surface. This reaction deposits a white efflorescence on the surface, indicating that the clay water system is saturated and the salts have not bound with anything in the clay body.

Examples of Useful Soluble-Salt Migration in Clay and Glazes

There are instances where soluble salts are encouraged, either in the clay body or the glaze. Egyptian paste—as the name implies—is thought to have been developed in Egypt approximately 5000 BCE. It is an extreme example of a clay body with intentionally high levels of soluble salts. As the soluble salts migrate to the surface, they form a glaze covering the entire exposed clay surface. Interestingly, areas such as the bottom of the piece resting on a table and not exposed to air while drying do not develop a soluble salt deposit and do not form a glaze. The Egyptian paste clay body lacks plasticity and is limited to low-temperature firing conditions from cone 010 (1657°F) to cone 04 (1945°F). Metallic coloring oxides of cobalt, copper, and iron or ceramic stains contribute color to the glaze.

⌄ White areas of soluble-salt crystal migration (efflorescence) on the surface of red bricks.

Typical Egyptian Paste Clay Body Formula

In most Egyptian paste clay body formulas, soluble materials such as sodium carbonate, sodium bicarbonate, soda ash, or borax can range from 3% to 18%.

Amy Waller Turquoise Egyptian Paste Clay Body

c/010 (1657°F) to c/04 (1945°F)	
Flint 325 mesh	85
Sodium bicarbonate	6
Kentucky OM #4 ball clay	5.2
Whiting	1.9
Custer feldspar	1.9
Copper oxide	1.0

Examples of Egyptian paste.

Carbon-Trap Shino

c/9/r	
Nepheline syenite 270 mesh	40
Spodumene	30
EPK kaolin	5
Kentucky OM #3 ball clay	17
Soda ash	8
Bentonite	2%

Eliminating Soluble Salts

There are several options that can eliminate soluble-salt migration. When developing a clay body or choosing a premixed moist clay, whenever possible select clays low in iron content, low in soluble-salt content, or both. Often this information can be obtained from ceramics suppliers who mix clay. Or, if clays high in soluble salts are required, try to use the lowest-possible percentage in the clay body formula.

The most widely used correction for soluble salts is the addition of barium carbonate, 1/16% to 2% on the basis of the dry weight of the total clay body formula. When thoroughly mixed into the

Soluble-Salt Migration in Glazes

The most notable example of soluble salts occurs in carbon-trap glazes. The addition of soluble materials such as soda ash (sodium carbonate), baking soda (sodium bicarbonate), or salt (sodium chloride) to the glaze can range from 3% to 17%.[6] As the glaze dries, soluble materials migrate to the surface, which then melts early in the firing cycle, sealing in the underlying glaze layer. As a reduction atmosphere (greater ratio of fuel to air in the combustion process) is achieved in the kiln, carbon is deposited on the glaze surface. The melting soluble material will then trap carbon, resulting in spotted random gray or black glaze surfaces on a white porcelain clay body.

Dark areas show carbon-trap Shino glaze.

clay body, barium carbonate will precipitate soluble salts from solution, yielding barium sulfate, which is insoluble.[7] Brick industries are the largest users of barium carbonate, where low-grade, high-iron-content, shale-type clays are used in the production of bricks.

Another alternative for eradicating soluble salts is the use of Additive A in the clay body. Additive A (type 1 and type 3) is a blend of lignosulfonates and barium carbonate. Produced by Borregaard (www.Borregaard.com), Additive A is derived from the paper pulp production process. It has been used in the brick industry since 1955. Aside from the benefits of stopping soluble salts, it also increases the green strength and plasticity of the moist clay. It can be used in clay body formulas from 1/10% to ½% on the basis of the dry weight of the clay body. It has the added advantage of lubricating the moist clay through any extrusion process.[8,9]

Some success has been reported with washing the exposed bisque or high-fired exposed areas of clay with vinegar, a weak acid, or products such as Muriatic Acid, a solution of 31.45% hydrogen chloride and 68.55% inert ingredients, mostly water; the latter product requires careful use in its application and storage. However, if the clay's interior still contains soluble salts, they will again migrate to the surface. In such instances a sealer containing silicone or polymer solutions are used to close the clay pores.[10]

9. CHOOSING THE RIGHT CLAY

One of the most important decisions a potter faces is what type of clay to use. Often the wrong choice in a clay body (a moist mixture of clay[s], feldspar, flint, grog, and other ceramic raw materials designed to achieve specific forming qualities, fired color, and temperature range) can propel the potter into time-consuming and labor-intensive missteps when forming and firing their work. Think of the clay body as the foundation upon which the forming techniques of wheel throwing, slab building, ram pressing, or slip casting must build. The appropriate choice of a clay body will allow the potter to achieve the desired fired color in the clay at the correct temperature. A clay body must also be adaptable to many different glaze formulas. Unfortunately, the wrong choice in a clay body, whether it is stock clay from a ceramics supplier or a formula the potters mix themselves, can result in the loss of pots or sculpture. There's no single clay body that will fit every individual's needs, and a little time spent experimenting with several different moist clays will benefit the short- and long-term aesthetic and functional quality of any ceramic object.

Mining Clay

The practice of making pottery can be viewed as a vertical progression, starting with mining one's own clay, buying dry clay to be mixed in the studio, or buying premixed moist clay from a ceramics supplier. In the past, potters mined their own clay and supplied pots to their local community. Inferior roads, the cost of transporting clay objects, and the abundance of indigenous clay deposits kept pottery making a local enterprise. Often a free source of labor was the apprentice potter, who was assigned the project of digging and preparing the clay for the master potter. In the 1950s potters either purchased dry clay and mixed it themselves or purchased premixed moist clay from ceramics suppliers. At the first stage, most potters do not consider mining their own clay due to finding the raw clay, digging/refining the clay, and then mixing the clay. How many potters could afford an earthmover to peel back the topsoil to expose a seam of clay or purchase the apparatus that would air-float (separate a clay by particle size) a clay? Even if these requirements were met, would the potter know what kind of clay he discovered or could he even ensure a consistent supply? As you can see, the skills and money needed for industrial mining are not realistic for any individual. Potters who want to make money selling pots do not mine their own clays. Such a situation would be equivalent to potters growing their own trees to fire a wood kiln. It just takes too much time and energy, and when evaluated in economic terms it is a very costly activity.

Mixing Clay

One stage higher than mining clay occurs when potters mix their own clay body, which by any definition is a labor-intensive process. At some point, after mixing his own clay and selling pots, the potter might calculate that it is impractical because the energy required to purchase dry materials, set aside storage space, and finally mix the clay is not worth the effort. In fact, the time can more profitably be employed making pots. When potters undertake the task of making their own clay, they in a sense create a business—clay mixing—to supply their original business, making pots. The new business requires capital expenditures for clay mixers and pug mills, as well as storage space for the dry materials needed to mix a clay body formula. Other factors such as clay-mixing machines and pug mill maintenance also add to the cost. While mixing clay is not an inherently difficult process, it is often best relegated to professional mixing operations, which have the personnel and equipment required for greater accuracy and safety. Potters who mix their own clay often feel they have a greater degree of control over the entire process of making pots. While this might be true or not, it comes at a high price in terms of time and energy expended. However, the romance of making pots and being fully involved in the process is entirely up to the individual.

When potters mix their own clay, they have the advantage of easily altering the clay body formula to suit their changing requirements. They also have the added benefit of mixing several different formulas for various forming methods such as throwing or handbuilding. Depending on the potter's technical ability, a diversity of clay body formulas can be mixed for soda/salt, raku, and reduction firing.

Premixed Moist Clay

Luckily for potters and ceramics suppliers, clay mines refine and separate out by particle-size air-floated clays, which are conveniently packaged in 50 or 100 lb. bags. Large industries that require clays and other ceramic raw materials have the economic force to impose specific quality-control standards, which we as potters can sometimes use to our benefit. Economic factors and industry scale dictate that potters use clays and other raw materials designed for larger, more-diverse markets. It would not be profitable for ceramics suppliers to mine their own clay for resale. The exception is Sheffield Pottery, in Sheffield, Massachusetts, which is located above a clay deposit that they use in several of their clay body formulas.

Ceramic raw materials have been used for years in many industrial applications, such as the production of paper, paints, cosmetics, aircraft engine blade coatings, sanitary ware, and landfill operations. The clay mines supply expertise and capital investment in processing equipment to provide consistent dry clays to the larger markets. It is always important to note that all the clays and ceramic raw materials available to potters are a marginal market for the mines. Any raw material can be discontinued at any time depending on the requirements of the larger industrial market. Albany slip, a popular low-temperature, high-iron-content clay used in many glazes, has not been exhausted even though production has stopped. It is no longer possible to open-pit-mine this clay due to its location in downtown Albany, New York. The central fact is that potters could not purchase enough clay or feldspars to keep any mine open. In fact, if potters represented the only market, we would be still digging clay with shovels and hauling it to our studios.

Another level in the process of making pots is the purchase of moist premixed clay. Several factors have led to a greater percentage of potters relying on premixed clays. As potters age, it becomes more labor intensive for an individual to constantly mix his own clay. Potters also become more conscious about safety and health and find the dusty clay-mixing operation is best removed from the studio environment, but the primary factor that leads potters to use premixed moist clay is economic. As potters gain more business experience, the cost/benefit ratio does not favor mining or making one's own clay. Reducing the cost of making pottery and increasing the profit margin eventually leads to premixed clay. However, it is still up to the potter to decide at which level to enter the pottery-making process.

Many suppliers also can make a private moist clay body, with the potter supplying the formula. Before considering this, it is important to know something about the ceramics supplier. There are a few guidelines to help the potter make decisions before purchasing any premixed clay. It is essential to realize that at some point, any given clay body formula can and will fail. Whether you mix your own clay or buy it premixed from a supplier, keep this fact in mind.

The rate of failure for any moist clay depends on several factors. Even the best quality-controlled raw materials sometimes are inconsistent in terms of particle size, chemical composition, and organic content. For example, fireclays are noteworthy for their inconsistency. As a group of clays they illustrate the inconsistency that is found in other clays, fortunately to much lesser degrees. Fireclays constitute a percentage of the clay component in many stoneware clay body formulas. This coarse refractory clay can contain large nodules of manganese dioxide and iron, which can cause black or brown blemishes on the fired-clay surface. Large particles of manganese can produce black "spit outs" or depressions in the fired clay's surface, while iron oxide particles tend to produce brown, smooth, irregular-shaped blotches on the clay's surface. Both conditions are visible when the large-particle metallic oxides contained in fireclays are fired in reduction kiln atmospheres. The size of the manganese and iron nodules and the amount of reduction are the determining factors in whether the potter gets a welcome brown-and-black specking or brown-and-black irregular concave and convex defects in the fired clay. Fireclays can also contain coal, lignite, sand, high levels of free silica, and other impurities, all of which can drastically fluctuate from one bag to the next. If your moist clay contains a bad batch of fireclay, a whole kiln load of pots can be ruined. The mine does not care about this kind of defect. The large industry that uses the fireclay finds it perfectly acceptable for their use, and the ceramics supplier may not be aware of the defect when they mix their clay body formulas, all of which means at some point, any raw material can fail.

A deficiency in formulating the clay body formula can also contribute to a failure in the forming and firing stages of the clay. Some premixed moist clays sold by ceramics suppliers are derived from marginal formulas first used by individual potters. The supplier then takes the formula and incorporates it into a stock clay body sold to a wide range of potters. Without a thorough understanding of how raw materials function in clay bodies, a formula can be unintentionally narrowly designed. The compromised formula can work only under a few conditions, which other potters may or may not reproduce in their forming, drying, and firing techniques. Often, potters think they have made a mistake in their firing, while the real cause of the defect began with a clay body formula that functions only under a narrow range of firing conditions.

An unexpected change in a moist clay body can occur when a ceramics supplier changes a raw material in a clay body formula without revealing it to their customers. Sometimes a less costly substitute is used or a raw material goes out of production, necessitating a change in the moist formula, all of which can affect the end result. Obviously, you don't want to be the first person to test a revised clay, so it is always useful to ask how long the current formula has been in production, before purchasing a premixed clay. In practical terms it is unrealistic and unprofitable for a supplier to notify every customer whenever something changes.

An economic factor that is not usually considered by the customer is the fact that suppliers run their business on very narrow profit margins, which often means that the people mixing your moist clay are earning a minimum wage and doing a very difficult job. Insufficient training, frequent worker turnover, and the need for fast production can lead to even well-intentioned workers making a mistake when weighing out and mixing clay batches. In theory and practice the best clay body formula is only as good as the person mixing it.

In some instances, ceramics suppliers do not have the technical knowledge to make compatible substitutions in clay body formulas. The fact that some suppliers try and hope for the best is often determined by their inability to afford a staff with technical training to monitor clay body formulas. However, it is sometimes assumed that having your own private-formula clay body is superior to a stock clay, but keep in mind that a supplier's stock clays represent high volumes used by a variety of potters under various studio conditions. If they were not consistently successful, they would no longer be sold. The real question is, Will the clay body work for you? Before jumping into a large order of clay, make several small purchases and fire the clay in several kilns. This advice is simple to give and hard to follow because daily studio operations can interfere with a conservative approach to clay testing. The overall best long-term advice is to test whenever possible and plan your production cycle to allow for testing.

Choosing a Ceramics Supplier

Most ceramics suppliers carry a line of clays ranging from low-temperature white casting slips to dark stoneware for throwing on the wheel. Specialized blends are frequently available for salt/soda firing, raku, midrange porcelain, and slip casting. It is also important to read the supplier's catalog carefully in regard to placing an order, back-order policies, taxes, shipping charges, and terms of payment. There should be no surprises when dealing with a ceramics supplier. Pottery making is a small world, and the "word" on each supplier is out in the community. Ask other potters where they shop for supplies, and note their comments. If a supplier does not have a good reputation, don't think the company will treat you any better than their current and past customers. If possible, choose a local supplier who has earned a good reputation for service and products. Choosing a supplier who sells low-priced clay and does not have a good reputation can be very expensive due to improperly mixed clay, random delivery schedules, lack of technical support, and substandard business practices.

A short supply line with a frequent delivery schedule makes for greater efficiency. A nearby supplier also reduces shipping costs. There is an obvious expense added to clay if it comes from across the country, but an unseen cost develops if clay is left on the driveway compared with it being delivered directly into the studio. If the potter has to move clay any distance from the point of delivery, time and labor are wasted. In fact, anytime anyone moves clay it costs money. However, keep in mind that the overriding consideration when choosing a ceramics supplier is not the cost of the clay or delivery charge, but the quality of the clay. Any small savings in choosing a clay just for its low price can be a negated if the clay formula is not sound or the mixing procedures are not accurately completed. The appropriate choice for moist premixed clay depends on several factors that are distinctive to each potter. The forming method, firing-temperature range, kiln atmosphere, glaze compatibility, and fired color are significant considerations when choosing a clay. Ceramics suppliers usually have several different premixed clays within a given range. For example, there might be four or five cone 6 clay bodies formulated for oxidation atmosphere firing. Using a sample of each premixed clay to see how it functions in your own kiln would give the most accurate results. This simple technique will ensure acceptable handling characteristics, shrinkage/absorption compatibility, glaze interaction, and fired color. Too often, potters choose a premixed clay without enough testing under their own firing conditions. Before making a final determination it is always best to use the premixed clay in several different firings to ensure consistent results.

Shrinkage and Absorption in Moist Clays

Descriptions of premixed moist clay, photos of the fired clay, and small sample chips of the fired clay all are available from the ceramics supplier. Potters should try to obtain any information available on how the clay will look at their particular firing temperature and kiln atmosphere. Suppliers also publish shrinkage and absorption percentages for every moist clay they sell. While the percentages can be important pieces of information in the choice of a clay, they can also be misleading since they are based on how the clay shrinks and absorbs water in the ceramics supplier's kiln and not in yours. Kiln size and the time it takes to reach the correct temperature can affect the shrinkage and absorption percentages. It can be unwise to compare one company's shrinkage and absorption figures with another supplier's, since it is unlikely they fired their test clays in the same type of kiln with the same heating-and-cooling cycle. Shrinkage and absorption percentages can give an indication of how a clay reacts when fired to its maturating range, but the percentages are most useful when comparing different moist clays produced and fired in the same kilns. For example, if a porcelain clay is listed as having a shrinkage of 13% at cone 6 with an absorption rate of 2%, and another porcelain clay is rated at having a shrinkage rate of 15% with an absorption rate of 0.6%, it can be assumed that the second porcelain clay has greater shrinkage and vitrification, or glass formation, at cone 6.

Problems with Moist Clay

It's not the clay, and it's not the ceramics supplier; it's the fact that potters cannot afford the price of better-quality clay, and the suppliers cannot afford to make better-quality clay because potters cannot afford to buy high-quality clay. This circular explanation does not really explain the economic motivation behind the central problem of potters obtaining high-quality clays. The profit markup on clays and raw materials is not high enough to allow the supplier to invest in industrial quality-control practices, so many problems may be passed directly on to the customer. Larger industries that use clay have capital to invest in machines to clean and refine a raw material before it is turned into a ceramic product. They also have trained staffs who are familiar with solving technical issues with clay. Ceramics suppliers sell moist clay for pennies per pound, while potters unrealistically are expecting a problem-free moist clay. However, potters are not economically able to pay dollars per pound to the ceramics supplier for the infrastructure and personnel needed for top-quality clay. If potters could sell handmade coffee cups for a hundred dollars each, they could then afford superior quality-controlled moist clay. The economics of producing a greater level of quality-controlled moist clay for the small pottery-buying market are against the potter.

Recommendations for Ordering Moist Clay

It is always best to reorder moist clay when half of the current supply is exhausted. While this purchasing procedure may involve tying up capital and storage space, it gives potters a chance to randomly test-fire the new clay while they are still using a proven batch of old clay. Not following this deceptively simple but sometimes hard-to-follow advice will eventually find the potter with a whole kiln load of defective clay. At some point in a potter's life, a defective clay batch will arrive, and pretesting it before committing the batch to production offers good insurance.

Keep Accurate Records of Clay Shipments

Keep careful records on each batch of clay and always note the production code on each box. Sometimes a shipment of clay will have more than one production code, since it can contain several different batches of mixed clay. Most suppliers package moist premixed clay in a 50 lb. box, sometimes containing two 25 lb. plastic bags of clay. Keep in mind that the plastic bags are semipermeable and that air will eventually begin to harden the clay within a few months.

Report Problems Immediately

Report any problems with the clay immediately to the supplier, listing the production code of the batch and a factual description of the fault, and be prepared to send a sample of the defect for evaluation. Supply all the relevant facts to support your position, and do not use a clay or any product once you have encountered a problem, since this act can constitute acceptance as is. As a standard business policy, ceramics suppliers have limited liability on dry and moist clay, which means that at best they will only replace the product if it is defective. Suppliers will not replace kilns, shelves, or posts damaged by defective clay. They will also not compensate the potter for lost time or lost potential sales. The replacement of the clay will take place only if it can be proven that the clay was at fault and you did not cause the defect through improper forming, glazing, or firing. If you mistakenly fire a cone 06 (1828°F) clay body to cone 10 (2345°F), do not expect a free replacement batch of clay.

On-Site Clay Mixing

If a local clay supplier is chosen, the potter also has the advantage of visiting the clay-mixing operation. During a visit, take a look at the clay storage and mixing areas. Are they reasonably clean and well organized? Do the people mixing clay appear motivated and knowledgeable? Are any special cleaning procedures enacted when mixing white clays or porcelain? What quality-control measures are taken when different clay body recipes are mixed? It is not necessary to test the pH level of the clay-mixing water or request the maintenance service records for the pug mill, but a few commonsense observations will reveal how seriously a ceramics supplier regards the clay-mixing part of their business. If you are not satisfied with your observations, look for another supplier. Obtaining correctly mixed clay is a vital part of any pottery-making operation, and frequently the correct choice of a supplier will determine if the potter will encounter minor or major technical problems.

Private Clay Formulas

Some suppliers offer the value-added service of mixing private clay body formulas. The potter might discover that the ceramics supplier's stock clay bodies do not meet his or her specific needs. At that point the potter finds or creates a clay body formula that the ceramics supplier then mixes. When mixing private formulas, the supplier does not assume any responsibility for potential defects caused by the formula. The potter must feel confident that the private formula clay will work in the following areas: forming method, kiln atmosphere, glaze interaction, temperature range, and fired color.

Since it is not generally economical for the supplier to mix up a small test batch, there is usually a minimum amount of clay required to fulfill the order, which can range from 1000 to 2000 lbs. If a supplier can mix up a small test batch, be prepared to pay a fee for this extra service. The fee is worth the insurance, since 2000 lbs. of untested clay can be a very expensive test. If a test batch by the supplier is not available, mix your own test batches before committing to a larger quantity of private-formula clay.

The ceramics supply company's sales and technical staff can be an added help in obtaining information about premixed clays. They can provide advice on how other potters are using the clay, and offer information on dry clays that are currently available for use in private clay body formulas. When a problem with a raw material develops, it is beneficial to know which people within the organization to call for advice. As we all know, the only thing consistent in ceramics is change. Having current information on clays—which are subject to change subtly or radically—is a valuable resource in any ceramics activity.

Become a Loyal Customer

Whether purchasing stock clays, private-formula clays, or any other ceramic-related materials, it is often the best policy to stay with one supplier rather than shopping around for the best price. Stay with a good supplier and become a valued customer, which will translate into enhanced service and a better chance at resolving future problems with clays or products. Searching for the lowest price on specific items from different suppliers in the long run is a very expensive strategy for making purchasing decisions. Ceramics suppliers try to satisfy each customer equally, but it is only human nature that customer loyalty plays a large part in resolving any difficulty. The ceramics supplier wants to keep loyal customers, and this fact will go a long way in resolving a complaint with goods or services.

Cheap Can Be Very Expensive

While the purchase of a car might require a search for the lowest price, this strategy will not work when buying clay. Often, potters choose a clay because it is a few cents less per pound. If not formulated correctly and produced accurately, cheap clay can cause a greater number of defects. The potter's greatest expense is the time and labor required to make pots, not the cost of raw materials, fuel for kilns, equipment, or supplies. Good-quality clay requires a trained staff and properly maintained clay-mixing equipment. Paying a few cents more for superior quality control translates into lower defect rates and higher profits. It is simply not worth the risk to make clay-purchasing decisions on price alone. The price of moist clay is irrelevant; the rate of defects produced by a given batch of clay is.

10. CLAY BODY FORMULAS

When using any clay body it is useful to know the function of each material in the formula. The potter should always try to expand his or her knowledge of the clay groups (ball clays, stoneware clays, fireclays, earthenware clays, kaolins, and bentonites) and raw materials such as flint, talc, feldspar, grog, mullite, molochite, and silica sand. Each material has specific characteristics contributing to the total clay body formula. Many published clay body formulas list only the materials and percentages used in the formula. Often the reasons for including a specific raw material or choosing one material over another are not noted. There are frequently omissions of the particle sizes of feldspars, grogs, flint, fireclays, and other raw materials. The lack of specificity can sometimes alter the handling qualities, fired color, thermal properties, and dry or fired shrinkage of the clay body formula. It is amazing, with such little information, that clay body formulas are successful in many different forming methods, various sizes of kilns, and variable firing cycles. It further stretches the imagination that many diverse glazes fit clay bodies, considering the general generic raw-material descriptions printed in books, magazine articles, and online sources and dispersed by potters.

Where possible, the ZAM clay body formulas list raw-material trade names, sources of origin (mines, processors), and mesh size. The recommended firing temperature and use for the clay body are also noted. Shrinkage and absorption percentages for each clay body are included but can vary by plus or minus 1% depending on the size of the kiln used for the firing and the length of time to reach the end-point temperature. Smaller kilns fired at faster rates of heat increase will yield lower rates of shrinkage and higher rates of absorption than larger kilns fired at slower rates of heat increase. Greater vitrification occurs with slower rates of heat increase and greater thermal mass of larger kilns. The fired color of each clay body is represented in oxidation and reduction kiln atmospheres but can vary depending on the length and amount of reduction. Shrinkage rates can increase or decrease depending on the amount of water used to mix the clay body formula.

When a clay or raw material is not available, it is always best to substitute from the same group of clays as the original. Fireclays, ball clays, stoneware, bentonites, kaolins, and earthenware all are common clay groups. The three basic groups of feldspar are sodium based, potassium based, and lithium based. A feldspar substitution should come from the original feldspar grouping. When possible, always first test a one-for-one substitution; if this does not work, a recalculation of the clay body formula is required. Many one-for-one substitutions are listed in *What Every Potter Should Know*.[1]

Clay-Mixing Water

The chemical composition of the water used in mixing the clay body can alter the plastic properties of the moist clay. If the water contains soluble salts of sodium or calcium, they can migrate to the clay surface in the drying stage, causing an irregular surface and interfere with the subsequent glaze application. The soluble material forms a glaze, which can result in blistering and carbon trapping. Household water softeners can introduce sodium into the mixing water, which can alter the handling qualities of the moist clay body. Sodium can also cause deflocculating characteristics in the moist clay, resulting in very soft clay under forming pressure. While the chemical composition of the water has a larger effect on slip-casting clay bodies, it should not be overlooked if discoloration or soluble salt crystals appear when the clay body is drying or if the moist clay is too soft and rubbery in the forming stages.

Any throwing or handbuilding clay body can benefit from the addition of Epsom salts (3/10%, based on the dry weight of the clay body or 5 ounces per 100 lbs. of dry clay) dissolved in the clay-mixing water.[2] However, higher concentrations can result in salt migration, causing a disruption of the clay body surface. Alkaline materials found in clays and raw materials or clay-mixing water can result in thixotropic clay (clay easily deforms under pressure) having too many negatively charged particles, which causes the clay particles to slip past each other when moist. Epsom salts lower the amount of negatively charged particles in the clay body by increasing the ratio of positively charged particles, resulting in platelets "knitting" together for better moist-clay-handling qualities.

The amount of water required to form the clay into a plastic mass is called the water of plasticity. The percentage of water required can vary with the individual clays and raw materials contained within the clay body. Some clay bodies, due to their high percentage of ball clay (small platelet sizes), might require 40% more water for plasticity than clay bodies containing higher levels of coarse fireclays and stoneware clays (large platelet sizes), requiring only 25% water.[3] The greater amount of water required for plasticity, the higher rate of shrinkage. Generally, 20% of water by weight is the standard percentage found in moist plastic clay bodies used on the potter's wheel or in handbuilding operations. Weighing 100 g of moist clay and then letting it dry will reveal a loss of weight. For example, if 100 g of moist clay has dried to 80 g, there was 20% of forming water in the original wet clay. Do not confuse the water of plasticity with the mechanical water still in the clay body—which does not leave until 212°F—and the chemical water tied up in clays, which is removed between 842°F and 1112°F.[4]

There are countless clay body formulas and many variations on original formulas that can be found in books and magazines. Formulas can also be obtained from other potters. However, the quantity of formulas is often not as important as the reasons behind the choice of raw material used in a specific formula. Acquiring this type of knowledge will allow potters to develop their own clay body formulas and better understand the nature of the formulas they utilize. Additionally, if a problem does occur, potters have the knowledge to adjust the clay body for their particular forming and firing method. No single clay body will be perfect for every potter; however, some formulas fit a wider range of potters' individual handling qualities, firing characteristics, and glaze fit. One potter's perfect clay body can be another potter's time-consuming and labor-intensive mistake.

Often, potters encounter too many choices and cannot evaluate which clay body will be suitable for use in their pottery or sculpture. Listed are several clay body formulas in low, medium, and high temperature ranges that have been mass produced and used successfully by many potters of different skill levels. While a clay body formula cannot be guaranteed, a good starting place to find acceptable formulas are in clay bodies that have been mass produced.

C/06 (1828°F) Clay Body Formulas

Zam #1 Low-Temperature White Clay Body

Zam #1 is a low-temperature white clay body; it is formulated to fit a wide range of commercial glazes. Similar clay bodies are used in many school ceramics programs because of their ease in forming, glaze fit, and white fired color. The clay body can be bisque fired to c/06. It can be formed on the potter's wheel and is suitable for handbuilding. The clay body fires to a white color and is used in electric kilns. The clay body is porous.

25%—Thomas ball clay (Old Hickory Clay Co.) is the primary source of plasticity, enabling the moist clay to be easily formed.

40%—Texas talc is a magnesium silicate that contributes some fluxing action. It is a major raw material in the low-fire white body, promoting glaze fit. Talc enables any free silica present in the clay body to convert to cristobalite; in the presence of magnesium in talc the silica changes to cristobalite. The resulting cristobalite has a high rate of contraction, resulting in a slight compression in the glaze and preventing crazing (a fine network of lines in the fired glaze).

20%—EPK is a plastic high-firing kaolin contributing to a white clay body color.

Zam #1. Low temperature, white, cone 06 (1828°F) to cone 04 (1945°F) oxidation atmosphere.
Absorption c/06, 13.5%; Shrinkage c/06, 6%.

10%—Minnspar 200 mesh is a sodium-based feldspar ensuring a white fired color and glaze fit.

5%—Whiting—calcium carbonate (Snowcal®) prevents glaze crazing due to its high rate of contraction. It also inhibits warping and reduces dry shrinkage since it acts as nonplastic material in the clay body.

15%—Texas Talc is a magnesium silicate that contributes some fluxing action to the clay body. It is also the major raw material in the low-fire, white-body-promoting glaze fit. Its primary purpose is enabling any free silica in the clay body to convert to cristobalite in the presence of the magnesium in talc. The silica then changes to cristobalite. The resulting cristobalite has a high rate of contraction, resulting in a slight compression on the glaze and preventing crazing (a fine network of lines in the fired glaze).

0.5%—Goldart Stoneware (Cedar Heights Clay, Resco Products, Inc.) is medium-platelet-size refractory clay that contributes to particle-size variation. The stoneware clay also allows the clay body formula to minimize deformation and shrinkage in the dry state.

6%—Grog 48/fine mesh (Maryland Refractories). Grog introduces an inert calcined material that reduces dry and fired shrinkage. Grog minimizes warping in the drying stage. It also adds "tooth" or the ability of the moist clay to remain rigid in wheel-throwing or handbuilding operations. The variation in particle size of the grog further aids in mechanically bonding the clay body raw materials in the moist state.

¼% to 2%—Barium carbonate (Basstech International). Additions of barium carbonate can neutralize random concentrations of soluble salts found in some types of clay.

Zam #2 Low-Temperature Red Clay Body

Zam #2 is a low-temperature, high-iron-content clay body that can be used on the potter's wheel or in handbuilding. When possible, it is preferable to use clays with different platelet sizes, which physically lock together and contribute greater plastic properties to the moist clay. The clay body can be bisque fired to c/06. It is compatible with a wide range of commercial glazes but can cause crazing with some glazes. The fired clay is porous and brick red.

65%—Redart (Cedar Heights Clay, Resco Products, Inc.) is a low-temperature, high-iron-content earthenware clay. It contributes plasticity, platelet-size variation, and color.

15%—Thomas ball clay (Old Hickory Clay Co.) contributes plastic properties and a small platelet size to the clay body, enabling the moist clay to be formed.

Zam #2. Low-temperature, red, cone 06 (1828°F) to cone 04 (1945°F) oxidation atmosphere.
Absorption c/06, 12%; Shrinkage c/06, 6%.

C/6 (2232°F) Clay Body Formulas

Zam #3 Medium-Temperature Porcelain Clay Body

Zam #3 is a midtemperature c/6 (2232°F), dense, vitreous porcelain clay body designed for use on the potter's wheel and in handbuilding operations. The clay body can be bisque fired to c/06 and fits a wide range of glazes. When formed into thin cross sections and fired to c/6, it is translucent. The clay body fires white in oxidation and blue/white in reduction.

45%—Grolleg kaolin (Hammill & Gillespie) is a high-temperature, white-firing, plastic primary clay. It contributes plasticity, handling qualities, and a white fired color.

5%—Edgar Plastic Kaolin (EPK) (Zemex Industrial Minerals, Inc.) is a high-temperature, white-firing, plastic primary clay. It contributes particle-size variation, which aids in plasticity and handling qualities.

25%—Flint 200 mesh (U.S. Silica Co., Silco Sil 75). With feldspar it contributes to the vitrification of the clay body during the firing process. It also reduces shrinkage and warping in the drying process.

25%—Custer feldspar 200 mesh (Pacer Corp.) is the primary flux or glass-melting material in the clay body formula.

1.8%—Macaloid or VeeGum T (R. T. Vanderbilt, Co. Inc.) is an inorganic, complex colloidal magnesium aluminum silicate that contributes plasticity. Due to its small particle size, it also promotes melting, with larger-particle clay increasing the total vitrification in the clay body. Macaloid or VeeGum T will not alter the fired color of the clay body.

Zam #4 Medium-Temperature Brown Clay Body

Zam #4 is a midtemperature c/6 (2232°F), dense brown clay body designed for electric kiln firing. It can be used on the

Zam #3. Porcelain, cone 6 (2232°F) oxidation atmosphere. Absorption c/6, 0.8%; Shrinkage c/6, 12.6%.

potter's wheel and in handbuilding. It is suitable for functional pottery or sculpture and works well with many glazes. The clay body fires to a medium brown in oxidation atmospheres. The clay component of the formula uses small, medium, and large clay platelets obtained from ball clay, stoneware clay, and fireclay. The diverse particle sizes increase the plastic handling properties in the clay/water structure. The recommended bisque-firing temperature is c/06.

45%—Hawthorn Bond fireclay 40 mesh (Christy Minerals Co.) is a coarse-particle-size clay contributing texture and "tooth" to the forming characteristics of the moist clay and decreasing warping. The fireclay is refractory and reduces excessive fired shrinkage in the clay body.

40%—Redart (Cedar Heights Clay, Resco Products, Inc.) is a low-temperature earthenware clay that contributes a red fired color to the clay body. Due to its high iron content, it also acts as a flux. Redart adds another platelet or particle-size structure, which aids in the forming qualities of the clay body.

5%—Goldart Stoneware (Cedar Heights Clay, Resco Products, Inc.) is a medium-platelet-size refractory clay that contributes particle-size variation. The clay also allows the clay body formula to withstand high temperatures without deforming and shrinking excessively.

10%—Thomas ball clay (Old Hickory Clay Co.) is a small-platelet-size clay that contributes plastic forming qualities to the clay body.

● Zam #4. Cone 6 (2232°F), medium temperature, brown, oxidation atmosphere.
Absorption c/6, 0.3%; Shrinkage c/6, 12%.

● Cone 6 (2232°F), medium temperature, light tan, oxidation atmosphere.
Absorption c/6, 3.2%; Shrinkage 12.4%.

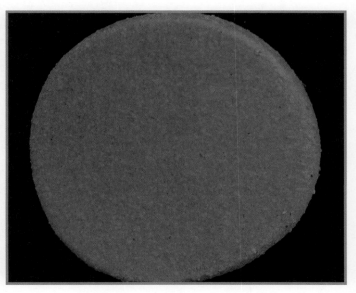

8%—Grog 48/fine mesh (Maryland Refractories). Grog introduces an inert calcined material that reduces dry and fired shrinkage. Grog minimizes warping in the drying stage. It also adds "tooth" or the ability of the moist clay to remain rigid in wheel-throwing or handbuilding operations. The variation in grog particle sizes further aids in mechanically bonding the clay body raw materials when in the moist state.

Zam #5 Medium-Temperature Light-Tan Clay Body

Zam #5 is a midtemperature c/6 (2232°F), light-tan, dense stoneware clay body. It fires to a medium brown in reduction kiln atmospheres. It can be used in electric kilns and also works well in natural gas, propane, wood, soda/salt, and raku kilns. The clay body fits a wide range of glazes and can be bisque fired to c/06. The formula uses small-, medium-, and large-platelet clays for increased plasticity in wheel and handbuilding forming operations.

20%—Hawthorn Bond fireclay 40 mesh (Christy Minerals Co.) is a coarse-particle-size clay contributing texture and "tooth" in the forming characteristics of the moist clay. The clay is refractory and aids in reducing warping and shrinkage in the fired clay body.

45%—Goldart Stoneware (Cedar Heights Clay, Resco Products, Inc.) is a medium-platelet-size refractory clay that contributes to particle-size variation. The clay also allows the clay body formula to withstand high temperatures without deforming and shrinking excessively.

15%—Thomas ball clay (Old Hickory Clay Co.) is a small-platelet-size clay contributing to the clay body's plastic-forming qualities.

12%—Nepheline syenite 270 mesh (Unimin Corp., Minex 3) is a sodium-based feldspar that acts as a flux with flint (silica), yielding a dense, vitrified fired clay body.

8%—Flint 200 mesh (U.S. Silica Co., Silco Sil 75). Flint along with feldspar contributes to the vitrification of the clay body during the firing process. It also reduces dry shrinkage and warping in the drying process.

5%—Grog Mulcoa 40/100 mesh (C.E. Minerals). Grog introduces an inert, refractory, calcined material that reduces dry and fired shrinkage. Grog minimizes warping of the clay body in the drying stage. It also adds "tooth" or the ability of the moist clay to remain rigid in wheel-throwing or handbuilding operations. The variation in particle size of the grog further aids in mechanically bonding the clay body raw materials in the moist state.

🔽 Cone 6 (2232°F), medium temperature, light tan, reduction atmosphere.
Absorption c/6, 3.0%; Shrinkage 12.6%.

🔽 Cone 6 (2232°F), medium temperature, light tan, oxidation atmosphere.
Absorption c/6, 3.2%; Shrinkage 12.4%.

C/9 (2300°F) Clay Body Formulas

Zam #6 High-Temperature Light-Tan Clay Body

Zam #6 is a high-temperature stoneware c/9 (2300°F) clay body formulated for throwing and handbuilding. It combines several different platelet-size clays for optimum plasticity. It can be used in electric kilns and can also be used in natural gas, propane, wood, soda/salt, and raku kilns. It fires to a light-cream color in oxidation and dark brown in reduction. The clay body fits a wide range of glazes and can be bisque fired to c/06.

25%—Hawthorn Bond fireclay 40 mesh (Christy Minerals Co.) is a coarse-particle-size refractory clay contributing to texture and "tooth" in the forming characteristics of the moist clay. The clay is refractory and aids in the high-temperature firing range while minimizing warping and shrinkage.

40%—Goldart Stoneware (Cedar Heights Clay, Resco Products, Inc.) is a medium-platelet-size refractory clay that contributes to particle-size variation in the clay body formula. The clay also allows the clay body formula to withstand high temperatures without deforming and shrinking excessively.

15%—Thomas ball clay (Old Hickory Clay Co.) is a small-platelet-size clay contributing to the clay body's plastic-forming qualities.

8%—Custer feldspar 200 mesh (Pacer Corp.) is a potash-based feldspar that is a flux when acting with flint (silica) in the clay body, yielding a dense, vitrified fired clay body.

7%—Flint 200 mesh (U.S. Silica Co., Silco Sil 75). Flint along with feldspar contributes to the vitrification of the clay body during the firing process. It also reduces dry shrinkage and warping in the drying stage.

5%—Newman Red (H. C. Muddox Co.) is a high-iron-content stoneware clay contributing particle-size variation and fired color.

10%—Grog Mulcoa 40/100 mesh (C.E. Minerals). Grog introduces an inert calcined material that reduces dry and fired shrinkage.

Grog minimizes warping of the clay body in the drying stage. It also adds "tooth" or the ability of the moist clay to remain rigid in wheel-throwing or handbuilding operations. The variation in particle size of the grog further aids in mechanically bonding the clay body raw materials in the moist state.

Zam #7 High-Temperature Porcelain Clay Body

Zam #7 is a high-temperature c/9 (2300°F), dense, vitreous porcelain clay body designed for use on the potter's wheel and in handbuilding. The clay body can be bisque fired to c/06 and fits a wide range of glazes. When formed into thin cross sections and fired to c/9, it is translucent. The clay body fires white in oxidation and blue/white in reduction.

50%—Grolleg kaolin (Hammill & Gillespie) is a high-temperature, white-firing plastic primary clay. It contributes plasticity, handling qualities, and a white fired color.

25%—Flint 200 mesh (U.S. Silica Co., Silco Sil 75) along with feldspar contributes to the vitrification of the clay body during the firing process. It also reduces dry shrinkage and warping in the drying process.

25%—Custer feldspar 200 mesh (Pacer Corp.) is the primary flux or glass melting material; it yields a dense, vitrified fired clay body.

2%—Bentonite Western 325 mesh (American Colloid Co.) is an extremely plastic clay that contributes to the overall plasticity of the clay body.

Zam #8 High-Temperature White Stoneware Clay Body

Zam #8 is a high-temperature c/9 (2300°F), dense, vitreous stoneware clay body designed for use on the potter's wheel and in handbuilding. It can be bisque fired to c/06 and fits a wide range of glazes. The clay body fires white in oxidation and blue/white in reduction. The stoneware clay body fits a wide range of glazes and offers the white firing color of porcelain with increased plasticity and handling qualities.

10%—Hawthorn Bond fireclay 40 mesh (Christy Minerals Co.) is a coarse-particle-size clay contributing to texture and "tooth" in the forming characteristics of the moist clay. The clay is refractory and aids in reducing warping and shrinkage in the fired clay body.

● High temperature, cone 9 (2300°F), porcelain, oxidation atmosphere.
Absorption c/9, 0.5%; Shrinkage 11.6%.

● High temperature, cone 9 (2300°F).
Absorption c/9, 3.2%; Shrinkage 12%.

35%—Edgar Plastic Kaolin (EPK) (Zemex Industrial Minerals, Inc.) is a high-temperature, white-firing plastic primary clay. It contributes particle-size variation which aids in plasticity and handling qualities and a white fired color.

6%—Goldart Stoneware (Cedar Heights Clay, Resco Products, Inc.) is a medium-platelet-size refractory clay that contributes to particle-size variation. The clay also allows the clay body formula to withstand high temperatures without deforming and shrinking excessively.

15%—Thomas ball clay (Old Hickory Clay Co.) is a small-platelet-size clay that contributes to the clay body's plastic-forming qualities.

14%—Custer feldspar 200 mesh (Pacer Corp.) is a potash-based feldspar that is a flux when acting with flint (silica) in the clay body, yielding a dense, vitrified fired clay body.

10%—Flint 200 mesh (U.S. Silica Co., Silco Sil 75). Flint along with feldspar contributes to the vitrification of the clay body during the firing process. It also reduces shrinkage and warping in the drying process.

8%—Molochite 50-80 mesh (C.E. Minerals) is a calcined aluminum silicate produced from low-iron-content kaolin. A uniform refractory material low in thermal expansion, producing a white color when fired in a clay body. It reduces shrinkage and warping in the dry and fired clay body.

Recommendations for Testing Clay Body Formulas

When books and magazines publish clay body formulas, what is usually not offered are procedures for testing the formula for use in your own kiln. A perfectly workable clay body formula not might be suitable for specific requirements in forming qualities, shrinkage, absorption, fired color, or its reaction with your glazes. The potter is often left not knowing why the clay body failed to translate from the written page to the actual pottery. Many potters have made the mistake of mixing a large quantity of clay from a given formula without the benefit of first testing a small batch. This offers a high potential of risk and is not recommended. Some ceramics suppliers will mix a private clay body formula, but most require a minimum

order of 2000 lbs. One ton of clay can turn into an expensive experiment if the potter does not have an accurate indication of how the clay body formula will perform for his or her individual needs. Whether potters mix their own clay or buy it premixed, the actual cost of the raw materials used in a failed clay body is not as expensive as the effort required in making the pottery. As stated, not every clay body formula will work for every potter, so some degree of testing is essential to ensure good results.

Clay Body Test Batch

Once a clay body formula has been chosen, the next step is to mix an appropriate amount of moist clay for testing. Ten pounds of dry clay body formula should yield approximately 12 lbs. of moist clay. At least six clay bars measuring 5" x 2½" x ¼" should be sufficient for shrinkage and absorption testing. The remaining clay can be formed into pots, which can be placed throughout the kiln. If a successful test firing occurs, a larger batch can be mixed for further testing. Do not assume that the clay body is ready for large-scale mixing until it has been fired in several kiln firings.

Not every kiln produces an even atmosphere or temperature, and placing test pieces in various locations within the kiln will offer an accurate indication of the clay body temperature range and color variation caused by the kiln atmosphere. With hydrocarbon-based fuels (natural gas, propane, wood, oil, coal, sawdust), the kiln can be manipulated to produce oxidation, neutral, and various intensities of reduction kiln atmospheres, all of which can affect clay body color. Oxidation atmosphere in hydrocarbon-based fueled kilns can cause variations in clay body color when compared to oxidation atmospheres produced in electric kilns, due to impurities in the hydrocarbon-based fuel and water vapor present during combustion. Reduction kiln atmospheres can also cause increased clay body vitrification as the metallic coloring oxides contained in the clay body are subjected to increased melting. However, in electric kilns there is a uniform oxidation atmosphere, causing little or no variation in clay body color, but temperature variations could still be present, affecting the shrinkage and absorption of the fired clay body. Higher temperatures can flux metallic coloring oxides in the clay body, causing darker fired colors along with increased vitrification.

Intermediate Testing

Small test batches of clay body formula can frequently produce good results. Mistakenly, the potter then goes on to mix a larger batch of clay, committing a whole kiln load of work on the basis of the results of a small sample. Often the gamble pays off and the fired results are as expected; however, there can be many unknown variables acting on the clay body when larger batches are produced. Small test pieces in a reduction atmosphere kiln might obtain too much or too little reduction, giving a false indication of the clay body color. This can occur due to their

placement in the kiln or variable reduction atmospheres from one firing to the next. Larger test pieces fired in several reduction atmosphere kilns would give a more accurate representation of the clay body.

Even-temperature heat might not be produced throughout the kiln, causing shrinkage and absorption percentages to be erratic, which is another reason for testing the clay body over several kiln firings. A small test piece by its very nature cannot duplicate the scale of a large pot or sculpture and the forces acting on the larger ceramic form. In some instances the mass of the ceramic form can differ from the same clay body in miniature. The actual size of the ceramic form can also affect the stresses induced by shrinkage and vitrification. The combined effects of both time and temperature during the firing process (heat work) will take a longer time to penetrate large or thick ceramic cross sections as opposed to small, thinner cross sections.

Generally, small clay objects tend to be more stable and less likely to develop stress cracks in heating and cooling compared to larger forms. This can occasionally be seen when making 1" square tiles that come through the drying and firing process intact. The same clay body fired in the same kiln when formed into 12" square tiles might produce drying cracks, warping, and firing cracks. It is best not to risk an entire kiln load of pots on the basis of an initial small test batch. Testing the clay in multiple firings with many glaze combinations will ensure an extensive body of knowledge indicating a reliable clay body formula. It is highly recommended that several clay body test bars be placed throughout the kiln. After the firing, shrinkage and absorption test results should be recorded. To achieve a higher degree of accuracy, the individual results of each shrinkage and absorption test should be averaged.

Studying Raw Materials

Whenever potters choose to mix their own clay body, they should understand the function of each material in the formula. It is important to know not only the characteristics of each material, but their combined reactions within the clay body formula. Additionally, the end-point firing temperature, kiln atmosphere, and firing cycle can influence the clay body formula. Fortunately, most clay body formulas contain various combinations or clay groups such as ball clays, fireclays, stoneware clays, and fireclays, with each group having a distinctive set of characteristics. For example, ball clays are small platelet size and highly plastic. Whether you are using Kentucky OM #4, Tennessee #1, Thomas, C&C, or any other ball clay, they all have similar qualities. Therefore, studying each clay group will yield a wide base of knowledge on individual clays within that group.

Other raw materials such as feldspars, grogs, flint, talc, and mullite serve specific functions in a clay body and can be incorporated into formulas as needed. At first it seems like an overwhelming task to master the characteristics of each material, but when broken down into easily manageable bits of information, usable knowledge will fall into place. There are a finite number of raw materials used in clay body formulas, and gaining a base of knowledge on each can be easily accomplished with some study. It is highly recommended to make three 5" bars of each raw material and fire one each to c/06 (1828°F), c/6 (2232°F), and c/9 (2300°F). The resulting series will give a good indication of each clay's fired color and density, which can help in choosing materials used in a clay body formula. Feldspars and low-temperature clays should be set onto a high-temperature ceramic plate, since at higher temperatures they will melt excessively.

Further shrinkage and absorption tests can be performed on individual clays, and the differences between them should be noted for future use. For a more involved test series, blends of raw materials can also be formulated. It is always best to do any testing in the actual production kiln and not a test kiln, since this will duplicate the firing cycle and thermal mass of the kiln, all of which influence the vitrification of raw materials. The fired samples can then be mounted on a board for easy reference. Often, having an actual fired sample of each clay is better than looking at photographs. Ceramic materials are fascinating in their dry and fired states, and any dedicated study will yield a base of knowledge useful for understanding and developing clay body formulas.

● Talc is a mineral that is often called steatite or soapstone.

11. TALC SUBSTITUTES

At some point, almost every clay body and glaze formula will require a raw-material substitution. The reasons can be wide ranging, but the goal should be a satisfactory replacement that retains the benefits of the original material. One raw material commonly used in clay bodies and glazes is talc, which has a long history of use in ceramics, having been incorporated in glazes as far back as the Tang dynasty (618–907 CE). On a commercial scale, talc is used in dinnerware, paper, rubber, insecticides, roofing materials, and food additives. Ceramics suppliers sell large quantities of talc to potters by itself or as a component in their moist clays. One major ceramics supplier uses 100 tons of talc every ten days in moist-clay production.

Talc Formation

This "silky" soft powder is basically a hydrated magnesium silicate ($3MgO_4SiO_2 H_2O$) found in metamorphic rock in layered deposits. It can range in size from 1 to 100 microns (1 micron = 1/24,500th of an inch), depending on the individual deposits. It is found in many geological locations, but there are just a few commercially workable deposits, which are open-pit mined. Talc is formed by the pressure and heat of volcanic action on ancient seabeds. Different alteration routes can produce changes in mineralogical composition, color, and crystalline structure. Trace amounts of iron, sodium, calcium, and potassium can also be present depending on the geologic formation, which can result in not all talcs being interchangeable in a clay body or in a glaze formula. A great many talcs are formed by modification of dolomite and magnesite in the presence of dissolved silica.

The Function of Talc in a Clay Body

Talc in low-temperature clay bodies c/06 (1828°F) to c/04 (1945°F) in conjunction with silica sets up a melting action, enabling the clay body to shrink and become dense and stronger in the firing. The glaze is then brought under slight compression, and the resulting stable clay/glaze fit prevents crazing, a fine network of lines in the glaze. Talc is also used as a major component in some raku clay bodies, offering thermal shock resistance due to its low rate of thermal expansion. Talc at high temperatures, c/6 (2232°F) to c/10 (2345°F), acts as an auxiliary flux in conjunction with primary fluxes such as feldspars, yielding a dense, vitreous clay body. It can also bleach iron in reduction-fired clay bodies to a light-brown/red color.

Controversy Surrounding NYTAL HR 100

For several years there has been controversy surrounding NYTAL HR 100, mined by R. T. Vanderbilt Co., Inc. This diverse mineral talc contains 40% tremolite, which can be found in nature in asbestos form or non-asbestos form. While potters and industry have used this talc for many years with good results, the shape and dimension of the tremolite component have been called into question. The factual evidence for removing NYTAL HR 100 for use by potters has not been proven to date.

The Connecticut Department of Public Health and Education advised schools in the state to stop using art clays that might have talc containing asbestos-like minerals. Soon after, Laguna Clay

Company announced it was using only Texas talc and no NYTAL HR 100 in any of its products. Thus, the subject of talc substitutes is important to ceramic artists and educators.

Other Talcs

Pioneer 2882: This talc is low in calcium with a gray raw color that fires to white; 98% can pass through a 200 mesh screen. Due to a consolidation of talc-mining companies, this product is now known as Texas talc. It offers good green strength and is used in many ceramics suppliers' clay body formulas.

TDM 92 Ceramic: This talc was originally mined by Milwhite, Inc., in Texas; 92% can pass through a 200 mesh screen. Pioneer 2882 talc was mined from the same layer of talc.

Pioneer MB 92: A West Texas talc that fires white; 92% can pass through a 200 mesh screen.

Pioneer 4388: A West Texas talc that fires to white; 88% can pass through a 200 mesh screen.

Sierralite: A refractory talc mined in Montana, with a high alumina and low flux content. Can be used in clay bodies where low thermal expansion and resistance to thermal shock are essential.

65/35 Talc: Mined in Texas, 35% is calcined at 1800°F. Most useful in pressing clay bodies and low-fire casting-slip clays. The calcining process heats the material to visible red heat above 1300°F. When clay is calcined, water is removed, resulting in an aluminosilicate.

Pioneer MB-92 Talc: Mined in Texas, 27% is calcined at 1800°F; 92% can pass through a 200 mesh screen.

Pioneer 4399 Talc: Mined in Texas; 88% can pass through a 200 mesh screen.

CERAMITALC HDT: A coarse, blended talc with high uniform thermal expansion and low moisture expansion that can be used in dry-press operations and in rapid-firing-cycle clay bodies to prevent glaze crazing.

Texas Talc (Pioneer Talc): Currently many individual potters and ceramics supply companies that mix clay are using Texas talc in their clay body formulas, having replaced NYTAL HR 100. Additionally, Texas talc is now used in many commercial glaze formulas. In ceramics this is just one of many raw-material substitutions that have and will come about due the variable nature of the industry.

Texas talc is mined 10 miles west of Van Horn, Texas. The open pit mine is ½ mile across, with a proven sixty-year reserve at the current rate of production.[1] The stripping ratio is less than 1:1, meaning that for every ton of overburden removed, 1 ton of talc is mined. Approximately 200,000 tons of talc are sold every year to the ceramics industry in the United States by the American Talc Company. The ore is drilled, blasted, trucked to the processing plant, sent through an automatic rock sorter, and then stacked and blended four ways into and out of 30,000- to 40,000-ton stockpiles to ensure a consistent blend. The talc is air classified in a milling process to ensure uniformity. It is then shipped in bulk or packaged in 2000 lb. super sacks and 50 lb. bags.

Texas talc is classified as a western plate structure talc and is nonfibrous. It has a dark-gray raw color due to organic material, which will burn off between 572°F and 1292°F, revealing a white clay. When raw glazing and once firing, it is best to fire the kiln slowly until it reaches 1292°F, which will burn off organic material in the talc. Excavated stockpiles of talc are tested and certified for the presence of asbestos fibers. The talc has been used by many large ceramics suppliers in low-, medium-, and high-temperature moist clays for many years and has an excellent performance history.

Comparison of Raw Color in NYTAL HR 100 and Texas Talc

Top: Texas talc used in cone 06 low-fire white clay body, bone-dry stage (dark color is due to organic content of the talc). Bottom: NYTAL HR 100 used in low-fire white clay body, bone-dry stage.

Comparison of NYTAL HR 100 and Texas Talc with Commercial Glazes, Commercial Underglazes, and Slips

Cone 06 colored slips were applied to leather-hard clay bodies then bisque-fired to cone 010. The results were similar in color and texture in both clay bodies. The commercial underglaze colors

From top to bottom:

Texas talc clay body
Different-color clay slips
½ of tile unglazed, ½ AMACO
F-10 Lead-free clear transparent

NYTAL HR 100 clay body
Different-color clay slips
½ of tile unglazed, ½ AMACO
F-10 Lead-free clear transparent

Texas talc clay body
Mayco Stroke & Coat underglaze colors
& Duncan Concepts underglaze colors
Duncan IN 1001 Clear Envision glaze

NYTAL HR 100 clay body
Mayco Stroke & Coat underglaze colors
& Duncan Concepts underglaze colors
Duncan IN 1001 Clear Envision glaze

Texas talc clay body
Mayco Stroke & Coat underglaze colors
& Duncan Concepts underglaze colors
AMACO F -10 Lead-free clear transparent

NYTAL HR 100 clay body
Mayco Stroke & Coat underglaze colors
& Duncan Concepts underglaze colors
AMACO F-10 Lead-free clear transparent

Texas talc clay body
Mayco Stroke & Coat underglaze colors
& Duncan Concepts underglaze colors
Mayco Series 2000 S-2101 Natural clear glaze

NYTAL HR 100 clay body
Mayco Stroke & Coat underglaze colors
& Duncan Concepts underglaze colors
Mayco Series 2000 S-2101 Natural clear glaze

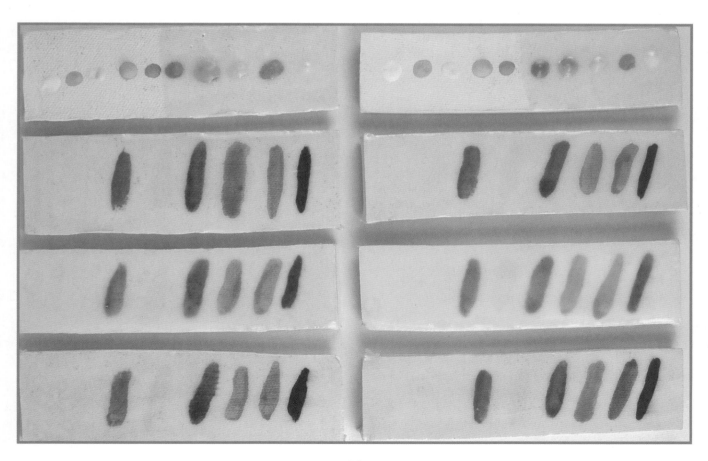

and glazes were applied to the bisque and then fired to c/06 in an electric kiln. They were identical in color response and intensity on both clay bodies. The commercial glazes applied to the bisque tiles and fired to cone 06 matched in transparency and surface texture in both clay bodies.

Mineral Analysis Comparison: Texas Talc and NYTAL HR 100

Mineral Analysis of Texas Talc[2]	
Talc	90%
Predominantly Limestone	10%

Mineral Analysis of NYTAL HR 100[3]	
Tremolite	40%
Talc	30%
Serpentine	20%
Anthophyllite	10%

Handling Characteristics of Texas Talc and NYTAL HR 100

While working with any moist clay can be a fairly subjective experience, some general descriptions can be used for evaluation. The low-fire white clay body containing Texas talc was similar in plasticity to the low-fire clay body containing NYTAL HR 100. Each clay body had a soft, moist feel when working on the potter's wheel and during handbuilding. Both clay bodies became progressively slicker and had a more gummy texture as water was added in the forming operations. A low-fire, white slip-cast clay body using Texas talc performed similarly in all aspects as a slip-casting formula using NYTAL HR 100.

Dry/Fired Shrinkage Rates of Texas Talc and NYTAL HR 100

Low-fire white clay using Texas talc: Dry shrinkage 5%, c/06 shrinkage 7.6%
Low-fire white clay using NYTAL HR 100: Dry shrinkage 5%, c/06 shrinkage 7.5%

Options for Non-talc Clay Bodies

Some potters will find it easier not to use talc either in clay bodies or glaze formulas. For the past several years, ceramics supply companies have formulated non-talc clay body formulas for low-, medium-, and high-temperature moist clays. In glaze formulas, a well-thought-out use of other raw materials can duplicate the effects of talc.

Low-Fire Clay Body Formulas Using Texas Talc
Cone 06–Cone 04

#1 Low-Fire White	#2 Low-Fire White	#3 Low-Fire Red
Thomas ball clay 25%	Tenn. No. 1 ball clay 25%	Redart 60%
Custer feldspar 10%	Texas talc 40%	Hawthorn Bond 35x 20%
Texas talc 40%	Whiting 5%	Texas talc 20%
Whiting 5%	EPK 20%	
EPK 20%	Minspar 200 10%	

12. NO MORE ALBANY SLIP, NO MORE BARNARD/BLACKBIRD

The depleted stockpiles of Albany slip and Barnard/Blackbird clays are unfortunate events but, in many ways, predictable occurrences in the history of raw materials used by potters. At some point in every potter's experience, one or more of his or her essential raw materials will become unavailable. Some older potters remember using Oxford, Maine, Clinchfield, Buckingham, or Kingman feldspars. Other raw materials such as Zircopax and Gerstley borate, and clays such as Jordan stoneware, Avery kaolin, Georgia Pioneer kaolin, North American fireclay, P.B.X. fireclay, and Ocmulgee stoneware—to name a few—have also gone out of production. Several discontinued materials are still listed in glaze and clay body formulas, although they are not being mined, while a few can often be found in potters' storage bins. However, once depleted they will not be available from ceramics suppliers. Potters should always find out if all of their raw materials are still available *before* mixing any glaze batch.

Once a raw material is removed from distribution, potters will have to develop an adequate substitution that will offer the same results in glazes and clay body formulas. In most instances the material's withdrawal from the market place is based on

economic reasons and not the actual depletion of the ore, feldspar, or clay. In fact, there are still geologic deposits of Albany slip and Barnard/Blackbird clays, but they are no longer being mined. These two slip clays have been used for many years by industry and potters. Looking through any ceramics book or magazine will reveal many glaze and clay body formulas that contain both popular low-fire, high-iron-content slip clays. Many potters' glaze notebooks will show one or more Albany slip and Barnard/Blackbird glaze formulas.

Locations of Albany Slip Clay

Albany slip clay is an alluvial deposit formed by the transportation of material by glacial action in the Albany– Hudson River region of New York State.[1] Records indicate that two mine sites operated at different times. One site was located near Livingston Avenue and North Lake Avenue beside Highway 1-90 in the city of Albany, on the edge of residential housing and industrial areas. Landfill from the Empire State Plaza project is now deposited throughout the site. The other mine was located off North Lake Avenue adjacent to the Tivoli Lake Wildlife Preserve (see maps).

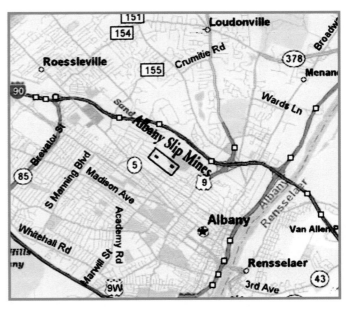

Albany, New York, mine sites in box.

At the site the overburden was stripped away, yielding four beds of clay that tested for uniform properties suitable for removal. The beds of clay were of variable thickness, with two layers 8 ft. thick separated by sandy layers.[2] The two were similar to deposits under the Empire State Plaza in the center of the city.[3] The city of Albany's urban renewal project in the 1960s excavated many metric tons of the clay from the capital area, since it was an impediment to the building site.[4]

⊙ Close view of Albany slip mines located at Prospect Avenue / Livingston Avenue and (Tivoli Lake) North Lake Avenue sites.

⊙ Digging Albany slip clay. Dorna Isaacs, ca. 1969, current vice president of Hammill & Gillespie.

⊙ Albany slip open-pit mine.

History of Albany Slip Clay

Albany slip clay has a complex mineralogy with high levels of alkalis and irons. This hydrous aluminosilicate clay is dark brown and nonplastic, having a silty texture.[5] Unrefined clay frequently contains stones and twigs. Potters used this once-common but now-scarce clay for over 250 years. The northern Hudson valley of New York State was an active pottery-making region; by the 1840s, almost sixty potters produced ware in and around the city of Albany. The records of Albany slip clay, commonly called "Albany mud," date back to the Revolutionary War period.[6] The newspapers of the 1800s advertised Albany slip clay as a substitute glaze for the toxic lead glazes that were commonly used on functional pottery of the period. Progressively improving roads and transportation systems also allowed the raw clay to be shipped in barrels to stoneware pottery producers throughout the country. It was a raw material that offered a low-cost, durable, and reliable glaze.

During this period, Albany slip was also used on the interior surfaces of salt-glazed ware due to the sodium vapor's inability to infiltrate the insides of functional forms such as crocks and jugs. Albany slip produced a smooth uniform melt and durable functional surface. Additionally, the salt kiln was stacked more efficiently by placing many pieces mouth to mouth, necessitating an Albany slip glaze on the interiors. Salt glazing offered an efficient method for glazing; salt was inserted into the kiln during the firing process, which, upon vaporizing, formed a sodium, alumina, silicate glaze surface. The most distinctive feature of the ware is characterized by an "orange peel" texture on exposed nonglazed, fired-clay surfaces. The onset of Prohibition led to the demise of stoneware and salt-glazed jugs and coincided with the popularity of glass containers. Today a trip to any antiques store will reveal many crocks, jugs, and other functional pottery containers that were glazed with Albany slip in the salt-firing process, as well as other Albany slip–glazed pots.

Numerous glaze variations were formulated using Albany slip clay (a slip clay is a naturally occurring clay that forms a glaze) as the minor or major ingredient. It has also been used as a decorative slip (engobe) applied over a raw glaze on functional ware. The earliest use of any slip glaze has been dated to Neolithic ware from Anatolia (Turkey) ca. 7000 BCE.[7] At higher temperature ranges, above c/9 (2300°F), Albany slip clay is almost a glaze by itself and is characterized by a glossy flowing surface ranging in color from light-yellow/green to dark-brown/black in reduction kiln atmospheres. Due to its high iron content, Albany slip was used in Temmoku iron crystal glazes, producing a wide range of glaze effects such as "hare's fur" (light streaks in the glaze) to "tea dust" (small crystals formed in the glaze upon cooling).[8] Albany's long history of easy availability and extensive distribution resulted in its use as a glaze material by many generations of potters. However, due to its lack of plasticity, it was not used extensively in wheel-throwing or handbuilding clay body formulas.

Albany slip clay had a history of use in commercial pottery production and industry. Rowe Pottery Works, makers of museum-quality reproductions, and Pfaltzgraff Pottery used the clay extensively. Rival Pottery, the manufacturers of Crock-Pots, used Albany slip as a glaze on their ware. Albany slip has been also employed on such diverse applications as electrical insulators, vitreous coatings for structural clay products, and stoneware pottery. This versatile clay was used as a smooth, nonabsorbent glaze for sewer pipe and has been employed as a bonding agent on abrasive wheels for over ninety years.

In 1962 Industrial Mineral Products acquired the Albany slip mine formerly owned by Rex Clay Company. The mine was located at the Prospect Avenue and Livingston Avenue site. Hammill & Gillespie, Inc., an importer and distributor of ceramic raw materials, was appointed exclusive agent for distributing the clay. They continued to supply ceramics supply companies, individual potters, and commercial/industrial users with the clay. The open strip mine a few blocks from the capitol in Albany, New York, encountered mounting economic problems such as higher insurance rates, increasing processing costs, fuel costs for trucking, and stricter Environmental Protection Agency regulations. After the extraction of clay, the pit had to be completely covered until the next harvesting. Once the raw clay was removed from the site, it went to the processing plant for grinding, screening, bagging, and palletizing. It was then ready for shipping to Hammill & Gillespie's warehouse.

The raw clay had a moisture content ranging between 18%

and 23%, which meant that for every 1000 lbs. of raw clay extracted from the mine and shipped to the processing plant, 180 to 230 lbs. was necessary to bring Albany slip clay to market. A $50,000 to $75,000 capital outlay was required to cover mining, transportation, processing, bagging, and storage costs to produce an eighteen-month stockpile. During this period the predominant percentage of clay sales was to potters purchasing a few pounds or one or two 50 lb. bags, which meant a slow payback on a low-profit material for a large capital investment. The same financial process was required every time a stockpile was exhausted. Such a financial structure was vulnerable to a price increase at any point in the processing or distribution process.

The last stockpile of Hammill & Gillespie's Albany slip clay was depleted in 1987. Keep in mind that, as with other discontinued raw materials, Albany slip clay remains in some potters' studios, but at present it is not to be found in any ceramics supplier's inventories.

Albany slip clay has changed over the years since it was first mined. The three sample analyses are "run of the mine," which means it can shift from batch to batch. A definitive analysis of any one shipment is often not possible. The clay was shipped in 50 lb. brown bags with black side lettering, and some bags were not marked with production lot numbers. The subsequent variations in chemical analysis of the slip and the variation in potters' kiln-firing atmospheres, clay bodies, and glaze application methods can account for the variations in the fired glaze. Remember, just because the name on the bag stays the same, what's inside may not be.

Albany Slip Clay

Chemical Analyses Chemical Analysis from Ceramic Database, Tony Hansen, Insight glaze calculation		Chemical Analyses Hammill & Gillespie, 1971		Chemical Analyses Hammill & Gillespie, 1973	
CaO	5.810%	CaO	6.280%	CaO	5.780%
K_2O	3.200%	K_2O	2.750%	K_2O	3.250%
MgO	2.710%	MgO	3.350%	MgO	2.680%
Na_2O	0.800%	Na_2O	0.400%	Na_2O	0.800%
TiO_2	0.400%	TiO_2	0.900%	TiO_2	0.800%
Al_2O_3	14.630%	Al_2O_3	11.540%	Al_2O_3	14.660%
SiO_2	57.820%	SiO_2	59.480%	SiO_2	57.640%
Fe_2O_3	5.210%	FeO_2	4.130%	FeO_2	5.200%
Loss on ignition	9.410%	Loss on ignition	10.400%	Loss on ignition	9.460%

Average trace oxides in samples—Ba, Sr, Li, Mn, Pb 0.13

Mineralogical composition: Illite, quartz, limonite, chlorite, calcite, dolomite

Average Screen Analyses—% residue[9]
60 mesh 0
120 mesh 1.0 max.
200 mesh 5.0 max.

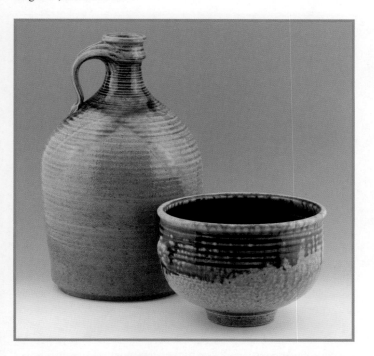

● Modern salt-glazed Albany slip–glazed jug; height 13" and bowl height 5"; 2300°F c/9/r.

⌃ Albany slip–glazed jug, 1900s; Albany slip top, clear glaze bottom; 2300°F; approximate height 11".

Chemical Analysis

The chemical analysis of Albany slip clay has changed over the years it was mined. The changes in part represent the variable qualities of glazes that employed Albany slip.

Original Albany Slip Clay

There is a 10-ton or less stockpile of original raw Albany slip clay, which can be purchased in small or large quantities from the Great American Wheel Works (phone no.: 518-756-2368). The clay comes with an instruction sheet on how to screen small pebbles, which constitute approximately 1% of the total clay content.

Albany Slip Substitutions

Due to its unique natural mineral content, which changed at various times in its availability, Albany slip clay has proven somewhat difficult to reproduce either by using other slip clays or building a substitute that duplicates its oxide content. As with other naturally occurring ores such as Gerstley borate and Barnard slip clay, there are no definitive chemical analyses of the materials to use as a baseline when considering a substitution. Additionally, trace materials found in the deposit can contribute to unique qualities that often do not lend themselves to duplication. In the past, Michigan slip clay was an acceptable substitute for Albany, but it was discontinued in the 1970s.

When a raw material is no longer available and potters exhaust their own supply, there is always a rush to find adequate substitutes. Unfortunately, many raw materials are unique in chemical composition, trace elements, particle-size distribution, handling characteristics, and organic content and do not lend themselves to a one-to-one substitution suitable for every temperature range and kiln atmosphere. In the past, ceramics supply companies have hurried to sell substitutes, which sometimes did not yield the desired results. Potters have often stockpiled reserves of the original raw material, which can tie up money and studio space. Several of the Albany slip substitutes listed work quite well in various glaze formulas; however, not all of the substitutes *work in every glaze formula* like the original. Therefore, as in using any substitute material, it is advisable to test it in a small batch of glaze and see the results in your own production kiln, not a small test kiln. Price should never be considered when choosing a substitute, since the cost of any raw material is insignificant when compared to the time and labor used to create and fire the ceramic ware. In any situation, if a substitute material works, pay the price.

Major Distributors of Albany Slip Clay Substitutes

Alberta Slip: A Canadian blended substitute distributed by Laguna Clay Co., 626-330-0631, and Axner Pottery Supply, 407-365-2600.

Albany Slip Substitute: A naturally occurring slip glaze mineral distributed by Laguna Clay Co., 800-452-4862.

Albany Slip Substitute, Alberta Slip, Ravenscrag Slip: Distributed by Bailey Ceramic Supply, 845-339-3721.

Albany Slip Substitute: A blend of Sheffield clay, a high-iron-content earthenware clay, and frits. Distributed by Sheffield Pottery, 413-229-7700.

Seattle Slip and Alberta Slip: Naturally occurring slip clay distributed by Seattle Pottery Supply, 35 South Hanford, Seattle, WA 98134, 206-587-0570.

Ohio Slip: A clean and consistent clay comparable to Albany slip, firing from cone 6 to cone 12. Mined by A&K Clay Company, 937-379-1495.

History of Barnard/Blackbird Slip Clay

Barnard clay, a high-iron-content, low-temperature, nonplastic clay, was first mined in the Revolutionary War period. The deposit is located in a heavily wooded area in central Pennsylvania near Harrisburg. During the period when it was available, Barnard/Blackbird clay was used in the brick and tile industries. Due to its high manganese content, it was a major ingredient in smelting iron ore. Hammill & Gillespie took over the operation of the mine, and Richard Isaacs, the president of the company, added the name Blackbird to the clay. In 1957 Hammill & Gillespie was named distributor by the former owners. The original stockpile of Barnard/Blackbird was exhausted by 1967, and the mine was reopened, with Hammill & Gillespie taking over the arrangements for processing the clay. The mine was open during the winter months, since trucking the clay out became easier due to the frozen condition of the logging roads leading out of the mine site. In the warmer months, rain sometimes made the dirt roads extremely slippery. When mining was reopened, the overburden (topsoil) was removed and 100 tons of clay were excavated at a time, which produced an eighteen-month supply. The raw clay was sent by truck to the processing mill, where it was dried, ground, and placed in 50 lb. brown bags with black lettering on the side plate. Aside from processing the clay, it was considered "run of the mine," with the probability of varying chemical compositions with each batch. Hammill & Gillespie sold the last stockpiles of Barnard/Blackbird clay in September 2002, the same year the mine closed.

Barnard/Blackbird Slip Clay

Listed are four sample analyses of the clay over its production history.

Chemical Analyses		Chemical Analyses		Chemical Analyses		Chemical Analyses Last analyses by X-ray spectroscopy	
CaO	0.62%	CaO	0.27%	CaO	Tr	CaO	—
MgO	0.74%	MgO	0.75%	MgO	Tr	MgO	—
K_2O	1.24%	K_2O	2.05%	K_2O	3.77%	K_2O	2.1%
TiO_2	0.25%	TiO_2	0.67%	TiO_2	0.85%	TiO_2	—
Al_2O_3	8.28%	Al_2O_3	10.84%	Al_2O_3	10.60%	Al_2O_3	15.4%
SiO_2	51.28%	SiO_2	59.74%	SiO_2	52.38%	SiO_2	34.5%
Na_2O	0.62%	Na_2O	0.12%	Na_2O	—	Na_2O_3	—
Fe_2O_3	36.97%	Fe_2O_3	14.65%	Fe_2O_3	20.27%	Fe2O3	25.9%
				MnO	3.23%	MnO	5.8%
						Minors	4.3%

Loss on Ignition ranged from 7.48% to 12.0%

Average Screen Analyses—% residue[10]

60 mesh	0
120 mesh	1.0 max.
200 mesh	5.0 max.

Modern Barnard/Blackbird slip-glazed bowl, fired at c/6/ox (2232°F); 2½' height, 3¼' width.

Chemical Analysis

Barnard/Blackbird was used in glazes and engobes for its suspension properties. Due to its variable chemical composition, the intensity of brown it produced in glazes varied depending on several factors. As with other glaze raw materials, the firing temperature, glaze application thickness, kiln atmosphere, and underlying clay body color all can be contributing factors in glaze color, opacity, and surface texture. However, Barnard/Blackbird's varying chemical composition, as with Albany slip's, added to its diverse glaze effects.

Barnard/Blackbird begins to melt at c/6 (2232°F). The clay is nonplastic and was not generally used as a clay body component. Hammill & Gillespie has mined and distributed the clay to potters, ceramics supply companies, and industry. Approximately 65% of clay production was sold to potters; the remaining 35%, to the brick and tile industries.

Potters who have used Barnard/Blackbird in glazes or engobes have noted its high iron and manganese content, which can stain hands, tools, and glaze-mixing equipment. Aside from the problems in handling and using the clay, it was a reliable glaze material and was readily available through many ceramics supply companies. As with Albany slip clay, it can still be found in individual potters' raw-material containers. However, there is a finite supply, and neither clay will be mined again in the foreseeable future.

The cost of mining and distribution of Barnard/Blackbird clay has steadily increased over the years. While a few costs could be passed on to customers, at some point it was uneconomical to produce the clay. Each cycle began with an outlay of $50,000 to

$75,000 to cover the cost of mining and processing an eighteen-month supply, which sold in 1987 for $0.24/lb. Tying up that much capital for a small company is a considerable challenge, since the money is not earning interest and could be used for a faster payback on investment. Increasing insurance costs for strip mining plus stricter federal regulations added to the expense, and trucking the clay to the processing plant on marginal roads and rising gasoline prices further reduced any potential profit. Barnard/Blackbird clay contained 30% water, which meant that for every 1000 lbs. of raw clay sent for processing, less than 700 lbs. was available after drying and screening. The processing plant over the years increased their prices on the basis of the extra cost of cleaning the screens clogged by the gummy, sticky clay. Other added costs were the new Environmental Protection Agency regulations regarding removal of dust waste created by the processing operation. Bagging, palletizing, and shipping the clay to Hammill & Gillespie's distribution center in New Jersey further drove up the cost due to steadily increasing gasoline prices. The increased mining, processing, insurance, and shipping expenditures were higher than the actual cost of the clay.

Substitutes for Barnard/Blackbird

Barnard/Blackbird clay will be difficult to replace for several reasons. The economics of mining, refining, and marketing a product that has high developmental costs and a low selling price, and is geared to a marginal market (potters), do not dictate a rush in finding a replacement. Essentially, the same market forces are in play as with other raw materials potters use, *except* that currently available materials such as flint, talc, dolomite, wollastonite, etc., are supported by large industrial demand, which keeps them in production. For example, if for some reason talc was not needed by the industries that use this magnesium silicate ore, the mines and processing plants would close. When ceramics supply companies and individual potters' stockpiles were depleted, it might be difficult to obtain talc for clay body and glaze formulas. Luckily, there are many raw materials and clays used by large industries that potters can use in clay bodies and glazes, but that does not guarantee that specific materials will remain available in the future. The ceramics fact of life: the larger customers of raw materials dictate the availability and quality of almost all of the materials potters use.

Barnard/Blackbird clay is unique in chemical makeup, organic content, particle-size distribution, and trace-material composition. There are probably other high-iron-content clays that are similar and can serve as substitutes, but they cannot be brought to market because of the high barriers to entry listed above. On the technical level, Barnard/Blackbird contains manganese as a natural component of the clay. Formulating a substitute from other clays and ceramic raw materials would entail the addition of prohibitively expensive manganese dioxide to match the naturally occurring percentage.

The total cost of the formulation would exceed the price that potters would be willing to pay. Furthermore, the larger industrial markets do not need Barnard/Blackbird clay today, a situation that does not help the raw-material needs of potters.

Orphan Ores

When large industries abandon the use of a raw material, the limited pottery market does not have the buying power to sustain its production. Orphan ores are ceramic raw materials that are left without viable market support. Small raw-material-buying markets, such as potters and ceramics suppliers, do not order sufficient volume to sustain raw-material production. Moreover, there is a delicate balance between the cost of mining, processing, and shipping the material compared to the price that potters are willing to pay for the material. If any cost of production increases while bringing a raw material to market, it becomes economically unfeasible to substantially increase the price to the eventual user.

One or more of these characteristics describe materials that have a high probability of becoming unavailable to potters:

- Orphan ores once had a viable economic basis for their production.

- Orphan ores currently do not have large and diverse industrial or commercial markets.

- Orphan ores have increasing processing costs vs. low selling prices.

- Orphan ores are used in products that have low intrinsic resale value (pottery).

- After being dropped from the larger markets, orphan ores are still used by limited markets that purchase small quantities intermittently.

Gold and Raw Materials

What does gold have in common with the raw materials used by potters? Nothing, except as a model of opposite values and their relationship to the market place. Gold is relatively scarce and has a very high value and wide market appeal. Currently the approximate price of gold is $1,200 per ounce, compared to the last quoted price of Albany slip clay, which was $0.35 per pound. There is an obvious difference between a rare high-value ore and a common ore of low value with limited market appeal. What does this mean in terms of supply and demand? The rarity of gold and its intrinsic value means that a great many individuals and industries are willing to pay a premium price. Furthermore, there is a high markup on gold jewelry, far exceeding the actual price of the gold itself. The costs of locating, mining, processing, and distributing are worth the effort on the basis of the perceived value, high retail price, and large and diverse market demand.

In contrast, Albany slip and Barnard/Blackbird clays have a low value with limited market demand. Additionally, the end-point users of the clays, whether individual potters, commercial potteries, or industry, are using it in products that have small profit margins. The profit margins for mining, processing, and distribution of clays and other ceramic raw materials are much lower than for gold and are subject to any number of increasing processing and transportation costs.

Mine Sites

The lands containing deposits of Albany slip clay and Barnard/Blackbird clay are still undeveloped and covered by overgrowth. The site near Prospect Road and Livingston Avenue has been used for landfill. The other mine site, across from North Lake Avenue near the Tivoli Lakes Wildlife Park, is overgrown with weeds. The vacant mine sites illustrate that the land is not currently utilized for more-profitable commercial enterprises, but the demise of Albany slip clay and Barnard/Blackbird clay was brought about by increasing production costs associated with bringing these clays to market.

Ceramic Raw-Material Economics

A closer examination of why Albany slip and Barnard/Blackbird clays are no longer available reveals the economic factors that control the entire spectrum of raw materials available to the pottery market. Many of our favorite raw materials are on a precarious balance of profitability to the companies that mine and supply them. Specifically, Albany slip and Barnard/Blackbird were on an economic knife edge of profitability during their production life. As we have examined, small changes in mining, processing, and shipping resulted in their demise. Overall, potters represent less than one-tenth of 1% of the entire raw-material market in the United States. This translates into little or no buying power compared to the larger commercial and industrial users, who dictate the supply and quality-control parameters of any given material. Individual potters or ceramics suppliers do not purchase in the quantities that guarantee any material will remain

consistent in chemical makeup, particle-size distribution, or future supply. The inequitable buying position that potters find themselves in is not brought on by their need for a specific raw material; it's just that they can't buy enough of that material to guarantee future supplies.

A stable market means that the cost of producing a raw material is below what potters will pay for it, leaving profit margins for the miner, processor, wholesale distributor, and retail seller. If a raw material has a long chain of intermediate suppliers, each making a small profit, any increase in production costs can upset the system and make it uneconomical for potters. Potters purchasing raw materials are for the most part unaware of the mining and processing costs, as well as the small distributor profit margins, but they are very aware of the price they will pay. Potters are caught between the unique qualities of making handmade functional objects and the *inability* of bringing economies of scale through mass production or economies of technology through less costly machine-made ware. In practice, potters have discovered that the market for handmade ceramic objects is very small, and within that population the subgroup that will pay $50 for a coffee mug is even smaller. If potters could consistently sell coffee cups for $50 each, they could then afford to pay a higher price for their raw materials, thus keeping orphan ores in production or at least giving a greater economic incentive for suppliers to find a substitute.

What can potters do to counter market forces beyond their control? There are several strategies that can be effective in avoiding a situation where your favorite raw material is no longer available. The first and most useful tool is to learn how raw materials function within clay body and glaze formulas. Potters often know they need a certain feldspar in a glaze formula, but they do not understand its function or know what other feldspars can be substituted. While there are many substitute materials that will produce the same glaze or clay body color, surface texture, or handling characteristics as the original material, many clay body and glaze formulas can be duplicated by the use of totally different formulas. Awareness of the current raw-material market is essential. While not every single one of the hundreds of materials have to be monitored, it is advisable to keep in touch with your ceramics supplier about the raw materials used in your glaze and clay body formulas. Do not assume that just because the bin in your studio is full, the material is still being produced. Another option, which ties up capital and studio space, is the stockpiling of raw materials in the eventual case one or more might be discontinued. However, this strategy often reflects a static view of ceramics and a potter's inability to manipulate raw materials to achieve functional and aesthetic goals. The economic forces behind Albany slip and Barnard/Blackbird's demise are still in place, and they will remove more of our favorite raw materials in the future.

The Future of Domestic Raw Materials

Ceramic raw-material markets in the United States have changed more in the last five years than in the proceeding twenty-five. Greater numbers of ceramic products are now being produced in China, Spain, Vietnam, Mexico, and other foreign countries, which rely on cheaper labor and their own domestic sources of clays and raw materials. Mines and raw-material processors in the United States are beginning to limit their production due to the domestic lack of demand. Does this mean that all domestic ball clays will be discontinued? No, but a mine might produce twelve instead of twenty different ball clays. At some point, a reduced inventory of clays and other raw materials will again cause potters to look for substitutes for their clay and glaze formulas. A diverse and thorough knowledge of raw materials will be the potter's only recourse in the current environment of fewer material options.

13. THE HISTORY OF G-200 FELDSPAR

This once commonly available 200 mesh potassium-based feldspar also contains sodium, alumina, silica, and traces of calcium and iron. It has been used in glazes and clay body formulas for over sixty years. G-200 feldspar acts as a flux, bringing other clay body and glaze materials into an active melt above cone 6 (2232°F). Potassium-based feldspars are used in art ware, pottery, high-tension electrical insulators, and hotel china. G-200 sold to potters and ceramics supply companies represents 5% to 10% of the market, a relatively small percentage compared to larger-industry sales. In the past, coarser grades of G-200 such as G 40 were used in the manufacturing of television tubes and laboratory glassware. However, sodium-based feldspars, widely known as F-1, F-4, Minspar 1, and Minspar 200, have had a higher demand and are used in ceramic tile, sanitary ware, tableware, fiberglass, and other glass applications. As with any ceramic raw material, market forces can dictate changes and availability. The history of G-200 and its variations such as G-200 HP and, currently, G-200 EU is just one example of feldspars that potters depended on that have gone out of production, such as Oxford feldspar, A-3 feldspar, Kingman feldspar, and, recently, F-4 feldspar (production stopped May 2009).

Historical Points in the Production of G-200 Feldspar

The Monticello, Georgia, operation was built and operated by the Feldspar Corporation, a subsidiary of Pacific Tin Consolidated Corporation (later renamed Zemex Corporation) of New York City. The company was started by a group of investors, including Carroll P. Rogers Sr., in 1929 near Micaville (Yancey County), North Carolina, as Feldspar Milling Company. The company survived the Great Depression and World War II and in 1949 built the first commercially successful flotation feldspar plant near Spruce Pine (Mitchell County), North Carolina, known as Feldspar Flotation Corporation.

Rogers, as general manager, oversaw construction of the new facility and in 1955 began construction of a similar plant on the site of an abandoned feldspar-milling operation near Monticello, Georgia. In the same year, Pacific Tin Consolidated Corporation purchased the two plants in North Carolina and the plant in Georgia and created the Feldspar Corporation.

The Froth Flotation Process

G-200 feldspar has been produced since 1955 in a facility just south of Monticello (Jasper County), Georgia. The ore was sourced locally from weathered pegmatite and granite deposits and was refined by using a process called "froth flotation." The process enables larger quantities of feldspar to be produced with greater consistency at lower cost than other processing techniques and was adapted from similar technology used in the metal-mining industry to concentrate feldspar from ores that also contained mica, silica, and iron-bearing minerals. It involves grinding the ore to a 16 to 30 mesh to achieve separation of the individual mineral particles, then selectively charging the minerals to be removed in order to coat them with an amine (a processed animal fat), making the particles relatively hydrophobic (tending not to combine with or incapable of dissolving in water). These particles attach themselves to air bubbles in the flotation cells and "float" to the top in a "froth," where they are raked off by rotating paddles. The process consists of three flotation steps: the mica flot, the iron flot, and the feldspar flot, with the final step yielding the concentrated feldspar. This concentrate is dried in rotary dryers and then is ground to 200 mesh and finer for ceramic and filler applications.

In 2003, Zemex Corporation was taken private through a tender offer by Cementos Pacasmayo, S.A., of Peru. After nearly four years Cementos Pacasmayo divided the Zemex assets and sold the Feldspar Corporation to Imerys North America Ceramics (a division of Imerys, S.A., of France), headquartered in Atlanta, Georgia. The purchase included the Spruce Pine and Monticello operations. Over the years, the G-200 from Monticello, Georgia, was produced from a blend of high-potassium and sodium feldspar

ores to yield a typically 10.5% K_2O content. This met the requirements of the ceramic industry and extended the reserves of high-potassium feldspar ore available to the Monticello facility. However, after purchasing the facility, Imerys announced the introduction of G-200 HP, a higher-K_2O version of G-200. This product apparently hastened the depletion of the local high-potassium feldspar reserves.

Imerys ceased production of G-200 HP (higher potassium) at the Monticello plant in February 2014, due to cost considerations in blending the feldspar and the depletion of existing reserves. Imerys now imports potassium feldspar from Spain as G-200 EU, which will match the original G-200's potassium levels.

Raw-Material Economics

The demise of G-200 and G-200 HP will directly affect potters who use them in clay body and glazes formulas. Currently, G-200 EU is available as a direct substitute for G-200 and G-200 HP. When the feldspar was sold to the larger industrial market, stocks depleted more rapidly than if it were sold just to potters. In fact, if it was economically possible to mine raw materials exclusively for potters, there are sufficient quantities for an almost endless supply. However, if it was sold only to potters it would not be profitable for the company to mine or blend the feldspar. Interestingly, the increased cost of G-200 EU should not keep potters from purchasing the feldspar; a careful analysis of the cost of *any* raw material—with the exception of tin and cobalt—will direct potters' attention to their largest cost factor, which is their own labor. The only prerequisite for any substitution is the quality of the result.

G-200 Substitution

Potters use only three of the twelve types of feldspar found in nature in their clay body and glaze formulas.[1] They are classified according to the dominant oxide aside from its alumina and silica content. When making a substitution, whether it is a sodium-, potassium-, or lithium-based feldspar, it is best to stay within the same group. Custer feldspar, produced by Pacer Corporation in South Dakota, has been mined for over eighty years, with at least a ten-decade reserve.[2] It has been used as a direct one-for-one substitute in clay body and glaze formulas for G-200 and G-200 HP, since they all are potassium-based feldspars.[3] While Custer feldspar has a higher iron content (see analysis) and will fire out slightly gray at cone 11 (2361°F), in a 100% comparison with G-200 the difference is not reflected in darker clay body colors. In porcelain clay body formulas, Custer Feldspar can produce black specking. However, as with any raw-material substitution, a test should be performed to ensure compatible results.

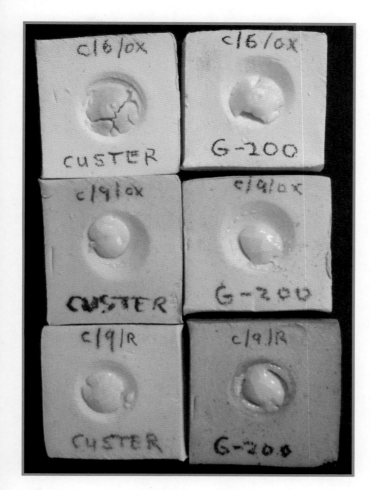

Comparison of Custer feldspar to G-200 at cone 6 (2232°F) and Custer feldspar to G-200 at cone 9 (2300°F), oxidation and reduction atmospheres.

Comparison of Custer Feldspar and G-200 in a Cone 10 (2345°F) Glaze Fired in an Oxidation Kiln

A one-for-one substitution was made in the glaze formula, using Custer feldspar instead of G-200. When fired in an electric kiln to cone 10 on a white stoneware clay body, both glazes produced a transparent glossy surface. The craze patterns and spacing of the craze lines were similar on both glazes, indicating that they were under the same level of tension when cool and had equal coefficients of expansion.

Comparison Glaze Formulas, Cone 10

Custer Feldspar	42	G-200 Feldspar	42
Ferro Frit #3195	35	Ferro Frit #3195	35
Flint 325 mesh	13	Flint 325 mesh	13
EPK	6	EPK	6
Whiting	4	Whiting	4

Comparison of Custer Feldspar and G-200 in a Cone 5 (2232°F) Glaze Fired in an Oxidation Kiln

A one-for-one substitution was made in the glaze formula, using Custer feldspar instead of G-200 feldspar. Both glazes when fired in an electric kiln to cone 6 on a white stoneware clay body produced a transparent glossy surface.

Comparison Glaze Formulas, Cone 6

Custer Feldspar	21	G-200 Feldspar	21
Ferro Frit #3195	50	Ferro Frit #3195	50
Flint 325 mesh	16	Flint 325 mesh	16
EPK	8	EPK	8
Whiting	5	Whiting	5

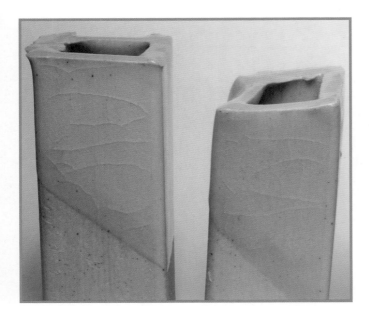

Cone 10. Custer feldspar in glaze (left) and G-200 feldspar in glaze (right).

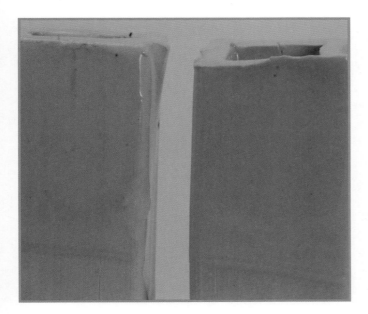

Cone 6. Custer feldspar in glaze (left) and G-200 feldspar in glaze (right).

50 lb. bag of G-200 feldspar.

Potassium-based feldspars	Sodium-based feldspars	Lithium-based feldspars
G-200 EU	Clinchfield #303[+]	Spodumene
Custer feldspar	Minspar 200 feldspar / NC-4[++]	Petalite
G-200 feldspar[+]	Kona F-4 feldspar[+]	Lepidolite[+]
G-200 HP feldspar[+]	Nepheline syenite[+++]	Lithospa
Buckingham feldspar[+]	C-6 feldspar[+]	
Clinchfield #202 feldspar[+]	Lu-Spar #4 feldspar[+]	
Keystone feldspar[+]	Minpro #4 feldspar[+]	
Yankee feldspar[+]	Eureka feldspar[+]	
Maine feldspar[+]	Bainbridge feldspar[+]	
Madoc H feldspar[+]	#56 Glaze Spar feldspar[+]	
Kona A-3 feldspar[+]	Oxford feldspar[+]	
Elbrook feldspar[+]		

[+] No longer in production
[++] NC-4 name changed to Minspar 200
[+++] Nepheline syenite is not a true feldspar and is classified as a feldspathoid mineral. It supplies potassium, sodium, and alumina but has less silica than feldspars. For substitution purposes it can be considered a sodium-based feldspar, but due to its lower silica content it can cause increased fluxing in some glaze formulas.

Oxide Analysis of G-200, G-200 HP, G-200 EU, and Custer Feldspar

The chemical analysis provides a "snapshot" of a raw material only at the time of testing, since analyses will fluctuate over its production history. However, the processor keeps each oxide within specific parameters to meet industry specifications. Quality control is carefully monitored, since a large shift in any oxide or particle size would make the material unsuitable for sale.

G200	G200 HP	G200 EU	Custer Feldspar
SiO_2 (%) 66.3	66.0	65.5	69.0
Al_2O_3 (%) 18.5	18.3	8.8	17.0
Fe_2O_3 (%) 0.08	0.09	0.08	1.5
K_2O (%) 10.8	14.2	10.7	10.0
Na_2O (%) 3.1	0.9	3.8	3.0
CaO (%) 0.8	0.3	0.8	0.30
LOI* (%) 0.15	0.15	0.15	0.30

*Loss on ignition

Data sources:
January 2013: Data sheet from Imerys comparing the three variations of G-200 feldspar.
Custer feldspar Digitalfire Ceramic Materials Database. The G-200, G-220 HP, and G-200 EU surface areas and particle sizes are the same.

Feldspar Substitutions

When it is necessary to replace any feldspar, the most suitable come from the same group, whether it's potassium, sodium, or lithium based. In almost all situations a one-for-one substitution from within the same group will work in any clay body formula. In glaze formulas the same rule applies; however, in a few instances the silica and alumina content of the glaze formula has to be adjusted, which can

be accomplished through glaze calculation software that is readily available. While some of these feldspars have gone out of production years ago, potters might still have stocks in their studio.

14. ANOTHER CHOICE IN FELDSPARS

Feldspars are a group of minerals found in over 60% of the earth's crust. They develop when hot magma cools and crystallizes into solid rock. The geology of the site dictates the physical and chemical properties of the feldspar. There are twelve types classified in nature, along with similar minerals called feldspathoids such as nepheline syenite.[1] Potters use three groups of feldspars: sodium, potassium, and lithium, each having its component of alumina and silica, which makes feldspars almost a glaze by themselves at cone 9 (2300°F) and above. The predominant amount of sodium, potassium, or lithium determines which group it falls into.

Feldspars are used as fluxing agents in ceramics, sanitary ware, and tableware. Feldspars supply alumina, which increases transparency and strength in glass, and are also used in paint, plaster, and fiberglass industries, constituting two-thirds of the market demand. The quality-control specifications for large industries ensure stable, consistent feldspars for potters in terms of particle size, mineralogical composition, chemical analysis, loss on ignition, and bulk density. Is every bag of feldspar exactly the same in every constituent? No, but statistically every bag will function the same in a glaze or clay body formula since the quality-control parameters are dictated by large industrial users.

Potters represent less than one-tenth of 1% of the feldspar market, and economics do not favor a new feldspar being introduced solely or in part only by potters' demand for such a product. A similar situation exists when your favorite feldspar is removed from production, since potters do not control or influence that event either. New feldspars, while formed eons ago, are brought to the marketplace only by the demand of industry, which supports discovering, mining, processing, and eventual availability to potters.

A Possible New Feldspar

I-Minerals, Bovill Kaolin Project, located in western Latah County, Idaho, is now in the development phase of a possible new feldspar: Fortispar, a potassium-based feldspar suitable for use in clay bodies and glaze formulas. The addition of Fortispar to the market will greatly increase a potter's choices when a substitution is required or used as an original addition to a glaze or clay body formula. Capital investment for expanding production is currently being sought to bring this feldspar to market. Fortispar can be produced in 635, 325, 200, and 30 mesh sizes. Generally, 325 mesh is used

in glazes and 200 mesh, a slightly larger particle size, is used in clay body formulas. Fortispar will be shipped in 50 lb. bags and 2000 lb. super sacks. To date, the testing of Fortispar has shown it to be a substitute for the commonly used potassium feldspars Custer and G-200 EU. However, when substituting any material, always test before committing to large-scale use.

The mine site for this feldspar was defined by test holes drilled to determine the extent of the deposit area. When mining begins, any overburden, which can consist of soil/sediment, rocks, and plants, is removed. The unprocessed ore at this stage, even if ground to the correct mesh size, would not be usable in clay and glaze formulas. Several steps have to be taken to refine the feldspar. If the ore is weathered, it can be soft enough to mine without blasting and is defined as a primary clay deposit. By using bulldozers and excavators, it is extracted and transported to the processing plant for stockpiling and refining.

The Flotation Process

Flotation is the current and most widely used system for refining feldspars. It has the capability to treat large quantities of mineral accurately and economically. The flotation process removes primary micas containing aluminum and potassium. Also removed are waste and tailing fractions containing quartz. Flotation involves two different processes. One procedure, beneficiation, is the extraction of gangue—or worthless tramp material—from the sand. The second process separates the sand into individual feldspar and quartz products.

The sand is fed into a closed-loop rod mill that consists of rods tumbling freely within a chamber to reduce the size of the ore,

establishing a grind of 100% passing 30 mesh. The oversized material is returned for additional milling. Material finer than 30 mesh goes to an attrition scrubbing circuit, where it is scrubbed to separate out fine material. The smaller particle sizes then move to a hydrosizer circuit, which is a compartment filled with water that lifts the finer particles upward, with the heavier particles settling to the bottom of the unit. The scrubbed material is then hydrocycloned to deslime it, which separates the particles in a liquid suspension and removes fines at a 200 mesh particle size. The result is a 30 by 200 mesh fraction that is ready for the flotation circuit.

The material is conditioned with reagents, causing chemical reactions in the ore, and then is sent to flotation cells for removal of iron contaminants, which are primarily micaceous (muscovite and biotite).[2] The froth overflow containing the iron fraction is discarded, and the remaining material is sent to another conditioning step prior to flotation. In the feldspar circuit, which consists of a rougher and cleaner two-step flotation process, the feldspar is concentrated in the froth overflow fraction while the quartz is depressed and remains in the underflow or tails. The feldspar product is dewatered by filtration and drying, and the dry product is subjected to a triple-pass rare earth magnet (REM) for further removal of iron contaminants.

The potassium-based product, designated Fortispar™, is then ready for packaging as 30 mesh or may be subjected to dry grinding to produce finer particle sizes. The grinding is performed in a circuit consisting of an air-swept media mill in closed loop with an air classifier and bag house to produce the desired fineness of grind. These products can then be packaged for market distribution.[3] The refined feldspar is eventually stockpiled for shipment.

Processing Fortispar

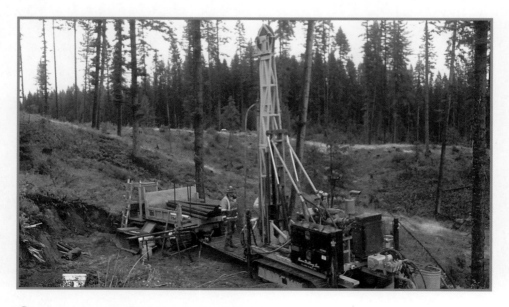

Test-drilling rig to determine the size of the feldspar deposit.

⊗ Feldspar flotation cells remove biotite and muscovite from original ore deposit.

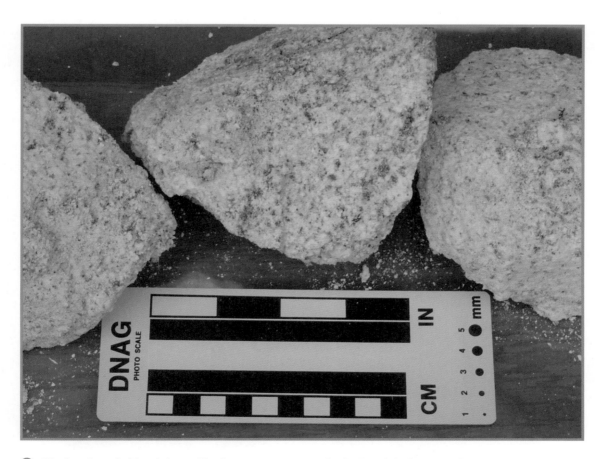

⊗ Weathered granitoid rock (crystallized magma, a coarse-grained mineral similar to granite, containing feldspar and quartz) mined from the pit.

⬆ Froth concentrates from feldspar flotation cells.

⬇ REM unit further removes iron contaminants, which prepares the feldspar for packaging unless a finer-particle product is required.

⬇ Pilot plant scale fine-grinding unit further reduces particle size of the feldspar.

Chemical Analysis

Chemical analysis of raw materials can be broken down as qualitative and quantitative analysis. Qualitative analysis is used to find elements present in an unknown sample of material; quantitative analysis calculates the actual weight of each compound in the sample. Several methods such as gas and paper chromatograph and mass spectrometer are employed for testing feldspars used in ceramics.

Comparing each feldspar analysis over a long period offers greater accuracy than just looking at an individual analysis. There are two different methods to obtain the chemical analysis of feldspar—the wet method and the X-ray fluorescence (XRF) method, the latter of which is more efficient and used by many feldspar mines today.[4] The interval of testing depends on the individual quality-control practices of the mine. As potters we are a minor part of the market, but the major users of feldspars in the paint, sanitary ware, glass, and plastic industries require a consistent raw material, and this dictates periodic testing to ensure uniformity.

When comparing the chemical analysis of each feldspar, first consider the higher value of iron (Fe_2O_3) in Custer feldspar as compared to Fortispar and G-200 EU. The higher iron content of Custer feldspar will not significantly alter the fired color of a glaze containing metallic coloring oxides. However, in white satin matte and white matte glazes it can produce a different tint to the white fired color. The percentage of feldspar or the other glaze materials in the formula can also affect the intensity of the white color. The higher iron content in Custer feldspar in porcelain and white clay bodies can produce an off-white color and in some instances black specking. In darker-colored clay body formulas there will be no significant difference in the fired color.

The other oxide percentages in feldspars can shift slightly depending on when the sample was tested. However, they did not produce noteworthy fired differences in the cone 6 and cone 10 100% samples or in the comparative cone 6 and cone 10 glaze test formulas.

Comparing Chemical Analysis (%)

	Fortispar	Custer Feldspar	G-200 E.U.
SiO_2	64.85	69.00	68.50
Al_2O_3	18.06	17.00	17.00
Fe_2O3	0.07	.150	0.095
TiO_2	—	—	0.03
CaO	0.14	0.300	0.50
MgO	0.03	—	0.80
K_2O	13.18	10.00	11.00
Na_2O	1.25	3.00	2.10
LOI*	0.28	0.30	0.50

*Loss on ignition

100% Samples of Fortispar, Custer Feldspar, and G-200 EU Fired to Cone 6

The 100% samples of Fortispar, Custer feldspar, and G-200 EU were formed into cone shapes and fired to cone 6 (2232°F). Each sample showed approximately the same degree of deformation. However, Custer feldspar has a higher Fe_2O_3 (iron) content than Fortispar and G-200 EU feldspars. This is evident in the gray color of the Custer sample (center), fired at cone 6 as compared to Fortispar and G-200 EU feldspars.

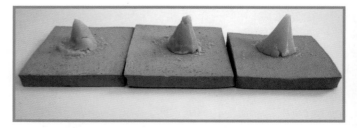

100% samples of Fortispar, Custer feldspar, and G-200 EU fired at cone 6 (2232°F).

⌄ Cone 6 close-up view of Fortispar, G-200 EU, and Custer base glazes, indicating similar craze patterns and comparable glaze tension upon cooling.

⌄ Cone 6 comparative glaze tests using Fortispar, G-200 EU, and Custer feldspar.

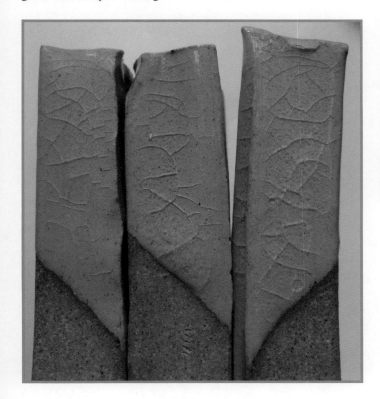

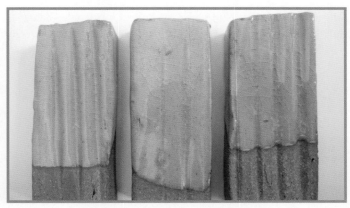

Cone 6 Gloss Glazes

Fortispar	40	G-200 EU	40	Custer	40
Flint 325x	16	Flint 325x	16	Flint 325x	16
Whiting	16	Whiting	16	Whiting	16
EPK	10	EPK	10	EPK	10
Gerstley borate	18	Gerstley borate	18	Gerstley borate	18

Substituting Each Feldspar in a Cone 6 Glaze

Above cone 6 (2232°F), feldspars are the primary fluxing agents, forming eutectics with refractory materials in clay body and glaze formulas and bringing them into a vitreous melt. In glassmaking, feldspars provide alumina, adding strength and hardness to the product, which are the same traits needed in pottery glazes. Feldspars as a group register 6 on the Mohs scale. Comparatively, this is between a steel knife and quartz in hardness.

A cone 6 gloss glaze formula was chosen on the basis of, in part, its high percentage of feldspar. Three variations of the glaze were tested, with the only difference being the feldspar, using Fortispar, G-200 EU, and Custer feldspar. Each glaze variation was mixed with water, placed through an 80 mesh sieve, and dipped onto a bisque tile. The test glazes were reduction fired to cone 6 (2232°F) in a 30 cu. ft. downdraft kiln. All of the fired tiles had the same degree of surface gloss, viscosity, and color development. Each of the feldspars produced the same results in the glazes.

While crazing (a series of lines in the fired glaze surface) is technically a glaze defect, in this instance it reveals a high degree of similarity in the three feldspars, an indication that one potassium feldspar may be substituted for another in glaze formulas. All three glaze variations had identical craze lines ⅛" to ¼" apart, demonstrating that all the glazes were under similar degrees of tension when cooling.

100% Samples of Fortispar, Custer Feldspar, and G-200 EU Fired to Cone 10

As in the cone 6 test series, 100% samples of Fortispar, Custer feldspar, and G-200 EU were formed into cone shapes and fired

to cone 10 (2345°F). Each fired sample showed approximately the same degree of deformation. However, Custer feldspar has a higher Fe_2O_3 (iron) content than Fortispar and G-200 EU feldspar. This is evident in the gray color of the Custer feldspar sample (center).

Substituting Each Feldspar in a Cone 10 Glaze

A cone 10 gloss glaze formula was chosen on the basis of, in part, its percentage of feldspar. Three variations of the glaze were tested, with the only difference being the feldspar, using Fortispar, G-200 EU, and Custer feldspar. Since all of the feldspars are potassium based, substituting from within this group reduces the variables in comparative testing. Each glaze variation was mixed with water, sieved, and dipped onto a bisque tile. The test glazes were reduction fired to cone 10 (2345°F) in a 30 cu. ft. downdraft kiln. All the fired tiles had the same degree of surface gloss, viscosity, color development, and opacity.

Cone 10 Gloss Semiopaque Glazes

Fortispar	42	G-200 EU	42	Custer	42
Ferro frit # 3195	35	Ferro frit # 3195	35	Ferro frit # 3195	35
Flint 325x	13	Flint 325x	13	Flint 325x	13
Whiting	4	Whiting	4	Whiting	4
EPK	6	EPK	6	EPK	6

Comparative Testing Results in the Glaze Formulas Tested at Cone 6 and Cone 10

Fortispar proved to be a reliable substitute either for G-200 EU or Custer feldspar. The introduction of Fortispar in 2016 represents another option for potters requiring a potassium-based feldspar for their glaze and clay body formulas. In previous testing, Fortispar

has proven to be a substitute for Custer feldspar and G-200 feldspar in cone 10 clay body formulas.[5]

The Economics of Raw Materials

One of the first questions potters ask is, How much does that material cost? Keep in mind that the greatest cost by far is the potter's labor in making, glazing, and firing the pottery. The focus for any purchasing decision should be how the material performs. The costs associated with shipping often equal or exceed the cost of the raw material but are still marginal factors in choosing a material. There is no real savings in choosing a lower-cost material if it produces a defect or is difficult to mix and apply to the ware, all of which are very expensive in recovering time and labor lost. Aside from a very few materials such as cobalt oxide (current US price $55.90/lb.) and tin oxide (current US price $22.50/lb.), the cost of raw materials should not be a factor in their use. Specifically, while all of the feldspars used in testing are competitively priced, potters now have several options depending on availability.

15. A SUBSTITUTE FOR GERSTLEY BORATE

At some point, potters working with raw materials used in glazes will encounter Gerstley borate. A little knowledge about this variable mineral will prevent many potential glaze defects. Deceptively, Gerstley borate functions correctly many times; if it failed completely it would not find its way into glaze formulas. However, it lulls potters into its use due to its variation in mineral content and solubility. At some point this material will cause a glaze failure.

For the past fifty years, Gerstley borate has been used by many potters in all temperature-range glazes. A survey of books and magazine articles will reveal numerous formulas requiring Gerstley borate in low-fire c/06 (1828°F) and midrange c/6 (2232°F) glazes.[1] Its raw color is white to light gray with dark specks. It is essentially a flux, bringing other materials into an active melt. Unfortunately, this calcium borate has a long and troublesome history from both economic and technical perspectives. Few ceramic raw materials have generated such controversy, misuse, and myth. It is not an understatement to say that over the years, Gerstley borate has given potters many problems in its use and availability. The difficulties can be traced to several major faults that do not show any indication of being resolved in currently depleting stocks.

● Cone 10 comparative glaze tests using Fortispar, G-200 EU, and Custer feldspar.

The History of Gerstley Borate

James Mack Gerstley, a mining executive, founded the mine in 1923; the local people then called the mine Gerstley's borate. Gerstley's company, Pacific Coast Borax, merged with U.S. Potash Company, which became U.S. Borax and Chemical Company. Eventually, the television show *Death Valley Days*, hosted by Ronald Reagan, was sponsored by U.S. Borax. Mr. Gerstley dedicated his remaining days to raising funds for the art community and was instrumental in organizing an endowment for the Asian Art Museum. He was nominated to the National Mining Hall of Fame in 2003 and died in 2007 at the age of ninety-nine. Since his discovery of the ore and his subsequent efforts on behalf of the arts, it's interesting to note that Gerstley borate continues to be used by potters.

The Gerstley borate mine is located near the town of Shoshone, California, population 52, near the Nevada state line, approximately 50 miles east of Death Valley. The mine is closed due to the increased cost of upgrading the safety equipment and the growing environmental restrictions. The relatively small production of less than 1000 tons of ore per year, when compared to more than a million tons per year of other borate minerals sold by the company, did not justify an increase in operating costs. The limited ceramic market was too small for the mine to yield a profit. At one point Gerstley borate was used as a fire suppressant, dropped from planes on forest fires, but even this secondary market did not justify continued operation of the mine.

In the beginning, Gerstley borate was sold to Hammill & Gillespie, Industrial Mineral Company, and Westwood Ceramics Company as unprocessed ore. However, in the 1990s Laguna Clay Company purchased Westwood and became the sole processor of Gerstley borate. At present there is an estimated five- to seven-year supply or less of the 3 mesh ore, which can be ground into a 200 mesh powder that potters can use in their glaze formulas. The stockpile is estimated at 80 to 100 tons. In early 2000, U.S. Borax announced the closing of the Gerstley borate mine. The news was published in *Ceramics Monthly*, which led to a substantial increase in sales by potters hoping to buy enough until a suitable substitute was found. Many older potters stated they have bought enough to last a lifetime. The mine will not be reopened, and once the existing stock is depleted the only material available will be on ceramics suppliers' shelves or in potters' storage containers.

Problems with Gerstley Borate

The naturally occurring ore suffers from the sin of complexity, meaning that there are many forces acting before, during, and after it produces a fired glaze. Gerstley borate is composed of ulexite (Na_2O $2CaO$ $5B_2O_3$ $16H_2O$), with small amounts of colemanite ($2CaO$ $3B_2O_3$ $5H_2O$) and probertite (Na_2O $2CaO$ $5B_2O_3$ $10H_2O$), resulting in low levels of pore water and much higher levels of chemically bound water. When used in a glaze it can result in excessive shrinkage, causing crawling (the glaze contracts on the clay body, resulting in "beads" of glaze and exposed clay body surfaces). The effect looks much like water on a glass tabletop. Additionally, when a kiln is fired too fast in its initial stages, the glaze can pop off the clay body surface due to the sudden release of vaporized water. This can yield areas devoid of glaze and a "halo" of glaze debris on the kiln shelf.

Gerstley borate is soluble and can take on water in dry storage, resulting in the possibility of inaccurate amounts being placed into a glaze formula. It can leach into the glaze water, causing an alteration of the glaze as it dries on the pot. The water wicks into the interior of the bisque pot, and as it dries, water carrying soluble material migrates to the ridges or high areas of the form, causing blistering and dry glaze areas. Many potters report that Gerstley borate glazes in storage can produce different results from one glazing session to the next, due to the breakdown of the glaze. It is not uncommon to find crystals growing on the surface of the wet glaze in the storage bucket, due to the solubility of the minerals within.

Gerstley borate glazes can outgas when containing iron oxide and rutile, a potentially volatile combination, and can cause blisters, pinholes, and cluster bubbles whether fired in an oxidation or reduction kiln atmospheres. Often these types of defects are difficult to diagnose, since some pots in the kiln with the same glaze are perfect in color and glaze texture. Additionally, when the glaze is applied too thinly, the lustrous color cannot be obtained, often revealing the underlying clay body color. Such glazes are hard taskmasters because they can produce random results that alternately exhilarate or disappoint.

Gerstley borate also contains gangue (pronounced "gang") or "tramp" material, often found as small black/brown specks in the raw material, causing blistering and pinholing in a fired glaze. Periodically, gypsum is present, causing glaze "pop outs." Obviously, if Gerstley borate produced any or all of the defects described *every* time it was used, it would have been eliminated as a glaze material many years

ago. The insidious nature of its random failure rate and its positive glaze effects have kept it in continuous use by unwary potters. Simply stated, aside from grinding the material, ceramics supply companies are selling an unrefined ore that can produce inconsistent results.

A Substitute for Gerstley Borate

The distinctive and much-appreciated feature of Gerstley borate is its ability to produce a variegated surface in glazes. Since the postings of its limited supply, many ceramics suppliers and potters have tried to find a substitute, with varying degrees of success. Part of the problem is unique to the material, since Gerstley borate is composed of several minerals. It also has wide swings in its chemical makeup, making it difficult to find a one-for-one replacement.

As the supply of Gerstley borate dwindled, Hammill & Gillespie's technical staff went to the lab and began experimenting. Beginning with X-ray diffraction to determine the mineral constitution of Gerstley borate, and following up with other physical and chemical tests, they fully characterized the material and identified three key characteristics: extended particle-size distribution including a colloid fraction, a specific and unique distribution of oxides, and a fired property that promotes a variegated color in many glaze compositions. To generate a replacement, a new material was created: Gillespie borate, virtually identical to Gerstley borate in terms of physical, mineralogical, and chemical composition. Gillespie borate is composed principally of ulexite (sodium calcium borate), with small amounts of colemanite (calcium borate) and other minerals—just like Gerstley borate. From a prefired perspective, the most critical element in the new material is its colloid content. Containing approximately 10% claylike materials, Gillespie borate disperses well in water and makes a reasonably stable glaze slip in the neat state. Further clay addition at the point of use is required to improve the stability of the slip, and prefired properties such as strength and adherence. In the fired state, Gillespie borate does produce better results in glazes than Gerstley borate.

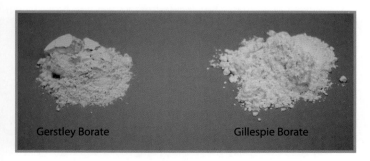

Gerstley Borate Gillespie Borate

⬆ Raw samples of Gerstley borate and Gillespie borate. Gerstley borate is a light tan / off-white in raw color. Gillespie borate is bright white in raw color.

The special behavior of Gerstley and Gillespie borates that produces the unusual glaze effects results from two mechanisms: immiscibility (the incapability of being mixed) and solubility. Boric oxide (B_2O_3), when added to a glass as a coarse raw mineral (e.g., ulexite), is slightly immiscible with silicate glass matrices, and the differential surface energy of the molten phase drives a mass transfer process along the interface (Gibbs-Marangoni effect) that generates the characteristic variegated texture. The slight solubility of these borates also contributes to the mottled glaze surface via migration of soluble oxides, although this effect becomes exaggerated when mixed glazes are stored for long periods. While Gillespie borate has the beneficial fluxing and glaze development properties of Gerstley borate, it does not have the variability or impurity levels that characterized Gerstley borate. Gillespie borate is a precise mixture of pure natural minerals and is manufactured under close quality-control supervision. Hence, Gillespie borate does not vary over time and is a consistent, reliable raw material. Since Gillespie borate does not contain the impurity levels that provided off-color Gerstley borate glazes, you may find your glazes whiter and brighter.[2]

Test Procedure

It was not possible to test every glaze formula that required Gerstley borate to demonstrate the suitability of a substitute. However, a popular cone 6 glaze, Floating Blue, is an example of the favorable characteristics produced by Gerstley borate; namely, the distinctive variegated surface colors. Floating Blue contains a relatively high percentage of Gerstley borate and, most importantly, produces a breakup of glaze colors. As a control, 26% Gerstley borate was used in Floating Blue. The same percentage of Gillespie borate was substituted, yielding Floating Blue Revised. All other materials were kept at their original percentages, and all methods of glaze application and firing were kept consistent.

The second test glaze, PV Variegated / Gloss Blue, cone 6, also used Gerstley borate, which was replaced with Gillespie borate on a one-for-one basis in PV Variegated / Gloss Blue Revised.

Two variations, a casting formula and a plastic formulation of the clay body, "Scooters Special Blend" (SSB), were used in these tests. Both clay bodies contain Greenstripe fireclay, VelvaCast, or Tile 6 Kaolin, FC 340 ball clay, or New Foundry Hill Cream ball clay, silica, Custer feldspar, and pyrophyllite.

Both glazes were mixed in 200 g test batches, 250 ml of water was added, and then they were screened through a 200 mesh sieve. The vertical test tiles were dipped into the glaze for 10 seconds, yielding a 0.12 mm application thickness. The glaze application was tested using a glaze thickness tester or penetrometer. The samples were fired in a Nabertherm Top 45 kiln (1.58 cu. ft. interior volume) with a Bartlett CF6 controller, using the following firing cycle:

100°F/hour to 220°F with a hold of 15 minutes

250°F/hour to 2080°F with a soak of 10 minutes to cone 6

Hyperglaze Screen Floating Blue and PV Variegated / Gloss Blue Glazes Used for Comparison

Floating Blue — C 6

| Color | Semi-Opaque Blue | Surface | shiny or glossy | | oxidation | | Tested |

INGREDIENTS	AMOUNTS	Batch: gm
Gerstley Borate	26.00	260.0
Nepheline Syenite	48.00	480.0
EPK	6.00	60.0
Flint	20.00	200.0
Totals:	100	1000.0

Also Add:

cobalt oxide	1.00	10.0
rutile	4.00	40.0
red iron oxide	2.00	20.0

Unity Molecular Formula

RO - Flux		R2O3		Graph UMF RO2
0.094	K_2O	0.535	Al_2O_3	3.598 SiO_2 T
0.392	Na_2O	0.429	B_2O_3	0.001
0.416	CaO	0.004	Fe_2O_3	
0.098	MgO	0.000	P_2O_5	
	Li_2O		Sb_2O_3	
	BaO		Cr_2O_3	
	PbO		V_2O_5	6.7:1
	ZnO			
	CuO	Glaze Type:		
	CoO			
	NiO			
	SrO			

Thermal Expansion — Estimated to be: 6.00×10^{-6}/deg C

Date: 12/16/10

Batch Cost $ 0.36

Hide Lines

PV Variegated Gloss Blue — C 4 - 5 - 6 - 7

| Color | Opaque Black | Surface | shiny glossy | | oxidation | | Tested |

INGREDIENTS	AMOUNTS	Batch: gm
PV Clay	15.00	150.0
Custer Spar	35.00	350.0
Flint	10.00	100.0
Whiting	10.00	100.0
Gerstley Borate	30.00	300.0
Totals:	100	1000.0

Also Add:

Mason Cobalt Free Black	7.00	70.0

Unity Molecular Formula

RO - Flux		R2O3		Graph UMF RO2
0.134	K_2O	0.236	Al_2O_3	2.400 SiO_2 T
0.131	Na_2O	0.369	B_2O_3	0.000
0.641	CaO	0.003	Fe_2O_3	
0.094	MgO		P_2O_5	
	Li_2O		Sb_2O_3	
	BaO		Cr_2O_3	
	PbO		V_2O_5	10.2:1
	ZnO			
	CuO	Glaze Type:		
	CoO	Ca		
	NiO			
	SrO			

Thermal Expansion — Estimated to be: 5.78×10^{-6}/deg C

Date: 4/16/07

Batch Cost $ 0.14+ Unknown Mason Cobalt Free Black Stain

Hide Lines

Val M. Cushing, *Cushing's Handbook, Third Edition.*

Glaze test-fired on the casting body of Floating Blue.

Glaze test PV Variegated Blue, with Gerstley borate.

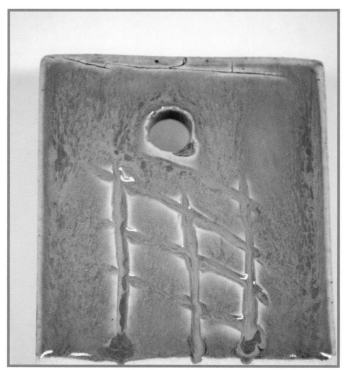

Glaze test using Gillespie borate in Floating Blue.

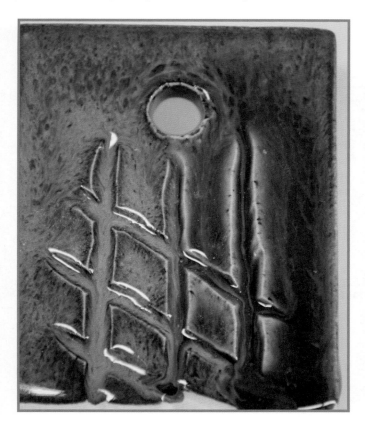

Glaze test using Gillespie borate PV in Variegated Blue.

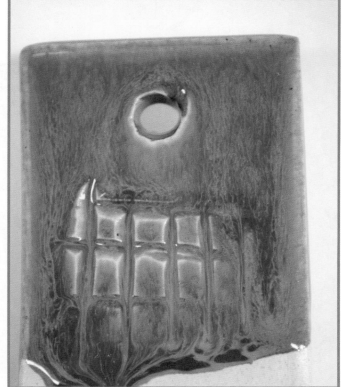

Glaze Software Insight Screens: Comparison between Gerstley Borate and Gillespie Borate

Using Insight Ceramic software, we can compare the molecular formulas for Gerstley borate and Gillespie borate. Column 1 shows Gerstley borate and column 2 indicates Gillespie borate.

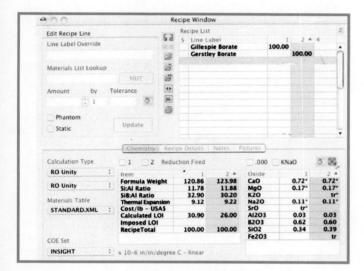

As you can see, Gerstley borate and Gillespie borate differ marginally in their respective levels of SiO_2 (0.39 vs. 0.34) and B_2O_3 (0.60 vs. 0.62), with Gerstley borate having trace amounts of K_2O and Gillespie borate having trace amounts of SrO. The ratios of silica to alumina are almost identical, as are the thermal-expansion rates. The close matching in the analysis is reflected in the actual glaze samples substituting Gillespie borate for Gerstley borate.

Recommendations for Using Gillespie Borate

Do not use excess water in mixing the glaze.

Store the wet glaze in a sealed container.

As when using any substitute material, always test it in a small batch of glaze.

Test the glaze in your regular production kiln (not small test kilns).

Test the glaze on the same clay body you will use in production.

After applying the glaze to several vertical test tiles, place them throughout the kiln.

Raw-Material Economics

Whether potters realize it or not, all of their raw materials are subject to economic factors in the marketplace, and Gerstley borate is a perfect example of this dynamic. When Gerstley borate was mined and processed, it was used as a fire retardant and as a binder in grinding wheels. Luckily, these markets enabled the material to become available to potters. Once larger buyers discontinued their need for Gerstley borate and stronger mining-safety restrictions were enacted, the cost of production rose to unacceptable levels on the basis of the selling price. In a perfect world, potters would be willing to pay a much-higher price for Gerstley borate, which in turn would offset the higher production costs and the decrease in market demand by larger industries. However, this was not the case and will not be for other raw materials that go out of production. Fortunately, Gerstley borate can be replaced on a one-for-one basis. This is a rare exception, since the development costs associated with most substitutions are prohibitive. An added factor occurs when the substitute does not match the original, which can necessitate a recalculation of the glaze formula, many testing cycles, or both to ensure an accurate result.

16. OLD AND NEW CORNWALL STONE

A material commonly used by potters, Cornwall stone was first commercially produced for the pottery industry in 1807 in the region of St. Stephen, St. Austell, Cornwall, England. It has many names: English stone, English Cornwall stone, Cornish stone, D.F. stone, China stone, and Carolina stone. In a way, the variety of names and chemical analyses are appropriate since there have been several variations in its chemical composition, depending on how it was processed or the site at which it was mined. Over the years, production has ranged from a high of 70,000 tons before the First World War to 28,000 tons on average per year from 1999 to 2003.[1]

Cornwall stone contains feldspar, quartz, kaolinite mica, and trace amounts of calcium fluoride. It is a partially decomposed

granite feldspathoid with a greater diversity of alkaloids, causing it to go into a gradual melt with less surface tension than true feldspars.[2] When Cornwall stone is used in a glaze, this characteristic can result in the elimination of crawling (the fired glaze surface rolls back on itself, resulting in exposed clay). This is due in part to the diverse composition of granite in various stages of decomposition and alteration from which it was formed.[3] Cornwall stone contains an equal molecular equivalence of calcium, potassium, and sodium, along with alumina and silica, making it a unique feldspar-like material. However, it is more refractory and goes into a melt at a higher temperature than either sodium or potassium feldspars, due to its higher silica content. Additionally, at cone 6 (2232°F) it is more refractory and melts less than other feldspars at this temperature range, due to its higher silica content. The high silica content of Cornwall stone when used in a clay body or glaze can also be a factor in reducing or eliminating crazing.

Cornwall stone is not one mineral but a complex group of minerals that at different times in its processing history have produced varied chemical analyses depending on the deposit being excavated and processed, resulting in no distinct chemical formula. In this respect it is similar to another common flux material used in glaze and clay body formulas, nepheline syenite; both are combinations of minerals. Cornwall stone has properties similar to feldspars in that it can be used as a flux above cone 6 in clay body and glaze formulas. However, it differs from true feldspars because it is partly kaolinized and responds well to flocculation and deflocculation adjustments in the glaze batch, resulting in increased wet-glaze-handling properties.[4]

Processing History

The processing history has played a major part in the chemical composition of Cornwall stone, which in turn altered the results it produced in glazes over its production run. From 1960 to 1973, fluorite and mica were removed from Cornwall stone, resulting in a designation of "D.F." stone, which was defluorinated. The processed Cornwall stone also contains quartz and feldspar. The D.F. stone had reduced fluorine, potash, calcia, iron, and alumina and increased silica. This was an improvement, since calcium fluoride in a glaze has the potential to exit as a gas, causing blisters in the fired glaze surface.

In 1973 the "D.F." refining of Cornwall stone came to an end due to increased production costs. After that, the material that was not defluorinated was distinguished by a vegetable dye that burns off in the kiln without a trace; the color is not due to fluorspar in the material. The raw color of Cornwall stone can change, perhaps indicating different batches from the mine.[6] After the "D.F." was discontinued, Purple stone was produced, which contained soda and potash feldspar, quartz, mica, and fluorite. A second type known as Hard White, with some of the soda feldspar being replaced by kaolinite, was also available. Hard White contains less fluorine compared to Purple stone. A blend of both Purple stone and Hard White was also

was sold. Since the chemical composition of Cornwall stone has changed, potters should be aware of which variation they will be using. Once known, it is best to obtain its chemical analysis sheet before using the material in a glaze formula.[7]

However, all variations of the material have low iron content. Cornwall stone is commonly used in cone 6 (2232°F) to cone 9 (2300°F) glazes as a flux, helping bring other materials into a melt. It can also be used in slips, since it has excellent adhesion properties to bind it to the underlying clay body. The raw color can be white, purple, or green; however, Cornwall stone melts to a white opaque glass between 2102°F and 2372°F. Because Cornwall stone is imported from England, it can cost more than domestically available feldspars.

As has happened with many other raw materials, the mine producing Cornwall stone has closed. Hammill & Gillespie, a supplier of specialty clays and minerals, has found a substitute named H&G Cornwall stone, which can be used as a replacement in most glaze formulas. However, it is always best to test any new material before committing to large-scale production.

Chemical Analysis of Original and New Cornwall Stone

Typical % Analysis

Original Cornwall Stone[8]		New Cornwall Stone	
SiO_2	72.90%	SiO_2	77.39%
TiO_2	0.02%	TiO_2	0.05%
Al_2O_3	14.93%	Al_2O_3	14.06%
Fe_2O_3	0.13%	Fe_2O_3	0.20%
CaO	2.06%	CaO	0.42%
MgO	0.09%	MgO	0.05%
Na_2O	4.00%	Na_2O	3.56%
K_2O	3.81%	K_2O	3.34%
		P_2O_5	0.22%
		BaO	0.05%
		PbO	0.02%
Loss on ignition	1.05%	Loss on ignition	1.06%

New Cornwall stone (left) and original Cornwall stone (right) fired to Cone 9 (2300°F).

Blue-glaze variation.

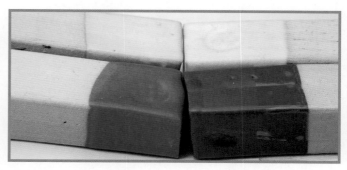

Comparison of 100% Samples of New and Original Cornwall Stone

Original and New Cornwall Stone in Glaze Formulas Cone 9 (2300°F) oxidation firing

Cone 9 (2300°F)

When matching the new Cornwall stone to the old Cornwall stone, the goal was to use glaze formulas that used high percentages of Cornwall stone in order to maximize the matching qualities of the substitute material.

A popular cone 9 glaze was chosen for comparative testing as a base glaze (no metallic coloring) and a variation with cobalt carbonate. The glazes were fired in an oxidation electric kiln.

Original Cornwall Stone Base Glaze
New Cornwall Stone Base Glaze

This popular satin matte light green glaze formula was fired to cone 9 in a reduction kiln atmosphere.

Base Glaze with original Cornwall Stone		Base Glaze with New Cornwall Stone	
Cornwall stone	46	Cornwall stone	46
Whiting	34	Whiting	34
EPK	20	EPK	20

Blue glaze variation		Blue glaze variation	
Cobalt carbonate	0.13%	Cobalt carbonate	0.13%

Glaze with original Cornwall stone		Glaze with new Cornwall stone	
Cornwall stone	46	Cornwall stone	46
Whiting	34	Whiting	34
EPK	20	EPK	20
Copper carbonate	4%	Copper carbonate	4%
Tin oxide	4%	Tin oxide	4%

Satin matte green glaze, using new Cornwall stone. *Photo credit, Jim Fineman*

🔽 Satin matte green glaze, using original Cornwall stone.

A cone 6 oxidation electric kiln fired satin matte glaze was used for comparing original and new Cornwall stone.

Glaze with original Cornwall stone		Glaze with new Cornwall stone	
Nepheline syenite 270 mesh	36	Nepheline syenite 270 mesh	36
Cornwall Stone	16	Cornwall Stone	16
Whiting	26	Whiting	26
Thomas ball clay	9	Thomas ball clay	9
EPK	8	EPK	8
Zinc oxide	5	Zinc oxide	5
Copper carbonate	3%	Copper carbonate	3%

A cone 6 oxidation, electric kiln–fired, transparent gloss glaze was used for comparing original and new Cornwall stone.

Glaze with original Cornwall stone		Glaze with new Cornwall stone	
Cornwall stone	61	Cornwall stone	61
Whiting	8	Whiting	8
Gillespie borate	3	Gillespie borate	3
Lithium carbonate	5	Lithium carbonate	5
Dolomite	7	Dolomite	7
Flint 325 mesh	6	Flint 325 mesh	6

The new (H&G) Cornwall stone can be purchased from Hammill & Gillespie, 869A State Rt. 12, Frenchtown, New Jersey 08825, 973-822-8000.

17. CHANGES IN FIRED MATERIALS

At some point, potters often wonder what would happen if they fired a nonceramic object in a kiln. In many instances, coins, glass, wire, and other items have been placed in kilns, with varying transformations. Curiosity can often lead to a greater understanding of how materials react when subjected to heat. However, some experiments are in need of greater thought as to their potential results. In one studio, potters cooked pizza in a kiln set at low temperature. While the pizza was good enough to eat, this method of cooking food is not recommended, since trace metals from previous glaze firings can still be present inside the kiln and be incorporated into the food. Placing a wide array of objects in the kiln is generally not recommended without a careful consideration of how they would affect personal safety and eventual kiln life.

An informative example takes place when baking bread. At the relatively low temperatures in kitchen ovens, we see the effects of heat transforming food every day. Baking bread offers a useful analogy for describing the numerous complex changes that common mixtures go through in the heating process. When bread dough is heated in a 400°F oven, high enzymatic activity takes place on the surface of the loaf, breaking down starches into sugar compounds and causing caramelization, at which point the dough expands. In the presence of steam, moisture gelatinizes starches on the surface of the loaf, and as they swell, the bread's surface becomes glossy. Steam promotes enzymatic activity, giving the bread a rich color and nutty flavor. It also keeps the surface of the bread moister longer, enabling greater oven spring (superior volume). While not a ceramic object, it does make you

aware of the diverse range of transformations that take place in ordinary heating situations.

Increasing temperatures can cause dramatic changes in many common objects other than bread and ceramics, since all have the ability to be transformed into solids, liquids, or gases depending on the substance and fired temperature. Just as a detective gathers clues to a crime, an examination of objects fired in a kiln can yield useful information and a greater understanding of ceramic materials.

Satin matte glaze, using original Cornwall stone (left); satin matte glaze, using new Cornwall stone (right).

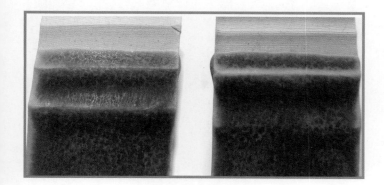

Testing Procedure

As in any experiment, controls on reducing or eliminating variable factors will yield greater accuracy in the results. Five different commonly available materials were chosen along with a cone 10 (2345°F) stoneware glaze for the test series. Elmer's nontoxic School Glue was used to attach the materials to the clay trays. All materials were photographed before and after heat treatment, and differences were noted and recorded.

The trays were made of Standard Ceramics stoneware clay #153 and bisque-fired to cone 06 (1828°F). The gas-fired kiln was heated to cone 10 (2345°F) with the test pieces. Total fired shrinkage of the trays was approximately 12% due to increased vitrification (glass formation) upon heating. During the firing, a reduction atmosphere was created in the kiln. The resulting carbon monoxide draws oxygen away from metallic coloring oxides in the clay body and glaze. This effect is also present in other test objects containing metallic oxides.

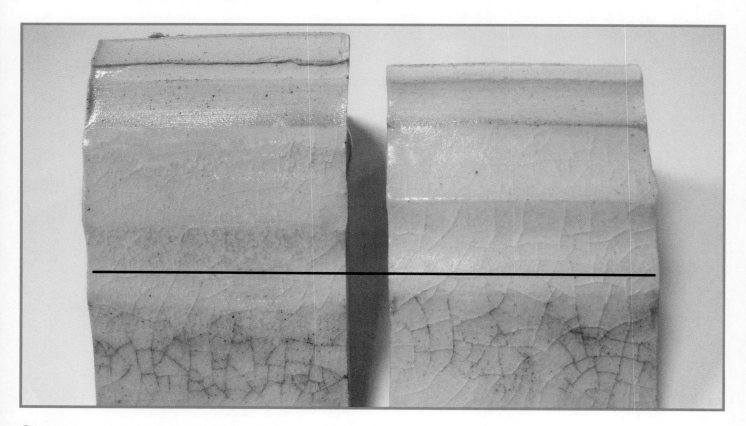

Transparent gloss glaze, using original Cornwall stone (left); transparent gloss glaze using new Cornwall stone (right). Note the lower half of the test tiles, where the artificially highlighted black craze lines are comparable in quantity and spacing on both glaze tests, indicating a similar glaze fit under tension.

Test 1: Wood Ash

The chemical composition of wood or plant ash can vary depending on factors such as hardwood or softwood, soil composition, time of year the tree or plant was turned into ash, and the location of the plant harvested. The predominant oxides found in wood and many plants in varying ratios are alumina, silica, sodium, potassium, calcium, phosphorus, and trace oxides. Vegetable ashes can contain carbon, sulfur, fluorine, and chlorine, while bone ash contains carbon, sulfur, and fluorine. Due to its alkaline nature, ash if fired to or above cone 10 (2345°F) turns into a glaze, with higher temperatures promoting greater glaze melting. Typically, in wood-fired kilns, ash lands on horizontal surfaces or the corners of pots. The ash deposit yields a brown/light-green rivulet or stringing glaze on vertical areas, while pooling on horizontal surfaces. The fired color and glaze surface texture depend in part on the type of ash used.

Test #1. Wood ash after firing. At high temperatures, volatile soluble alkalis in the ash migrate to the clay body, fluxing its iron and leaving a dark-brown halo around the ash. During firing, the movement of the kiln atmosphere carried the alkali deposit (upper-left corner of the image), causing an irregular wider area of iron fluxing. Additionally, in the top-center section of the ash image, the concentration of soluble alkali is higher, causing a brown shiny glaze. In this instance the fluxing alkali deposit has combined with the silica, alumina, and iron in the clay body to form a brown glaze. The fired center section of the ash has melted into a green/brown glaze, with micro crystal growth upon cooling contributing to areas of opacity.

Test #1. Wood ash before firing. Shows the dried ash, which has been sieved and placed on the bisque tray.

Test 2: Glass Marbles

Marbles are manufactured from glass with varying coloring oxides. The glass contains silica, alumina, and flux materials, which cause the refractory silica and alumina to melt. However, marbles contain less alumina and silica than glazes, which results in a low-viscosity (highly fluid) glass when fired to cone 10.

Test #2. Glass marbles before firing. The three marbles on the left are light blue and contain cobalt. The three on the right are dark blue, containing greater amounts of cobalt. Potters use cobalt oxide or cobalt carbonate in many glazes for the blue colors they impart. Cobalt is one of the strongest coloring oxides; one part of cobalt can tint 100,000 parts of white glaze. Marbles are manufactured from sand, soda ash, lime, zinc, alumina hydrate, and coloring oxides. The materials are blended and fired to 2300°F.

Test #2. Glass marbles after firing. The marbles have melted into a pool of light-blue and dark-blue glass due to their lower amounts of alumina and silica. Conversely, adding clay—which contains alumina and silica—to the marbles could turn the fired marbles into a glaze that would not run on vertical surfaces. The higher percentage of cobalt in the dark-blue marbles acts as a flux. The dark-blue marbles have a lower viscosity when molten and flow down into the lower-right side of the tile, displacing some of the light-blue marbles. The light-blue marbles have a lesser amount of cobalt and less flux, producing a higher-viscosity, stiffer glass when molten.

The halo of dark-brown clay around the pool of glass is caused by sodium vapor (soda ash [sodium carbonate] contained in the marble), fluxing the iron in the clay body. Upon close examination, the light-blue glass reveals crazing, a network of fine lines in the fired glass that are greater in number and more closely spaced than in the dark-blue glass. The light-blue marbles containing less cobalt produced a glass under tensile stress, contracting more than the underlying clay body upon cooling, causing the craze lines. The closer-spaced craze lines in the lighter-blue glass indicate it is under greater tension than the dark-blue glass.

Test 3: Seashells

The five shells were from a Florida beach. They are formed from the secretions of the mollusks that live within the shells; color depends on the diet of the mollusk. In warmer waters there is a greater variety of foods contributing to the many colors of the shell. The shells are composed of calcium carbonate.

Test #3. Seashells before firing. Several different-colored shells were placed in the recessed area of the ceramic tray.

Test #3. Seashells after firing. By 1571°F, the calcium carbonate shells have decomposed to calcium oxide and carbon dioxide gas, which was driven off in the cone 10 firing. The shells are white, since their original coloring was due to organic materials in the mollusks' diet. The brown halo around the shells is sea salt (sodium chloride) volatilizing off the shells during the firing. The sodium vapor has reacted with iron in the clay body, causing it to flux a darker brown than the surrounding clay tray. If the fired shells were ground into a fine powder, they could be used in any glaze formula requiring whiting.

Test 4: Chicken Foot

The chicken foot was boiled for 1 hour then roasted for 3 hours at 275°F.

🔺 Test #4. Chicken foot after firing. The dark halo around the chicken foot is from calcium phosphate, which acts as a flux, causing iron oxide, silica, and alumina in the clay body to melt, revealing a dark-brown color. A general analysis of bone ash would reveal calcium oxide, phosphorus oxide, fluorine, silica, and alkaline oxides. In glazes, bone ash is used as an opacifier. Bone ash has also been used in bone china clay body formulas, which also contain feldspar.

🔺 Test #4. Chicken foot before firing. The chicken foot was placed on a ceramic tray.

Test 5: Leaves

Two different magnolia species (*Magnolia grandifolia*, large, dark-brown leaf above; *Magnolia virginiana*, smaller blue leaf below).

Test #5. Magnolia leaves before firing. The leaves were placed on the tray.

Test #5. Magnolia leaves after firing. Any moisture in the leaf was driven off at 212°F. The remaining part contains alkaline material, which forms a brown glaze surface, reacting with the clay body at higher temperatures. Different types of leaves can contain trace minerals, which can alter the fired alkaline glaze surface. However, the irregular, mottled brown/green glaze residue is typical of any wood or leaf fired in this temperature range.

Test 6: Glaze

Glazes are composed of alumina and silica, both of which are refractory and cannot melt at the temperatures achieved in a potter's kiln. However, once one or more flux materials are added, the combination forms a eutectic, lowering the melting point of the glaze and making it usable at kiln temperatures used by potters.

Water was added to the dry glaze materials. The wet glaze was placed through an 80 mesh sieve three times to ensure complete mixing. The glaze was then applied to a bisque tray and fired in a reduction atmosphere kiln to cone 10.

The glaze formula:

Satin Matte Blue/Gray Glaze

Glaze Materials		Oxides contained in Glaze Materials
EPK	10	Alumina, Silica
Flint 200x	25	Silica
Whiting	15	Calcium
Custer feldspar	40	Sodium, Potassium, Alumina, Silica
Talc	10	Silica, Magnesium
Cobalt oxide	5	Cobalt
Rutile powder	15	Titanium, Iron
Bentonite	2	Alumina, Silica

During the Firing

From 212°F to 392°F, the water used in mixing the glaze is driven off. From 575°F to 1292°F, organic matter in the glaze materials and clay are oxidized and removed. Chemically combined water in the glaze materials is removed between 450°F and 1112°F. For example, EPK clay theoretically contains one part alumina, two parts silica, and two parts chemical water, the last of which is driven off in this temperature range. Before actual glass formation begins, dry materials begin to stick together in a process called sintering. As the kiln temperature reaches 2192°F, Custer feldspar, the primary flux, brings other glaze materials into a melt.

Until cone 06 (1828°F), more air than fuel from the burners was introduced to create an oxidation atmosphere, which removed any organic materials from the clay body and glaze. After cone 06 the burners produced a slightly reducing atmosphere until the end of the firing. This was achieved by adding more fuel than air during combustion. The resulting carbon monoxide atmosphere removed oxygen from the metallic coloring oxides in the clay body and glaze. Reduction kiln atmospheres can flux iron in the clay body and change the colors of other metallic coloring oxides such as rutile.

Evaluation of the Glaze after the Firing

The blue/gray glaze can be classified by several methods: predominant flux, fired color, light transmission, and texture.

Oxides underlined are found in the raw materials used in the glaze formula.

Predominant flux: Custer feldspar is the primary flux, helping to bring oxides contained in other raw materials into a melt. Custer feldspar at cone 10 can be considered a glaze by itself, since it contains potassium, sodium, alumina, and silica, all of which are found in glaze formulas.

Fired color: The light-blue/gray color is caused by the cobalt oxide in the glaze. Rutile contains iron, which can also cause a blue glaze color. Muting of the color occurs from micro crystal growth, primarily from magnesium found in talc. Additionally, titanium found in rutile and calcium in whiting contribute to the micro crystal growth as the glaze cools, bleaching the glaze color.

Light transmission: Titanium in rutile and magnesium in talc contribute to micro crystal growth and glaze opacity. Calcium in whiting also promotes close crystal growth and opacity during glaze cooling.

Texture: Magnesium in talc produces a mottled effect and a "buttery fat" texture to the glaze surface. Magnesium also increases the glaze's surface tension, producing a rounded edge on the fired glaze form (note brown glaze on the tray's smooth rounded edges).

As we can observe from the various objects fired to cone 10, nonceramic materials can often reveal many useful clues when

Test #6. Glaze after firing.

evaluating a fired glaze. Frequently, potters are very good at doing the actual testing; however, they sometimes have difficulty evaluating what they are looking at. It is not uncommon to have hundreds of fired glaze tests and not draw any useful ideas on what to do next to achieve a first-rate glaze. Unfortunately, a ceramics education cannot be obtained in one place. Potters need to read the literature, experiment with materials, and expand their range of knowledge on how ceramic materials react under increasing temperatures. There are many opportunities to take classes, attend workshops, or exchange information with fellow potters.

18. CHOOSING THE RIGHT GLAZE AND ADJUSTING GLAZES

At some point, many potters want to experiment with glazes. Whether they start by using commercial premixed glazes or they grow tired of their own glaze formulas, the need for diversity is present. Venturing outside the tried and true reliable glazes of the past into a new glaze palette can produce an exciting and frustrating series of glaze tests. Often the first step for a new glaze is looking at published formulas or formulas from other potters. The concept of a new glaze and the reality of the glaze working successfully on your pot can result in several disappointing missteps that can be avoided with a few facts. How many times have we copied a glaze formula from books or magazine articles only to find it did not work as advertised? Many potters also obtain glaze formulas when attending workshops or from other potters, all or some of which might not work as expected. In

magazines, the pictures of glazes always look so enticing. Occasionally, we actually see other potters' glazes with the same formula we copied down in our notebook, but the results are frequently different on our own pots. In some discouraging instances, the fired glazes look close but are never exact duplicates of the original. Our glazes can run, become opaque, or have surface blemishes that are not present with the original glaze formula. The process of working with clay and glazes is inherently problematic without the added frustration of starting with a known glaze formula and achieving a different outcome. What are the factors that influence glazes, especially when we carefully copied down the exact formula only to find it did not duplicate itself in our own kiln firing?

There is a widespread use of generic names for raw materials, which are often not accurate representations of specific materials. For example, raw materials such as dolomite, talc, whiting, bentonite, or zinc oxide can have different chemical compositions based on their original source of processing. Each ceramics supplier can use different sources for the raw materials that they sell to potters. Further adding to the potential confusion is that each processor or wholesaler can have several different grades of that material. The result is a common name for a raw material that can be different in particle size, chemical composition, or trace elements depending on where it is processed and eventually sold. A talc or whiting on the East Coast might not have the same chemical composition or particle-size distribution as talcs sold on the West Coast. Raw-material economics dictate that some common glaze materials are purchased from sources as close as possible to the ceramics supplier. Often the raw-material costs will equal shipping cost. West or East Coast ceramics suppliers would think twice before ordering a specific raw material from the opposite coast if a closer, less expensive source is available. While raw-material variability can be minimal and not cause a different glaze result, occasionally discrepancies can produce significant changes in the fired glaze.

Several other factors, which are not usually noted in glaze formulas, are the application techniques and thickness, all of which can greatly influence the final result. A percentage of glazes are especially sensitive to the precise way in which they are applied. The same glaze can look very different when brushed, dipped, or sprayed. Glaze application technique can deposit varying layers of glaze on edges and recessed areas of the ware, resulting in an uneven glaze coat. A stiff glaze that does not move or flow when it is melting can reveal brushstrokes on the finished ware due to the bristles moving the glaze aside during the application process. Thick applications can cause the glaze to flow when mature, or to pool and collect in recessed areas of the form. Often, glaze formulas do not include a notation on the specific techniques used to apply the glaze or its correct thickness, both of which can change how it appears in its fired state.

One of the largest areas of misunderstanding occurs when potters do not fully appreciate the effects of heat work on clay and glazes. Heat work is defined as the length of time a glaze and clay body are exposed to the temperature within the kiln. Every kiln heats and cools differently; sometimes the difference is enough to change a glaze radically. When a glaze formula states that it should be fired to c/9 (2300°F), does the potter know what size of kiln the glaze was fired in or how long it took to reach the

maturing temperature? It is important to know what questions to ask yourself when reviewing a glaze formula. Such questions come from an understanding of ceramic materials and experience from many sources. A number of potters have been educated in their craft by a rote learning technique, which simply meant copying exactly what their instructor told them to do. A narrow, limited education in ceramics can produce many areas for failure. Working with clay and glazes requires a broad and deep theoretical and practical base of knowledge. Potters at some point in their career should educate themselves on how ceramic materials react to kiln atmosphere and temperature conditions, which affect all clay bodies and glazes. Leaning about ceramic raw materials used in glazes does not have to be an infinite process, since twelve to fourteen raw materials are commonly used in approximately 80% of c/9 glaze formulas. For example, it might be useful to know how nepheline syenite melts at c/9 as compared to flint. A comparison of a fired sample of each material might reveal nepheline syenite yielding a semiopaque, crazed glaze, while flint would be a dry white powder at the same temperature. Fusion buttons of individual raw materials of dolomite, Custer feldspar, talc, nepheline syenite, whiting, wollastonite, spodumene, EPK, zinc oxide, and barium carbonate will reveal the melting characteristics of each material. For advanced study, blends of each material will yield further information that can be used in the future to interpret glaze formulas.

One way to look at any glaze formula is to view it as an iceberg, with the majority of its potential information hidden from view. More often than not, it is the unstated information that causes problems for the potter trying to duplicate a glaze. It is a curious fact that many glazes published in magazines and books at first look complete and detailed; however, upon closer examination there are many pieces of information on how to make a glaze work that are not included in the typical glaze formula. The lack of sufficient glaze details is often not noticed by readers, due to the assumption that the printed glaze formula is complete. Often the missing details can be critical in determining the success of the glaze formula. Missing information can include the individual characteristics of raw materials and the conditions under which they are heated in the kiln. Listed are several factors to consider before mixing and firing a glaze copied from any source, whether it is found in books or magazine articles or obtained from other potters. Asking some questions before beginning the process of glaze duplication and testing will save time, reduce defects, and produce results that have a greater degree of accuracy. Let's look at a glaze formula to determine the factors that can alter any glaze at any firing temperature or kiln atmosphere. ZAM Gloss Blue is a typical cone 9 (2300°F) glaze that you might see published in a ceramics magazine. It can be evaluated in several ways to ensure an accurate rendition.

Glaze Preparation

Once the dry glaze materials are gathered and weighed, water is added. At this point, most glaze recipes do not state whether the glaze should be sieved, or, if they do, what mesh sieve should be used. Most glazes will successfully work when placed through an 80x mesh sieve. The small size of the screen causes a mechanical mixing action of the glaze materials suspended in the glaze water. The sieve breaks down any nodules or conglomerate particles into a homogenized mixture of material and water. Using a finer- or smaller-mesh sieve can add extra time to the mixing process without a further increase in quality. A coarser sieve can allow large particles of material such as EPK or flint to remain intact, eventually depositing themselves on the raw glaze surface as small specks. Soluble materials such as Gerstley borate, colemanite, soda ash, borax, or pearl ash (potassium carbonate) can clump together in storage and have to be broken into smaller particles by the screening process. Such concentrated materials do not go into a complete melt during the firing process, causing surface irregularities. Metallic coloring oxides and their reaction with glazes can also be influenced by the size of the screen. For example, cobalt oxide when used in a satin matte or matte glaze can sometimes reveal itself as a blue glaze with blue specks in the fired glaze surface. Cobalt oxide has a larger particle size than cobalt carbonate, which will pass undisturbed through a coarser-mesh sieve.

Particle Size

The particle sizes of ceramic raw materials are critical factors in their ability to melt. A smaller particle size denotes increased surface area, which melts more efficiently than a larger particle size. A finer mesh material might cause a lower melting point, which can result in the fired glaze dripping or a semiopaque glaze appearing transparent. All glaze materials look like powder, so knowing the actual mesh size is an important step in being able to duplicate any glaze formula. For example, flint, a glass-forming oxide and a major component in any glaze, can be purchased in 60x mesh, 100x mesh, 200x mesh, 325x mesh, and 400x mesh, along with finer mesh sizes available by special order (the larger mesh numbers indicate smaller-sized particles). Flint is also produced in the form of fused silica (amorphous silica), having a very low shrinkage rate, which can affect glaze fit. Frequently, a glaze formula will not specify a mesh size for flint. In such instances, use 325x mesh flint.

Nepheline syenite, a feldspathic material high in sodium, found in c/6 (2232°F) and c/9 (2300°F) glazes, is a flux. It is commonly available in 270x mesh and 400x mesh sizes. However, Unimin Corporation produces nepheline syenite in 700x, 400x, 270x, 200x, 100x, 111x, 40x, 31x, and 30x mesh sizes. It is important to note the mesh size of any ceramic material used in clay body and glaze formulas. If the glaze formula does not specify a mesh size for nepheline syenite, use 270x mesh. When reordering any glaze material, always specify the mesh size where applicable. For an accurate duplication of any glaze, know the mesh size of every glaze material. The ceramics supplier should be able to furnish this information upon request.

Whiting (calcium carbonate) is produced by many processors in various mesh sizes, all of which look and feel like white powder. Each can contain different percentages of trace materials, some of which are magnesium carbonate, silica, clays, alumina, and iron. In most instances the total amount of trace material is not enough to change a glaze, but the particle size is relevant. Coarser-mesh whiting when used in the glaze formula can cause the liquid glaze to sink to the bottom of the glaze bucket. Larger-particle-size whiting can also cause a clear, transparent glaze to become semiopaque when fired due to incomplete melting of the material in the glaze matrix. *Do you know the mesh sizes of all the materials used in the glaze formula?*

Kiln Size

The size of the kiln can play an important part in the development of surface texture (gloss, satin matte, dry matte), light transmission (clear, semiopaque, opaque), color (red, green, blue, brown, etc.), and glaze hardness (soft surface: easily scratched, or hard surface: abrasion resistant). Ceramic materials melt under several conditions aside from the absolute or end-point temperature they reach in the kiln. The time it takes to temperature and the rate of cooling are factors that inhibit or promote more melting in clay bodies and glazes. Kiln size also influences the vitreous quality of the clay body. Larger kilns have greater thermal mass, which is composed of kiln bricks, posts, shelves, and stacked pots, all factors that radiate heat. Larger kilns radiate more heat during their heating-and-cooling

cycles than smaller kilns. The larger kiln promotes more heat work and greater melting in clay bodies and glazes. Larger kilns can cause a different glaze reaction compared to smaller kilns with less thermal mass, which dissipate heat at a faster rate. Because they have less thermal mass, small test kilns are an inaccurate indicator of clay body and glaze reactions when compared to larger kilns. ZAM Gloss Blue will work best in kilns from 15 to 120 cu. ft. *Do you know the size of the kiln that produced the glaze?*

Kiln-Firing Cycle

A fast kiln-firing cycle will produce an immature clay body that can be highly absorbent and less durable and contribute to glaze problems such as crazing, a fine network of lines in the fired glaze. A fast kiln-firing cycle can alter the fired color, texture, glaze durability, and light transmission of the glaze, while an excessively long firing cycle can cause the glaze to become markedly glossy or run off vertical surfaces. Some glazes work best when held at their maturing temperature for a given period of time. Other glazes when held at temperature can blister or run down vertical surfaces, due to increased heat work at the high end of glaze vitrification. The kiln-cooling cycle can also play an important part in the development of a glaze. Devitrification or crystal growth can cause small or large crystals to develop in the cooling glaze. The growth of crystals is dependent in part on the glaze formula, clay body, and rate of cooling. While there are no perfect kiln-firing cycles

Typical Glaze Formula

(Some questions to ask before mixing a glaze formula)

ZAM Gloss Blue c/9		(what kiln-firing atmosphere?)
Nepheline syenite	55	(what mesh size?)
Flint	27	(what mesh size?)
Whiting	8	(what chemical composition and particle size?)
Gerstley borate	10	(variable in chemical composition and soluble)
Cobalt	6%	(cobalt oxide or cobalt carbonate?)

● ZAM Gloss Blue c/9 glaze

The type of kiln atmosphere can affect any glaze color, texture, or melting capacity. The cobalt oxide colorant in ZAM Gloss Blue will fire blue in almost any kiln atmosphere, but there can be variations in the intensity of the color due to the atmosphere in the kiln and the fuel used to maintain that atmosphere. In soda and salt firings, ZAM Gloss Blue can run or drip on vertical surfaces or pool in horizontal areas, due to the fluxing action of sodium vapor in the kiln atmosphere. In wood-fired kilns the alkaline content of the wood ash during the firing can flux the glaze excessively, causing glaze dripping and glossy areas. In many instances, the glaze reactions to salt and wood firing are aesthetically pleasing, but both atmospheres can flux or melt the pyrometric cones prematurely if they are not protected. *Do you know what kind of atmosphere was used in the glaze firing?*

that will work for every glaze, a 75°F–80°F heat increase per hour from c/06 (1828°F) to c/9 (2300°F) using the self-supporting Orton cones is a recommended starting basis for high-temperature glazes. ZAM Gloss Blue will work best at this rate of heat increase.

Most commercial gas and electric kilns are constructed with the correct insulation properties, which allow for an acceptable rate of cooling. However, if the potter decides to build his or her own kiln, the type of refractory and hot-face/cold-face width of the refractory have to be determined correctly or the kiln can be under- or overinsulated. Both conditions can lead to clay body and glaze defects in the fired ware. *Do you know the kiln firing cycle of the glaze? If so, there is a greater chance of duplicating the glaze.*

Kiln Atmosphere

Electric kilns generate clean, repeatable oxidation atmospheres. However, carbon-based fuels such as natural gas, propane, wood, coal, oil, and sawdust can produce oxidation (more oxygen than fuel in the combustion process), neutral (equal amounts of oxygen and fuel in the combustion process), and various intensities of reduction (more fuel than oxygen in the combustion process) atmospheres. It is the intensity and duration of the reduction atmosphere that can be very difficult to reproduce, since one potter's medium reduction can be another's heavy reduction atmosphere. The amount and duration of reduction atmosphere in the kiln can have significant effects on a clay body and glaze. Reduction kiln atmospheres can cause greater melting due to the increased fluxing action of the metallic coloring oxides contained in the clay body and glaze. Variations in the duration and amount of reduction can also change clay body / glaze colors and glaze surface textures. Statistically, in glazes designed for reduction kiln firing, the greatest percentage of glazes not firing as expected are due to the variability of the atmosphere in the kiln.

Pyrometric Cone Reading

Potters read the melting position of the pyrometric cones at different positions. Some potters consider that the cone reaches its correct temperature when it bends at the 3 o'clock or 9 o'clock position, or bending over halfway in relation to the bottom of the cone pack. Other potters read the cone as being down when it actually touches the cone pack. Certain glazes are very sensitive to slight temperature variations indicated by the exact position of the pyrometric cone. In these glazes the exact position of the cone can alter color, opacity, or glaze texture. Keep in mind that kilns can "coast," or continue to supply more heat work to the clay body and glaze after the kiln has been shut down. This condition can be observed when the potter turns off the kiln and notices the position of the cone. When the kiln is cool, the position of the cone has fallen, indicating heat work was affecting the cone after the heat source was turned off. It is unlikely that a potter will know the exact

● Pyrometric cone pack (cone 5, 6, 7, 8) with cone 6 (second from left) at the 9 o'clock position.

position of the cone from a glaze formula in a magazine article or book. The ZAM Gloss Blue glaze has a maturing range and will work successfully at c/9, c/10, and c/11. *Do you know the exact position of the cone in the glaze firing?*

Glaze Fuming

Under various conditions of temperature, kiln atmosphere, proximity of glazes, and the combination of glaze materials, a glaze can fume off, affecting the color of another glaze. Fuming occurs when part of the glaze formula vaporizes during the firing. A fuming reaction is most noticeable when a glaze containing chrome oxide is placed next to a glaze containing tin oxide. A pink blush on the glaze containing tin is the result. In fact, pink ceramic stains contain combinations of chrome and tin. In some instances, metallic coloring oxides such as cobalt can fume off the surface of the glaze, leaving blue specks on adjoining glazes. ZAM Gloss Blue has proven in the past not to fume off onto other pots in the kiln; however, it should be tested before use in production. *It is always best to test-fire different glazes in close proximity before committing a new glaze to an entire kiln load of pots.*

Raw-Material Substitutions

There are several levels of difficulty when considering a raw-material substitution in a glaze. Any substitution has the potential to cause a different outcome than expected. Many glaze formulas were first developed using feldspars, clays, or other raw materials that are no longer in production. Potters can make the mistake of using a raw material in their studio while thinking it is still being sold. For example, Oxford feldspar, an alkali aluminosilicate feldspar that is potassium (potash) based, is no longer being mined. If you have a container of Oxford feldspar in your studio and use it in the glaze, there might not be a readily available resupply of this particular feldspar.

In some instances, if the raw material is still in production, it might have subtly changed in chemical composition, particle size, or organic content, all of which can alter the current glaze result. Often, ceramics suppliers are unaware of changes in the raw materials they sell. The best course of action, though time consuming and somewhat inefficient, is to test raw materials before committing to a large-production batch of glaze. The potter can also ask the ceramics supplier if there have been any current problems or customer complaints with a raw material. It is important to think of ceramic materials as always changing. Some changes are insignificant to the end result in the glaze, while some changes can compromise the glaze.

Another potential source of error occurs when potters use an inappropriate substitute material in the glaze formula. Often,

a particular raw material is not in the studio, and a substitution has to be considered. Some of the most common substitutions involve feldspars. A frequent mistake occurs when the glaze formula requires a potassium (potash) feldspar such as Custer feldspar, and a soda-based feldspar, such as Minspar 200, a (sodium) based feldspar, is substituted. The different melting properties and sodium-to-potassium ratios can affect glaze maturity and color. Feldspars that are used in ceramics are grouped as potash, sodium, and lithium. Substitutions should be made from within the same group. For example, Minspar 200 can be substituted in ZAM Gloss Blue for nepheline syenite (a feldspathoid mineral), since both are sodium-based minerals.

To prevent the need for a substitution, make sure all of the materials required for the glaze formula are still in production. If a substitution is required, clays in the glaze formula should be replaced within the same general group, such as ball clays, kaolins, fireclays, stoneware clays, bentonites, and earthenware clays. Each group has subgroups based on metallic oxide content, plasticity, organic content, and particle-size distribution. However, a good starting point is to obtain a chemical analysis sheet from a ceramics supplier. The information listed will aid the potter in determining the most suitable substitution. *When making a substitution, always use a material from within the same group of clays, feldspars, or raw materials.*[1]

Change in Raw Materials

It is not unusual for ceramic raw materials used in glaze formulas to fluctuate, occasionally from one bag to the next, or sometimes slowly over a period of years. Do not assume that a raw material remains consistent because the name on the bag stays the same. Raw materials, even the best quality-controlled materials, can sometimes shift in chemical composition, particle size, and organic content. To illustrate this ceramic "fact of life," we can look at ball clays, which contribute alumina and silica—the basic building blocks of any glaze—plus metallic oxides and organic matter. Any type of clay in glazes, due to its alumina and silica content, helps keep the molten glaze from running off vertical surfaces. Clay also aids in the suspension properties of the liquid glaze because of its platelet structure, which acts as small, horizontal supports for denser raw materials.

While various changes in raw material take place due to geologic causes, economic forces in the market place initiate some changes as well. In fact, economic factors of the larger industrial markets dictate the specific clays and the quality of clays that potters use in their craft. A common practice occurs with Kentucky Tennessee Clay Company's Old Mine #4 ball clay, which was once mined from a single pit. In the 1970s, the supply was becoming depleted, and several clays were blended together to duplicate the original clay. Unfortunately, the unique qualities of the original Old Mine #4 ball clay were missing in the blended mixture. The mine combines individual clays to achieve consistency and prolong their deposits, but subtle characteristics of the clay can be lost in the process.

Of all the raw materials listed in ZAM Gloss Blue, Gerstley borate is the one most likely to change in chemical composition. It is also a soluble material, which can induce another range of defects in the glaze. Because of its variable chemical makeup and solubility, it is always best to take specific precautions when storing and using this popular material.[2]

Boraq or Gillespie borate are the two most reliable substitutes for Gerstley borate. *To ensure consistent materials, first mix a small test batch of any new glaze.*

Source of Raw Materials

The processing of a raw material can play a major part in the ability to duplicate a glaze formula. Many potters do not realize that assorted companies process raw materials, producing a material with different particle sizes, trace elements, or chemical compositions. Adding to miscalculations is the fact that the many possible processing variations of the raw material will have the same name. Whiting, or calcium carbonate, is a familiar glaze material. In most glaze formulas it is simply stated as whiting; however, this generic name does not truly define a particular whiting. For example, whiting produced by Delta Carbonate, Inc., is composed of 86% to 90% calcium carbonate and 6% to 12% magnesium carbonate, while Mississippi Lime Company's whiting contains 98.60% calcium carbonate and approximately 0.60% magnesium carbonate. Will the increased amount of magnesium carbonate found in Delta Carbonate's whiting affect the glaze? The best answer would be to test the glaze before committing to using the whiting in a production glaze formula. Whiting is also produced under the trade names of Snowcal 40, Vicron 2511, York White, Whiting 55C, Whiting 3C, and Goldbond Whiting #10. Each has a slightly different chemical composition and particle size. When in doubt about a particular whiting, a little time spent testing the material can ensure an accurate glaze result.

The particle-size difference in whitings can also cause variations in the suspension properties of the glaze. The finer grind of a material in glaze formulas, such as flint, nepheline syenite, frit, or whiting, will require greater amounts of water than their coarser alternatives. The coarser grind of any glaze material can settle faster in the glaze bucket than the same material at a smaller grind. In short, a generic name of a raw material does not guarantee consistency when trying to duplicate a glaze or clay body formula. Each ceramics supplier of raw materials has the option of ordering their raw materials from different sources. Ceramics suppliers frequently search for the lowest-cost processor without understanding the underlying characteristics of the raw material. With this factor in mind, potters should make inquires of their ceramics suppliers whenever ordering raw materials.

Another commonly used glaze material is talc; it is listed in many glaze formulas as just talc, with no further explanation of its source. Talc contributes silica and magnesium to the glaze formula; however, not all talc is the same. On the East Coast, NYTALC HR 100 was available, with Pioneer-2882 being a good substitute. Westex talc is a platelike nonfibrous talc that can be used in clay bodies or glazes but might produce a slightly off-white color compared with NYTAL HR100 and Pioneer-2882. Soapstone 78SS, TDM 92, and Talc 80/20 (partly calcined) are other talcs that can be found listed in glaze formulas.[3]

Individual raw materials can also differ in the trace elements they contain. Again using whiting as an example, different whitings can contain silica, alumina, iron, and clays as trace elements. What effect a trace element will have on the final fired glaze is dependent on many factors. Very rarely will a glaze formula list the original processor of a specific raw material. To ensure consistency, always try to purchase raw materials from the same supplier and periodically check to be sure they have not changed processors. Ask for a chemical analysis sheet for each raw material; it will list the particle size, chemical composition, and trace element components. It is always best to know as much about the raw materials as possible so that corrections to the glaze formula can be initiated if required. ZAM Gloss Blue contains nepheline syenite from Unimin Corporation, flint from U.S. Silica Co., whiting from Delta Carbonate, Gerstley borate from Hammill & Gillespie, and cobalt oxide from Hall Chemical Co. *Do you know the chemical composition and particle size of each raw material?*

Metallic Coloring Oxide/Carbonates

Metallic coloring oxides and their carbonate forms such as cobalt oxide, cobalt carbonate, manganese dioxide, manganese carbonate, copper oxide, copper carbonate, nickel oxide, and nickel carbonate, along with chrome oxide, iron chromate, rutile light, rutile dark, ilmenite powder, red iron oxide, and its variations, are processed by different companies, foreign and domestic. Each can differ in purity, particle size, and trace material content depending on the processing plant. For example, cobalt oxide (Co_3O_4) is processed in three grades: 71.5%, 72.5% (ceramic grade), and 73.5%. The percentage represents the cobalt contained in the oxide. Each grade can affect the intensity of the blue that will be generated in a glaze. In addition, the quantity of trace elements in a metallic coloring oxide can influence its effect on the glaze color. As examples, rutile can contain trace amounts of iron, alumina, silica, phosphorus, and sulfur, while copper oxide can have trace amounts of magnesium, sodium chloride, lead, and other heavy metals. While slight differences in trace metallic oxide content usually will not cause a radical color change, particle size can affect the look of a glaze. ZAM Gloss Blue contains 72.5% grade cobalt oxide. *Use the same processor of metallic coloring oxides when ordering materials; when not possible, always test the oxide.*

Clay Body and Glaze Interaction

The clay body and glaze interface is where the fired clay and glaze meet and fuse together. The interface plays an important part in the development of the fired glaze. The interaction of clay body and glaze can influence the texture of the glaze, depending on the clay body formula, glaze formula, kiln atmosphere, and clay body maturity. Some clay bodies will draw part of the flux content from the forming glaze during the firing process. This reaction can cause opacity or dry surface textures in the glaze. ZAM Gloss Blue glaze will function correctly when fired on a vitreous mature clay body. *When testing a glaze formula, consider the vitreous characteristics of the clay body.*

Glaze Application/Thickness·

The depth of the glaze layer can play an important part in duplicating a glaze effect. Too thin a glaze layer and the color of the clay body predominates. Often a thin application can retard the development of color, texture, and opacity in the fired glaze. Too thick a glaze layer can cause the glaze to run off vertical surfaces or pool excessively in horizontal areas. Unfortunately, most glaze formulas do not contain a notation offering information on glaze thickness or application techniques.

The actual application of the glaze is a factor in how it will look on the ceramic surface. Glazes can be sprayed, dipped, or brushed. Generally, a spray application will impart a more uniform layer than a dipped or brushed application. However, much depends on the skill of the potter as to the application technique(s) and the fired glaze result. Dipping a ceramic piece into a glaze can sometimes result in drips as excess glaze runs off the ceramic surface during the initial stages of drying. A glaze drip shows most prominently in the fired ware, since this is where the glaze layer is thicker, revealing the true color or opacity of the glaze. Brushing the glaze can result in uneven thickness depending on the viscosity of the glaze and the skill of the potter. ZAM Gloss Blue when applied too thinly will not achieve a rich deep-blue color but will show more of the underlying clay body color. ZAM Gloss Blue, like a large percentage of glazes, can be applied slightly thinner than the thickness of a dime, or about as thick as three business cards stacked together. *When possible, determine how thick the glaze was applied and what method of application was used, along with any special glazing techniques.*

Glaze Water and Soluble Materials

The amount of water used in a glaze formula is rarely stated. Even when other potters share their favorite formulas, they seldom mention how much water was used in the glaze batch. It's odd that such a central component in any glaze is frequently not noted. The volume of water added to a dry glaze is one of the major areas of miscalculation, which can result in too thin or too thick a glaze layer. Each formula will require a different amount of water due to the particle density of the raw materials, glaze suspension additives, glaze gums, glaze material solubility, and chemical composition of the water used in mixing. The method of application, whether the glaze is sprayed, dipped, or brushed, also plays a part in the amount of water needed for a successful application.

As a general rule, if you can drink the water, it can be used in a glaze. However, the glaze viscosity (thickness or thinness) can be affected by the characteristics of the water as well as the amount used. The hardness of the water can flocculate (liquid glaze appears thick in the bucket) the glaze, or soft water can deflocculate (liquid glaze appears thin in the bucket) the glaze.[4] Soluble glaze materials can break down in the water system of the glaze, depending on the chemical composition of the water and the level of soluble materials in the glaze. When excess water is removed from a glaze, it can alter the chemical composition due to soluble material dissolving into the glaze water.

Soluble glaze materials can also cause other changes, as in Gerstley borate, which is soluble and often causes viscosity changes in the wet glaze. When used in a new glaze batch, it often acts as expected. However, when the liquid glaze remains in storage it can produce any number of defects, such as pinholes, blisters, or dry areas in the fired glaze surface. This is caused by the migration of soluble materials in the glaze water concentrating on the high points and ridges of the ceramic surface as the glaze dries. The breakdown of Gerstley borate can also cause the wet glaze batch to look like thick "oatmeal," and many potters make the mistake of adding more water in the hope of thinning out the glaze. The result of this miscalculation is often a dilute glaze that does not function correctly on the ware in the application or firing stages. Dry soluble materials can also take on moisture in storage. Soluble-material weight can change depending on the amount of moisture it has absorbed, with such transformations having an effect on the total glaze formula. The ZAM Gloss Blue glaze required 1 quart of water to 1000 g of dry glaze. An important question to ask before mixing any glaze is, *Do you know how much water was used in mixing the glaze?*

Glaze-Testing Procedures

The first step in trying to duplicate any glaze is to obtain all the raw materials needed for a testing program. While there is no single testing procedure that will suit all potters' work habits and objectives, there are several recommendations that will ensure greater accuracy in duplicating glazes. With all the qualifications on using glazes from published formulas, or from other potters, it is amazing that most glazes reproduce accurately with a minimum of additional information. However, it is always best to start a testing program with the understanding that

occasionally a glaze formula will not work as described in books or magazines. We all know of potters who obtain a glaze formula and then go on to mix up 30 gallons without considering that it might fail. Experimenting on such a large scale is not a good idea, since eventually there will be a major glaze failure, which could affect kiln shelves, posts, and other pots in the kiln. The main goal in testing glazes is to find out how they react on a small scale. If the tests are not successful, the potter has a chance to adjust the glaze for further testing.

Record Keeping

One frequently overlooked item in the glaze-mixing process is a notebook readily at hand. A common problem when weighing out glazes is forgetting what materials were placed in the glaze container. Writing down each weigh-out of material is more effective than memory. It is also a good idea to develop a numbering system for every test and record them all in a notebook. In a very short time the number of test pieces can grow, and without some notation system it becomes difficult to refer to past glaze test results. Many times, potters have had to repeat tests because of inaccurate records. Such mistakes are time and energy consuming and delay obtaining a workable glaze.

Ordering Raw Materials

Knowing the current status of raw materials is critical when trying to obtain accurate glazes. Some raw materials will be dropped from the market due to larger economic forces. Make sure all the materials required for the glaze are still in production. To achieve consistent results when ordering raw materials, try to purchase new materials before the existing supplies are exhausted; this will prevent the need for substitutions.. It is important to note in the records when a new raw material is used, since a glaze defect might be traced back to the material.

Raw materials for glazes should be purchased in their original 50 or 100 lb. bags (metallic coloring oxides / carbonates, gums, suspension agents, lusters, tin oxide, and stains are the exceptions due to their high costs). Not only is it less expensive per pound to purchase raw materials in large quantities, it prevents someone at the ceramics supply company from mistakenly labeling a material. You don't want to order 5 lbs. of flint when it was mistakenly packaged as 5 lbs. of feldspar, both of which are white powders. Also, ordering the whole bag allows the potter to obtain the exact material when reordering. The processor's name and mesh size of the material are usually displayed on the end plate or side of the bag.

Vertical Test Tiles

The test tile should reveal if a glaze might run or drip on vertical surfaces. Some glazes will work well on horizontal surfaces but, due to their extreme fluidity when mature, will run on vertical surfaces. Vertical test tiles should be at least 4" in height and 2" wide. The test tiles must also be of sufficient surface area to approximate the actual pottery. Many times a small test tile will be successful because the molten weight of the glaze is not heavy enough to cause it to run down vertical surfaces. However, when larger areas are glazed, the weight of the fluid glaze might cause it to be pulled down, causing drips or runs on the pots or kiln shelves. Placing the test tiles in many kiln locations will give an indicator of how well the glaze responds to different temperatures. Not every kiln fires evenly, and the test tiles will show the maturing range of the glaze. For accurate results the test tiles should be formed from the same clay that will be used in production. If the production pot was thrown on the potter's wheel, the test tiles should be thrown to accurately duplicate the surface variations in the forming process. A 300 g batch of glaze with the appropriate amount of water should be adequate to glaze several test tiles. With the goal of obtaining as much information as possible from the test tile, a thin, medium, and thick glaze application should be applied, which when fired will indicate the appropriate glaze thickness.

Surface Textures of Test Tile

Some glazes can form razor-sharp edges on the fired clay body. The test tile is the place to find out if this particular glaze defect takes place. Obviously, sharp glazed edges are detrimental to any functional pottery.

Multiple Kiln Firings

The results of one glaze test should not be the determining factor indicating a successful glaze. The first test should be followed by placing more glaze tests in several different firings. Many kilns do not transfer heat evenly throughout their interior, and not every kiln fires consistently in each firing cycle. There are always slight variations depending on the firing cycle, quantity of pots or sculpture stacked in the kiln, and the placement of kiln shelves, posts, and ware. The tests should be placed in several different kilns, since they will indicate if the glaze is stable under various temperature or atmosphere conditions. Once the potter is confident with a glaze's track record, larger batches can be mixed and slowly incorporated into the existing glaze palette.

Vertical glaze test tile.

Small Test Batches to Larger Batches (Intermediate Testing)

A 300 g test batch will allow the potter to glaze several test tiles. The tiles can then be placed in a number of different kiln firings, after which, if the test glaze does not need an adjustment, it is often a good policy to mix up a preproduction batch of 4000 g, or roughly 1 gallon. This larger batch will allow the potter to glaze several pots and place them throughout the kiln. Going from a small test batch to the eventual large-volume glaze batch involves intermediate testing, which is often neglected or not recognized as an important part of ensuring a glaze formula's reliability.

Adding Dry Materials to a Liquid Glaze

A measurement of 4000 g of dry glaze materials will yield approximately one liquid gallon of glaze. Not every glaze will conform to this ratio, but it is a workable calculation whenever a dry raw material has to be added to a liquid glaze. Such additions can occur when adding a suspension agent, metallic coloring oxide, gum, stain, or dye to a glaze. As an example, a liquid glaze that is settling in the bucket can be kept in suspension by adding bentonite, a highly plastic, small-particle-size clay. An addition of 2% bentonite (80 g) in a 4000 g batch of glaze will keep it in suspension. Since the bentonite will not completely blend into the liquid glaze, the entire mixture should then be placed through an 80x mesh sieve three times before use.

Suggested Mixing Procedure

Once all the dry glaze materials are accurately weighed and placed in a container, water is added to the mixture. Every glaze will require different amounts, but it is best to use *less* water in the initial mixing stage because it is always easier to add more for a final adjustment. The liquid glaze is then placed through an 80x mesh sieve three times for a final mixing process. In most instances a 60x mesh sieve is too coarse, allowing larger particles of raw materials to remain in the liquid glaze. A 100x mesh sieve can be used, but it will take longer for the wet glaze to pass through the screen. If a wet glaze is stored for a week or longer, it should be placed through the sieve again to achieve a homogeneous mixture.

In order to obtain the optimum glaze layer, start with an application thickness of three cardboard matchbook covers stuck together, or slightly thinner than a dime, since approximately 80% of glazes seem to work successfully within these parameters. It is also a good practice to leave several glazed test pieces out of the firing. The unfired pieces can then be compared to the test pieces that went into the kiln. Using a needle tool, the potter can scratch down through the unfired glaze test to the bisque surface, visually noting the glaze thickness. This simple procedure allows for a before-and-after indication of how thick to apply the glaze in the next session. The human eye can be of greater accuracy in determining how thick to apply the glaze once it has a standard for comparison.

Characteristics of a Good Glaze

The cost of glaze materials is not relevant, but the potter's time and labor are very significant. Every decision on raw-material purchasing should be based solely on potential technical and aesthetic benefits to the glaze. When purchasing tools, supplies, or equipment, the same economic principle can be extended to all aspects of ceramics.

Raw-Material Reliability

Choose raw materials for their reliability and stability in particle size, chemical composition, and organic content. Many raw materials used by industry are suitable starting points for additions to the potter's glaze material list. However, there are other materials that vary in consistency but can produce desirable texture effects or variegated surfaces in the glaze.

Whenever Possible, Do Not Use Soluble Glaze Materials

Soluble materials such as borax, boric acid, Gerstley borate, colemanite, soda ash, wood ash, Gillespie borate, Boraq, potassium bichromate, and pearl ash (potassium carbonate) are the primary sources of solubility in glaze formulas. Other glaze materials such as lithium carbonate, magnesium carbonate, nepheline syenite, strontium carbonate, and some frits can have lesser degrees of solubility, but generally they do not interfere with the glaze application or fired glaze effects.

The use of soluble materials is required in some instances, since they contribute distinctive characteristics to a glaze. For example, in Shino (a high-temperature, viscous, feldspathic glaze first developed in Japan over 400 years ago and now used in various forms in the United States) glaze formulas, the inclusion of soda ash, a soluble material, causes the glaze to melt at lower temperatures, sealing in the reduction atmosphere of the kiln. The reaction causes carbon trap, leaving black to gray patterns in the fired glaze surface. When soluble materials are required in a glaze formula, they should be stored in waterproof plastic bags. A conservative approach is to mix only enough glaze containing soluble material for one glazing session, since the stored liquid glaze can change over time.

Glaze Compatibility with Metallic Coloring Oxides and Stains

Base glaze formulas should be calculated on a 100% basis as a standard glaze notation. Base glazes do not contain metallic coloring oxides / carbonates, stains, suspension agents, gums, or dyes, all of which are used as additions to the base glaze. A compatible base glaze should accept a wide range of metallic coloring oxides / carbonates or stains without altering their color.

Defect-Free Glazes

A glaze should be free of defects, which can interfere with its function. Glazes used for eating or drinking surfaces should be considered for their aesthetic qualities, but more importantly for smooth, defect-free surfaces, which enable easy cleaning. Glazes used for functional pottery should never be considered as sealants or barriers to hold a liquid because there will always be small imperfections that allow moisture to seep through to the underlying clay body, causing unsanitary conditions. Any break or disruption of the fired glaze surface or its bonding action to the underlying clay body indicates that the glaze should not be used for functional pottery.

In sculptural pieces, glaze acceptability can depend on the specific aesthetic quality it brings to the piece. Certain glaze defects might detract or add to the visual and tactile effects of the sculpture. For example, a glaze defect that might not be suitable for a sculptural piece is shivering (the fired glaze peels off the underlying ceramic surface, much like a paint chip, due to the glaze being under extreme compression). In this case, shivering can cause some of the glaze surface to fall away in time. Shivering can also shed sharp-edged pieces of glaze.

In nonfunctional ceramic pieces, other glaze defects might in fact enhance the aesthetic quality of the work. Another type of glaze defect is crawling, which occurs when the fired glaze rolls back from the underlying clay body, much like water on a glass tabletop. This common defect is caused in part by a glaze with high surface tension or a glaze not mechanically adhering to a dirty or dusty ceramic surface. On sculptural pieces, crawling might be a stable, nonsharp, desirable glaze condition. However, these considerations are entirely dependent on the artist's conception of what is desired in the finished piece.

Glaze Application

Whether it is sprayed, dipped, or brushed, one of the best qualities for any glaze is its ease of application. This characteristic is especially important in production pottery situations, where many pots have to be glazed in an efficient manner. The potter cannot be troubled with time-consuming touch-up procedures for a glaze that drips or pinholes on the pot. It is important to develop glazes that will need minimal or no touch-ups. While there are several gums and suspension agents that will improve glaze application, it is often more efficient to choose glazes that do not require additives. There is a trade-off in terms of the time and effort needed to choose the correct additive and the appropriate percentage to use in the glaze, as opposed to using a nonadditive glaze.

Glaze-Maturing Range

Glazes with a two to three pyrometric cone maturing range are desirable, since not every kiln will fire evenly. While the glaze might not look the same at its lower maturing range as it does at its higher limit, it should be functionally correct, with a smooth, unpitted surface. Conversely, glazes that fail (immature or overfired) within a narrow temperature range can be troublesome and time consuming to correct.

Glazes Should Have an Abrasion-Resistant Surface (Functional Pottery)

The surface of functional pottery is critical in that it must be smooth and not pitted so it will not trap food particles or liquid. The glaze surface must also stand up to common soaps and dishwasher detergents without abrasion or discoloration. One of the most common faults in soft glazes is the presence of knife marks from daily use. Smooth, defect-free surfaces and the fired glaze's hardness are not central issues on nonfunctional ceramic objects.

Glazes Should Not Leach (Functional Pottery)

Functional pottery glazes must be stable and inert and not leach their oxides into food or drink. There are several factors that can influence leaching. Some glazes are based on variable chemical-composition raw materials, which can change over time, causing glaze instability. Other factors that can affect leaching are the additions of coloring oxides or stains, the unstable nature of the glaze formula, glaze application techniques, and glaze thickness. Clay body formulas and kiln-firing cycles can also increase or decrease the leaching ability of a glaze. A combination of all or some of these factors can cause a glaze to be stable in one configuration and unstable in another. Many glazes look smooth, glossy, and stable when fired but can still leach their oxides into food or drink. Acidic foods such as tomato sauces, lemons, and vinegar or dishwasher liquids can intensify glaze leaching in unstable glazes.[5]

Same Glaze, Another Formula

Some glazes are generic in nature, meaning that the same color, surface texture, or light transmission qualities can be obtained when using a different formula. As often happens, a glaze formula copied from books or other potters cannot be duplicated for one or more reasons. However, this does not have to be a dead end in attempts to duplicate the glaze. The option of using an equivalent glaze formula does require knowledge of how ceramic raw materials react under various combinations, temperatures, and kiln atmospheres. For example, a high-temperature feldspathic green, transparent glossy, celadon glaze can be obtained with many different formulas. The flexibility to know which formulas will produce the same glaze effect is certainly a function of experience and the ability to interpret test results. To gain this type of knowledge it is often best to take ceramics courses in glaze calculation and raw materials, since these subjects are the building blocks of any glaze. The multiplying effect of many students doing glaze tests with various raw materials and sharing the information cannot equal the lone potter in his studio testing a limited number of materials. With increased understanding of ceramic raw materials, the potter has a greater array of tools to adjust any glaze or develop new ones.

19. LINER GLAZES

While potters have a good idea of what characteristics constitute a glaze, such as color, light transmission, temperature range, and surface texture, liner glazes can offer some challenges to achieving their intended function. Liner glazes are used on the surfaces of pottery that come into direct contact with food or drink. They are much like other glazes but with some important features pertaining to resistance to chemical attack, thermal shock, and durability. Liner glazes should be stable over their entire life and inert when in the presence of acidic/alkali materials contained in foods, liquids, or dishwashing soaps. Liner glazes must remain stable in repeated thermal-shock conditions with heating-and-cooling cycles encountered in oven/microwave and freezing conditions. A good liner glaze must resist abrasion from utensils and cleaning pads. It is often difficult to tell if a glaze meets all of these qualifications just by a visual examination. Additionally, liner glazes should be aesthetically pleasing and complement other glazes used on the pottery. The question then becomes how to develop your own liner glazes or recognize such characteristics in glazes that are available through books or magazines or obtained from other potters.

Glaze-Leaching Perspective

Offering a balanced view on the toxicity issues associated with glaze leaching is a subject that should be approached conservatively on the side of safety. Even when making nonfunctional pottery, keep in mind that the end-point user might in fact use it to hold food or drink. We do not want glazes to cause health problems for people eating or drinking from our pottery, even though the history and limited documented research does not indicate this outcome. Over fifty years of anecdotal information shows no reported instances of health problems caused by glazes used by potters in the United States. In 2000 the National Council on Education for the Ceramic Arts (NCECA) sponsored a health-and-safety study of potters. The scope of the survey included potters of all experience levels and workshop conditions and teachers coming into contact with many students. Their responses did not indicate any glaze leaching causing health problems. In *Mastering Cone 6 Glazes*, by John Heselberth and Ron Roy, the authors state, "with the exception of glazes containing one material—lead—there have been no documented instances of anyone having been harmed by material leaching from a ceramic glaze." It is also important to note that every case of toxic levels of leaching originated with lead glazes in storage vessels. While the survey results and statements are encouraging, they do not reveal if there could be glaze-leaching health problems that go unreported or unnoticed. For this reason it is necessary to ensure that our glazes are safe when coming into contact with food and drink.

Glaze Stability in Acidic/Alkali Conditions

Liquids or foods in contact with glazes that have low resistance to acidic or alkali conditions can become contaminated with elements extracted from the glaze.[1] The most problematic glazed pottery forms are food storage containers and especially those holding liquids since the duration rates with attacking substances are greater than encountered with a dinner plate, which is cleaned after use. The major cause of solubility in unstable glazes is extremely low or high pH levels in liquids, foods, and cleaning detergents. Acidic foods such as lemons can have pH levels of 4. While most foods have pH levels of 5 to 6, water, being neutral, has a pH of 7. On the other side of the pH scale, alkali substances such as dishwashing detergent can have pH levels of 10. Acidic or alkali conditions from lemons or dishwasher soap can attack glaze surfaces, resulting in discoloration, pitting, or penetration of liquids into the glaze. However, the glaze could be compromised even before these visible clues are observed.

Exactly what happens when an unstable glaze comes into contact with a strong acidic or alkali substance?

Solutions containing water are the most common and corrosive mediums that react with unstable glaze surfaces.[2] In the presence of strong alkali (high pH), silica in the glaze converts to caustic sodium silicate, altering the original glaze as well as feeding on itself, causing further damage. Anyone who has observed the pitting effects of sodium silicate (water glass) on glass surfaces is familiar with similar reactions on glazes in high-alkali environments. In extremely acidic (low pH) conditions found in food or drink, alkalis are drawn out of unstable glazes. The leaching effect can discolor or mar the affected glaze surface. This reaction is often observed when tomatoes, limes, or lemon juice (all acidic) are left on compromised glazed surfaces for any length of time.

Acidic lemon causing discoloration on glaze surface.

Strong alkali dish detergents can cause pitting and discoloration on glaze surfaces.

Glaze Surface Disruptions

Any concave or convex disruption of the glazed surface such as blisters, pinholes, or clay body eruptions through the glaze are possible sources of entry for contaminants, corrosive reaction, or both. One of the most common glaze defects is crazing, a fine network of slightly recessed lines in the fired glaze surface. Crazing is caused by the glaze being under tension as it cools, and not fitting the underlying clay body. While a crazed glaze pattern can be aesthetically pleasing, it does not serve the functional use of the pottery. A crazed glaze weakens the pottery, making it less resilient to normal handling and cleaning. We all have eaten at a roadside dinner and noticed the brown stains and crazing in the thick, off-white coffee mugs. Crazing exposes more of the glaze surface area to contamination and provides a suitable place for bacteria and mold to grow. The increased surface area also subjects the glaze to chemical attack. In some instances, seemingly intact glazes will craze at a later date. In opaque or dark-colored glazes, crazing may not be apparent, but often, breathing on the glaze surface will reveal a hidden craze pattern. Delayed crazing can occur days, months, or years later in unstable glaze / clay body combinations. Moisture in the atmosphere and the daily washing of pottery can induce glaze crazing if the clay body absorbs water and expands under the glaze layer. To prevent current and future liner glaze crazing, take the time to understand clay body / glaze compatibility and develop glazes that will be stable.

Some of the most prevalent glaze stains occur with cups that hold coffee or tea. Hot liquid is being placed into an unstable glaze and contained for a period of time, day after day, which can cause staining of glaze surfaces. Both coffee and tea have pH levels ranging from 4 to 6.5 and are acidic. Just as they have the capability to stain teeth, they can stain glazes that are not formulated correctly.

Firing Conditions

All glazes contain fluxes, along with alumina and silica in the appropriate proportions, which react under heat to form a glass. In order to ensure a chemically inert, abrasion-resistant surface, a glaze must be matched with a compatible clay body. Most importantly, the clay body and glaze must be fired in a suitable cycle that yields in glaze maturity. A once-reliable liner glaze might not retain its stability if it is overfired or underfired. Firing the glaze too fast to its end-point temperature can also result in unstable glaze surfaces, yielding microscopically jagged surfaces that can catch a knife blade, leaving metal embedded in glaze surface voids. Kiln-firing conditions can change the glaze surface and clay body maturity, causing it to leach oxides or trap food particles. Furthermore, glazes and clay bodies can become unstable in overreduction or underreduction kiln atmospheres or when exposed to wood, salt, or soda firing. Atmospheric kiln-firing

⊙ Glaze crazing stains on plate surface. A fine network of lines caused by the glaze being under tension as it cools.

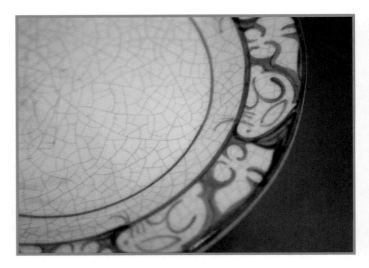

⊙ Coffee stain in bottom of cup. Acidic-based liquids such as coffee and tea have reacted with an unstable glaze surface.

conditions can introduce variable factors, retarding or intensifying the melting action and surface texture of the glaze formula. Incorrectly firing the kiln can produce soft glazes subject to abrasion from metal utensils and subject to chemical attack. The resulting scratches and voids on the glaze surface can also harbor bacteria.

A clay body can also alter the covering glaze layer and draw or wick out oxides from the glaze, inhibiting its melting potential. The resulting immature glaze is subject to leaching or rough, nonsanitary surface areas trapping food particles, which can allow liquids to accumulate in microscopic voids. Oxides with lower melting points can be volatilized off if the glaze is overfired or held at temperature for an excessively long time. Some matte glazes can also be unstable, leaching their oxides into foods or

liquids because they achieve their matte effect through underfiring or fast firing. Such glazes are immature, which can also cause chipping, crazing, and scratching or display a bleached, lighter fired color, all of which can result in degradation of the glaze.

Aggravating Conditions

Time, *temperature*, and extreme *pH levels* are the three factors that influence over 90% of attack by acidic and alkali substances on unstable glazes.[3] The remaining 10% includes the hardness of the water, sanitary condition of the container, and any suspended material in the water. The longer *time* a glaze is exposed to acidic or alkali substances, the greater the leaching level. The higher the *temperature* of acidic or alkali substances, the greater the leaching level, and extremely low or high *pH levels* can increase leaching in glazes. Conversely, under normal use, *time*, *temperature*, *and pH conditions* will have no adverse effect on stable glazes but can accelerate deterioration in unstable glazes.

Developing a Stable Glaze for Acidic/Alkali Conditions

There are several raw materials that can enhance glaze stability in acidic and alkali conditions. Acidic conditions attack alkaline materials in the glaze, such as feldspars or high-alkaline frits. To a lesser degree they also react with alkaline earth materials such as dolomite, calcium carbonate, magnesium carbonate, and strontium carbonate. Often, substituting alkaline earth materials for alkaline materials will increase the glaze's resistance to acidic/alkaline conditions. However, high percentages of a single alkaline earth material such as magnesium, found in magnesium carbonate, dolomite, and talc, can contribute to a matte surface texture and glaze instability. Since both groups of alkaline and alkaline earth materials act as fluxes in varying strengths, they should be used in the lowest amounts possible to achieve a vitreous melt. Neither alkaline nor alkaline earth fluxes will contribute color to glazes, but these do influence color when metallic coloring oxides are present. Greater glaze stability can be achieved by using combinations of fluxes as opposed to a single flux.[4] Unnecessarily high levels of feldspar or frit in a glaze can subject it to chemical attack. Often, lowering their percentages will result in a nonleaching glaze.

Increasing the silica content of a glaze can prevent acidic or alkali reactions on the glaze surface. However, a glaze with not enough flux and too high a silica content will be immature and subject to chemical attack, while additions of alumina, titania, and zirconia improve a glaze's acid resistance. Alumina and silica can be readily found in kaolins such as EPK, or ball clays such as Kentucky OM #4. A common source of titania is titanium dioxide.

Zircopax Plus, Opax, and Ultrox are opacity-producing agents that contain zirconia. A balance of fluxes, alumina, and silica will produce stable glazes when accompanied by appropriate firing conditions. A surprising number of glazes when critically examined are overly fluxed and can accept more silica (flint) to achieve a resilient glaze. One indication of overly fluxed glazes is running on vertical surfaces or even a slight beading where the glaze ends and the foot begins. Furthermore, additions of alumina, titania, and zirconia are often not considered for their resistance to chemical attack in glaze formulas.

Glaze Durability, Abrasion Resistance

It is important to note that glazes that are subject to alkali and acid attack can also scratch due to their surfaces being etched and abraded. Often the first indication of a problem occurs when tilting the pottery under intense lighting and noticing a series of scratches in the glaze surface. The scratches are often observed on dinner plates that come into repeated contact with a knife blade when food is cut. When a glaze shows scratch marks, it indicates the physically soft quality of the glaze giving way to a harder material moving on its surface. In some instances the marred surface is so dense that the original glaze color is lightened. When a finger is run across the glaze, small indentations are felt. While it is almost intuitive to think of a fired glaze surface as hard, some glazes can in fact be soft when exposed to common household utensils and scrubbing pads. Glazes can be scratched when they have not reached their maturation temperature or have achieved their correct temperature at too fast a heat increase (fast-firing the kiln). Both conditions can result in insufficient glass

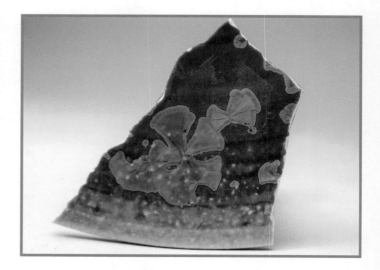

Macro crystal glaze: large crystals can have rough surfaces that can trap food or liquids. The crystal surface can also mar or abrade against metal utensils.

formation. Often, immature glazes are incorrectly classified as satin matte or matte, having a semiopaque or opaque light transmission and a rough surface texture. The simplest solution is to fire the glaze to a higher temperature, a longer time to temperature, or both. Both methods subject the glaze to greater heat work, bringing the silica and alumina content into greater vitrification. Another method to promote greater melting in an immature glaze is to increase the primary fluxes such as feldspars or frits. However, adding too much feldspar or frit can subject the glaze to acidic or alkali attack. A careful balance of flux materials, silica, and alumina, fired to maturity in a compatible kiln-firing cycle, is required to develop glazes that resist chemical attack and abrasion.

A disrupted glaze surface can occur with any of the zirconium silicates such as Superpax, Opax, or Ultrox, since they are inert refractory materials that do not readily melt in the molten glaze. This group of opacity-producing materials leaves microscopic raised surfaces and fine cracks around the zirconia protuberances, causing the glaze surface to trap metal from knife blades even though the surface appears smooth to the touch. However, some glaze formulas will encase the zirconium silicates more effectively, which will not interfere with a knife blade. A finer-mesh zirconium silicate can also create a smoother glaze surface. Zirconium silicates do contribute to glaze hardness and can be used even in clear glazes at 3–4% levels without causing opacity.[5] Increasing the levels of alumina and silica in a glaze by the use of clay is another alternative for promoting opacity in glazes; however, too much clay can cause a matte, opaque, rough glaze surface texture.

Heavily devitrified glazes (crystal growth) can present rough irregular surfaces that can trap food, causing unsanitary conditions. Dense fields of crystals on the glaze surfaces can also leave knife marks. Crystals can be large (macro) or small (micro), which can often make the glaze surface uneven and rough to the touch. In some instances a glaze will grow crystals on the inside of a covered form and not on the outside. The extra insulation offered by the enclosed form can delay glaze cooling and increase crystal growth, as opposed to the outside of the form, which cools faster. Unfortunately, the insides of casseroles or covered jars are the surfaces that come into contact with food or liquids. Crystal growth can also take place in a slower-cooling area within a kiln. It is not unusual for one glaze to take on different looks due to crystal growth, on the basis of location in the kiln. In some instances, kiln shelves and posts radiate heat after the kiln is turned off, which slows the rate of local cooling. Such heat banks can grow crystals on the side of the pot that faces the kiln furniture. Fast-cooling the kiln after the glaze has reached maturity in the 200°F–250°F range can inhibit crystal growth. Another alternative is recalculating the glaze, eliminating the most common crystal-growing materials such as titanium, zinc, rutile, and ilmenite.

A glaze's resistance to abrasion is in part determined not only by its being fired to maturity but by the amounts of alumina and silica present in the formula. Glazes fired to cone 6 (2232°F) and above generally have better abrasion resistance than lower-melting glazes, due to the greater quantities of alumina and silica and lower amounts of flux. In higher-temperature glazes the increased kiln temperatures are bringing the glaze into a melt, requiring

Glaze scratch on immature glaze due to microscopic concave areas trapping metal particles. Soft glaze surfaces are easily abraded by metal kitchen utensils and can be subject to leaching the glaze oxides into food or drink.

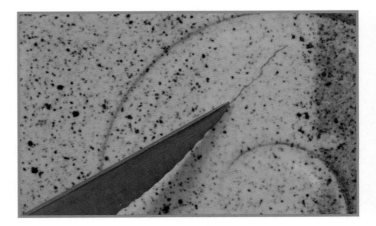

Micro crystal glaze: small crystals can cause raised surfaces in the glaze, trapping food and liquids or leaving knife marks.

fewer flux materials. Stated another way, fluxes in a glaze (sodium, potassium, magnesium, lithium, calcium, barium, strontium, lead, or zinc) that bring alumina and silica into a melt can also contribute to a soft glaze surface if used in excess. In high-temperature glazes the increased temperature of the kiln is a factor in improving glaze durability. In low-fire glazes ranging from c/06 (1828°F) to c/04 (1945°F), having less alumina and silica and higher levels of flux materials, it is more difficult to achieve hard, durable surfaces but not impossible, since they require the correct ratios of flux, alumina, and silica and a compatible clay body.

Boron is a glass former and reduces the melting point of a glaze. It is found in Gerstley borate, Ulexite, colemanite, Boraq, Laguna borate, Murray's borate, Cadycal, Gillespie borate, and

some frits. However, boron in most glazes lowers durability. It is not uncommon for glazes containing Gerstley borate, a widely used boron ore, to scratch easily.

The macro crystal and micro crystal glazes are the same; however, the micro crystal glaze was on the inside of a covered casserole and was subjected to a slower rate of cooling in the kiln than the macro crystal glaze on the outside of the form.

Thermal-Shock Testing

At some point in unstable clay body / glaze combinations, a piece of pottery will break when coming into contact with boiling water. Sharp, jagged cracks can also occur when pots are moved from a refrigerator directly into a hot oven. Both failures are due to thermal shock. Under ideal conditions the clay and glaze should cool in the kiln at a compatible rate, with the glaze coming under slight compression. If the glaze is under tension, crazing can result. Shivering can occur if the glaze cools under extreme compression, causing slivers of sharp glaze to break off from the underlying clay body. This type of defect is most noticeable on the edges or raised surfaces of the form. When unstable clay body / glaze combinations occur and pottery is subjected to extreme temperature ranges, it can stress its ability to remain intact. Failure can occur through crazing, shivering, or complete cracking of the ware, which can take place when the pot is taken from the kiln or in lesser instances months or years later. However, in most situations, once the glaze cools it is prestressed and stable. The pottery can be dropped on the floor and broken into pieces, but essentially what you see is what you get. This type of stability is illustrated by pottery shards that are recovered from archaeological sites, which retain intact glaze surfaces.

Obviously, any type of failure must be discovered before the pot is in the hands of its eventual user. There are a few simple tests that will assure potters of the durability of their pots. For practical reasons it is not necessary to test every pot, but periodically, random samples should be tested. Certainly any time a new clay or glaze is used would mandate a test. Since clay body / glaze fit is in part determined by the size of the kiln, end-point firing temperature, kiln atmosphere, and the firing cycle and time, if one of these variables changes, then the pottery should be tested.

Pottery can be placed in the freezer for 3 hours then taken out and carefully filled with boiling water. This test should be enacted in a safe area that assumes the pot will break. After a short time, the water is poured out and the pot is dried, then it is examined carefully for any defects. A water-based ink can be applied to the ware to accent any craze lines. Dark glazes will frequently hide craze lines, but they can become visible by placing the pot over steam and then looking at the glazed surface. Glaze shivering can often be induced through vigorous taps on the edges of the pottery with a screwdriver. If one glaze shivers, assume that all the glazes with that same clay body / glaze formula combination are suspect and the glaze is under extreme compression. Such glaze combinations

Glaze shivering: when the glaze cools on the clay body, it is under extreme compression and can peel off like a paint chip.

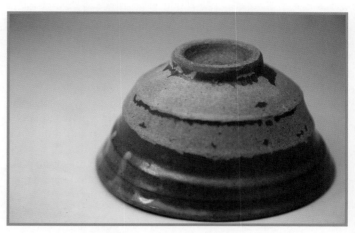

should be tested, since they might fail in the future. A conservative testing procedure requires that a representative sample of pottery that passed the first test series be tested again after a few months, since delayed crazing and shivering can result.

Another more stringent test conforms to the America Society for Testing and Materials (ASTM C554-93) procedure.

Place the pottery in an oven heated to 250°F for at least 45 minutes. After the pottery is removed from the oven, carefully pour water in the form. When the water has cooled, dry the pottery and examine it for defects. Place the pottery without any defects into the oven and repeat the test for three cycles at oven temperatures increased by 25°F increments until a temperature of 450°F is reached. It is possible for a single piece of pottery to pass the test, but others with the same clay body / glaze combination, fired in the same kiln, can fail. To ensure a statistically valid result, test as many pieces as possible. In any test procedure, always wear protective glasses and gloves.

Glaze Calculation Programs

It is often difficult at first to comprehend alkaline and alkaline earth groups of materials or what effect they have on a glaze, or how the alumina-to-silica ratio will affect the surface texture and opacity of the glaze. The student beginning a ceramics education often feels overwhelmed. It might seem there are many bits and pieces of information that are related in some unknown configuration but not fully comprehended. One method to understand ceramic materials is to keep reading and approaching the subject through many forms of education. Often, returning to the subject matter with an increased level of knowledge reveals new insights and perspectives. One of the best learning tools is glaze calculation software. In the past few years there have been many different programs and technical texts that can be downloaded or purchased on a CD. Developing safe liner glazes is just one part of ceramic theory fitting into the larger comprehension of

glazes, clay bodies, kiln firing, and making durable pottery.

Today, formulating new glazes or adjusting existing formulas becomes much easier and faster due to glaze calculation software programs. In the past, the slide ruler and then the pocket calculator, along with paper and pencil, were the primary tools with which to calculate glazes. Aside from the accuracy of instructional notes to be followed and the numerous steps required, it was a time-consuming process often leading to a misstep due to a small mathematical error. Anyone who has ever used the new software programs realizes that the speed of calculation gives the potter the ability to add or delete materials from the glaze and observe the results on several levels, such as batch weight and unity formula. One of the most effective ways to use the software is in conjunction with actual glaze testing. If the fired glaze needs revising, recalculating it through the software is efficient and fast. One or two cycles of calculation and testing should yield a successful glaze.

Simply stated, when you do something to a glaze formula, the consequences are immediately apparent. In the past, potters would frequently use glazes without the knowledge of how to alter the color, texture, light transmission, or temperature range. In many instances, test trials were needed to make up for this lack of understanding. Glaze calculation programs allow the potter to comprehend the effect of specific ceramic raw materials on the glaze formula. However, whether the potter knows how to interpret the results or understands the limitations of the glaze calculation program is another matter that can require further education. Glaze-calculating programs are great tools, but they are only as effective as the potter understanding and applying the data coming out of the program.

When using glaze calculation programs or developing your own glaze formulas, always check to ensure that you are using the most recent chemical analyses of the raw materials, since materials such as feldspars and clays can shift in their oxide content.[6] A ceramics supply company might not have the current chemical analysis sheets on each raw material, but contacting the mine or processor can yield up-to-date information, increasing the accuracy of the calculation. Many programs allow for the introduction of new glaze materials or revisions of the chemical-analysis data in existing materials.

Limit formulas for glaze calculation programs list the minimum and maximum amounts of oxides required to produce surface textures, opacities, and temperature ranges. However, they do not indicate if the glaze can withstand abrasion or resistance to chemical attack. For example, a program can show the ongoing results of lowering a glaze's alkali content (which can be lowering its feldspars or frit) while increasing its alumina and silica content (which can be found in clays), all of which are factors in stable glazes. As the results of the adjustments are revealed, they can be compared to limit formulas to ensure there will be a glaze at the given temperature range, but it will still have to be tested for leaching and abrasion resistance. Glaze calculation programs impress with their ability to condense the whole process of formulation, allowing the potter to obtain an overall picture of the glaze at every step of adjustment.

Below is an excellent, stable c/6 liner glaze with several color variations suitable for electric kiln firing.

John Hesselberth & Ron Roy's Cone 6 Clear, Transparent Liner Glaze

Custer feldspar	22
Ferro frit #3134	26
EPK	17
Talc	5
Flint	26
Whiting	4
Gloss Black Variation (called Licorice by the authors)	
Red iron oxide	9%
Cobalt carbonate	2%
Gloss Blue Variation	
Cobalt carbonate	1%–2%
Gloss White Variation	
Superpax	9%–12%

(reproduced with the permission of the authors)

Any safe glaze can be made unstable by firing it to an incorrect temperature or reaching the correct temperature at too fast a rate of heat increase. In part, ceramic materials melt when subjected to absolute or end-point temperatures: the higher the temperature, the more melting, but they are also influenced by the time it takes to reach maturity. Every clay body and glaze combination will react differently to the rate of temperature increase in the kiln. As a general guideline, it is recommended taking at least 12 to 14 hours firing time to reach c/6 (2232°F) in a fully loaded electric kiln. In a computer-controlled electric kiln, use the SLOW setting with a fully loaded kiln. If there are not enough pots to fill the kiln, place shelves and posts in the kiln to create greater thermal mass, which will contribute to an even heat distribution and slow the rate of heating and cooling. Hydrocarbon-fueled kilns and larger kilns with greater thermal mass might require different firing

cycles to achieve glaze and clay body maturity. Glaze maturity is especially important in liner glazes, since they are often applied to enclosed forms such as covered jars, teapots, or casseroles, which can be insulated somewhat from outside heat sources. Ceramic materials are good insulators of heat, and it is possible that enclosed interior glaze will not mature as fully as the outside surfaces of the form if the kiln is fired too fast or does not reach glaze-maturing temperature.

Stable liner glazes can be used on eating surfaces and non–eating surfaces of functional pottery. However, otherwise-durable safe glazes can also be made unstable by overloading them with metallic coloring oxides. When multiple metallic oxides are used, even in low levels, their combined effect might cause leaching in stable base glazes. While iron oxide and cobalt carbonate are used in the above glaze formula examples, care must be taken when using other colorants, since they can cause the glaze to become unstable. Additionally, the actual amount of overloaded oxides such as cobalt, copper, or chrome depends on the base glaze formula, firing temperature, time to temperature, kiln atmosphere, glaze thickness, and clay body composition. Any one or a combination of these factors can influence the ability of a glaze to "hold" in a stable form the metallic coloring oxide contained in the glaze.

Frequently, potters will use a liner glaze just because they like how it looks, without taking into consideration how it will react when in contact with food or drink. Some potters believe that any glaze that melts can serve as a liner glaze. They are often influenced by color, surface texture, ease of application, or past reliability. The visual representation of a glaze can be misleading. While glazes can look good and can be stable, it does not mean that these two qualities will be found in every glaze. It is often difficult to go beyond the habit of using a favorite glaze and develop nonleaching, abrasion-resistant glaze formulas. Some potters will not want to get into the basics of glaze development, but they should learn how to distinguish existing stable liner glazes if they want to make functional pottery.

Preliminary Studio Glaze Testing

Potters often use their pottery then discover in time that a glaze crazes or stains, even though that same type of glazed pottery has been sold for years. Field testing of the ware is an essential step in assuring that future users will not experience defects in the glaze, clay body, or both. In fact, the more cycles of actual use that the pottery can go through without a defect, the greater probability it will function correctly in the hands of others. Testing pottery under day-to-day usage requires considerable planning before committing to creating kiln loads of pottery. Often, potters are making pots, trying new glazes, and dealing with the daily concerns of production, which do not allow time to test the pottery over weeks and months. For most potters it's not a question of

actually making the pottery, but one of planning enough time to demonstrate the durability of the clay body and glaze combinations before it is used by others. If you cannot take the time to pretest the pottery, there are several methods to condense the many usage cycles a pot will experience. It is highly recommended to use the pots yourself before placing them in the hands of others. Preliminary testing for acidic/alkali attack and abrasion resistance is intended to screen and remove from consideration the glazes that do not need to be sent to a recognized testing laboratory.

Alkali Exposure Test

It is always best to place the pottery in multiple dishwasher cycles and to note any color or texture differences compared to a control sample of the fired glaze. Dishwasher liquids and baking soda (sodium carbonate) have relatively high pH levels, which can cause alkaline exposure to glazed surfaces. Mix either with enough water to a thick "soup" consistency. Place the glazed tile into the solution and let it sit for 24 hours, then rinse with water and wipe dry. Note any color or texture differences as compared to a control sample of the fired glaze. If there is a color change or surface texture abrasion, it is not necessary to send the glaze to a testing laboratory.

Acid Exposure Test

Many foods are acidic. Often, staining can be seen when blueberries, tomatoes, or limes are left on an unstable glaze surface. A simple test is to cut a lemon in half and leave it on the glaze surface. Wait 24 hours and note any color alteration. If any discoloration or bleaching is noticed, the glaze will not be stable in everyday use.

Abrasion Resistance Test

To test for abrasion resistance, run a steak knife over the glazed surface as you would when cutting food. The greater the number of problem-free rubbing cycles, the better it will hold up well in everyday use. Pottery that fails abrasion resistance testing might also be subject to alkali/acid attack.

While there are several glaze testing methods the potter can perform for leaching and abrasion resistance, they are not definitive. In some instances, even when yielding a satisfactory test result the glaze can still scratch or leach oxides in the future. The best function of a studio test is to eliminate glazes that need not be sent to the testing laboratory. Glazes that pass the studio test and do not show obvious signs of discoloration or abrasion should be sent to a laboratory that has experience with more-precise testing procedures. The testing laboratory should be able to explain the results in plain language so that the potter can then determine if he or she wants to use the glaze.

Laboratory Testing

The question of what constitutes a safe glaze can be somewhat ambiguous. At present the technology exists to determine the parts per million of any material leaching from a glaze, but aside from lead and cadmium there are no federally stated safe release levels. This unfortunate situation results in potters sending a glaze to a testing laboratory and then having to educate themselves on the results of the test. Fortunately, *Mastering Cone 6 Glazes* by John Heselberth and Ron Roy (published by Glaze Master Press) is an excellent reference for leaching data. In the final evaluation, the potter's common sense, studio testing, and laboratory testing along with some research will yield durable liner glazes.

Liner Glaze Requirements

Whether developing your own glazes or using formulas from books or magazines, a reliable liner glaze should have several critical properties.

Glaze should not contain lead or lead frits. While such glazes can be formulated for safe use, there are many variables that make the formulation process and storage of raw materials impractical for most pottery operations.

If the glaze contains over 5% of metallic coloring oxides, it can be soluble and should be tested. However, metallic coloring oxides or their carbonate forms such as cobalt oxide, cobalt carbonate, and iron oxide, which are readily soluble in the glazes, can also be used in small amounts (under 3%).

Glazed surfaces should be smooth without concave or convex irregularities.

Glazes should be free of crazing (a fine network of cracks in the glaze surface) and shivering (the glaze peels off the fired-clay surface, much like paint chips).

Glazes should apply evenly to the pottery surface by dipping, brushing, or spraying.

Glazes should have high abrasion resistance when fired, creating a strong, blemish-free surface when in contact with household utensils.

Glazes should resist high alkali and acidic conditions in daily use.

Glazes should be easily reproducible, giving consistent results in every kiln firing.

Glazes should be stable when fired slightly above or below their recommended firing temperature.

Glazes should be stable in normal variations of kiln atmosphere.

Glazes should be field tested under actual heating, freezing, and cleaning conditions.

Suspect glazes should be sent to the appropriate testing laboratory.

20. THE WHITE SPOTS OF MAIOLICA WARE

Maiolica History

Maiolica pottery (pronounced "my OH lick uh") was developed by potters that came from an island off the eastern coast of Majorca, in Spain.[1]

The term "Maiolica" was used exclusively to identify lusterwares from Majorca, mainly due to writers such as Dante referring to the island of Majorca as *Maiolica* and not its proper name, Majorca.[2] It is believed that this type of pottery originated in Mesopotamia in the ninth century CE.[3] Subsequently, Moorish potters from Majorca working in Sicily might have introduced the pottery to the Italian mainland.[4] Maiolica ware achieved its highest form in the Italian Renaissance from the thirteenth century to the 1600s; major centers for production were Naples, Pesaro, Rome, Faenz, and Deruta.[5] The technique eventually spread to northern Europe. The traditional pottery workshop consisted of several workers who processed clay, prepared glazes, and formed pots while working under the direction of a master potter.[6] The procedure of applying a thin wash of color over an opaque white raw glaze was already practiced by fresco painters of the period. By the sixteenth century, Maiolica ware was characterized by the primary colors of red, yellow, and blue, along with purple, orange, pink, and brown, all of which were fired on glossy glazed surfaces. Maiolica

pottery was especially useful in sanitary ware and apothecary jars due to its nonporous glazed surface. Italian potters, with their paintings on the surface of glazes, further elevated the aesthetic of the functional pottery.

Many different forms were made for functional use and decorative display, including cups, bowls, serving dishes, cake display stands, wall display plates, face jugs, busts, compotes, jugs, and cups. Floor tiles and sculptures were also produced. Maiolica ware is characterized by a low-fire red clay common in Italy, formed on the wheel or handbuilt, after which a white opaque glaze was applied. In fact, the essential element in Maiolica ware was the abundance of cheap clay available in many countries. In Venetian potteries the glaze contained lead, a low-temperature flux, and a binding agent such as gum Arabic to harden its surface in preparation for the overglaze color. Tin oxide was used to produce opacity.

After the glaze had dried, different metallic coloring oxides were applied by brush. The pottery was then ready for the glaze firing, which fused the glaze and the overglaze coloring oxides together. Italian potters kept precise records of every stage of Maiolica production, which were specifically chronicled in 1548 by Cipriano di Michele Piccolpasso (1524–1579). He was a member of a prominent patrician family and founded the Accademia del Disegno, one of the earliest academies for Italian artists.[7] He describes in detail how the glaze had to be applied as thin as "a glove's leather." The brushes were made of goats' and asses' hair, while fine detail was applied with brushes made from the whiskers of rats and mice.[8]

Chinese Porcelain vs. Maiolica Ware

The term "Maiolica" at some point came to denote ceramics made in Italy. Its popularity was due in part to its superficial resemblance to Chinese export porcelain being shipped to Renaissance Italy. Chinese porcelain and Maiolica had white surfaces, suggesting purity and refinement, and both allowed for decorative strokes of brushed colors. However, the technical differences between the two types of pottery were dramatic. Chinese porcelain was formed from various combinations of refractory white kaolins, feldspars, and other indigenous materials, fired in climbing kilns at high temperatures (2300°F), which European kilns could not achieve at that time. In an attempt to duplicate the white, almost translucent porcelain clay body, the brown earthenware Maiolica ware was covered by a white slip and then decorated with coloring oxides. While it was not translucent, it did produce a white background for decorative motifs. In the production of porcelain, metallic oxides of chrome, copper, and cobalt were painted on the white clay surface. The fired porcelain clay body and glaze had an integrated look and feel due to a fully developed vitreous interface between the clay body and glaze, resulting in a denser, stronger, more durable pottery than Maiolica ware. Chinese imports did not eliminate Maiolica but did result in porcelain being more

expensive. It was not until the eighteenth century that the secrets of porcelain technology became available in Europe.

Significantly, Maiolica pottery was wood fired in single-chamber kilns reaching temperatures of only 1742°F–1850°F. The ware was placed in saggers (ceramic containers) to prevent direct-flame and ash impingement. The updraft exhaust stack design of the kiln did not produce even heating; additionally, the kiln bricks could not withstand the higher temperatures required of porcelain production. This type of kiln was used in many of the Mediterranean countries.[9] Due to its limitations it produced ware of higher porosity and less durability than porcelain.

Modern Maiolica White Spotting

The Maiolica technique survives in ware produced by many potters today. Ceramic stains, metallic coloring oxides, or their carbonate forms of cobalt, copper, manganese, rutile, or iron oxide are used along with a flux to bring the overglaze wash into a melt on the underlying white base glaze. Maiolica pottery for the most part is characterized by white spots in the color field of the overglaze design. While some potters have used techniques to reduce the spotting, many examples displayed in current publications and ceramics exhibitions show unrelenting white spots. Traditionally, potters share information on technical problems; however, the correction for this particular defect does not seem to be widely disseminated or known. A survey of potters indicates many remedies, most of which are ineffectual or relieve the white spotting only on a random basis. In fact, many potters just accept the white spots as part of the aesthetic quality of their pots. While this is an individual decision, white spots do not have to be present in Maiolica pottery.

Examples of White Spots

⬆ Modern Maiolica pottery produced in Sorrento, Italy (close-up image). Notice white spotting in the blue, red, turquoise, yellow, and red color designs.

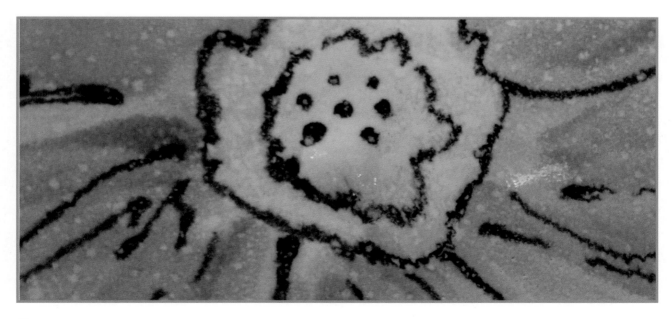

⬆ White glaze using Superpax for opacity, with overglaze color showing white spots.

The Theory of White Spots

There are several possible theories on the origination and elimination of white spots in Maiolica glazes. After many discussions with potters experiencing this problem, a working theory was developed. We believe that the white spots in the overglaze wash color field are caused by organic material in the clay body that has not been completely removed either during the bisque- or glaze-firing cycles. Subsequently, in the glaze firing it then burns out, causing a gas that moves through the glaze layer, separating the overglaze color and revealing a smooth-surfaced round white spot in the glaze. Additionally, in *Tin-Glazed Earthenware: From Maiolica, Faience and Delftware to Contemporary*, author Daphne Carnegy states, "It is important in the biscuit firing to make sure that all the carbon and sulfur gases are burnt out. If the firing is too rapid, the gases remain trapped beneath the surface, only to cause pinholing or white spotting in the subsequent glaze firing (if it is higher in temperature)."

During glaze testing, we were aware of developing a confirmation bias, which can result when recognizing test results that confirm only our own theories. Therefore, we structured the test series to allow for as many variable factors as possible while still proving our original theory. Since potters who have white spots on their Maiolica use several kiln-firing cycles and different clay bodies, glazes, and overglaze wash formulas, either from ceramics suppliers or their own formulas, it was necessary to develop a methodology that would take these variables into consideration while still producing a satisfactory recommendation for everyone.

Elimination of White Spots

For many potters the attempts to eradicate the white spots have produced intermittent degrees of success. Their frustration is in part due to several factors, which might be found in the *clay body*, *glaze characteristics*, or, most importantly, the *kiln-firing cycle*. However, the predominant cause is the level of organic content in the clay *not* released during the bisque-firing cycle, the early part of the glaze-firing cycle, or both. The temperatures between 572°F and 1292°F are critical in maintaining a complete oxidation atmosphere in the kiln to remove organic matter from the clay. Additionally, sufficient time must be allowed for these reactions to be completed.[10] A 100°F or slower rate of heat increase per hour during this period will ensure that trapped gases can be ejected from the clay body. The slower firing is especially important when plates or flat forms such as tiles are in the kiln, since they do not release organic material as efficiently as vertical forms.

Kiln-Firing Cycles

The bisque-firing cycle and early part of the glaze-firing cycle, before the glaze has started to sinter (where the dry glaze materials have started to melt together and their porosity has decreased), are critical periods for the release of organic materials from the clay body. Individual kiln-firing cycles vary depending on the size of the kiln, how densely it is packed, and the end-point temperature reached. For example, a densely loaded kiln where plates are stacked one on top of another might trap carbon in the clay, due to oxygen not reaching all parts of the plate during the firing. Or low bisque-firing temperatures or fast firing cycles can leave little time and heat work to free carbon from the clay body.

Aside from the bisque- and glaze-firing cycles listed here, each potter should first experiment with longer bisque firings. A well-vented kiln using an Envirovent exhaust system draws excess oxygen through the kiln, aiding in the combustion of organic matter in the clay body. As a general rule, a longer bisque-firing cycle is less likely to cause unintentional defects in the clay body. Excessively long glaze-firing cycles when the glaze is already in a fluid state can result in an overfired runny or blistered glaze surface. Overfiring the glaze or too long a hold period when the glaze is molten can also result in a "bleed edge" to overglaze colors. It is always best to incrementally increase hold times and total firing times to maturity in the glaze-firing kiln and to note any changes in the fired glaze before increasing either.

Clay Body

Traditionally, potters use a high-iron-content clay as part of their clay body formula, contributing to the red color of the fired pots. In some instances, clays such as Redart or Newman Red can compose 50% or more of the total formula. All clays have some form of organic content such as lignite, coal, or other organic matter laid down when the clay deposit was formed or when the clay was transported to another location. The amount of organic content can vary depending on the site where it was mined, and can fluctuate over its production history. In many instances, potters are unaware of these changes. Often, potters do not change a bisque- or glaze-firing cycle, which might not completely remove organic material from a particular batch of clay.

Glaze Characteristics

One aggravating factor in the appearance of white spots is the very nature of the gloss, low-fire glazes employed in current Maiolica ware. Zirconium silicates such as Zircopax Plus, Superpax, Opax, or Ultrox are frequently used in producing opacity; tin oxide is less

regularly employed due to its expense. Zirconium silicates do not go into a melt within the glaze but float in the glass matrix, causing opacity. Such glazes have a high viscosity, being "stiff" in the molten state. Gas released from volatizing organic matter in the clay body travels through the stiff molten-glaze layer. At this point the gas is more likely to travel though the white base glaze and spread apart the overlying color field without the color returning to its original position on the glaze surface. In some instances a thinner glaze application will resolve the white spot defect, but it does not address the underlying cause of the problem. It only offers a thinner cross section of molten glaze for the escaping gas to go through from the clay body.

Essentially, the elimination of white spots has been achieved by the *complete* removal of organic material from the clay body during the bisque-firing or glaze-firing cycles. Several potters have discovered that cleaner firing results have produced an unblemished color field in the overglaze design. Our own independent testing of different firing cycles, clay bodies, and glaze combinations have also proven this theory. Listed are several firing cycles that prevented white spots.

What Works

The significance of eliminating white spots in the glaze is the additional time added to the bisque- or glaze-firing cycles (or both), which allows for the complete burnout of organic material in the clay body. There is a low potential for defects when adding extra time in the bisque-firing cycle, so this is a good starting point for potters testing in their own kilns. An inordinately long glaze-firing cycle when the glaze has reached maturity can cause an overfired glaze. However, if the glaze-firing cycle is prolonged *before* the glaze starts to sinter (lower temperature than liquid phase of glaze formation), organic material in the clay body can be released through the soft-powder glaze state.

Below are some examples of our test series using various clay bodies, glazes, and overglaze washes, along with bisque- and glaze-firing cycles.

Clay Bodies

Highwater Clay Company: Stan's Red Clay, Earthen Red, and Lyman Red.

Glaze Formulas

Stan's Maiolica cone 05 (1888°F)	
Ferro Frit #3124	73.33
Flint 325 mesh	13.33
EPK	13.33
Zircopax	11.00
Arbuckle Maiolica cone 05 (1888°F)	
Ferro frit #3124	65.8
Kona F-4 feldspar	17.3
EPK	10.8
Nepheline syenite 270 mesh	6.2
Bentonite	2.0
Tin oxide	4.0
Zircopax	8.0

Overglaze Wash Colorants

+ 40% stain / 60% Ferro frit #3124, "watercolor" consistency application

+ 50% stain / 50% Gerstley borate, "watercolor" consistency application

Bisque-Firing Cycle—Cone 03

The bisque- and glaze-firing cycles used an L&L 7 cu. ft. kiln.
 Slow bisque-firing cycle—Total firing time 15 hrs.
 100°F to 250°F holding 5 hrs.
 250°F to 1100°F fired at 250°F per hour 1100°F to 1987°F

Glaze-Firing Cycle—Cone 05

Slow glaze-firing cycle—Total firing time 15 hrs.
 200°F per hour to 1100°F, then 100°F per hour to 1651°F, then 80°F per hour to 1890°F

Examples of Longer Bisque- and Glaze-Firing Cycles

● Maiolica glaze fired with longer bisque- and glaze-firing cycles.

● Bisque cone 03, glaze cone 05; 15 hours total time for both cycles.
Photo credit, John Britt

Elimination of White Spots

Photographs 4 and 5 show Maiolica ware produced by Damariscotta Pottery, using the following firing cycle.
 Kiln: L&L 10 cu. ft.
 Firing Cycles:
 Bisque-firing cycle on computer-controlled SLOW BISQUE

setting to cone 07 (1789°F)
 Glaze-firing cycle on computer-controlled SLOW BISQUE setting to cone 05 (1888°F) then enter a 2-hour and 15-minute hold until cone 04 (1945°F) is reached

Another Firing Cycle Resulting in No White Spots

Bisque Firing: approximately 16 hours, Laguna R2 terra-cotta clay body
 100°F/hour to 220°F, hold for 1 hour
 150°F/hour to 1000°F, hold for 1 hour
 200°F/hour to 1800°F, hold for 1 hour for a perfect cone 05 firing (1888°F)

Glaze Firing

 100°F/hour to 220°F, hold 30 minutes
 150°F/hour to 1000°F, hold 10 minutes
 200°F/hour to 1805°F, hold 10 minutes for a perfect cone 05 glaze firing (1888°F)

Maiolica bowl by Damariscotta Pottery; no white spots. *Photo credit, Rhonda Friedman*

Maiolica surface; no white spots (close-up). *Photo credit, Rhonda Friedman*

Old Maiolica, No White Spots

Common Factors in No White Spotting

Conversely, there are several factors that inhibit the appearance of white spotting in Maiolica glazes.

Higher bisque- and glaze-firing temperatures (bisque firing cone 04 (1956°F), glaze-firing cone 1 (2079°F)

Longer bisque firing (increase time to burn off organics in clay)

Higher and longer glaze firing (increase time to burn off organics in clay)

Glaze only the inside or outside of the pot (allows a pathway for organic material in the clay to exit the pot)

Apply glaze to a bisque pot, then fire it to dull-red heat (1000°F). Cool, apply overglaze colors, and then fire to glaze temperature (this allows the clay body to release organic material over multiple firings).

In sharp contrast to modern Maiolica pottery, ware produced before the late nineteenth century rarely has white spotting. Aside from firing cycles and varying techniques of applying the glaze, lead plays an important part in the absence of white spotting in these pots. Early Italian and Dutch Maiolica pottery used a lead-based glaze, with many formulas also containing alkaline fluxes and additions of silica. The availability of lead and its technical benefits in glaze development spread its popularity among factories producing Maiolica ware. Italian potters traveled to Minton, England, in the mid-1800s, where they helped promote lead as a major flux, replacing tin as the major glaze constituent.[11] The presence of lead as the major flux in the glaze had several important benefits; namely, flexibility when molten and low coefficients of expansion, fitting a wide range of clay body formulas, and uneven firing temperatures within the kiln.

Lead also contributed a stabilizing, broad-maturing-range glaze with exceptional *healing* qualities, allowing for the slow release of gases from the clay body. The glazes also had a low alumina content, which was not an impediment to glaze melting, since the firing temperatures were relatively low; however, the glaze was flexible when molten, contributing to glaze elasticity as gases traveled through it during the firing.[12] Lead-based glazes had a different surface tension when molten, which allowed for the color field to recombine once the gas escaped through the underlying white base glaze, as opposed to current glazes that contain frits as their major flux, which are stiffer when molten. John Britt supplied test results and kiln firing information.

Recommendations for Elimination of White Spots in Maiolica Ware

Bisque hot in a well-vented kiln

Use pre-reacted materials in your glazes: frits as opposed to Gerstley borate

Thinner rather than thicker glaze application

Slower rather than faster firing curve after the glaze sinters

Apply white slip to leather-hard pot, then low bisque fire. Cool, apply overglaze colors, followed by a thin coat of clear, and refire.

21. MIXING GLAZE COLORS

At some point, all potters consider expanding their palette of glaze colors. The most reliable, exciting glaze color of today can become boring and static tomorrow. In some instances, the change of color is initiated by economic factors when sales start to decline. Market forces can cause today's midnight-blue glaze to become passé. Ideally, the potter should have been working on alternative colors before a drop in sales indicated a change in product color. Aesthetic considerations also can promote a change of glaze color. A ceramic sculptural object might require a different color depending on the artistic considerations of the piece. In fact, there are as many reasons for investigating color in glazes as there are potters making pots or sculpture. Two methods used by many potters to achieve color in glaze are based on metallic coloring oxides and ceramic stains.

Base Glazes

There is no single method to test various color combinations in glazes, but one reliable method depends on using a base glaze

formula as a starting point. A base glaze formula should be calculated to equal a 100% batch weight. It will produce either a clear, transparent, glossy surface; a satin matte, semiopaque surface; or a matte, opaque glaze surface. For example, a base glaze should look like:

#5 ZAM base clear c/6 (2232°F)	
Ferro frit #3195	60
Flint 325x	22
EPK clay	12
Whiting	6
	100%
Bentonite	2%
Cobalt oxide	1%

Any metallic coloring oxide, metallic coloring carbonate, stain, gum, suspension agent, or dye is listed after the 100% total batch weight glaze.

Uniformity of Language

There are several reasons for using a base glaze as a 100% total. It readily allows one glaze to be compared to another. For example, if glaze A contains 60% frit—a glass former—it will be more fluid and glossy than glaze B, containing 30% frit. While other variables come into play when making an approximate comparison with another glaze, with practice and experience the potter can find this aspect of comparing glazes instructive and usable. Ceramics literature also expresses glaze formulas in 100% batch weights, so in a sense the potter is using the same language found in the body of knowledge researched in the field of ceramics.

Reliability / Minimizing Variables

Choosing one or more base glazes for color development allows the potter to start from a known quantity; namely, a glaze that is reliable and functionally correct in its firing characteristics. Different metallic coloring oxides or stains in varying percentages can then be added so that the potter expands the glaze results while working on a steady foundation of base glaze reliability.

Using a limited selection of base glazes also reduces the variable factors associated with different glaze materials, which can affect the color development in the glaze. For example, glazes that contain tin oxide can produce a pink color with additions of chrome oxide. Glazes with high levels of zinc oxide can produce an intense blue with the addition of cobalt oxide or cobalt carbonate. A potential problem when interpreting the results of any glaze test is tracking these variable factors. It is always best to start simply with a few base glazes and then expand the scope of testing once reliable results are accurately interpreted in the fired test pieces.

Testing Procedure

Having a plan to test color in glazes will greatly lessen the chance of error. It will also reduce the time and labor in carrying out the testing program. By choosing a base glaze from each of the three general categories, *clear, transparent glossy, satin matte semiopaque,* and *matte opaque,* a wide range of color variations can be achieved with the same percentage of any coloring oxide or stain. As stated, it is always advisable to use base glazes that have a proven record for reliability and consistency, since this will focus the test results on color development and not glaze defects. A given percentage of cobalt carbonate will produce a different intensity of blue depending on the opacity and surface texture of the base glaze. In a clear, transparent, glossy glaze, the blue color will be brighter and more intense than in a matte opaque glaze, which can cause a muting effect on the color.

For example, three cone 6 (2232°F) (any temperature range glazes will work) base glazes can be used for color variations. A 100–300 g test batch of each glaze is recommended. It is advisable to add small increments of water to achieve the correct glaze viscosity. Adding excessive amounts of water can cause a thin glaze layer on the test piece. If too much water is added, it can be siphoned off after allowing the glaze to settle for a few hours. However, if there are soluble materials in the glaze, removing the excess water can change the actual glaze formula.

Once three base glazes have been chosen, 5% of cobalt carbonate can be added to each. It is important to make at least three or four samples of each glaze, showing a thin and thick glaze layer on each test. The test pieces should then be distributed throughout the kiln. Keep in mind that not every kiln heats evenly, and separating the tests will reflect the temperature variations throughout the kiln.

Glaze Tests

With any test, the goal is to generate as much information as possible. The test piece should have sufficient surface area to reflect the viscosity of the fired glaze. On small test pieces the weight of molten glaze is often not sufficient to cause glaze running. However, the same glaze applied to a larger surface area can drip due to the pulling effect of the weight of the molten glaze. The test pieces should be at least 4" to 5" in height, with a minimum of 1" unglazed on the bottom. Some glazes will run on vertical surfaces, and the test piece, not the actual production pot, is the place to determine this.

Once a series of successful glaze results have been completed, intermediate testing is essential to ensure that the glaze will remain stable and consistent. Mixing a preproduction batch of glaze (1 or 2 gallons) would be the next logical step. At this point, a few pots should be glazed and placed throughout the kiln. Once several kiln firings have produced acceptable results, the glaze is ready for larger-production glazing and firing operations.

#1 ZAM base clear c/6		#8 ZAM base satin matte		#15 ZAM base matte	
Ferro frit #3195	50	Whiting	15	Nepheline syenite 270 mesh	45
Custer feldspar	21	Nepheline syenite 270 mesh	40	Whiting	18
Flint 325 mesh	16	Flint 325 mesh	38	EPK	20
Whiting	5	EPK	7	Flint 325 mesh	5
Bentonite	2			Zinc oxide	12

Vertical glaze test piece; 5" height, 2" wide.

Cobalt carbonate 1%.

Cobalt carbonate 10%.

Percentages of Metallic Coloring Oxides or Stains Used in a Base Glaze

As a general rule:

0.25%–0.5% of metallic coloring oxide or stain will tint a base glaze

5%–7% of metallic coloring oxide or stain will produce a half-tone shade of color

10%–12% of metallic coloring oxide or stain will produce a full-color-intensity effect

The images show cobalt carbonate added to a base glaze in 0.5%, 1%, and 10% increments.

Cobalt carbonate 0.5%.

Metallic Coloring Oxides vs. Stains

Metallic coloring oxides or their carbonate forms can produce depth of color and variations in shades of color, giving the glaze diffusion and variability. They can also be used in combinations to produce many different colors. Metallic coloring oxides can differ in their particle size, trace material content, and percentage of oxide present in the individual sample, depending on their processing source, which can cause possible inconsistencies of color.

Stains will produce a flat, static color response in glazes. Stains are manufactured from metallic coloring oxides and various color-enhancing and color-stabilizing oxides such as zinc, silica, alumina, and calcium. The raw materials are calcined, a process in which raw materials are heated, creating new compounds. After cooling, the material is ground into a fine powder. Stains offer the advantage of reproducing a specific shade of color consistently along with other colors that are not easily reproducible when using raw metallic coloring oxides.

Factors Influencing Glaze Color

Several factors can either completely change the intended glaze color or cause variations in intensity or hue. Before starting any program of glaze color testing, consider the following primary causes of color discrepancies.

The base glaze formula can promote or retard color response in a glaze. For example, glazes high in magnesium, in the form of magnesium carbonate, talc, or dolomite, can have a muting effect on a glaze color.

Kiln atmosphere plays a critical part in color development. Electric kilns will produce an oxidation atmosphere. Carbon-based fuels such as wood, natural gas, propane, oil, or coal, when used to fire kilns, can produce oxidation, neutral, or reduction atmospheres, all of which can change the color and surface texture of the glaze.

The firing cycle used to reach temperature can affect glaze color and texture. An increase in firing time to glaze-maturing temperature can cause greater melting of the glaze. A fast firing time to glaze maturity can yield a pale or muted color due to immature glaze development.

The rate of kiln cooling can influence glaze color in the form of devitrification or crystal growth. Micro or macro crystals developing on the glaze surface can have a bleaching or spotting effect on glaze color.

The color of the clay body can alter glaze color. Lighter-colored clay bodies promote contrasting surfaces for glaze colors, while darker clay body colors can lessen or darken glaze color responses.

The thickness of the glaze can influence color. A thin application reveals more of the underlying clay body color.

The glaze application, whether sprayed, dipped, or brushed, can influence color due to the irregular or uniform thickness of glaze.

The amount of metallic coloring oxide or stain and its particle size can influence the fired color of the glaze. For example, cobalt oxide, having a larger particle size than cobalt carbonate, can yield a blue field with blue specking in a satin or matte glaze.

Rutile and cobalt oxide in a glaze, producing depth and variation of color.

Blue stain producing a static color in a glaze.

Overlapping one glaze with another can introduce a combination of materials into a melt, which can alter the color, texture, and viscosity of the glaze.

Clay slips applied to a clay body can influence the development of the covering glaze color.

There are a number of factors influencing color and surface texture in glazes that combine to enhance, stabilize, or negate color responses from stains and metallic coloring oxides. An understanding of ceramic raw materials and how they function under conditions of temperature and atmosphere will give the potter a basic understanding of how to manipulate color in glazes.

22. USING DECORATIVE ENGOBES

The history of engobe use by potters dates back to 3000 BCE, the date at which archaeological excavations reveal Neolithic potters using variously colored clay decorations. Whether it's sprayed, dipped, or brushed on pottery, ceramic sculpture, or structural materials, the terms "slip" and "engobe" have been used interchangeably. Technically, the precise term is engobe, a coating that masks the color and texture of the clay body, imparting color or opacity, which may or may not be covered with a glaze.[1] An engobe is not as glasslike as a glaze but can be slightly more vitreous than the clay body it covers. Engobes contain many of the same raw materials found in both clay bodies and glazes, but they are used in different ratios. They can be applied to ceramic pieces that are leather hard, which shrink more than engobes applied to bisque ware. In both types of engobe the goal is to achieve a compatible fit with the clay body. In some ways, engobes can be more difficult to use than glazes. They have to shrink at compatible rates when applied to the clay body *and* also fit the covering glaze, while glazes only have to match the clay body.

The Zam White Engobe and the Easy Engobe are designed to fit leather-hard clay. They can be fired from c/06 (1828°F) to c/12 (2383°F). Both can be used in oxidation, reduction, salt/soda, and wood kiln firing atmospheres, but colors may vary. It is always best to test the engobes on your own clay body to ensure a correct clay body and glaze fit.* Often, the potter's clay body can be the basis for an engobe. In many situations it will fit better because it shrinks at a similar rate as the underlying clay body. However, if the clay body is a dark fired color, lighter colors or white engobes cannot be produced from this dark clay.

Easy Engobe cone 6 (2232°F)	
Kentucky OM #4 ball clay	70
Custer feldspar	20
Flint 200x	10

Tom White Engobe cone 6 (2232°F)–cone 12 (2383°F)	
Helmer kaolin	60
Grolleg	25
Nepheline syenite 270x	15

Directions: Weigh the dry materials, totaling 100 g, and add approximately 90 g of water. Place the wet mixture through an 80 mesh sieve before applying to leather-hard clay. The engobe must be the correct consistency for the intended method of application. It should be free of coarse particles and air bubbles, be homogeneous, and remain in suspension.

Recommended Testing Procedure: Always test any engobe to ensure a compatible fit with the underlying clay body and the covering glaze. The clay body should be free of dust and surface particles before applying the engobe. Bisque-fire the test tile, after which spray, dip, or brush the covering glaze. Place the test tile in the kiln, and fire to the appropriate glaze temperature. Small test kilns may not produce accurate results due to their faster rates of heating and cooling and lower thermal mass.

Engobes can be used as accent colors on unglazed clay, or a glaze coating can be applied over the engobe.

Engobes offer the potter an alternative method of introducing color and texture to the ceramic surface. They can be used to mask the color of the underlying clay body or introduce new color variations that can interact with covering glazes. Engobes can also respond to the kiln atmosphere in reduction-, wood-, salt-, and soda-fired kilns. In some instances, engobes can be applied thickly, resulting in a raised surface that can add another dimension to the ceramic form. It is always amazing how many "old techniques" can be rediscovered and utilized on modern ceramics.

Zam White Engobe cone 06 (1828°F)–cone 12 (2383°F)			
Grolleg kaolin	25	Yellow	
EPK	14	Mason stain #6404	8%
Kentucky OM #4 ball clay	10	Blue	
Nepheline syenite 270x	14	Spectrum stain #2044	10%
Flint 200x	10	Pink	
Superpax	10	Spectrum stain #2083	10%
Soda ash	5	Black	
Ferro frit #3195	10	Spectrum stain #2004	12%
VeeGum CER	2	Green	
		Spectrum stain #2033	10%

⊘ Applying different-color liquid.

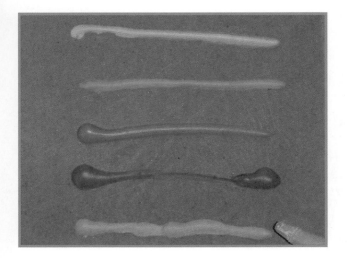

⊘ Blue engobe trailing on black clay body.

⊘ Applying clear glaze over engobes.

⊘ Yellow engobe on platter soda-fired to c/9 (2300°F).

⊘ Clear c/06 glaze covering different engobes to a test piece color engobe.

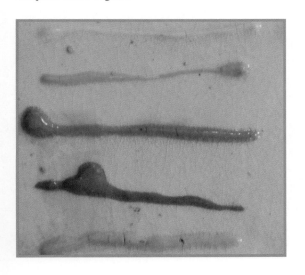

⊘ Yellow engobe detail fired to c/6 (2232°F).

23. CLAY BODY AND GLAZE DEFECTS

When problems occur in raw materials, glazing, or kiln firing, diagnosing the fault is essential in solving the issues. Sometimes the potter observes a problem in the ware but does not understand the actual cause, which can result in lost time and effort. One of the most important elements in correcting a clay body or a glaze defect is determining what type of fault you are observing. Change is inherent in the ceramic medium. Clay body and glaze materials are composed in part of ceramic raw materials that have impurities and can fluctuate in chemical composition, particle size, and processor from one batch to the next. Generally, ceramic materials are subject to strict quality-control procedures at every step in the mining and processing stages, since they are used for large industries that demand a consistent product. However, at some point a defect will occur, and the correct solution will depend on the potter's ability to solve the problem.

While there are some types of defects that are unquestionably clay body related and some types that are attributable to glazes, sometimes the defect is caused by the interactions among kiln firing, clay body, and glaze. Clay and glaze defects can also be caused by any number of other miscalculations, which can range from choosing the wrong clay body or glaze formula for the firing temperature, raw-material mixing errors, inferior clay construction techniques, and a general lack of knowledge on how ceramic materials react in their forming and firing stages. There are many possible clay body defects along with compound defects, which result in more than one type of defect on a pot or ceramic sculpture. Additionally, there could be more than one underlying cause for an individual defect.

Glaze Defects

Generally, if a glaze defect occurs and a thinner glaze application in a subsequent firing removes the defect, it does not remove the underlying cause of the defect. If a glaze is calculated and fired correctly, it should be able to produce a good result if applied too thick or thin. Glaze maturity and heat work play an important part in any firing. For example, when a glaze defect occurs, if it can be refired and corrects itself it means the first glaze firing should have been longer. In this situation, even firing to the same temperature the second time subjects the glaze to more heat work, resulting in increases of melting.

Cracks Tell a Story

The first question that potters ask when they are looking at a failed piece is, Why did this happen? Cracks in the fired ware represent a failure in glaze materials, forming methods, or firing cycles. When examining a crack, first determine if a sharp- or round-edged crack is present in the ware. Once the type of crack is accurately diagnosed, the path to correction can begin. Cracks can also reveal other aspects of the causes of failure. The widest part of the crack in a clay body is where it started. Often, these types of cracks occur when the pot is placed too close to the heat source, whether it is an electric element or gas burner.

Round Edge Cracks

Round-edged cracks are visible after the ware comes out of the glaze kiln: the glaze rolls back from its edge. In some instances the crack might not be seen until after the glaze firing. Round-edged cracks can form under several different conditions. The important thing to know is if the crack was created in the forming, drying, or bisque-firing stage and *then* it was glazed, covering the crack.

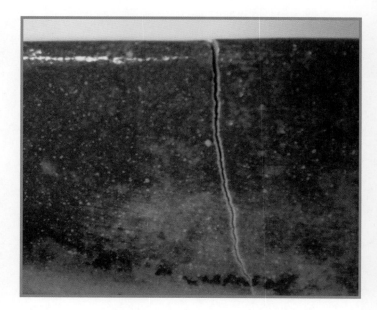

Round-edged crack where the glaze rolls back from the edge.

Forming Cracks

In some instances the pottery is formed incorrectly, such as very thick cross sections of clay butting up against thin sections, resulting in unequal shrinkage upon drying. If excessive water is used in the forming process, clay platelets can be physically separated only by water, causing a crack in the drying stage. Cracks can also develop when deep cuts or holes are cut into the ware, along with any joined handles or knobs, since these areas are potential crack sites due to unequal stresses upon drying. In some instances, sharp edges or holes cut at severe angles can also cause cracking upon drying.

Drying Cracks

Fast drying and or unequal drying can often cause cracks, since both conditions exert asymmetrical forces. This situation is more likely to occur in larger pieces, since increasing scale can magnify the stress upon drying.

Bisque Firing

Fast-firing the bisque kiln can result in cracks due to going through the mechanical- (free water) and chemical-water stages too fast between 212°F and 392°F. At higher temperatures, chemical water is driven off between 752°F and 1112°F (dull-red visible heat in the kiln).

Pottery can also be broken when stacked upon each other too high in the bisque kiln. The cracking might not be visible when unloading the kiln or glazing the pots.

Thermal-shock cracking can occur when the bisque kiln is prematurely unloaded during the 842°F–1112°F region, due to volume changes when the pottery goes through quartz inversion.

Bisque pottery is fragile and easily broken, or, more insidiously, a small stress crack will occur from incorrect storage or mishandling. One such event can occur when glazing a large platter and dipping one part into the glaze, causing the unequal weight of the wet glaze to crack the pot. Once the glaze is applied and the pot is fired, the molten glaze rolls back from the preexisting fissure.

In some instances when one form is tightly placed inside another, one or both can crack in the firing process. This type of defect often happens when nesting bowls are fit tightly together.

The important thing to know about round-edged cracks is they occur BEFORE the piece is glazed, so inspect the bisque carefully for cracks. If in doubt about a possible crack, wipe a wet sponge over the bisque surface, which will accent a crack if present.

Sharp-Edged Cracks

Sharp-edged or hairline cracks occur in the glaze after it has cooled in the kiln. The crack looks like the pot was hit with a hammer. They can occur if the kiln is cooled too fast, resulting in thermal shock. The kiln should not be opened until the temperature has fallen below 200°F. Do not open the kiln if the glaze is "pinging" or making any sound, since this can be the first indication of possible sharp-edged cracks or glaze crazing. Sharp-edged cracks can also happen when a glazed piece is heated or cooled unevenly. When the kiln is cooling, the shelves retain heat longer than adjacent pottery. If large, flat platters are resting directly on the hot kiln shelf, the temperature difference between the hotter shelf and the relatively cooler platter can cause a cooling crack. In this instance a higher stilting of the platter is required to remove it from the radiant heat given off by the kiln shelf. Sharp-edged cracks can also happen if the pot is placed very near a source of heat such as a burner or electric element, Uneven heating causes one side of the pot to heat faster than the other, subjecting the ware to thermal stress.

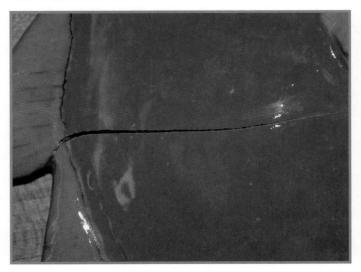

⬤ Sharp-edged cooling crack.

Glaze Crazing and Shivering

Crazing is one of the most common glaze defects. In some instances—depending on the surface texture and color of the glaze—crazing might not be noticeable when it first occurs. If you work with glazes long enough, eventually a glaze / clay body mismatch will take place, causing any number of problems in the

finished ware. However, an accurate diagnosis of the defect will lead you on the path to a successful correction. Glaze crazing, a fine network of lines in the fired glaze surface, and glaze shivering, which looks like a paint chip flaking off the clay body, are examples of clay body and glaze contraction and expansion forces resulting in defects. Both can occur at any temperature range or kiln atmosphere. Significantly, each is caused by opposite reactions of contraction or expansion when the glaze cools in the kiln. Glazes can withstand ten times more compression loads than tension loads, so most successful glazes are under a slight compression. Fortunately for potters, if the clay body and glaze are stable and intact when they come out of the kiln, there is a high probability they will remain so indefinitely. However, in some instances, delayed crazing can take place since the fired clay body can take on moisture from the atmosphere or repeated washings, causing the clay body to expand slightly, disrupting the glaze fit.

Glaze Crazing

While not primarily a clay body defect, crazing can be corrected through adjusting the clay body, glaze, or both. When the clay body and glaze reach temperature in the kiln, everything fits perfectly. At this point, think of the glaze as a honey-like viscosity on the rigid underlying clay body. Upon cooling, the glaze contracts more than the clay body. The glaze is now under *tension*. Glazes are most stable when under slight *compressive* loads. Some glazes can craze while cooling in the kiln or immediately upon opening the kiln. The primary craze lines can be joined by delayed crazing or secondary crazing days or months later. In some instances a glaze might look intact and then craze when in contact with moisture.

One of the many methods to correct crazing is the addition of low-expansion material such as flint to the glaze. The addition of flint will bring the glaze fit into a slight compression upon cooling. Other corrections depend on substituting low-expansion oxides in the glaze formula for the relatively high-expansion oxides that are currently in the crazed glaze. One question to ask is, Do all or most of my glazes craze? If yes, the correction might be more readily found by adding 5% to 10% flint to the clay body. In this case the flint or silica remains as a crystalline solid within the clay body and not a glass, as when silica is added to the glaze, the end result being a compatible clay/glaze fit. Many glaze-crazing defects can be traced to an immature clay body or a clay body that is overfired. An often-overlooked situation occurs when the potter fires the kiln to the correct temperature, but the actual firing time to temperature is short. Ceramic materials need the proper time to temperature, as well as absolute end-point temperatures to vitrify and mature.

Ceramic materials fail ten times more frequently under tension than under compression, which approximates the rate at which crazing occurs compared with the failure rate of shivering. Crazing can be aesthetically pleasing, but the lines can also harbor food particles and stains. The greater surface area of the glaze can also

be subject to acid and alkali attack from foods, liquids, or detergents.[1] Crazed ware is also less durable, since the clay body / glaze structure is compromised by the unequal stress.

Crazing is most frequently observed in porous clay bodies fired at any temperature. The clay, once out of the kiln, takes on the moisture in the atmosphere, causing an expansion of the body, while the overlying glaze cannot move and is under tension. In high-temperature glazes above 2232°F, crazing can occur in alkaline-based materials such as feldspars or frits. These common raw materials contain sodium and potassium oxides, which have high rates of contraction. In fact, sodium- or potassium-based feldspars or frits, when test-fired to 2300°F by themselves, will show a semiopaque crazed glaze. Crazing can also develop in underfired or overfired glaze / clay body conditions, since the stable, slight compression fit of the glaze is compromised.[2] As a general rule, if a glaze crazes, the same glaze in another part of the kiln, if not crazed, might develop delayed crazing.

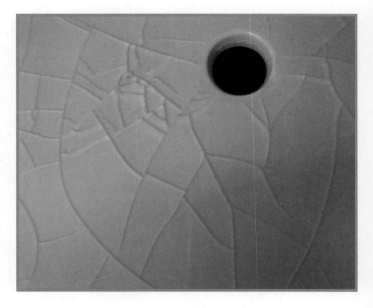

Glaze crazing, a fine network of lines in the fired glaze surface.

Correcting Crazing

The first step in eliminating crazing is selecting a clay body that will mature at the same temperature as the glaze, ensuring a slight compressive load on the glaze as it cools.

Fast-firing the glaze kiln is a significant cause of crazing, producing an immature clay body that does not fit the covering glaze. While the final temperature achieved is important, it is also the *time* it takes to reach the end-point temperature that affects the clay body maturity. On the

opposite end of the spectrum is exceptionally slow firing or overfiring, both of which affect the clay body / glaze fit. In some instances the same glaze will craze in one kiln and not in another, which is due to different firing cycles that promote the glaze forming under a slight compression in one kiln and not the other.

The greater the tensile stresses between the clay body and glaze, the closer the craze lines.[3] Conversely, if the craze lines are ½" or farther apart, many glazes can be corrected by adding silica (flint) 325 mesh, 400 mesh or finer, to the glaze in 5, 10, 15, or 20 units of measure; for example, if your glaze has 50 g of flint, increase it to 55 g, 60 g, etc., while keeping all other glaze materials at their original amounts until the problem is solved. Silica has a low expansion/contraction rate in the glassy or glaze state, reducing tension in the glaze. Finer-mesh silica is more reactive in the total glaze formula, which can be more effective in eliminating crazing. Fused silica at 325 mesh or finer, having a lower rate of expansion/contraction, is even more effective in correcting crazing.

Where the craze lines are closer together than ½", additions of flint will not correct the problem. The entire glaze formula should be recalculated by using one of the many available glaze calculation software programs. Such programs make it easy for the potter to replace materials with high expansion rates with materials with lower expansion rates, while keeping the total glaze formula within limits. The goal should be to decrease the high-expansion materials such as feldspar or frits, or any materials containing high levels of potassium, sodium, or calcium oxides. Increasing other low-expansion materials, including boron (B_2O_3), can also correct crazing.[4] The end result should cause the glaze to be under a slight compression when cool, since this is the most stable clay body / glaze configuration.

The addition of silica (flint, 200 mesh) to the clay body in 5, 10, 15, or 20 units of measure can also correct crazing, since silica remains in a crystalline form with a high rate of contraction, thus bringing the clay body into a correct fit with the glaze. However, when one glaze is crazed, a correction through the glaze formula is best. Where many glazes are crazed on the same clay body, a correction of the clay body should be tried as opposed to trying to adjust every crazed glaze.

If possible, firing the glaze kiln one or two cones higher might bring the clay body and glaze into a more compatible fit. Also, a longer firing time to the end-point temperature will increase the maturity of the clay body and glaze. However, if the clay body and glaze are already at their maturity range, greater crazing can occur.

In low-temperature clay bodies, increasing the bisque-firing temperature by one or two cones might bring the clay and glaze into a better fit.

To prevent crazing, slow cool the glaze kiln, especially if you hear pots "pinging" when the kiln door is open. Ideally the pottery should be unloaded barehanded or at least at temperatures below 200°F.

If the glaze formula contains frit, choose one with a lower coefficient-of-expansion rate.

Crazing can sometimes be eliminated by a thinner glaze application, but this action never addresses the underlying cause of the defect.

Frequently a combination of methods will work, depending on the severity of the problem. It is important to be flexible in your thinking while evaluating test results. If the craze lines are moving farther apart, you are on the right track. If the craze lines are closer together, try something else. While these corrections are not the only way to correct glaze crazing, they have consistently shown good results.

Glaze Shivering

As with crazing glaze, shivering is also a clay body glaze nonfit event upon cooling. However, in shivering, the fired glaze is under too much compression and begins to buckle or flake off in sheets, exposing the underlying clay body. Shivering is less common than crazing, but in some respects more severe. Shivering glaze chips can range from ¹⁄₁₆" to 2" in size. It often looks like a sharp paint chip coming off the fired clay body, and sometimes enough force is created to break the clay body, causing a sharp, jagged crack. Shivering frequently occurs on the edges or ridges of ceramic forms. Many times, hitting the edges of the pot with a metal tool can induce shivering in such highly stressed, compromised glazes. If one glaze shivers, all other ware in the kiln with the same glaze / clay body combination can be suspect and compromised. Some ceramic pieces might look stable when unloaded from the kiln, but shiver at a later date.

⊙ Glaze shivering; the glaze peels off the fired pot.

Shivering Corrections

Since the glaze is under *extreme* compression, the reverse corrections of crazing—where the glaze is under tension—are required. Increasing feldspars, frits, or other high-expansion materials in the glaze will shrink the glaze onto the clay body as cooling progresses. For example, increasing the feldspar component of the glaze by 5, 10, or 15 units of measure while keeping all other materials at their original amounts will shrink the glaze onto the clay body. Often, the shivering glaze is on a "knife edge" of fit or nonfit. A 2% to 4% increase of feldspar or other high-expansion materials in the glaze formula will bring the glaze into a stable configuration.

Decreasing the flint—a low-expansion material—in the clay body by five or ten parts while keeping other materials the same will bring the covering glaze into less compression.

Substituting a sodium feldspar, which has a higher coefficient of expansion, for a lesser coefficient-of-expansion potassium feldspar will shrink the fired glaze. Be aware, though, that some glazes will change due to this type of substitution and can yield differences in color, surface texture, or firing range.

To correct shivering in the clay body, add 5, 10, or 15 units of feldspar, frit, or other high-expansion materials while keeping

all other materials at their original amounts, causing the feldspar to take quartz particles into a solution in the melt, resulting in less thermal expansion in the clay body. Less thermal expansion during heating results in less contraction upon cooling. High-contraction clay body formulas can put the overlying glaze under extreme compression.[5]

In high-temperature clay bodies, the creation of mullite above 2193°F helps the development of a strong clay body / glaze interface (where the clay body ends and the glaze layer begins), releasing bubbles in the glaze, which are potential stress areas. In part, mullite development in the clay body can be achieved by the correct temperature increase in the kiln to clay body and glaze maturity.[6] Often, a fast firing to the correct pyrometric cone does not take the place of a slower firing to the end-point temperature. Statistically, some of the best firing cycles occur at a 75°F–80°F temperature increase from 1828°F (cone 06) to 2232°F (cone 6), or if the pottery is fired to 2300°F (cone 9). A slow increase in temperature allows for a stronger, more durable clay body and glaze fit.

Other less practical methods for correcting shivering include lowering the maximum firing temperature and firing fast to the maximum temperature, either of which should reduce the expansion coefficient of the clay body. However, at a certain point the clay body and the glaze maturity can be compromised.

Choosing clays with lower iron and lime content should also improve the clay body / glaze fit.

Soluble-salt migration to the surface of the clay body can cause an intermediate layer, preventing a secure glaze formation on the clay body. Additions of ⅛% to 2% barium carbonate will neutralize soluble salts in the clay body.

Glaze shivering can also occur when a high-iron-content clay body is overreduced in the kiln firing, the result being a layer of carbon interfering with the covering glaze, which flakes off when cooled.

Another course of action is to simply use another clay body of the same fired color and temperature range. Statistically, shivering glaze / clay body mismatches are rare when compared with the many possible glaze and clay body combinations that do work compatibly.

As in glaze crazing, if only one glaze has shivered among several, the corrections should take place with the defective glaze. If more than one glaze has shivered, an adjustment to the clay body is required. Crazing is ten times more likely to occur than shivering.

◐ Black coring in low-fire red clay body.

Bloating

To further complicate the diagnosis of a clay body defect, keep in mind that some defects have more than one possible cause. The potter must be an inquisitive detective to weed out the elements that are not relevant to solving the problem. For example, if a clay body is bloating (a series of bubbles or voids within a fired piece of clay), is the defect caused by an overfired kiln, causing the lower melting materials in the clay to overflux, or is the clay body mixed incorrectly, fluxing the clay past its point of maturity? Gases trapped in the clay during its vitrification phase can also cause bloating.

How to correct: To overcome this type of defect, a complete oxidation atmosphere in the kiln must be achieved during the 662°F–1292°F region, which will remove organic material from the clay.

◐ Black coring in low-fire red clay body.

Black Coring

If organic material is trapped within an iron-bearing clay at higher temperatures, it turns into a gas. The gas will react with the iron, causing silica to flux in the clay body. The fluxing action stops oxygen from penetrating the clay body during the firing and prevents carbon from being removed during the early stages of the firing. The end result of this reaction is a black core, since the gas cannot escape the vitrified clay body.[7]

How to correct: How can the potter determine which factor led to the clay body bloating or black coring? Asking a series of questions can narrow the possible causes. Was the kiln fired to the correct temperature? Did the bloating problem start with a new batch of clay (possibly an error in clay body mixing)? Was the kiln fired in a completely oxidation atmosphere in the early stages (an oxidation atmosphere will burn out any organic material in the clay and prevent black coring)? Many potters fire their bisque kiln the same way every time and get good results; however, if a batch of clay is delivered with higher-than-normal organic content, the standard bisque-firing cycle might not volatize the organic materials completely. Wide-based forms such as plates and tiles can hold carbon during the firing if not properly placed in the bisque kiln to allow for complete air circulation around the forms. Often, a bisque kiln firing cycle that has worked well for functional pottery will not work when firing sculpture, due to the larger surface areas coming into contact with the kiln shelf, blocking oxygen from reaching the clay. Thicker cross sections of clay also need more time in the bisque firing to allow for carbon to be volatized out of the clay. Never take anything for granted when working with ceramic raw materials. The importance of keeping accurate records of clay deliveries, clay body formulas, and kiln firings helps focus an investigation and leads to the problem's origin and eventual resolution.

◐ Clay body bloating, releasing gas.

◐ Bloating can be caused by an overfluxed clay body or an overfired clay body. Trapped gases from incomplete combustion of organic material not volatized in the initial stages of the firing can form gases in the dense clay body, which cannot escape.

Scumming

Scumming occurs when soluble salts are released from clay(s) in a clay body formula. It appears as a white crystalline powder on bone-dry clay, fired clay, or both. It frequently happens on red, low-temperature, high-iron-content earthenware clay bodies. Scumming can readily be observed on common red building bricks as a white powder. Soluble salts can "wick" to the surface of the clay body as water evaporates during the drying process. When scumming appears after the clay is removed from the kiln, atmospheric moisture draws the soluble salts to the surface. Soluble salts can discolor an unglazed, fired-clay area and can also cause defects on a fired glaze surface by interrupting or overfluxing the clay/glaze boundary layer.

How to correct: A 1% to 2% addition of barium carbonate added during the clay-mixing process can neutralize the soluble-salt content contained within the clay body. A clay body additive such as Additive A types 1, 3, or 4 (a modified calcium lignosulfonate) adds green strength and plasticity to the moist clay and can also neutralize soluble salts due to its barium component.[8]

Lime Pop

Limestone in the form of calcium oxide nodules can occur in some clay. The size of the limestone particle is the determining factor in its future ability to cause a clay body defect. Lime pop can occur once the clay is out of the kiln and moisture expands the lime (calcium hydroxide) particle. A lime pop can produce a half-moon-shaped crack in the fired clay body. If the crack is pried up, there sometimes is a black or white nodule at the bottom of the conical-shaped hole. It is this particle that expands when in contact with moisture. If the same amount of lime is dispersed as a powder, the smaller particle size will not cause an excessive expansion when in contact with moisture.

How to correct: Lime pop can be eliminated if the contaminated clay is placed through a sieve to remove the limestone particles; however, this can be an expensive, labor-intensive process. If potters are buying moist clay from a ceramics supplier, they should ask for a replacement batch of clay.

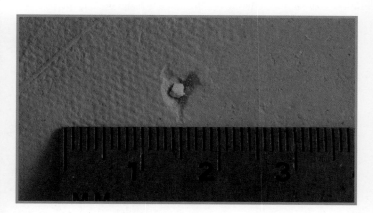

⬆ Lime pop: particles of lime can be found in clay. When the fired clay is in contact with moisture, the nodule of lime expands, leaving a half-moon-shaped crack. In some instances at the bottom of a conical-shaped hole, there is a black or white particle of lime (calcium hydroxide).

Cooling Crack

A unique type of cooling crack occurs when the glaze and the clay body shrink at incompatible rates upon cooling. The defect is often characterized by a loud, sharp, spiral-shaped crack. If a glaze and clay body are incompatible, often glazing only one side of the pot (inside or outside) will cause a crack upon cooling. Most glazes are compatible with most clay bodies,

⬆ Scumming: soluble salts within the unglazed, low-temperature earthenware clay migrate to the fired clay body surface, revealing a random pattern of white crystalline powder. Scumming can occasionally be found in high-temperature clay bodies.

and in such stable configurations a glaze can successfully be used on only one surface of the pot.

The presence of too much free silica in the clay body is interesting, since many stoneware or high-temperature clay bodies contain fireclays, which are the least quality-controlled group of clay used by potters. Fireclays can periodically have high levels of free silica (silica not tied up with clays, feldspars, talc, or other clay body materials), often in the form of fine sand, which can result in spiral-type cooling cracks in clay bodies. Since irregular batches of fireclay are random, it is most difficult to determine if adjusting the clay body will solve the problem. In many instances the next batch of fireclay or another type of fireclay will not have high levels of free silica. Potters often blame the type of fireclay that has caused the problem; however, if all types of fireclays are tracked over millions of pounds, they have almost equal rates of failure.

How to correct: One correction for this type of cooling crack is to add more flux to the clay body, most commonly in the form of feldspar or frit in low-temperature clay bodies. Often as little as a 5% addition will bring about a stable clay body and glaze configuration. Additions of feldspar or frit will bind up with the free silica, resulting in less contraction in the clay body. As an alternative fix, changing the clay body or changing the glaze most often brings about a correction, since the chances of a nonfit are considerably less.

Fast Bisque Firing

A fast bisque firing can result in a clay body crack or in some cases an explosive burst in the clay body, causing nearby pots to crack or explode. Clay contains mechanical water and chemical water, which have to be driven off slowly. The removal of mechanical or free water is accomplished from 212°F to 392°F, followed by the removal of chemically combined water from 842°F to 1112°F. While there are other changes taking place in the clay during the bisque and subsequent glaze firings, fast heat increases in the early stages of the firing can result in cracking and exploding pottery.

The general rule for bisque firing follows that slow is better than fast, and, when in doubt, a slow bisque firing can do no harm to the pots. For most functional pottery forms that are dry to the touch when placed in the bisque kiln (pottery still has mechanical and chemical water), a 12-hour total firing time is recommended. Slower bisque-firing times are required if the pots are thicker than ½" or taller than 14". If plates, tiles, or wide-based forms are to be bisque fired, a longer firing is also required.

Bisque tile showing indications of carbon trap (gray, center area). Carbon in the bisque is caused by incomplete combustion of organic material in the raw clay. It can be removed by a complete oxidation firing in a well-vented kiln.

Fast bisque firing. A fast bisque firing can cause the water contained in the clay to turn to steam at a fast rate, causing cracking or blown-out sections in the pottery.

Glaze Crawling

Glaze crawling occurs during the firing when the molten glaze, having a high surface tension, draws away from itself, leaving areas of exposed clay. The defect often looks like beads of glaze of various sizes. The high surface tension of water on a glass table top is similar visually, with the same forces at work. In glaze crawling, the glaze does not mechanically bond to the underlying bisque or, in once firing, the raw clay body. Crawling can be caused by any medium that disrupts the clay/glaze interface, allowing parts of the glaze to pull away from the clay body during the firing. Glazes that are "dusty" and fragile (glaze materials not bound to each other or the underlying clay surface) when drying are subject to crawling as the glaze matures in the kiln firing.

How to correct: Bisque pottery should be covered when not intended for glazing operations. Any bisque dust should be blown off the pottery. Often, moving over the pottery with a damp cloth only moves the small surface particles to another location on the pot. Any particles that come off when handled before glazing raw or bisque ware should be suspect of possible crawling sites. In glazing raw ware for a once-firing process, mechanical and chemical water has to be removed slowly in the first stages of the firing (212°F–1112°F); if not, a disruption of the covering glaze layer can occur. Additionally, a slow firing cycle through these temperature ranges ensures a measured release of water vapor pressure, thus preventing cracking.

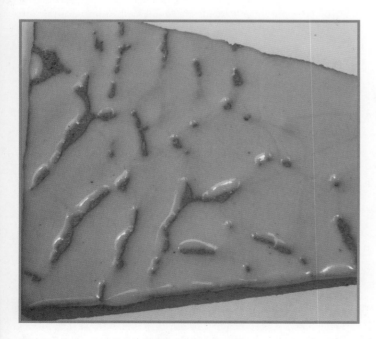

Glaze crawling: the fired glaze rolls back, exposing the bare clay body. This type of defect is often compared visually to water on a glass table.

High-Clay-Content Glaze Formulas

High-clay-content glazes also have high shrinkage rates, which can sometimes be observed as cracks in the glaze as it dries on the pot. Shrinkage continues during the firing, causing a flawed bond with the underlying clay body.

How to correct: Use calcined clay for half the clay component in the glaze formula. Calcined clay, having been already fired, shrinks less than unfired clay when used in the glaze formula. Another alternative is to use a clay that shrinks less than the original clay component of the glaze formula. If the original formula calls for ball clay, a high-shrinkage clay, kaolin with less shrinkage might be substituted. Less glaze shrinkage at this stage can eliminate crawling as the fired glaze begins to mature. Add VeeGum CER or carbonxymethylcellulose (CMC) to the glaze; both materials act as binders.[9] Glaze binders keep the high-shrinkage and light-density glaze materials together long enough for the sintering or melting process to take place. The best situation is a uniform, continuous-bonded glaze layer over the clay body surface.

Low-Density- and High-Shrinkage-Rate Materials in the Glaze Formula

Low-density glaze materials can also cause crawling. For example, magnesium carbonate, a light, soft, and fluffy material, has a very low density. Bentonite and other types of clays shrink excessively. Both characteristics contribute to crawling. Low-density materials do not compact well on the clay body when the water leaves the glaze, and a soft, powderlike surface forms. Often the glazes are difficult to handle and load into a kiln without damaging the dried raw glaze surface. Once the water evaporates it can leave light-density materials "unpacked" and loose, causing an insufficient bond with the clay body underneath the glaze.

How to correct: Where possible, use materials in a glaze that have higher densities. When not possible, consider the use of VeeGum CER or CMC to bind the glaze together in the application and drying stages.

Materials that have excessive shrinkage rates, such as Gerstley borate, colemanite, soda ash, and borax, can hold massive amounts of mechanical or chemical water. Zinc in a glaze can also cause crawling due its shrinkage rate at high temperatures. A glaze material that is excessively ball milled can also cause crawling due to the increased amount of surface area that must be made wet for glaze application.

How to correct: Substitute a coarser grind of the light-density material, or use VeeGum CER or CMC as a binder. Often, frits can be used (less shrinkage due to the calcining process) in place of Gerstley borate or colemanite. In some situations, lesser amounts of the high-shrinkage material can be used in the glaze.

Bisque-Firing Faults

Bisque-firing faults can cause crawling when the firing temperature of the bisque kiln is not high enough for correct glaze absorption. If the ware is too absorbent it can cause a thick buildup of glaze. Thick glaze applications are more likely to crack upon drying, which results in crawling. Too high a bisque temperature or uneven hot spots on the bisque ware can cause the glaze to adhere incompletely, which can cause crawling at the firing stage.

How to correct: Fire the bisque kiln evenly throughout and choose a bisque temperature that will allow the glaze to build up uniformly and to the proper thickness. Most stoneware clay bodies can be bisque fired at c/06 (1828°F).[10] Porcelain bodies usually require a c/04 (1945°F) bisque due to their high refractory clay composition as compared with stoneware bodies.

Wet Glazed Pots in a Fast-Firing Kiln

Some potters will start the kiln firing when the water has not fully evaporated from the glazed pots. Fast heating can cause the water in the glaze to turn into steam, which as it expands blows off parts of the glaze.

How to correct: Place glazed pots in the kiln when they are dry to the touch. Increase the kiln temperature slowly (from 212°F to 1100°F) to drive off mechanical and chemical water in the glaze at a safe rate.

In a once-firing cycle or raw glazing (no bisque firing), steam in the clay body and glaze can increase the crawling potential of any glaze. Many once-fire glaze formulas contain high amounts of clay, which can shrink excessively upon drying, causing crawling in the glaze.

How to correct: Many once-fire glazes adhere well with the addition of VeeGum CER or CMC glaze binders. Spraying the glaze on the pot decreases the amount of water needed in a glaze, and reduces the chances of the raw glaze shrinking and eventually crawling off the pot. Again, slow heating in the 200°F–1100°F range will allow any water present in the clay body and glaze to be released safely.

Overlapping Glazes

Overlapping glazes can cause crawling due to the overlapping glaze drying to a dusty condition. The dusty glaze is frequently soft and fragile to the touch, showing a noncompacted dry surface texture. When this happens, the mechanical bond between the two overlapping glazes is compromised. The glaze in such a condition might crawl even if no overlapping glaze is applied. The dusty glaze or overlapping glazes act like "ball bearings," causing a nongripping condition.

How to correct: If the materials that are causing the "soft or dusty" glaze surfaces cannot be replaced, additions of VeeGum CER or CMC should be used in the base glaze, the overlapping glaze, or both.

Refractory and Dusty Underglaze Stains or Metallic Coloring Oxides

Refractory or dusty underglaze stains or metallic coloring oxides are often applied to raw ware or bisque. Frequently, different-colored metallic oxides or stains are used with a clear or semitransparent glaze covering the color wash. Some stain and metallic oxide colors are more refractory than others and do not readily go into a melt. Metallic oxides or stains containing manganese, chrome, cobalt, and nickel are very difficult to melt. Often, underglaze washes are refractory and will cause the covering glaze to crawl or bead up during the firing.

How to correct: Ferro frit #3195 can be used to flux or melt refractory colors. Try a mix of 60% stain or metallic oxide to 40% Ferro frit #3195 for a c/06 (1828°F) firing. For c/6 (2232°F), use 70% stain or metallic oxide to 30% Ferro frit #3195. For a c/9 (2300°F) firing, mix 80% stain or metallic oxide to 20% Ferro frit #3195. The frit acts as an adhesive, tacking down the refractory stain and thus allowing the covering glaze to take hold and bond with the underlying stain or metallic coloring oxide.

Once the underglaze wash has dried on the raw clay or bisque pot, it should develop a smooth, hard surface that will ensure a stable bond with the covering glaze. If the underglaze wash is dusty and flakes off, glaze crawling is likely to take place.

How to correct: Add 0.5% to 2% VeeGum CER or CMC binders on the basis of the dry weight of the underglaze wash. Water is added until the mixture is at a "watercolor" consistency, then the wet mix is screened through an 80 mesh sieve. The binder also enables the underglaze to flow off the brush in a smooth motion, preventing the brushstroke from skipping across the clay or bisque surface. In situations where an underglaze wash is both refractory and dusty, frit and binders can be used together.

Excessive Glaze Water Penetration in the Bisque Body

Excessive glaze water penetration in the bisque body happens when thin-walled pots are first glazed on one side. The water in the glaze will penetrate through the pot wall, causing a damp or wet clay surface on the opposite unglazed side of the pot. If a glaze is applied to the wet surface, crawling can occur due to the glaze not bonding properly with the underlying clay body.

How to correct: When glazing thin-walled pots, wait for the opposite clay body surface to dry completely before applying the glaze coating.

Spray Glaze Application

Glazes are likely to crawl if the spraying continues after the first glaze layers are still wet. Excess water in the glaze as it evaporates leaves dry glaze particles loosely compacted. Any interruption of the glaze-bonding surface can promote an unstable platform for the forming glaze.

How to correct: Spray glaze until the surface becomes moist, then stop. The glaze should pack or compress itself on the clay body surface, resulting in a stable bond.

If the glaze is sprayed from too far a distance, a dry, dusty, lightly packed glaze layer can develop, conditions that promote glaze crawling.

After spraying, when the glaze is dry, touch or lightly rub the glaze surface; it should not dust off excessively. The glaze must remain fixed and in place on the bisque surface. Practice spraying with different concentrations of water to glaze and at varying distances from the clay surface to obtain the best results. The raw-material makeup of a glaze formula determines the amount of water required for successful spraying. In short, some glazes need more water for good spraying results, some less.

Soluble Salts

Soluble salts in the clay body can cause crawling. Soluble materials can be found in high-iron-content earthenware clays and fireclays. Often, soluble salts will leach out to the surface when the clay dries. Bisque firing will not completely remove the salts that form a loose surface on which the moist glaze must try to adhere. The glaze layer will then make insufficient contact with the clay body, causing the glaze to mature in "midair." Excessive ball milling of the glaze can release soluble material, which can also cause crawling.

How to correct: Washing or scraping the salt deposits off the bone-dry or bisque clay is a waste of time. Barium carbonate mixed into the clay body (0.25% to 2%, on the basis of the dry weight of the clay body) will prevent the formation of soluble salts. Additive A types 1, 3, or 4, used as a clay body additive (0.06% to 0.25%, on the basis of the dry weight of the clay body), will also neutralize soluble salts.[11] The barium carbonate component in Additive A is tied up safely with a ligneous polymer.

Chemical Changes in a Glaze

Chemical changes in a glaze can occur due to soluble glaze materials leaching into the glaze water. An increase or decrease in the water pH levels can also develop due to the breakdown of raw materials or from the original water source.[12] Glazes stored in the liquid state for long periods can develop bacteria or mold growth. Any changes in pH or organic conditions can alter the glaze bonding capability.

How to correct: Try to use insoluble glaze materials when possible, or add acid-based or alkaline material to adjust the glaze water pH level. One or two drops of bleach per gallon of glaze can counteract mold or bacteria growth in the glaze.

High Surface Tension Glazes

Glazes that contain high percentages of alumina, tin, Zircopax, Superpax, or any of the other zirconium silicates can cause the fired glaze to become "stiff" when molten. Often, glazes containing such materials are opaque when fired, and some glazes have matte surfaces, all factors that contribute to a high-surface-tension glaze in the molten state. Frequently, the glaze does not run or pull down on vertical surfaces and does not fill voids or crevices in the clay body. Pinholes can often be seen in the fired glaze surface. A glaze with a high surface tension will condense or pull into itself, exposing areas of bare clay. Conversely, a glaze with a low surface tension flows out, filling surface cracks and voids in the underlying clay body.

How to correct: Reduce the percentages of alumina, tin, or other glaze materials that produce high surface tension. In some cases, substituting a raw material with a lower surface tension will be necessary. However, most glaze crawling is not due to high surface tension, but to other factors such as glaze adhesion, glaze thickness, and raw-material shrinkage rates.

Glaze Pinholes

Pinholes are one of the most difficult glaze defects to diagnose, since there can be many potential causes. Pinholes are often confused with glaze blistering because the outer ring of the defect can sometimes have a slightly sharp edge. However, pinholes have a smooth edge while blisters have a sharp crater edge. Pinholes are characterized by a round hole in the fired glaze, revealing the underlying clay body. They can range from small pinprick sizes to ¼" in diameter. Thicker glaze coatings are more conducive to pinholes due to the greater distance the bubbles have to travel to reach the top glaze layer. Conversely, a thinner glaze layer will lessen the possibility of pinholes or other glaze defects; however, the underlying cause of pinholing and other glaze defects should be addressed in either instance.

Glaze pinholes: a round void in the glaze surface, revealing the underlying clay body and having a smooth outer edge.

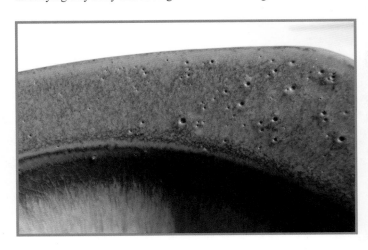

Bisque Firing

Organic materials in clay body formulas, such as lignite, organic material, or sulfur, if not efficiently volatilized out during the first 572°F–1292°F of a bisque or raw firing, can leave organic matter in the clay, which releases as a gas at higher temperature. The gas then goes through the molten-glaze layer, causing a pinhole. Low bisque temperatures can also result in pinholing, since the glaze is absorbed too quickly into the bisque surface, creating voids that can be noticeable after the glaze dries. Some glazes are not fluid enough when mature to fill in the voids.

How to correct: A longer or higher bisque or raw firing is required to remove organic materials from the clay. Pottery, especially horizontal forms such as plates or tiles, should be stacked with allowance for air circulation during the firing. With hydrocarbon-based fuels, an oxidation atmosphere (more air than fuel in combustion) is essential throughout the firing to completely combust the trapped carbon in the clay body.

Underfiring Glaze

Immature glazes that have been underfired can pinhole due to incomplete melting, resulting in a "stiff" glaze that cannot flow into voids caused by escaping gas either from the clay body or glaze.

How to correct: Firing the glaze to its correct temperature and the correct length of time to maturity will decrease or stop pinholes. Holding the glaze at its maturing temperature range will also cause a greater degree of melting and fluidity in the glaze, filling in the voids left by escaping gas.

Overfiring Glaze

Glazes can pinhole if overfired or if the glaze formula has exceeded its flux limit. In some instances, pinholes can occur if the glaze is calculated correctly and fired to the correct temperature but held at its maturing point too long, thus increasing its melt.

How to correct: Ensure that the glaze has the appropriate amount of flux, fire to the correct temperature, and do not institute excessively long hold times when the glaze is mature.

Decomposition of Glaze Materials

Many glazes in their maturing stage go through a process where gases from the decomposition of glaze materials and air spaces between materials are released as bubbles rising to the top of the glaze layer. In most instances, potters are not aware of the bubbles breaking at the glaze surface and then producing a smooth glaze surface. For example, whiting contains calcium and carbonate, which is released as a gas during the firing.

How to correct: Whenever possible, use raw materials that do not contain a carbonate component. When materials such as whiting are used in a glaze, try firing the kiln longer to release any gas bubbles.

Clay Body Contamination

Foreign matter in raw materials, clay-mixing procedures, and glazes can result in possible organic matter not being removed from the fired clay, and in glazes that can be released as a gas through the glaze layer. Often, dry glaze particles that contain trapped air fall into the liquid glaze batch, causing air pockets in the applied glaze, all of which can produce pinholes in a glaze.

How to correct: Whenever possible, use quality-controlled raw materials in clay bodies, thoroughly clean clay-mixing equipment, and sieve liquid glazes before using.

Overglaze/Underglaze Surfaces

Underglaze colors can be color washes (metallic coloring oxides or stains combined with gums and water to produce a "watercolor"-consistency painting medium) or actual colored glazes that can be applied over or under the base glaze layer. Any dusty overglaze, underglaze, or glaze surface is subject to pinholing during the firing. Dry, unbound particles trap air, which is then released during the glaze maturation period. While some glazes have low viscosity (for example, water has a low viscosity and high fluidity, while honey has a high viscosity and low fluidity) when molten and can heal any irregularities, many glazes are stiff and have higher viscosities, which trap and hold any air bubbles.

How to correct: Gums such as CMC or VeeGum CER in additions of 0.25% to 3% can be added to underglaze, overglaze, or color washes to "tack down" dusty fragile surfaces. Additionally, if the base glaze is dusty, gums can be added in the above percentages to form a stable glaze surface for any color applications.

Pinholes in Slip Cast Ware

The presence of bubbles in the liquid slip can lead to future pinholes in the fired glaze. Pinholes offer a path for escaping gas to enter the molten-glaze layer. Slip-cast formulas offer a unique series of potential defects in the mixing cycles and the variable character of the liquid slip, especially in comparison to clay body formulas used in handbuilding and wheel-throwing forming operations. Violent agitation in mixing casting slips can introduce air bubbles into the slip, which during the firing can exit the clay into the glaze layer, causing pinholes.

Organic Content of Slip Materials

Clays used in casting slip such as ball clays can have high levels of organics such as lignite, or other combustibles such as sulfur compounds, which if not removed in the first stages of the firing can exit as a gas through the glaze layer.

How to correct: Choose clays with demonstrated lower levels of organic materials in addition to firing the kiln longer in an oxidation atmosphere to remove combustible components.

Slip-Mixing Times

Pinholes in the cast ware can develop if the slip is not given enough time for complete assimilation to take place, or if reclaimed slip is introduced into the mix. Both situations allow for air bubbles to remain in the slip formula without being completely released. Contamination from dirt and dust can also be present in the dry slip scraps, all of which introduce air or foreign particles into the slip. Furthermore, the casting slip cannot be violently agitated in the process, since this will also introduce air in the mixing blades' vortex.

How to correct: Allow enough mixing time for all of the materials to be thoroughly saturated, and allow for any bubbles to come to the surface and dissipate during the mixing process. The use of reclaimed scrap slip should be carefully monitored to avoid contamination. When in doubt, it is less expensive to throw away any suspect reclaimed slip. If reclaimed slip is used, an increased mixing time should be considered, allowing for air bubbles to be released from the liquid slip.

Coarse Materials

Any coarse materials found in the slip can cause voids in the water/solids mixture. Such spaces trap air, which can be released in the mixing, pouring, or casting stages as bubbles. This condition is especially prevalent in high-viscosity slips, which are slow moving and allow for trapped air pockets.

How to correct: Try to vary the particle sizes of clay and other materials in a slip formula. If the formula cannot be adjusted, longer mixing times are required to thoroughly remove any bubbles.

Fast Pouring into Molds

High pouring speeds when the slip is placed into the mold can cause bubbles to set up in the casting process.

How to correct: Pouring the slip slowly into molds helps reduce or stop bubbles from forming as the slip dries.

Alterations in Casting Slips

Casting slips are an amalgam of water, clays, raw materials, and deflocculants, all of which react with each other in the mixing and

storage stages. Organic materials in clays can affect the deflocculants, starting a fermentation process in the slip and causing changes in its viscosity. The pH factor of the water and any organic materials it contains can further alter the slip. The unique feature about casting slip is its ability to change during or after the mixing process, all factors for creating air spaces in the slip, which form as bubbles.

How to correct: After mixing, do not assume that the casting slip will maintain the same viscosity or ability to dissipate and potential bubbles. It is always best to check the stored slip and adjust for viscosity and, if necessary, sieve the slip to break up any bubbles before pouring it into molds.

Dry Molds

Newly made or excessively dry molds can "wick" water out of the casting slip at fast rates, causing bubbles, much like water placed on a dry sponge.

How to correct: There is a balance between having an extremely dry mold and one that is so saturated with water that it causes an excessively long setup of the slip. Often, wiping a nonlint cloth over a dry new mold will prevent bubbles from occurring in the casting slip.

Dusty Molds

In storage between castings, molds can accumulate dust, dry slip particles, and other contaminants, which can cause voids in the casting slip.

How to correct: Keep molds covered when not in use. Wipe any foreign particles from molds before pouring casting slip.

Slip Contamination from Pipes and Containers

Dry slip particles or other contaminants can collect in piping and containers. It is not unusual to have "chips" of dry slip fall back into storage containers.

How to correct: Thoroughly clean slip storage containers and piping after every use. The most effective procedure is to have the slip pass through a sieve before entering the molds.

Change Happens

Ceramics materials, forming methods, and kiln-firing techniques are constantly changing. Some variations are so slight that they are not noticed in the final pottery. However, at some point a variation will exceed those parameters and cause a defect. There is a vast range of clay body defects, which can be caused by unbalanced clay body formulas, forming irregularities, firing deviations, and raw-material variables in terms of chemical composition and particle size. Some defects are in fact caused by an incompatible clay body / glaze combination. Seeing and touching an actual example of the defect will be an invaluable experience in identifying and correcting future clay body defects. Often, potters encounter a defect and do not have the experience to identify the problem correctly. At this point, resolving the defect becomes less possible. It is often a good idea to assemble a collection of different faults as a visual guideline for correcting future defects. Potters should avail themselves of the many ceramics books that can be used as reference guides in determining the correct course of action that will resolve a specific defect.

It is often said that "the only thing consistent about ceramics is its inconsistency." The best defense against the variable nature of ceramic materials is knowledge. It is important to understand the individual characteristics of each raw material and how it reacts with other materials in various kiln-firing conditions. An extensive and varied ceramics education is ultimately the best tool in correcting clay body defects.

If moist clay is purchased from a ceramics supplier, the supplier has only a limited liability and is responsible only for replacing the defective batch of clay and not for any damages caused by the clay. The limited-liability policy is an industry standard that applies when it is proven that a substandard material or mixing error has occurred. Commercial glazes have a degree of reliability. Both premixed clay and commercially prepared glazes are thoroughly tested and used by many potters, establishing a good track record. However, commercially prepared ceramics products are not perfect, and at some point, if other sources of defects are ruled out, they should be investigated.

24. DIAGNOSING GLAZE BLISTERS

Diagnosing glaze blisters deserves a separate chapter, since this defect is one of the most complicated to diagnose and solve because there are so many possible causes. Often the potter thinks he or she is correcting the fault, only to discover that it continues to surface in subsequent firings. *Glaze blisters appear as pronounced, sharp-edged burst bubbles that look like craters on the fired glaze surface, often revealing the underlying clay body.* Glaze blistering can really tax potters' investigative abilities. Any exploration into this common defect will require an analysis of kiln firing, clay body, and glaze conditions. The first priority is to accurately diagnose the problem and then to determine what incident or series of events caused it. Only then will it be possible to enact the appropriate correction.

Possible Causes of Glaze Blisters

⊙ Glaze blister: blisters can be random or in specific areas, depending on many factors.

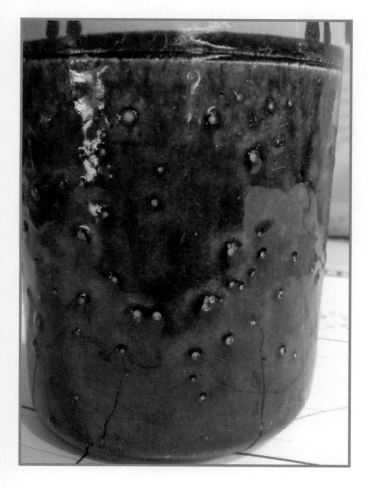

Kiln Firing Conditions

Overfiring can result when any glaze is taken past its maturation temperature, and lower-melting-point oxides within the glaze volatize (see image on page 164). The effect is similar to water taken past its boiling point. *Correction: Firing the glaze one or two cones lower will bring it into its maturing range.*

Excessively long firing in the glaze-maturing range can cause volatilization of oxides, resulting in blisters. A longer time to temperature imparts additional heat work in the glaze even if it is taken to its correct maturating temperature (see image on page 164). *Correction: Shorten the firing cycle while still firing the glaze to its maturing range.*

An excessively long cooling cycle in the glaze kiln contributes more heat work when the glaze is in the molten state, causing oxides to boil in the liquid glaze. Similar results can occur in overinsulated kilns, which allow the glaze to remain in its maturing range for extreme periods of time. *Correction: Long cooling cycles are more prevalent in hydrocarbon-fueled kilns (natural gas, propane, wood, oil, sawdust), which tend to be better insulated and larger in size, having more thermal mass than electric kilns. Upon reaching temperature, pulling the damper out and unblocking the secondary burner ports for a short time will cool the kiln faster.*

Down-firing the kiln, or leaving burners or electric elements on after the glaze has reached maturity, exposes it to excessive heat work when molten. *Correction: In most instances it is not necessary to down-fire a kiln to achieve a stable glaze. However, if a particular glaze requires downfiring, progressively shortening the down-firing interval will decrease its time in the maturing range.*

Fast firing leaves blisters in the glaze that would have healed in a longer firing. Some glazes go through a heating period when they boil and blister on their way to maturity. If this interval is too short, blisters are "frozen" in place and do not heal. Fast firing can also trap mechanical and chemical water locked in the glaze materials, which are not completely driven off until above 932°F. *Correction: Extend the length of time to reach the end-point temperature.*

Firing the glaze below its maturation range can leave a dry, pale color or blistering in the glaze surface. *Correction: Fire the glaze to its correct maturing range.*

Fast firing of the bisque kiln can trap organic materials in the clay, which can then volatize during the glaze firing. The gas exits through the stiff liquid glaze, causing a blister. *Correction: A longer bisque-firing cycle will enable organic material to escape.*

Nonoxidation bisque firing can trap organic material in the clay; the organic material exits at higher temperatures as a gas through the molten glaze as a blister. Large platters stacked together or tiles placed atop one another do not allow for combustion and removal of organic material, due to their relatively large surface areas touching. *Correction: In hydrocarbon-fueled kilns, always use more air than fuel to create an oxidation atmosphere. In electric kilns, the use of an active venting system removes organic matter from the kiln atmosphere.*

◉ Glaze blister (close-up): blisters are characterized by sharp-edged craters that are generally round and range from ⅛" to 1" in diameter. Overfired or overfluxed glaze runs on vertical surfaces. This type of blister can form when lower-melting glaze oxides volatilize and boil out of the molten glaze.

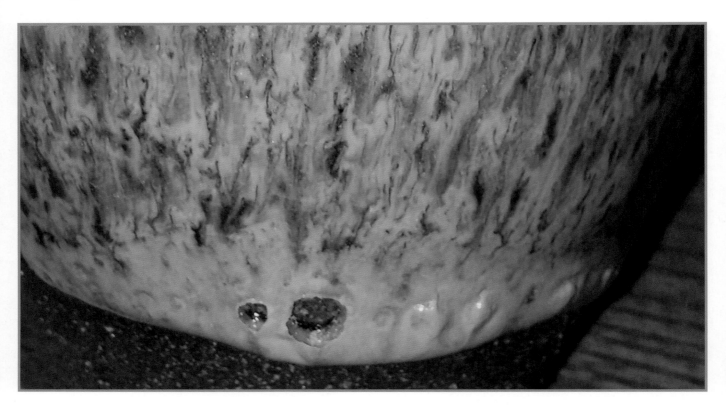

Direct-flame impingement can result in an overfired or overreduced area on a glaze, causing a blister. *Correction: Moving pottery away from the heat source will stop overreduction and overfired areas on the glaze.*

Early or too-heavy reduction in the glaze kiln can trap organic material in the clay or add carbon through excessive fuel introduction. Carbon trapped in the clay body can release at higher temperatures as a gas through the molten glaze, causing a blister. *Correction: Use an excess of air-to-fuel ratio in the burners until 1860°F, since it will remove organic matter from the clay body, then use a slightly reducing atmosphere until the end-point temperature is reached.*

A loosely stacked glaze kiln reduces thermal mass and subsequent radiant heat in the transmission to pottery. *Correction: A densely stacked kiln can produce slower increases and decreases of temperature while radiating more heat between pottery, kiln shelves, and posts. A densely packed kiln is a factor that can apply more heat work to the glaze, which liberates gases trapped in the glaze.*

A kiln atmosphere with no movement—most prevalent in electric kilns—can allow a saturation of volatile glaze materials, resulting in blisters. *Correction: In electric kilns, an active venting system can circulate the kiln atmosphere. In hydrocarbon-fueled kilns, changing damper settings and primary and secondary air intake at the burner ports will increase the kiln atmosphere movement.*

Clay Body Conditions

Higher-than-normal levels of organic material are not removed from the clay during bisque firing. Periodically, some clays—notably fireclays—can contain abnormally high percentages of organic material. In such instances, a "normal" bisque-firing cycle will not remove all the organic material from the clay. During the subsequent glaze firing, organic material carbonizes and releases as a gas through the clay body into the molten glaze, causing a blister. *Correction: A clean oxidization atmosphere in the bisque kiln, fired to the correct temperature in enough time, will release organic material from the clay.*

Clay bodies containing high percentages of plastic clays, when raw glazed, can trap organic material. During the firing, when the covering glaze vitrifies, the resulting carbonaceous gas in the clay exits through the glaze, causing a blister. *Correction: Substituting coarser- for finer-particle clays will open the clay body and help release trapped organic material.*

Grog exposed in the clay body during the trimming process can cause glaze contraction around the particles, leaving air pockets and eventual blisters in the glaze.[1] *Correction: Less surface area will be exposed when using a finer-mesh grog. The grog can also be pushed down into the clay during the trimming process.*

Clay slip (engobe) applied to once-fired or bisque pottery can release mechanical and chemical water, which can turn into a gas exiting through the covering glaze layer. *Correction: The amount of water used in mixing an engobe can be reduced by the addition of small percentages of a deflocculant (such as sodium silicate, Darvan #7, or Darvan 811). Also, slowing down the rate of heat increase until 1112°F is reached will allow mechanical and chemical water to escape through the glaze layer.*

Raw-glazing an unfired clay body can drastically increase its absorbency. When glaze is applied, it can be drawn into the clay body too rapidly, causing bubbles and air pockets as the glaze dries. During firing the bubbles migrate to the surface, causing a blister.[2] *Correction: The use of gums such as CMC (carbonxymethylcellulose), VeeGum CER, or other binders (⅛% to 2% added to the dry weight of the glaze) can slow down the drying rate of the glaze, preventing fast absorption.*

Raw glazing can trap organic material or moisture in the clay body or engobe, which at higher temperatures exits as a gas through the glaze layer. *Correction: Slowing down the rate of heat increase in the 572°F–1292°F range can safely release volatile organic materials and moisture from the clay body.[3]*

Soluble salts in the clay body can migrate to the surface as the clay dries, leaving a disruptive layer of sulfates releasing gas into the covering molten glaze. *Correction: The addition of barium carbonate (0.25% to 2%, on the basis of the dry weight of the clay body) can neutralize soluble-salt migration.*

Thin-walled pottery saturated by water during spraying, dipping, or painting during glaze application. Trapped moisture on the clay surface can be released as a vapor during glaze firing, causing a blister. *Correction: Less water used in the glaze batch and waiting until the first glaze layer dries before applying another will prevent blisters.*

Granular manganese added to the clay and naturally occurring nodules of manganese decompose at 1112°F and liberate oxygen at 1976°F, which can exit as a gas through the molten glaze, causing a blister.[4] *Correction: Decreasing the rate of heat increase in the 1112°F–1976°F temperature range can allow the slow release of oxygen through the glaze layer.*

Low bisque firing can yield extremely absorbent ware that "sucks" in the wet glaze. If the glaze is highly viscous, air pockets formed in the application process can migrate to the surface, leaving blisters in the stiff glaze. *Correction: Increasing the bisque firing by one or two cones will decrease the absorbency of the pottery. Also, gums such as CMC, VeeGum CER, or other binders added to the glaze (⅛% to 2%, on the basis of the dry weight of the glaze) can slow down the drying rate of the glaze.*

Warm glaze on a cold bisque pot can trap air in the glaze layer, causing a blister during firing. *Correction: Match the temperature of the glaze and pot before applying the glaze.*

Contamination of the bisque clay body from the breakdown and disintegration of organic materials such as sponges, used to clean the bisque before glazing.[5] *Correction: Use a clean source of water, tools, and sponges.*

Contamination in the clay from a plaster molds or deteriorating wedging boards can impart plaster chips into the moist clay, which, upon heating, release gas, water vapor, or both in the covering glaze layer. *Correction: Covering the wedging board with canvas will prevent chips from entering the clay. Mixing plaster with the correct ratio of water will ensure maximum set strength. Discarding molds that show signs of wear can prevent plaster contamination in the moist clay.*

Glaze Conditions

Bubbles forming in leadless glazes are common, with some breaking the surface and remaining unhealed as blisters. When lead was used in glazes, it caused a strong reactive effect with other oxides and increased the release of glaze bubbles, creating a smooth, blemish-free surface.[6] Since lead is not a recommended glaze material, greater care must be taken in glaze formulation and application and kiln firing to ensure a defect-free glaze surface.

High surface tension, from high-viscosity glazes that contain zirconium, can trap escaping gases from other glaze materials, metallic coloring oxides, stains, gums, and binders. This type of "stiff" glaze is less likely to heal itself of surface irregularities due to its inability to flow when molten. *Correction: Lowering the percentage of zirconium in the glaze or substituting other opacifiers such as titanium dioxide or tin oxide.*

Any operation that violently agitates the wet glaze can introduce bubbles during the application, resulting in blistering as the glaze matures. *Correction: Mix the wet glaze carefully to prevent bubbles from forming. Rock the glaze bucket slightly until any remaining bubbles come to the surface, and then skim them off.*

Glazes containing manganese dioxide, which decomposes at 1112°F and liberates oxygen at 1976°F, can exit as a gas through the molten glaze, causing a blister. *Correction: Slowing down the rate of heat increase in the 1112°F–1976°F temperature range will allow the liberation of oxygen from the manganese.*

A metallic coloring oxide such as manganese used in an underglaze wash or engobe can break down, releasing oxygen bubbles into the covering glaze and causing blisters. *Correction: Slowing down the rate of heat increase during the 1112°F–1976°F temperature range will allow the liberation of oxygen from the manganese in the glaze.*

Cobalt oxide in an underglaze or glaze, along with copper oxide and iron oxide in reduction atmosphere, loses oxygen at 1652°F, which can migrate through the glaze layer, causing a blister. *Correction: Slowing down the rate of heat increase until 1652°F allows oxygen in the underglaze to dissipate.*

Glazes containing an overload of metallic coloring oxides in reduction kiln atmospheres can cause blisters due to excessive fluxing of the glaze. *Correction: Decreasing the percentage of metallic coloring oxide or decreasing the amount of reduction atmosphere in the kiln (or both) will eliminate blistering.*

Contamination of the glaze with materials such as silicon carbide, wood, rust, salt, or other pottery shop materials can cause blisters. *Correction: Carefully clean and maintain the pottery shop, tools, equipment, and supplies. Always sieve the wet glaze before application, since this will remove any unwanted particles.*

A delay in the second glaze application can result in insufficient bonding of glaze layers, resulting in blisters. *Correction: Try applying the second glaze application while the first layer is slightly damp.*

Overlapping glazes can have a eutectic effect where a combination of oxides increases the melting action of both glazes. *Correction: Before committing to production, test every overlap glaze combination on vertical test tiles to determine compatibility.*

Glaze sprayed with excessive pressure or spraying wet glaze on wet glaze can break the glaze bond with the clay body or other glaze layers, causing blisters in the fired ware. *Correction: Spray the glaze with less pressure or move the spray gun back from the pottery surface (or both). Spray the glaze only when the surface is slightly damp or dry. Never spray the glaze on a wet surface.*

Extremely thick glaze application can result in a blister. In thicker glazes, any bubbles that form take longer to reach the surface. *Correction: Try successively thinner glaze applications.*

Extremely fine raw materials in a glaze or too much ball milling of the glaze increases soluble salts found in some frits. Overgrinding of frits can cause hydration and subsequent water release during glaze maturation, resulting in blistering. *Correction: Reduce ball-milling time and do a coarser grind of raw materials in the glaze batch.*

Overfluxed glazes or low-temperature fluxes in high-temperature glazes can blister due to excessive melting or the lower melting oxides "boiling" off when the glaze matures.

Correction: Reduce the percentage of flux in the glaze and use the appropriate flux for the glaze temperature.

Incompatible glazes placed too close together can release fumes during firing, causing the glazes to blister. *Correction: Increase the separation of incompatible glazes in the kiln.*

Lead in glazes or frits in reduction kiln atmospheres can blister due to the removal of the oxygen component in the lead. *Correction: Remove lead and lead frits from the glaze and use a nonlead frit or other appropriate fluxes.*

Chemical water in glaze materials driven off between 842°F and 932°F and the decomposition of clays and organic materials between 1044°F and 1652°F can release gases into the forming glaze. Other commonly used glaze materials, such as barium carbonate, strontium carbonate, talc, zinc oxide, manganese dioxide, manganese carbonate, nickel oxide, nickel carbonate, cobalt oxide, cobalt carbonate, rutile, iron oxide, dolomite, crocus martis, Cornwall stone, fluorspar, and whiting are also capable of releasing gases or chemically combined water, as is the case with some frits that travel through the molten glaze, causing blisters. For example, whiting (calcium carbonate) is a widely used glaze material, but it loses over 40% of its weight above 1650°F, releasing carbon dioxide gas into the melting glaze.

Feldspars when heated release gases, most likely generated by the decomposition of impurities within the material. Soda feldspars such as Minspar 200, Kona F-4, NC-4, and closely associated nepheline syenite, release small bubbles that can be trapped in the glaze, often exiting on the surface, sometimes as a blister. Potash feldspars such as Custer feldspar, G-200, and Primas P can release larger bubbles into the glaze.[7] Alkali- and zirconium-based glazes can be highly viscous and stiff when mature, resulting in large bubbles that are trapped on the glaze surface.

Additionally, a rapid heat increase during the molten-glaze period can dissociate gases that form a blister or many small, clumped blisters. Glaze can go through a transition period when gases are released, causing bubbles in the glaze and blisters on the glaze surface. Correction: A slower firing cycle will allow blisters to flatten and dissolve. Each glaze has appropriate time-to-temperature parameters that will produce a nonblistered glaze surface.

A general rule is that ceramic materials offer better results when heated and cooled slowly, allowing mechanical and chemical water to leave the clay without excessive pressure and without cracking the ware. Always allow the glaze to dry before placing it in the kiln. Slow increases in heat also allow for gases in raw materials to safely dissipate through the glaze layer. All the ceramic raw materials listed have been used in clay body and glaze formulas, provided the appropriate heating and cooling cycle is employed in the kiln.

An excessive amount of medium used in underglazes, engobes, glazes, or overglazes, such as oil, organic gum binders, gum arabic, glue, CMC, or VeeGum CER can ferment, causing gas bubbles exiting as blistering in the glaze layer. The rate of fermentation, if any, is in part determined by the wet storage life of the materials, storage temperature, water pH, and organic materials in the mixture. *Correction: Use less medium and keep wet mixtures in cooler storage areas.*

The glaze viscosity in the fluid state can promote blisters. High-viscosity glazes (stiff glazes) can trap bubbles that break at the surface, forming blisters. *Correction: Lowering the viscosity by increasing the time to maturity or firing the glaze to a higher temperature will increase the flowing characteristics, allowing for any bubbles to rise to the surface, break, and heal. Also, increasing the flux content of the glaze will allow it to flow when mature.*

Excessively thick glaze applications can delay the time for bubbles to reach the glaze surface. Once bubbles are at the surface, the firing cycle can already be completed, leaving a blister. *Correction: Many glazes can be applied more thinly, resulting in acceptable surface texture, opacity, and color.*

Diagnosing the Potential Causes of Glaze Blistering

Asking Questions Can Yield Answers

When confronted with any kind of defect, it is important to determine the point of origin and then apply the appropriate adjustment(s). Obviously, if the wrong correction is enacted—aside from being ineffective—there is a loss of time and labor,

so it is imperative to diagnose the defect correctly. It is essential to have a systemic approach to isolate the actual factor(s) causing blistering. Specifically, there are several questions the potter can ask to isolate glaze blistering. The answers will offer guidelines to determine the appropriate correction.

Questions to Ask

Does the blister glaze heal when fired again? A general rule that can apply to any glaze defect: if the glaze can be refired successfully, it should have been fired longer during the first glaze firing. The second firing supplies more heat work to the glaze, which can bring it into a defect-free configuration.

Are different glaze formulas in the same kiln blistered? The problem probably originates in the firing procedures, glaze-mixing errors, or a common raw glaze material.

Are the blisters only on one side of the pot? If so, direct-flame impingement might cause an overfired area, an overreduced area, or both in hydrocarbon-fueled kilns.

Are the blisters only on overlapping glaze surfaces? Incompatible glazes when overlapped can have a eutectic effect, with resulting overfluxed areas and blisters.

Are the blisters only on horizontal surfaces? High-surface-tension glazes with high viscosity are stiff and do not move when molten. Gravity on the vertical molten glaze pulls down, causing the formed blister to heal. Another possible cause occurs when flat pots are placed directly on the kiln shelve. If the glaze is not formulated or fired correctly, the radiant heat from kiln shelves upon cooling can cause it to remain in its maturity range longer, causing a blister.

Are the blisters only on the edges or high areas of the pots? Fast cooling of the kiln, loosely stacked pottery, or both can "freeze" the glaze in its maturation process.

Are blisters present only in one kiln and not in others? This could be an indication of an error in kiln firing.

Are blisters present in only one part of the kiln? Check for direct-heat-source impingement or kiln atmosphere irregularities.

Are blisters present on one clay body and not another? Check the level of organic material in the clay body causing the blisters. Has the clay body been bisque-fired long enough in an oxidation kiln atmosphere? If the clay body contains high levels of iron-bearing clays or iron oxide, it can be more reactive to extreme reduction in the glaze firing, which can cause glaze blistering.

Are blisters present only on underglaze, engobe, or overglaze areas? Check levels of gums and percentages of metallic coloring oxides used in the underglaze, engobe, or overglaze formulas.

Does the glaze have high percentages of whiting or other raw-material gas-producing components? Statistically, whiting (calcium carbonate, $CaCO_3$) is one of the leading causes of glaze blistering. Wollastonite (calcium silicate, $CaOSiO_2$), which dissolves more readily in the molten glaze, can be substituted with an adjustment to the silica content of the glaze.

Are blisters present only on one color of glaze and not on other color glazes that use the same base glaze formula? Some glazes have an excessive percentage of metallic coloring oxides. Has the kiln atmosphere been too heavily reduced?

Are blisters present only after a new batch of glaze is used? It is best to carefully weigh a new batch of glaze and to note any new raw materials used in the problem batch.

While the defect itself is readily apparent (a sharp crater like void in the fired glaze surface) glaze blistering represents one of the most difficult problems to diagnose correctly due to its many possible causes. A little time spent investigating the cause will save a lot of time in resolving this frustrating glaze disruption.

25. A PROBLEM WITH COBALT?

Cobalt oxide and cobalt carbonate are ceramic raw materials widely used by potters. They are frequently found in glaze and slip formulas, contributing, under varied circumstances, a light- to dark-blue color, depending on the amount employed. Cobalt has traditionally been used in everything from Chinese porcelain to American salt-glazed stoneware. However, its use today reflects

a wider problem that potters face when employing any ceramic raw material.

The dilemma is not with the specific raw material but with the lack of pertinent health statistics relating to the effects of ceramic raw materials on potters. The available statistics are based on industrial populations of workers whose exposure and duration rates are significantly different from potters working in craft centers, schools, and private studios. In the wider economic world, large industries have the incentive and money to assemble and document health problems associated with the workplace. There are numerous statistical records in commercial areas such as mining, paper production, and metal industries as to the effects of raw materials on workers. From the data obtained, many procedures have been enacted for the safe handling of raw materials. There is also an economic incentive for industry to protect its workers and prevent potential litigation. This is not the case with individual potters, who have no economic resources for such health-related documentation. A central question that has not been addressed is, "Can an accurate extrapolation of industrial statistics be applied to potters who have lower rates of exposure and duration?"

On the basis of the lack of health-and-safety statistics as they relate to the small population of potters, can it be possible that ceramic raw materials will become the next "asbestos type" material for potential litigation? Society in general has become more litigious, a description for taking legal action over a real or imagined injury to a person or damage to property. It is not surprising that this mania has come to the field of ceramics. It is present even in lawsuits generated from customers scalding themselves from a cup of hot coffee. The economic reactions to lawsuits, or even the possibility of lawsuits, can have a negative effect on ceramics suppliers and eventually on potters who purchase ceramics equipment, supplies, and raw materials.

Ceramics is a small industry. In fact, the term "industry" really does not apply to ceramics supply companies, equipment manufacturers, glaze companies, and clay producers who sell to potters. For the most part, ceramics supply companies are staffed by few employees, and the potters whom they sell to are individual craftsmen. With such a small market for goods and services, any negative influence on profit margins can have large penalties for producers and consumers of raw materials. Larger industry has the capital and personnel to bear the possibility of legal actions regarding their products or services. Ceramics supply companies do not have staffs of lawyers or high profits to pay for any type of legal action that a raw-material complaint might produce.

Not only can an individual potter be sued, but a ceramics supplier can conceivably be named as party to a lawsuit for selling items to the potter that caused the eventual user real or imagined harm. For example, if a potter sells a coffee cup with a glaze containing cobalt carbonate and the user claims that the glaze transferred harmful amounts of cobalt into his body, problems can exist on many levels. Conceivably, the potter who made the pot and the ceramics supplier who sold the raw materials used in the pot could be named in the lawsuit. Such lawsuits are going after "deep pockets," or defendants who can afford to pay damages. Depending on the circumstances of the case, a party can be dropped from the

suit, but the process does require a lawyer, who expects a fee for services. Defending against a potential or actual lawsuit can be an expensive and time-consuming process for any individual or business. Aside from the costs involved in such actions, the tangible area of liability has to be evaluated as to the declared damage inflicted on persons or property. Most, if not all, ceramics supply companies and individual potters would not knowingly allow a situation to exist where a product could inflict damage or illness on their customers, but good intentions have little to do with the factors driving litigation. Even if negligence cannot be assigned, the time and cost to defend oneself is considerable. In many instances even if the case does not go to court, legal fees are incurred.

During the past few years, there has been a steadily increasing amount of conjecture and embellished claims concerning the use of raw materials by potters. Many undesirable things can grow in a climate of ignorance and speculation. Ceramic raw-material toxicology has become increasingly subject to exploitation and misunderstanding by the uninformed and misguided. Ignorance of ceramic raw materials by the legal profession and exploitation by individuals who make their income from distorting data have been steadily increasing. This disturbing trend is in part due to the revenue potential associated with any form of litigation. A steady flow of articles have been published warning of new ceramic "poisons of the month." The topic of health factors relating to ceramic materials has attracted alarmist "experts" with access to undiscriminating print media. Rather than counter such biased reporting, knowledgeable potters and centers of ceramic learning have consistently remained silent. While it is understandable that individuals cannot access the resources to scientifically counter misconceptions regarding ceramic materials, it is inexplicable why institutions of higher learning have not undertaken ceramics-related health studies to counter false claims and rumors.

Cobalt

Reliable deposits of cobalt are currently mined in Canada and southern Africa. It is extracted as a byproduct of nickel ore mining. Cobalt carbonate ($CoCO_3$) and the stronger cobalt oxide (CoO_2) are metallic coloring agents that have been employed by potters throughout the history of pottery making. Cobalt can be found as a decorative element in the earliest twelfth-century salt-glazed ware produced in Germany. Individual artist potters in the United States have been using cobalt in both forms for over fifty years. Cobalt will produce stable blues in oxidation and reduction kiln atmospheres at various temperature ranges. It is one of the most potent colorants and produces a strong blue when added to slips, glazes, and overglaze/underglaze washes. One part of cobalt can tint 100,000 parts of a glaze or slip. This widely used metallic coloring oxide can also generate a range of blues and black in clay bodies. Cobalt can also be found in many commercial glazes, stains, and underglaze colors; large-scale industrial uses of cobalt occur in the formulation of steel and chromium alloys.[1]

Cobalt carbonate Cobalt oxide

Cobalt black clay body with cobalt slip decoration

A court case concerning cobalt carbonate has come about by a confluence of specific events driven by greed, ignorance, and an atmosphere of misguided consumer protection. As in most accidents, a series of actions aligned in such a way to produce a flawed outcome for everyone involved. Eventually, ignorance of ceramic raw materials by laymen and experts, along with the legitimate health concerns of a potter, were brought together with lawyers who did not do their homework.

The Potter

A semiprofessional potter with over twenty years of experience producing high-temperature functional pottery in a garage studio claimed to have contracted cobalt poisoning. The potter used approximately 5 lbs. of cobalt carbonate every four years in various overglaze washes and glazes and a blue slip. The slip formula contained 2 tablespoons of cobalt carbonate to 1 cup of slip. It was applied by a brush-spattering method to greenware: the slip was loaded onto the brush and flicked onto the pots. The floor of the pottery studio was exposed to the excess cobalt slip from mixing and application operations. A glaze containing 3% cobalt carbonate was mixed in 30-gallon containers, which were refilled every three years. The glaze was applied by dipping or pouring it on the bisque ware. The potter glazed 6 to 8 hours a day five days a week for a five-month period every year. An overglaze wash containing 60% cobalt carbonate was also brushed over some glazes. The slips, glazes, and overglazes were applied to a clay body that was mixed in the studio. All the pots were fired in a 30 cu. ft. sprung-arch downdraft kiln to cone 9 (2300°F). The potter has been a pipe smoker for thirty-three years, using approximately thirty pipe fills of tobacco a day. He also consumed approximately 4 liters of diet soda a day. He ate, drank, and smoked in the ceramics studio, which was cleaned periodically with a garden hose.

The Symptoms

After noticing symptoms of fatigue, gastrointestinal problems (acid reflux), muscular pain in all major joints, shaking when fatigued, depression, anxiety attacks, headaches, sore mouth, scalp irritation, poor sleep, and prolonged infections, he visited his local doctor. After examinations by several physicians, he was placed on a number of medications to relieve the symptoms that had been developing over the last fifteen years of working in his pottery studio. On one of his visits to another doctor, who happened to have taken a pottery course, it was suggested that he might have developed heavy-metal poisoning from the cobalt used in his studio. A hair sample was taken, and it was found to contain cobalt. He was informed it was also possible that the range of his medical problems fit many of the symptoms associated with cobalt poisoning. At this time, the potter was given over ninety-five chelation treatments, which are used to draw out heavy metals from the system. The potter also did a significant amount of research on the Internet, believing his symptoms fit cobalt poisoning.

He then went to the Mayo Clinic in Rochester, Minnesota, and was evaluated by a number of medical specialists, including internists, neurologists, gastroenterologists, rheumatologists, psychiatrists, and a physician specializing in occupational medicine. Their findings did not indicate heavy-metal poisoning. Significantly, blood and urine tests were negative for heavy-metal poisoning, but a test did indicate an abnormally high level of arsenic in his blood. However, one doctor did tell him that "symptomatically" his ailments fit cobalt poisoning, but this opinion was unsupported by the medical facts of the case. In fact, the symptoms for cobalt poisoning are characterized by functional effects on the ventricles and enlargement of the heart (cardiomegaly). There are no demonstrated musculoskeletal or neurologic effects as a result of exposure to cobalt. Gastrointestinal effects primarily from ingestion include nausea, vomiting, and diarrhea.[2]

The Trial

The potter claimed that he contracted cobalt poisoning because the ceramics supply company, which sold the cobalt carbonate, did not list safety instructions and precautions on the packages he purchased before 1998. His purchases of cobalt carbonate after that year did have safety information, but he claimed that the labeling was not adequate to inform him of the potential hazards when using the material. In the petition for damages filed by the potter's lawyers, they claimed that the product sold to the plaintiff, as designed, constructed, assembled, manufactured, and distributed, was defective and unreasonably dangerous when put to a reasonably anticipated use. At some point in the presentation, his claim was extended to include manganese and arsenic poisoning because the initial test of the cobalt carbonate sample contained arsenic and 5.6 parts per million of manganese as trace materials.

The Potter's Position

The potter alleged that he was unable to earn a living and could not work as a result of the ceramics supply company's negligence due to insufficient labeling of their product, cobalt carbonate, which also contained manganese and arsenic. He had stopped making pottery, which he believed was the cause of his health problems. The potter wanted compensation for economic and pecuniary harm, including but not limited to past and future medical bills and expenses and past and future lost wages and income. It was further claimed he suffered and will continue to suffer pain, emotional and psychological harm, and distress and loss of enjoyment of life. He believed that his symptoms were directly related to the cobalt carbonate contained in his slips and glazes. The claim for damages was in excess of five million dollars.

The Ceramics Supply Company's Position

The ceramics supply company's position was that the safe use of any ceramic raw material was in part the responsibility of the user to inform himself of the health-and-safety procedures needed when working in the field of ceramics. On the basis of the potter's education and training, he should not have been eating, smoking, or drinking in his studio. Most significantly, they claimed that the potter did not have cobalt, manganese, or arsenic poisoning, since his extensive medical examination did not indicate such a diagnosis. However, the ceramics supply company was not required to prove what

illnesses the potter was suffering from since the onset of his symptoms. Additionally, several physicians and toxicology experts in environmental medicine testified that the potter's history of symptoms did not indicate poisoning from any heavy metal, with one physician speculating that the symptoms could be caused by the array of drugs he was taking for unrelated illnesses.

Evidence was also presented by the ceramics supply company's lawyers demonstrating that cobalt, manganese, and arsenic poisoning was not found in the population of potters. Previously, this information had been based on anecdotal reports accumulated over fifty years by individual potters and informal surveys taken at the National Council on Education for the Ceramic Arts (NCECA) annual meetings. A statistically accurate study of potters and their use of raw materials was sponsored at the 2000 NCECA meeting. The Potters Health & Safety Questionnaire was issued to all participants.[3] The questionnaire was also listed on the Internet and was available at ceramics supply companies throughout the United States. The results of the survey indicated the four most serious health problems that potters experience are back pain, carpal tunnel syndrome (repetitive motion), cuts (from glaze shards), and burns (from reaching into hot kilns). While a small percentage of potters reported illnesses attributed to raw materials, a search of the National Library of Medicine data banks and other medical libraries did not reveal any diagnosed cases of potters contracting cobalt, manganese, or arsenic poisoning. Duke University Medical Center, Department of Community & Family Medicine, Division of Occupational & Environmental Medicine, had reported that the original cobalt carbonate sample was reanalyzed by using a test of greater accuracy and that it did not contain arsenic. Furthermore, it was determined that the hair sample taken from the potter, which was reported as having high concentrations of cobalt, was within normal limits for the general population.

The most significant finding, of which potters should take note, occurred at Duke University's Medical Center for Occupational & Environmental Medicine. The potter's actual glaze and slip formulas were tested for respirable and ingestible concentrations of cobalt. The exposure assessment was conducted under controlled conditions, duplicating the poor ventilation found in the potter's studio. The exposure to cobalt was tested by a modeling technique where each activity was carried out duplicating the actions of the potter in his studio. The glaze and slip formulas were mixed and applied with the same spatter technique as used by the potter. Respirable exposure and ingestion levels were calculated for an average adult male on the basis of the mixing operations in the potter's studio. Test results, even allowing for a combination of incidental additive ingestion and inhalation in cleaning, mixing, and glazing activities, determined that daily absorption of cobalt would be in the range of 170–945 micrograms per day. The levels of cobalt the potter was exposed to in his studio were the same as in the general population in the United States. This was reflected in testing hair, blood, and urine, values that fell within the normal range. A risk assessment for cobalt found no adverse effects in humans at exposures of 3400 micrograms per day.[4] The assessment of the potter's studio by Duke University's Medical Center for Occupational & Environmental Medicine is

believed to be the first documented case of cobalt material toxicity testing in a private ceramics studio.

Aside from the environment, the general population is exposed to cobalt from many sources; the most significant are food and drinking water. Food ingestion alone can average 5–100 microns per day. Drinking-water levels can average from 2 micrograms per liter to 107 micrograms per liter per day. Background cobalt air levels can range as high as 0.61 micrograms.[5] In addition, cobalt is found in vitamin B_{12}. A typical multivitamin contains 4 micrograms of cobalt in the form of B_{12}.[6] Cobalt is a necessary element, with background exposures from vitamin preparations, water, and food in the range of 30–37 micrograms per day.

The Verdict

The trial was held in the potter's hometown and lasted six days. After reviewing the testimony of the ceramics supply company's expert witnesses, the potter's expert witnesses, and the potter, twelve jurors took less than 3 hours to reach a verdict in favor of the ceramics supply company.

The Impact

The court of law can be an imprecise instrument for solving ceramics-related toxicology questions. It is simply the wrong tool for determining the health-and-safety factors associated with the potter's use of ceramic raw materials. This case represents several related issues concerning the current realities in ceramics. First and primary is the potter's past and current health and the debilitating symptoms that he is experiencing. An inaccurate assessment by himself and others has caused a delay in the correct medical treatment of his illness. If nothing else, the medical evidence submitted at trial should eliminate cobalt, manganese, or arsenic poisoning as the possible causes for his symptoms. One hopes that the information presented will direct him to the correct diagnosis and treatment.

The economic impact of the trial on all parties was extensive. Preparation and research and payment to expert witnesses, in addition to legal and court fees, were substantial. The cost to the ceramics supply company, which is essentially a small business, caused a revision in its selling practices to prevent future litigation. The adjustments will not appreciably increase the safety margins to workers or customers but will increase the costs to customers. Even though the ceramics supply company defended itself successfully, many companies will eliminate raw materials and services that *might* cause legal problems. Such preemptive tactics will not serve potters' health interests and will not protect ceramics supply companies from litigation. The economic balance between the safe handling and selling of ceramic materials and reducing legal exposure to lawsuits depends in part on access to expert technical advice, which many ceramics companies cannot afford. Defending against this type of litigation for the ceramics company, no matter what the outcome, was a battle that need not have taken place.

A legitimate array of physical symptoms by the potter, which led to a hair sample test for cobalt, caused the potter to seek legal action. When the symptoms did not match cobalt poisoning, manganese and arsenic poisoning were claimed to be the causes of the potter's health issues. While the cobalt carbonate used by the potter did contain 5.6 parts per million of manganese (trace amounts), it did not contain arsenic. Unfortunately, what was needed at the onset of contemplated legal action was not present; namely, knowledge of ceramic materials and their toxicological effects on potters. Without this understanding, a course of action was taken, giving an economic incentive for the potter and his lawyers to move proceedings along even when the medical facts did not line up with the physical symptoms. Once the legal mechanism was underway, the cost in time and money for both the defendant and plaintiff started to accrue.

No one is arguing for less stringent safety procedures in selling raw materials, accurate labeling, or potters adhering to their own studio safety measures. Anything that will promote safety in ceramics should be considered, even though raw materials used by potters have had a good safety record. One step in learning about raw materials is for potters to request from their ceramics supplier a Material Safety Data Sheet (MSDS) for every raw material they purchase. It contains useful information such as the chemical name, chemical family, hazard class, formula, occupational exposure limits, emergency first-aid procedures, waste disposal, respiratory protection, and precautions for handling and storage. Each category of information will help potters establish safety guidelines for raw-material handling procedures within their studios. In order to reach a wider audience of potters, courses in material safety should be part of every college ceramics and craft center curriculum.

Raw materials can be handled safely with the proper barrier methods of protection, such as respirators, kiln-viewing goggles, rubber or latex gloves, and high-temperature kiln gloves approved by the National Institute for Occupational Safety and Health (NIOSH), to name a few items that should be used consistently by every potter in his or her studio. Raw materials, as used by potters in their studios, have a remarkable safety record considering the varied safety procedures used and not used by potters over the years. There is no room in the ceramics studio for ignorance or misconceptions about the raw materials that we as potters come into contact with on a daily basis. When cobalt was placed on trial, it highlighted several areas of future concern for the ceramics community. Ignorance of the toxicological effects of raw materials caused a false diagnosis, which initiated a rush to litigation. The trial caused an economic loss for the potter and the ceramics supply company *without* an acceptable solution for either party. A lack of knowledge almost perpetuated an incorrect assessment of cobalt carbonate for the pottery community. For a detailed explanation of safety issues for ceramics studios, see my books *Safety in the Ceramics Studio* and *What Every Potter Should Know*, available from www.jeffzamek.com.

A Supplementary Look at Cobalt on Trial

Clay, glazes, metallic coloring oxides, slab rollers, extruders, and kilns are common elements when working in ceramics. Safety concerns always seem to surface with the notice of another potter's illness or one's own medical symptoms. As potters we ask ourselves, Is that cough just a cold or do I have silicosis from not using my respirator when mixing glazes? Is that stomach ache from too much food or did I ingest manganese from that new glaze on my coffee cup? These concerns are highly individualistic and in part dependent on the personality of the potter, but there is a blank or unknown element about the potential harm we as potters are encountering in our studios.

When talking about studio safety and ceramic raw materials, a few interesting exchanges sometimes take place during or after the lecture. There is no such thing as zero risk in any activity, whether going to the store or working with ceramic materials. Then the real question becomes how much risk am I exposing myself to by making pots. Since an exact definitive risk factor is not known—unlike the risk factors of flying on a commercial jet—we have to use the limited information we have, which at best can cause some people to be worried about their health. Again, the fact that this knowledge is limited or distorted further causes people to be concerned and confused about the risk factor. One potter, after attending my safety lecture, became very upset. After my explanation on the use of barrier methods of protection such as respirators, kiln gloves, and kiln-viewing goggles, she was still very concerned about health issues relating to ceramics. On the way out of the lecture I observed the potter lighting up a cigarette as she said to me, "Your talk made me so nervous I needed a smoke." I don't think this statement needs any further comment except to say that many risk factors are not evaluated logically.

A more discerning question came from a potter at another lecture. After my 2-hour talk on ceramic toxicology and the safe handling of ceramic materials, a woman asked, "Mr. Zamek, after listening to your thorough explanation on the safety of ceramic materials, would you let your children play with clay in your studio?" This apparently simple question cut to the heart of the matter. We all assume a certain risk level for ourselves, but we always want a higher level of safety for our children. In a sense this woman was asking if my assurances of safety for potters also met a higher level of concern for my children. Or, to put it another way, would I bet my children's health on my belief in the safe handling of ceramic materials? My answer was yes, I would let my children play in the studio with safety measures in place, age appropriate observation, and guidance. My seven-year-old would require a greater level of supervision and instruction than my twelve-year-old. However, I would be in the studio with both children at all times.

While these insights seem to be peripherally involved with cobalt, the information contained in the cobalt lawsuit is the first step in quantifying by scientific methods how ceramic materials affect potters in their studios. I hope that more studies with other ceramic materials will offer a complete base of knowledge concerning their actual risk. I feel that the information revealed in the cobalt trial will present readers with a balanced assessment of the risk factors when using cobalt in their ceramics activities.

26. DEVELOPING COLOR AND OPACITY IN A RAKU GLAZE

Most potters think of the raku firing method as a unique technique and come to the process while also engaged in more-traditional firing methods. However, an added benefit to a potter's education comes about by the fast firing and swift feedback on glaze results. Often, keeping things simple with one or two glazes produces several benefits; foremost is gaining an in-depth knowledge of raw materials. Conversely, working with many different glaze formulas at one time often leads to not knowing any one of them in depth. Many times the desire to immediately see how glaze colors and textures look overrides the longer-term benefits of learning how the materials actually work in a glaze.

A simple approach to glaze fit, color development, and opacity coupled with the fast-firing raku process can greatly aid in learning about the effects of adding metallic coloring oxides, stains, and opacity-producing agents to a base glaze formula. In most kiln-firing operations the potter has to wait days or weeks to discover what the addition of copper, chrome, cobalt, or any number of other coloring oxides or stains produced in a fired glaze. In the raku process the ceramic form is bisque fired to approximately 1828°F then glazed and placed in the kiln. Temperatures in excess of 1600°F are easily reached in 20 to 30 minutes. The pot is removed red hot and either oxidized (left in the air to cool) or reduced (placed in combustible material, which creates carbon monoxide, drawing off an oxygen molecule from the metallic oxide in the molten glaze and resulting in color variations). Carbon from the noncombustible material also causes black to light-gray flashing on nonglazed surfaces. While the technique sounds complicated, the results can be fast and dramatic. Most importantly, the compressed time between cause and effect reveals principles in glaze development that can be applied to any temperature range.

Raku Glaze Requirements

Raku glazes are appreciated for their ability to offer various color and textural variations; however, there are several requirements for an effective glaze.

For safety reasons in formulating the glaze and their possible use, lead or lead-based frits are not recommended for raku glazes.

The raw materials for the raku glaze should be easily available.

Soluble glaze materials such as Gerstley borate, colemanite, borax, pearl ash, soda ash, and boric acid can be used in raku glazes. However, they can leach into the glaze water, resulting in unpredictable glaze effects. In some instances the results can be aesthetically interesting, but soluble glaze materials can also cause blistering, running, and dry areas in some glazes. Pouring some of the excess water off the glaze can change the glaze formula.

A raku glaze must stay in suspension for a reasonable length of time to allow for glaze application.

Ease of application for raku glazes is important. Glazes should be suitable for brushing, dipping, or spraying.

Raku glazes must be able to mature over a wide range of temperatures, since not all kilns fire evenly or accurately.

Raku glazes must be able to withstand variations in reduction atmospheres and thermal shock inherent in the raku process.

The fired glaze must not have jagged edges, which could cut the hands.

Making Your Own Raku Glaze

Making your own glaze can be a simple process. Just a few raw materials are needed to produce a glaze with different colors and surface textures. For example, using 80% Ferro frit #3110 and 20% EPK will result in a raku glaze formula. As a general rule 4,000 g of dry material will yield one gallon of glaze. Zircopax Plus, which can cause opacity in the glaze, can be purchased in 1 lb. increments. Metallic coloring oxides and stains, being more expensive, can be ordered in ¼ lb. increments. When making a small test, measure a 300 g batch, which will allow for several vertical glazed test tiles.

Base Glaze Formula

A base glaze formula (one that is clear, semiopaque, or opaque in light transmission and glossy, satin matte, or matte in surface texture) is the foundation for any addition of metallic coloring oxides, stains, or opacity-producing agents. It offers a known constant to judge the effects of color and opacity. In the raku temperature range, cone 010 (1657°F) to cone 04 (1945°F), any frit can be considered a glaze by itself, since it contains a combination of flux oxides, alumina, and silica, which form a low-fire glaze. Additions of clay can decrease glaze running and at higher percentages can increase opacity and matte surface texture, while the Superpax further aids in opacity.

Whether using any of the metallic oxides (iron oxide, cobalt oxide, copper oxide, chrome oxide, nickel oxide, iron chromate, manganese dioxide, rutile) or their carbonate forms (copper carbonate, cobalt carbonate, manganese carbonate, or nickel carbonate), approximately a ⅛% will yield a tint, 5% will yield medium intensity, and 10% will impart the most intense color to the glaze. The advantage of using just one base glaze—aside from the simplicity of understanding cause and effect when using ceramic materials—is that glaze color variations can be overlapped with a good chance of compatibility. However, it is always best to test the base glaze and any color variations on vertical tiles of at least 4" in height, with 1" unglazed on the bottom to ensure a nondrip glaze.

Ferro frit #3110 performs the melting action in the glaze. EPK, a clay containing alumina and silica, prevents the molten glaze from running down vertical surfaces. Bentonite, a fine-particle clay, keeps the liquid glaze in suspension. Mason stains provide color to the base glaze. Zircopax Plus will make the clear, gloss, transparent base glaze opaque, gloss white.

▲ Raku base glaze, clear gloss crackle.

174

Base Glaze Options

Raku Base Glaze Clear Gloss Crackle		
Ferro frit #3110	80	melting action in glaze
EPK	20	controls flow of glaze on vertical surfaces
Bentonite (optional)	2%	helps keep the glaze in suspension
White Opaque Gloss		
Zircopax Plus	15%	causes opacity
Blue Variation		
Mason stain #6306 Vivid Blue	10%	develops color
Green Variation		
Mason stain #6271 Mint Green	10%	develops color

Blue variation of the raku base glaze.

Using the Raku-Base Clear Gloss

Adding five, ten, or twenty more parts of EPK to the base will result in a stiffer glaze that's less likely to run. Essentially, by adding more EPK, which contains alumina and silica, both refractory oxides, you are making a higher-temperature glaze while still firing to the original temperature. However, as the amount of EPK increases, the glaze becomes more opaque and develops a drier surface texture. Conversely, deleting five, ten, or twenty parts of EPK from the base will make it more fluid.

Another method to adjust the flow of the glaze is to work with the flux part of the formula (Ferro frit #3110). Using the original glaze formula with additions of Ferro frit #3110 can cause the glaze to become increasingly fluid, while decreasing the frit can cause the glaze to become less fluid when molten.

Adjustments to the Raku-Base Clear-Gloss Crackle Glaze

Adjusting for Molten Viscosity

When using a glaze, always calculate the glaze to a 100% batch with coloring oxides, stains, or suspension agents listed after the 100%. When adjusting a glaze either by adding or subtracting, move materials by five-part increments. When a modification is successful, the revised glaze can easily be recalculated to the 100% batch weight.

Adjusting for Glaze Opacity

Another method for creating glaze opacity other than adding EPK (which can affect surface texture) is the addition of zirconium silicates such as Zircopax Plus. Tin oxide additions will also result in opacity with a softer white as compared to zirconium silicates. A 3% addition of either will yield a slight opacity, while 5% to 20% will yield increasing opacity in the glaze.

Adjusting Glaze Fit

The spacing of the craze crackle lines will depend on the fit of the clay body and glaze upon cooling. Different frits have various rates of contraction when cooling, which can enlarge or expand the craze lines in the glaze. Additionally, other materials in this

⊙ Green variation of the raku base glaze.

⊙ Raku fiber kiln firing.

glaze, such as EPK, can influence crazing by introducing silica and alumina. The craze line pattern is also affected by the rate of contraction in the clay body.

To stop crazing in this glaze, several strategies can be used. Another frit with a rate of cooling compatible with the clay body will bring the glaze under slight compression and possibly stop crazing. A 5, 10, or 15 part addition of flint to the glaze will move the craze lines farther apart or remove them totally. A different clay body can also set up a compatible glaze/clay fit. Metallic coloring oxides, their carbonate forms, stains, and zirconium silicates can also affect glaze fit. In some instances, craze lines are in the glaze, but the colorant masks their appearance. Glaze fit can also be improved by recalculating the formula with glaze calculation software. Fundamentally, the highly absorbent clay body needed to withstand thermal shock in the raku firing will induce crazing in most glazes. Lead or lead frits promote glaze fit but are not recommended because of health issues and possible lead leaching in the fired ware.

A Single Glaze Can Yield a Lot of Information

By using just one glaze and adjusting it for viscosity, opacity, color, and fit, a potter can learn the fundamentals of manipulating any glaze at any temperature. Many of the basic glaze adjustments tools can be executed with the raku process of fast firing, yielding timely results for further testing.

⊙ Raku pottery by Steven Branfman, utilizing coloring oxides and opacity-producing zirconium silicates.

⊙ Placing pots into reduction medium (sawdust).

27. GLAZE DESCRIPTION / GLAZE NOTATION

Glaze description and notation offers clearly defined methods to classify and write glaze formulas. It also offers a starting point to compare one glaze with another and to adjust formulas for firing temperatures, glaze defects, and kiln atmosphere conditions. In short, glaze description and notation is the communication method we use to understand and transmit information. Just imagine being in a foreign country and not understanding the language. It would certainly limit your ability to travel or communicate. What can be said about a glaze? Plenty. We all have been in the position of trying to describe our favorite glaze to another potter or to ourselves. If the actual glaze is not present, the verbal account can leave a lot to the imagination and yield an inaccurate image. A more formalized standard language has been developed that can communicate the many qualities of a glaze. The glaze description language is an agreed-upon meaning to the many characteristics found in glazes. It uses several key words and phrases to define a glaze. The idea, as with all languages, is that everyone understands what is meant by the standardized terms. The glaze description language allows the listener or reader to formulate an accurate mental image of how the fired glaze looks and functions.

One area of potential error occurs when writing or describing glazes. Many potters still refer to a glaze formula by its popular name. For example, we all have called glazes Randy's Red or Bob's Blue. While there is a certain personal and informal quality in referring to glazes in such a manner, it can lead to numerous inaccuracies in exchanging or understanding glaze formulas. Just referring to a glaze by its common name does not tell enough about characteristics such as color, texture, or light transmission. As an added measure of error, the actual glaze formula for Randy's Red could have changed many times since Randy developed the glaze. Identifying glazes only by their names is an inaccurate attempt to transfer information and can indicate a potter's wider lack of knowledge about glaze formulas.

Even potters who know better are still drawn into the easy habit of referring to a glaze only by its name. However, there is another method that can transfer information with greater accuracy. Once the vocabulary is known, it makes the task of explaining how a glaze looks easier, faster, and more accurate. We're not talking about deciphering Sanskrit or Egyptian hieroglyphics, but just a few simple categories that add to the enjoyment of making and describing ceramic glazes. Keep in mind that there are no set rules about the number of terms to use in describing a glaze; however, it is critical that any terms used have some universal understanding. Additionally, too many descriptive terms can be overly cumbersome to use in actual practice. Many potters choose only those descriptions that accurately focus on their particular glaze.

Several problems can originate from misinterpreting a glaze formula. There are numerous variables when working with ceramic raw materials, and it is essential to be precise and technically descriptive whenever possible. When a glaze does not perform as expected, the potter can sometimes wrongly assume that the defect was caused by a raw-material variable, incorrect glaze application, or kiln-firing fault. Whether the potter is looking through books or magazines or copying from another potter's notebook, many formulas simply do not offer enough information when trying to achieve the desired result. The next time you want to tell someone about your favorite glaze, try this glaze description method.

Glaze Description

These several characteristics will define a glaze in specific terms.

Firing Temperature – c/06 (1828°F), c/6,(2232°F), c/9 (2300°F)

The firing temperature or pyrometric cone rating is critical in the description of any glaze. The three most common temperature ranges used today are c/06 (1828°F), c/6 (2232°F), and c/9 (2300°F).[1]

Most clay body and glaze formulas have been developed for these temperature ranges. Published glaze and clay body formulas also fall within these widely used pyrometer cone ratings and temperatures.

Preparation: Frit or Raw Oxides

Frits are manufactured from specific raw oxides, which are calcined (fired to a molten mass, cooled, then ground into a fine powder). Frits are frequently used in low-, medium-, and some high-temperature glazes, acting as a major flux or glass former. A raw glaze is composed of nonfritted ceramic materials such as feldspars, clays, dolomite, whiting, zinc, talc, magnesium carbonate, and other naturally occurring raw materials.

Composition:
Lead, Alkaline, and Alkaline Earth

The composition of any glaze can determine its surface texture, light transmission, viscosity when molten, and color development when used with stains or metallic coloring oxides. The major, but not the only, ingredients in glazes fall within three broad categories. They are lead-based glazes containing lead; alkaline-based glazes containing feldspars, frits, or both; and alkaline earth-based glazes containing calcium, magnesium, barium, strontium, or beryllium.

Texture: Gloss, Satin Matte, Dry Matte

The fired glaze can develop gloss, satin matte, or dry surface texture. A gloss surface is shiny and smooth to the touch. A satin matte surface is similar to a satin ribbon, with a semismooth surface texture, while a dry matte glaze can have a gritty surface. The surface texture of the glaze is not to be confused with the light-transmission qualities of a glaze.

Light Transmission:
Transparent, Semiopaque, Opaque

The ability of light to penetrate the glaze layer will determine whether the glaze is transparent, semiopaque, or opaque.

Color: Green, Yellow, Red, Blue, etc.

Glazes can be formulated in any color by using stains or metallic coloring oxides. Color is often one of the major defining characteristics in describing any glaze.

Special Effects:
Wood, Soda, Salt, Raku, Luster

Glazes can be developed for wood, soda, salt, luster, raku, or any number of applications or firing techniques.

Application:
Sprayed, Dipped, Brushed

A glaze can be sprayed, dipped, or brushed. The application method can also play a part in the total fired-glaze effect.

Atmosphere:
Oxidation, Neutral, Reduction

A glaze can be fired in an oxidation atmosphere (more air than fuel present in combustion), a neutral atmosphere (equal amounts of air and fuel) or a reduction atmosphere (more fuel than air present in combustion). The kiln atmosphere can alter any of the above glaze characteristics, depending on the particular glaze formula and firing cycle.

Glaze Hardness: Soft, Hard

While not typically a glaze characteristic that is noted, some fired glazes can be described either as hard or soft in their resistance to abrasion or solubility.

While it is not necessary or required to use every glaze description characteristic, an example using them would be the following: I am currently firing a c/9, fritted, alkaline, gloss, transparent, blue, soda-fired, and spray-glazed, in a reduction kiln atmosphere, and it has a hard-fired surface. More frequently, a description of this same glaze would be stated as such: I am currently firing c/9/reduction, gloss, transparent blue, soda-fired glaze.

Standardization in describing glazes will lead to accuracy in talking and writing about glazes, all of which can create a greater understanding of ceramic materials. Disseminating accurate glaze information to other potters will also prevent many glaze defects that are caused by misidentification of glaze characteristics.

Glaze Notation

Now that we can describe a glaze in more detail, the next step is a standardized method for writing a glaze formula. We have all heard the phrase "let's compare apples to apples," which is exactly what a standardized glaze notation offers. A uniform system of writing or reading glaze formulas is a required element for the accurate transfer of information. There are many variables when using and firing any ceramic material, which makes it critically important to be specific and exact wherever possible. Clearly, the written glaze formula is one area where uniformity and accuracy can be utilized to reduce the variable qualities inherent in the ceramic process.

100% Batch Glaze

The individual glaze materials when added up should total 100% in the glaze batch. Gums, suspension agents, dyes, opacifiers, metallic coloring oxides, and stains are listed after the 100% batch weight. Using a system where all of the glaze ingredients are listed as percentages permits one glaze to be compared to another. This standardized method also allows the batch weight of each glaze material to be easily increased. For example, if a glaze formula requires Custer feldspar 53%, the potter can simply add zeros for a larger batch. Custer feldspar can now be stated as 530 g or 5300 g. The same method of adding zeros can be used in other glaze materials to increase the total glaze batch.

Examples of Additives That Are Listed after the 100% Batch Glaze

Coloring oxides/stains: cobalt oxide, cobalt carbonate, copper oxide, chrome oxide, Mason black stain #6600, Alpine Rose #6001, Deep Sea #6244, Teal #6305, etc.

Opacifiers: tin, Superpax, opax, ultrox, etc.

Gums: CMC, VeeGum CER, etc.

Suspension agents: bentonite, VeeGum T, Macaloid, Epsom salts, etc.

Dyes: organic colorants used to tint raw glaze, which burn out during the firing.

All glaze materials listed in the 100% batch glaze can be rounded off to the nearest whole number. If a glaze requires 45.9%

whiting, it can be rounded off to 46% without changing the basic characteristics of the glaze. Any additional materials listed after the 100% base glaze, such as cobalt carbonate, bentonite, Superpax, CMC, or green dye, should be weighed out exactly as stated in the glaze formula. They should not round off to the nearest whole number, since small changes can greatly influence color development, suspension properties, opacity, or raw unfired color.

Whenever possible, the mesh size of any raw material should be listed, since there is a great difference in a glaze whether flint 200 mesh, 325 mesh, or 60 mesh (silica sand) is used in the formula. As a general rule, finer-mesh raw materials, having more surface area, will combine into a glass more easily than coarse materials. Also, several raw materials such as whiting can be processed in different mesh sizes, which can affect the ability of the glaze to remain in suspension, and coarser-mesh whiting can cause transparent glazes to become semiopaque. In many instances the generic name of a raw material is listed but not its mesh size. When possible, list the processor of a raw material or trade name.

Following these guidelines, a typical glaze formula should look like this:

ZAM c/6, oxidation, fritted, alkaline, gloss, opaque, blue, dipping glaze	
Ferro frit #3195	60
Flint 325x mesh	22
EPK	12
Whiting (trade name Atomite)	6
	100%
CMC	1%
Superpax	10%
Bentonite	2%
Cobalt carbonate	1.4%
Green dye	0.5%

c/6, oxidation, fritted, alkaline, gloss, opaque, blue, dipping glaze.

Simple Recalculation to 100% Batch Weight

One of the most misunderstood areas of glaze notation can occur when shifting an existing glaze formula into a 100% batch glaze. For this procedure, a simple pocket calculator is all that is needed. An example of changing a glaze to a 100% batch is:

XXX feldspar	340	43%
Flint	200	25%
Clay	100	13%
Dolomite	150	19%
Total	790	100%

Step 1. XXX feldspar 340 divided by total 790 = 0.4303

Step 2. Move the decimal point two places to the right.

43.03

Step 3. Round off to the nearest whole number.

43

Step 1. Flint 200 divided by total 790 = 0.2531

Step 2. Move the decimal point two places to the right.

25.31

Step 3. Round off to the nearest whole number.

25

Step 1. Clay 100 divided by total 790 = 0.1265

Step 2. Move the decimal point two places to the right.

12.65

Step 3. Round off to the nearest whole number.

13

Step 1. Dolomite 150 divided by total 790 = 0.1898

Step 2. Move the decimal point two places to the right.

18.98

Step 3. Round off to the nearest whole number.

19

As a mathematical check, the recalculated totals of 43, 25, 13, and 19 should add up to 100%. In some instances the rounding-off process will not yield exactly 100% but 99.9% or 100.2%, either of which is perfectly acceptable.

Working with clay, glazes, and kilns is often described as frustration waiting to happen. While it is true that ceramics can at times produce variable results, it is important to realize that some areas of inconsistency can be reduced or eliminated. Using the glaze description and notation methods will enable the potter to understand and compare various glazes. It will also allow potters to use the same language and share information accurately.

28. BASE GLAZES

Base glazes will yield a clear, transparent glossy, semiopaque satin matte, or opaque matte surface. When fired, they will appear clear, semiopaque white, or opaque white. Metallic coloring oxides, stains, gums, suspension agents, opacifying agents, and dyes are *not* included in base glazes. Why use base glazes? Often, potters are faced with a wide array of glaze choices. It is not uncommon for potters to use ten or twelve different glazes, each having a different formula. The fired results can be frustrating to interpret, the relationships between raw materials hard to track. There is simply too much information to evaluate. A less complex approach involves using fewer glazes and observing how they react when fired. Once a level of confidence is established, slight variations in a formula allow for changes in color and surface textures while still yielding a "functionally correct" glaze result. A starting point for alterations can be an increase of five parts plus or minus of any base glaze material. Coloring oxides or stains should be increased in only one-quarter- to one-part increments, since small amounts have greater effects on color than base glaze raw materials. This technique will allow the potter to gain knowledge on a few specific materials in a glaze, which can then be expanded with simple variations.

Before mixing any glaze formula, ask your ceramics supplier if all the raw materials are currently available. Many potters use a raw material found in their studio only to discover that it has been discontinued when they try to reorder. For raw materials used in base glazes, try to purchase the entire factory bag. Not only will the price per pound be less expensive, but, more importantly, when it's time to reorder, you can read back the entire label description listed on the bag to ensure an exact match.

Getting Started

Choosing one glaze formula from each group (transparent glossy, semiopaque satin matte, or opaque matte glazes) will let the potter learn how a limited number of ceramic raw materials function in the glaze. Additions to the base glaze can yield variations in color, texture, and opacity. One-half percent coloring oxide, stain, or opacifier will result in a tint, 5% will produce a half tone, and 12% will yield intense color, opacity, or both.

CONE 6 (2232°F) BASE GLAZES					
Zam Transparent Glossy		**Zam Semi Opaque Satin Matte**		**Zam Opaque Matte**	
Nepheline syenite 270 mesh	20	Whiting	15	Nepheline syenite 270 mesh	60
Whiting	20	Nepheline syenite 270 mesh	40	Dolomite	15
EPK	20	Flint 325 mesh	38	EPK	10
Flint 325 mesh	20	EPK	7	Flint 325 mesh	15
Ferro frit #3124	20				

Glaze Testing Procedure: Weigh a 100 g test batch of glaze, add water, place the wet mixture through 80x sieve, and apply to several 4" vertical test tiles with both smooth and textured surfaces. Distribute the tiles throughout the kiln.

Weighing-out dry glaze materials.

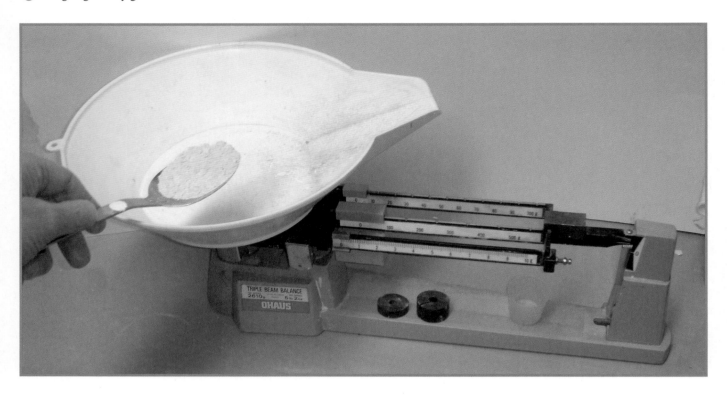

Small increments of water are added to the dry glaze to achieve the correct consistency.

◉ The wet glaze is placed through an 80 mesh sieve three times to complete the mixing process.

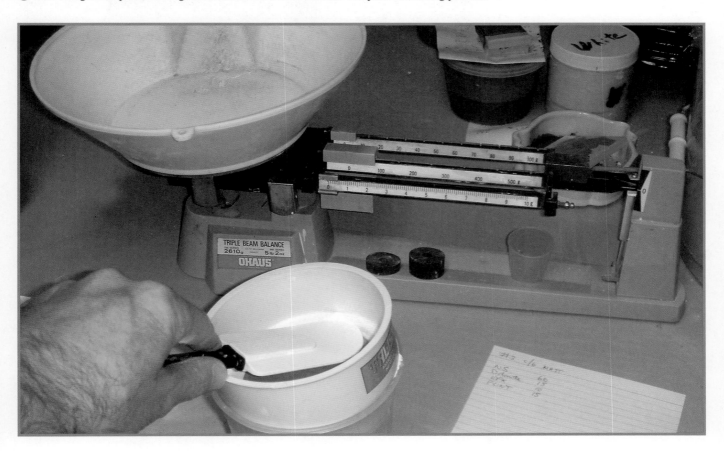

◉ A test tile is dipped into the glaze.

Transparent gloss to opaque matte glaze variations.

Adjusting a Glaze

Any glaze formula can be adjusted by several methods. A simple and effective procedure is to increase the clay component. Additions of five, ten, twenty, or more parts of clay will cause a gloss glaze surface to become satin matte or matte. Clay, being refractory, will also result in a clear glaze becoming semiopaque or opaque. Furthermore, many glazes that drip on vertical surfaces or pool in horizontal areas can be corrected by increasing their clay content, since the heat-resistant clay component of the formula will decrease the glaze flow

Transparent Gloss to Opaque Matte Variations

Increasing the EPK (clay) component of the transparent glossy glaze by fifteen parts and thirty parts causes it to become opaque in light transmission and matte in surface texture.

The enduring instrument in the potter's tool kit is the ability to understand raw materials. Over 80% of glazes contain one or more of just ten to twelve raw materials. Learning the characteristics of how they function can be the basis for future experimentation. One method to achieve this type of ceramics education is choosing a few base glazes and becoming familiar with how they function.

Transparent Gloss Glaze		Semiopaque Satin Matte Glaze		Opaque Matte	
Nepheline syenite 270 mesh	20	Nepheline syenite 270 mesh	20	Nepheline syenite 270 mesh	20
Whiting	20	Whiting	20	Whiting	20
EPK	20	EPK	35	EPK	50
Flint 325 mesh	20	Flint 325 mesh	20	Flint 325 mesh	20
Ferro frit #3124	20	Ferro frit #3124	20	Ferro frit #3124	20

PART 3 - PROTECT YOURSELF— PHYSICALLY AND ECONOMICALLY

29. POTTERY STUDIO AIR QUALITY

When air pollution is mentioned, many people assume we mean outdoors. However, according to the Environmental Protection Agency, air pollution indoors (where we spend 90% or more of our time) is one of the top five environmental threats to public health. There are few situations that focus our attention on what in the atmosphere—gas or particulate—we are inhaling, but at some point when working in a pottery studio, we all have questioned the quality of the air we breathe. The undetected and unknown potential hazards of airborne ceramic materials are a condition worthy of consideration.

The high concentration and the effects of prolonged inhalation of alumina and silica contained in clays, flint, alumina, and other ceramic raw materials are medically recognized as causing aluminosis, silicosis, and other lung diseases. Materials such as iron, manganese, chrome, and cobalt, found in many glazes, also can cause respiratory distress. Such cases are thoroughly documented in government and medical research statistics relating to industrial workers and miners. Certainly no potter would go into a closet, open a bag of flint, and stay there for an entire workday, every day for ten or twenty years, but he is exposed to many of these same particles nonetheless. Since potters are not exposed to airborne particles of flint or other raw materials in the same concentrations and durations as industrial worker or miners, is the air quality in pottery studios hazardous?

The very nature of working with clay and glaze materials propels countless micron-sized particles into the studio environment. The real questions are these: What concentrations are dangerous, how long do they remain in the environment, and how can they be safely removed? The oral history of potters over the past sixty years does not indicate respiratory difficulties among potters, but it is still the best course of action to reduce studio airborne particles as much as possible, thereby increasing the safety margins.

Particle Sizes of Raw Materials

Before discussing the removal of ceramic particles from the studio, it will be helpful to understand their unique qualities. To the naked eye, what looks like gray or off-white dust contains a much-smaller world of shapes and sizes interacting with air currents and surfaces. The average diameter of clays, whether they are ball clays, stoneware clays, fireclays, kaolins, earthenwares, or bentonites, can range from 0.01 to 100 microns in size.[1] For reference, 1 micron = 1/24,500 of an inch, or 1 millionth of a meter. By comparison, the diameter of a human hair is 100 to 150 microns and can remain airborne for 5 seconds. Cell debris from the human body can range from 0.01 to 1 micron in diameter and can remain airborne for hours or days. The same suspension characteristics are true for clay platelets of a similar size. Their ratio of horizontal plane to thickness is 10 to 1, meaning they have a greater surface area on their planes than their width. The hexagonal, flat shape of a clay platelet makes it similar to a lifting body or sail, causing it to be suspended and carried by air currents in the studio.

Flint or silica commonly found in clay body and glaze formulas can range from less than 1 micron to 44 microns in a 325 mesh material.[2] Their shape is classified as fractioned and shattered. Feldspars can typically run from 1 to 100 microns in size, with their shape being irregular and blocky.[3] For example, 270 mesh nepheline syenite, a feldspathic material used in clay body and glaze formulas, can have an angular particle shape and range from 9 to 11 microns in diameter.[4] Other clay body and glaze materials such as wollastonite, whiting, dolomite, zinc oxide, and magnesium carbonate are also very small in particle size and can remain on horizontal surfaces or in the air for long periods of time.

Any potter who mixes dry glaze materials can see particulates suspended in the air, which can eventually result in a thin film deposited on work tables and other horizontal surfaces. However, it is not the visible particles that are the most significant health risk; it is the micron-sized invisible particles that can enter the lower respiratory track. The average adult breathes 3000 gallons of air per day. The human lung is efficient at removing and filtering airborne particles greater than 10 microns, which can get caught in the nose and throat and be expelled through coughing or swallowing. However, particles of less than 10 microns are easily inhaled into the lungs and can impose health risks. Individuals who are sensitive to smoke, have allergic reactions, or have asthma

are at even higher risk for respiratory distress caused by any foreign irritant, whether outside or inside the studio environment. Particles of less than 1 micron have the potential of entering the lower respiratory tract and are the most difficult for the body to remove. Keep in mind: the smaller the particle, the more deeply it can imbed in the lungs, and the longer it will remain.

Common Raw Materials Used in Clay Body and Glaze Formulas That Can Be Released into the Studio Environment

Ball clay Talc EPK Bentonite Feldspar Flint

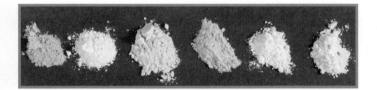

Potential Sources of Airborne Particles

Almost any studio activity has the potential for releasing dry materials into the atmosphere. You don't even have to work in the studio; just open a window and fine dust is in motion. Even the simple act of walking into the studio—no matter how cleanly it is maintained—sends small particles into the air. Work tables, shelves, or any horizontal surfaces will collect particles until a draft reintroduces them into breathable air.

Other activities such as trimming pots, mixing clay/glaze/ plaster, reprocessing clay scraps, sweeping, and opening or moving raw-material bags all are sources of airborne particles. Spraying glazes, using clay-encrusted tools, or even touching raw glazes on bisque pots can also generate raw-material residue on studio walls and floors, which can eventually be released into the air.

Currently there is a lack of definitive statistics on airborne health risks to potters when working in their studios. A conservative approach is to simply accept that lowering any airborne-particle level in the studio is a desirable goal. To that end there are several techniques and procedures that are easily incorporated in any studio operation.

Removing dry clay from a 50 lb. bag.

Weighing dry glaze material.

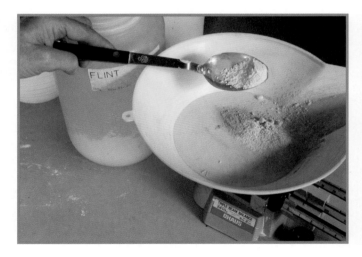

Using newspapers to help with floor cleanup.

⊙ Wiping dry raw materials off a worktable.

⊙ Dry sweeping the studio sends dust into the air.

Preventive Measures When Working with Raw Materials

Commonsense housekeeping procedures and regular preventive measures can be used in the ceramics studio alone or in conjunction with an air filtration unit to ensure a safe work place. (See also chapter 24 for more on health and safety statistics.)

Respirators. Use an approved respirator during any operation that releases dry materials into the air.[5]

Wear studio clothes. Have a separate set of washable clothes for studio use only.

⊙ Dry glaze surfaces can release airborne particles.

Wipe spills immediately. Any glaze spill can dry into a fine dust that can be released into the studio atmosphere.

Clean the studio frequently. Have a regular schedule for cleaning the studio.

Do not eat, drink, or smoke in the studio. Reserve the studio for ceramic-related activities only.

Close all dry material containers. Open containers and bags of materials have the potential for releasing dust particles.

Wet-wipe all work surfaces and floors. Use a wet mop or wet sponge to periodically clean all studio surfaces.

Design the studio to remove, where possible, all horizontal surfaces and any dust-catching features such as rugs or architectural moldings. Horizontal surfaces capture dust. The ideal studio would let all particulates fall to the floor, where they can be wet mopped.

Do not store unnecessary materials in the studio. Any object can trap clay dust, so it is essential to have only equipment and supplies related to pottery production in the studio.

Clean tools and equipment after use. Do not let dry clay and glaze materials adhere to tools. Wash all tools after use.

Ensure adequate ventilation for the studio. Air should be circulated throughout the studio, preferably through an effective filter system.

While it is not necessary to have a dedicated air filtration system in the studio, if you decide to purchase one, make sure it can remove the sub-micron-sized particles encountered when working with clay and glaze materials.

Air Filtration Systems

The effectiveness of any air filtration system depends on several factors. It should have the capability to filter and clean the air in the studio several times per hour. The higher the air flow rate, the faster that particulate matter can be trapped. While there are many air filters on the market, the IQAir HealthPro Plus was chosen for its superior performance in particle retention. The unit filters viruses, bacteria, pet allergens, mold spores, mildew, dust, pollen, and raw materials used in ceramics at a minimum 99.97% efficiency. Each unit is tested before shipping, has variable fan speeds, and indicates when filter changes are required. The IQAir HealthPro Plus has a five-year warranty and is recommended for individuals with lung problems such as asthma and allergies. As an indication of performance, the units are currently used in hospital operating rooms. The unit works by drawing room air through its bottom, where it reaches the prefilter, eliminating over 90% of the particle mass. It then passes through the gas-and-odor filter, which removes 200 different potential gaseous pollutants. This filtration chamber is composed of activated carbon that has been impregnated with active alumina, both of which adsorb various gases and volatile organic compounds (VOCs). Further filtration is performed by a Hyper-HEPA filter (high-efficiency particulate air—clean-room grade), which traps small and ultrasmall particles, bacteria, viruses, allergens, and sub-micron-sized dust.[6] The filtered air exits through a low-velocity diffuser at the top of the unit. The design of the IQAir HealthPro Plus helps disperse the filtered air throughout the entire studio. For more information, visit www.iqair.com to find a local dealer.

IQAir HealthPro Plus[7]

⊙ Internal view, showing multiple filters.

⊙ External view: 28" x 15" x 16", 35 lbs.

Actual Studio Testing

A potter's studio was used to test the effectiveness of the IQAir HealthPro Plus. Dimensions are 13 by 25 ft., with an 8 ft. high ceiling, yielding 325 sq. ft. of usable studio space and a total volume of 2600 cu. ft. The studio has a cement floor and contains a potter's wheel, wedging table, clay storage area, work table, and shelves. A portable scanner was used to measure airborne particles 0.3 micron or larger. The scanner uses a finely calibrated laser and a specific volume of airflow to measure the particles passing through. The data are then extrapolated to provide the total number of particles per cubic foot of ambient air. The particles could be mold spores, clay dust, pollen, plant material, pet/human dander, or any other airborne material. While the scanner does not differentiate between clay particles and other materials, it does give a reading on the effectiveness of the air filtration unit. Comparative air testing was divided into four sampling sessions. Each session was sampled five times, and the total particles per cubic foot were averaged. The air in the studio was circulated at 170 CFM (cubic feet per minute), allowing for 3.923 air changes per hour in the 2600 cu. ft. studio. The data follow.

	No Filter	With Filter Running
Not working in studio	332,600 particles per ft.3	53,200 particles per ft.3
Working in studio	400,200 particles per ft.3	90,000 particles per ft.3

Analysis of Air Sampling

It should be noted that the air coming out of the IQAir Health Pro Plus unit measured zero particles per cubic foot. This means that the filtered air is free from particles and can be considered clean. If the entire room is sealed off, there is no movement to stir up settled dust, and there are no sources generating new dust, eventually the ambient room air will work toward zero particles as well; however, in practical use this is just not possible. When the studio door is opened, new air that has not been filtered is introduced to the room. Also, the person walking in will stir up dust and debris that has settled in the room and reintroduce it into the ambient air. The person's body effluence, such as breathing, sweating, or skin scale shedding, will also affect particulate levels. With so many unmeasurable variables, the specific numbers in our data can be best used for identifying trends. The particle count in the studio with no work going on and no filter being used can be considered the background level. Variables such as humidity, activity in the room, or room furnishings can affect background level readings. Working in the studio with no filter running leads to an increase in ambient particulate levels over the normal background levels. Particles are generated during work, and without a way to contain and reduce them, the total number will continue to rise. With the air filter running, the particulate levels drop drastically, over 75%. This means that the filter is achieving the desired effect. Again, with so many variables, the exact numbers in our data are not as helpful as the general trends. Depending on where in the room the measurement was taken, how long the filter was running, and the exact nature of the work being done, we may see very different numbers, but the trend should hold true. A good-quality air filter such as the IQAir Health Pro Plus has the potential to improve indoor air quality, but buyers beware—there are many poor-quality models on the market. Be sure to speak with a qualified representative about any air filter before making a purchase. A much less expensive and more localized way to safeguard against ambient particulate matter is a NIOSH-approved N95 respirator mask. NIOSH is the National Institute for Occupational Safety and Health, and the N95 refers to 95% efficiency at 0.3 micron. These masks are not as effective as a true HEPA filter, but because you wear them over your nose and mouth, you can be assured that every breath has at least been filtered to some degree.

Monitoring air particles in the pottery studio.

Particle counter measuring particles in the studio environment.

Filtered-Air Considerations

Whether the potter decides to purchase an air filtration unit or employ other preventive measures, common sense in handling dry materials and simple studio housekeeping procedures will go a long way in helping to maintain a safe work environment. Individuals must research and compare the risk of encountering a health problem when working with clay and glazes to the level of protection they are willing to buy. Certainly, if the potter has any allergies or breathing problems, a higher level of protection is recommended. The level of personal risk has to be balanced against the knowledge of how to handle ceramic raw materials safely.

30. FUNCTIONAL POTTERY SETS

Whether working on the potter's wheel or forming pottery by handbuilding methods, repetition and duplication of forms builds technique and skills. It is not an uncommon exercise for the student to make multiple forms as part of the learning process. One method in building the skills necessary to become proficient as a potter is to simply work in the studio, making ceramic forms repeatedly. Once the potter has achieved some degree of skill in making ceramic forms, it is a small step to move on to making sets. Just as in learning any craft, the tools of discipline and repetition through making sets are not to be considered an end on to itself but as a means to creatively make a statement in the ceramic medium.

Aside from the technical challenge of making a pottery set, there is also an economic advantage to potters in terms of incorporating sets into their existing lines. The reality of making and selling pottery in the United States is that potters are engaged in a marginal activity selling to a limited market. With such economic constraints, any strategy that will sell more pots at greater profit margins should be considered. In the wider field of retail sales the technique of "bundling" has become very popular and is a widely used sales strategy. This marketing technique groups similar products together into a saleable package for the consumer. Potters can use the same practice when they make sets of cups, bowls, plates, or complete dinnerware sets. In the production of dinnerware sets, the idea is to show the consumer what is possible with the varied functional objects displayed as a whole package. The presentation of an entire set of dinner plates, lunch plates, cups, bowls, pitchers, and associated forms is a strong visual inducement for prospective customers. It takes the guesswork out of having to choose the items themselves to make a set. In many instances a customer does not have any inclination to buy a set until he or she actually sees the pottery display. In fact, many potential customers when confronted with

various individual pieces of pottery cannot choose items for a set. Too many options often create inaction. It is best for the potter to group glazes or design elements to form a set, which the customer can view and buy.

◯ Set of bowls; glaze color, shape, and glaze pattern determine a set of bowls.

◯ Set of cups; any number of pieces greater than one can constitute a set.

What Is a Set?

Most potters at some point in their career will attempt to make a set. One question that is apparent before starting such a project revolves around what exactly a set is. Let's say you are thinking of making a set of bowls. What defining characteristics will categorize a set? Will the bowls be the same size, shape, or glaze color? A set can also have the same surface design elements and clay body color. Another question is, How many pieces will be produced? Luckily, as with many artistic endeavors, you can decide for yourself what elements will determine the boundaries of a set. However, a set

🔽 Stacked pots; when making functional pottery, it is best to "field test" in a kitchen to see if they will fit in cabinets, dishwashers, and sinks. For example, plates should be of a size and shape that can be easily stored in standard kitchen cabinets.

🔽 Plate set can be glazed in one color and made the same size.

🔽 Brown/yellow set of lunch plates with the same glaze pattern.

should be apparent to others when it is in use or on display. Working toward this goal, both the potter and the intended audience should have a common understanding of what constitutes a set. Simply put, when customers enter a display booth or visit a potter's studio, they should recognize a designated group of objects as a set.

Part of the creation process is in some sense the ability to make a statement and fashion your own view of the world in a ceramic object. However, keep in mind that if the idea is to fashion functional pottery, there exist some external disciplines that have to be executed in order for the objects to work. We all know that bowls should have the capacity to hold liquids or solids, stack easily, be cleaned without difficulty, and generally fit into the kitchen workplace. A pitcher should be able to pour without dribbling. Covered jars should have lids that fit properly. In short, functional objects should function. It is always surprising how many so-called functional pottery pieces are poorly designed. Often, the best solution is for the potter to make several prototypes and then take them into the kitchen for a trial run in every conceivable way they will be used.

Apart from functional considerations when making a set of bowls, there should be some theme in the set that says "I belong to a family," not necessarily "I belong to a set of identical twins or triplets." This can take the form of the bowls being the same glaze colors, the same size, or even a series of nesting bowls, one fitting within the other. Sets should have some common design element that holds them together visually, structurally, or both. Sets don't have to be exactly alike but should be similar on some levels. Keep in mind that machines are very competent at exactly reproducing items; that is a machine's strength. Human beings are unique, and handmade pottery sets should reflect that aspect. The element of handmade is one of the most important points in selling functional pottery. Potential customers, whether attending a craft show, gallery, or studio, are a self-selected group who by

definition are looking for a personal quality to the pottery. The customer realizes that a handmade object will not have the same degree of uniformity as a machine-made product. In fact, if they wanted such products, they could easily buy them at a variety of retail stores.

Why Make a Set? (Think It—Do It)

Pottery is more than just a physical activity. Before the pot becomes a reality, the potter at some level has to imagine it. The thought process can take place weeks, hours, or seconds before the clay is even touched. The mental discipline in deciding what constitutes a set and the act of making it develops critical skills of mind, eye, and hand. Most times, perfection in all areas is not reached, but the ability to think of a set of soup bowls, and the skill involved in forming the bowls, is a central theme in making functional objects. If there were no other reasons to make sets, the discipline of determining a goal and following through to its

⚫ Lids fit; covered jars require lids that fit, indicating care in forming and good craftsmanship.

completion would justify the exercise. Because the single pot represents a potter's statement in three-dimensional form, a set of pots can be compared to multiple statements linked together by a common theme. Aside from the skill required to tie or bind several forms together in a physical form, the potter is also faced with the intellectual challenge of deciding what elements of design define a set.

Sets Offer a System (More Pots = Better Pots)

Often, potters will make a set of six bowls, trimming, bisqueing, glazing, and then firing them. After unloading the kiln, they will take the bowls home to see how they work. Design aspects are tested in real-life situations. Some questions that have to be answered are, Do the bowls sit on the table in a stable manner, do they readily allow a spoon to take out liquids or solids, and can they stack up easily in the kitchen cabinets? Does the glaze color make food look appetizing? After some "real life" testing, revisions are often made in the next set of bowls. In short, producing sets offers a system to advance technical skills and reconsider aesthetic decisions. Often,

⚫ Sets and sales: To ensure a degree of uniformity when throwing on the wheel, weigh each ball of clay in the set.

the first few pots in the set are "stiff" and self-conscious in form, while succeeding pots become more fluid and confident. It is not unusual for the potter over several kiln loads or production cycles to make improved editions of individual pieces within the set or in some instances rework the entire set.

How to Make Sets

When throwing forms on the wheel, weigh out a fixed amount of clay for each pot in the set; this simple step will ensure a degree of uniformity. For example, weighing out four 1 lb. pieces of clay will enable the potter to throw four coffee cups of approximately the same size. This technique can also be applied to handbuilding methods. Each piece of clay should have the same moisture content, since this will help in achieving consistency in the forming process. Soft clay throws or handbuilds differently than hard clay. A central idea in producing sets is to eliminate as many variables as possible so that the potter can concentrate on making each piece similar. When handbuilding, try to maintain the uniform wall thickness, since this will ensure the same forming qualities in each piece.

While some degree of random qualities or handmade features are a definite promotional point in functional pottery, selling items to the public does require a number of basic constraints as to the size and shape of the pottery. For example, it would not improve the selling qualities of plates if they were of a size that did not fit into a standard dishwasher or kitchen cabinet. Likewise it does not pay to make dinner plates with deep, recessed throwing ridges that do not allow a flat surface for the cutting of food. The general public is very much interested in a handmade product, but not to the point of causing extra washing or storage considerations. Those people do not mind that they are essentially a subset of an already small market interested in non-machine-made functional pottery.

⊘ Plate editions; lunch plates, top and bottom view, with an edition number on bottom plate. The plate was the first in a set of six. Often, signing an edition of a set attracts customer interest in the pottery and increases its sales potential.

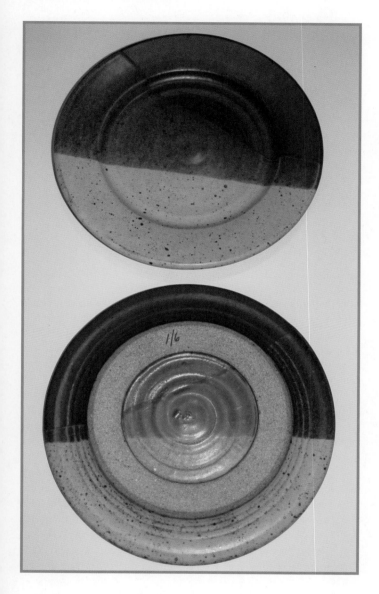

The market is small enough without trying to search out or depend on even smaller markets that will take special time-consuming steps when using pottery in their homes.

The potter whenever possible should try to make a set at one sitting. Through repetition in the forming process, it will become easier and more efficient to make similar forms. On the wheel, most functional pottery can be thrown in a few minutes (if you are spending 30 minutes making one cup, remember that the clay takes on water as it is being formed and becomes structurally weaker as the pot progresses). The average time to throw a small cup should be 1 to 2 minutes. Throwing one or two cups and then coming back later in the day or next week to finish the set can

sometimes not achieve the same degree of consistency compared to making all the cups in one session. In handbuilding, especially with large forms, the system of forming pieces in one session might not be practical, but an effort should be made to develop techniques that are simple and consistent.

Series Can Also Be Sets

One of the best ways to advance throwing skills is to make a series of the same form. A series can denote a slight but intentional change in each piece. The evolution can be in shape, scale, glaze pattern, or whatever the potter envisions. Often, working in a series is a good system to use when the potter wants to move techniques or artistic concepts along within a guideline or framework. A wheel-thrown cylinder offers an excellent example of one way to think about series. Starting from ½ lb. of clay, a small cylinder can become a teacup; 1 lb., a coffee cup; and 3 lbs., a vase. The same procedures can be applied to creating a set or series of nesting bowls just by increasing the amount of clay used to make the same shape at ever-increasing sizes.

Build It—Then Build It Better

In the past, with an apprenticeship system, the beginning potter would start off by learning only one form. After he had gained a level of consistency, another form would be introduced, and the cycle would begin again until the potter was proficient with all the different pots produced in that shop. Today, some beginning students throw a bowl, a cup, a plate, and a teapot all in one session. While such diversity is interesting, it's a hard way to develop consistent throwing techniques. Throwing one form at a time allows the potter to build throwing skills through practice and repetition. Learning to use the potter's wheel is the same as acquiring any skill, since it takes practice, patience, and persistence to achieve any degree of advancement. As with any tool, the primary objective is to achieve a functional or aesthetic goal rather than allowing the technique of using the tool to dominate the project.

When handbuilding using slabs or coils, it takes experimentation to know how the clay behaves at different moisture levels. Building objects with slabs of clay takes a degree of planning as to when the slabs are the correct moisture content for constructing a specific shape. Slabs that are too soft will result in warping or sagging, while too dry a slab can make it difficult to attach other pieces to the form. Through trial and error, the potter acquires the information on how to successfully construct ceramic pieces. When the potter devotes a prolonged period of time to an individual piece, it can result in a delayed and costly failure due to many factors such as drying or firing cracks. As with throwing forms on the potter's

wheel, working in series allows the potter to move on to the next piece if a failure occurs at any time during forming, glazing, or firing stages.

Improving Glazing Techniques

Sets allow for the continuing development of glazing techniques. Working with the same or similar ceramic forms, the potter can then experiment with different glaze application methods. It is often easier to try various glaze patterns or colors on similar forms. Working from a standard object (similar pots or sculpture pieces in a set or series), glazes can be applied in numerous patterns. One piece can be glazed blue and yellow, the next yellow and green and the next yellow and brown. Developing ideas on how a piece is to be glazed when the actual pots are also going through alterations is often difficult. In short, things can get complicated very fast when working with many variables. It is often most productive to stay with one type of form and to work out the glazing techniques either through repetition or slight variations. Faster, more efficient glazing techniques result in less time spent with each pot, which translates into a greater profit.

Firing Sets

Making sets can offer easier kiln-stacking options. Since all the pieces in the set will be the same or have some common design elements, stacking the pots in a bisque or a glaze kiln might make them fit in the limited kiln space more efficiently. In the bisque kiln, nesting bowls can be placed within each other, saving space. In the glaze kiln, sets of cylinders can be placed very close to each other, utilizing every part of the kiln shelf. The overall goal in any type of firing is to have as many pieces in the kiln as possible. Strive for a minimum of dead air space and a maximum of ceramic mass, since this will ensure even heating-and-cooling cycles. Denser stacking of the bisque and glaze kilns translates into more pots per cubic foot, reducing fuel costs. Also, consider that the movement of similar pieces through the studio will progress more efficiently, since the potter has to pick up each piece, place them in the bisque kiln, unload the bisque kiln, apply wax, apply glazes, load the glaze kiln, and finally unload the glaze kiln, all with similar forms.

Making Sets, Selling Sets

When creating functional pottery, a point is reached where most potters begin to sell their work. Whether a potter is selling pots at stores or craft shows, potential buyers are attracted to sets. At craft shows, people run from booth to booth, seeking a bowl to match a set of cups they just purchased. One potter's booth had two-dozen different coffee cups displayed. Many customers came over and found the cup they liked and *then* searched through all the remaining cups to complete a set. Humans have an inclination to group items together. The natural tendency is to build order and familiarity out of random disorder. Just think of that customer searching for matching coffee cups and its implication for sales. To increase total sales and generate points of interest in your display booth, consider making sets. Knowing what factors influence consumers' purchasing decisions makes good business sense. In many instances, selling six dinner plates might be easier than selling just one. Sets of nesting bowls will open many possibilities for their eventual uses to a customer. The motivation for shoppers to make a purchase is stronger when they can visualize a variety of uses for the product.

Limited Editions

A limited edition in printmaking is defined as a finite number of prints made from a single plate. Each edition printed on paper is signed and numbered. As we all know, people love to collect, and if the collectible has a rare or limited quality to it, so much the better. This principle can also be applied to pots. The potter can decide to produce thirty platters of a certain glaze or shape. Each is signed by the potter with the date it was produced, and the edition number, such as 15/30, which indicates it was the fifteenth platter out of a total edition of thirty. While potters should not expect a single customer to purchase all thirty platters, this technique does infer a value to each platter.

The editions could be cups or covered jars. Often, customers will come back and ask if other editions will be released in the future. Making limited editions is a simple but effective method for the potter to make sets and still sell individual pieces. A similar idea can be accomplished by making theme pots with a design element such as a tree pattern in the glaze, or a calligraphy pattern on pitchers. Customers look to collect theme items and strive to acquire the entire set.

While both marketing techniques might sound too commercial, remember that the challenge is to introduce your own aesthetic within the selling environment. If you are selling pottery, as with selling any commodity, a balance must be struck to incorporate sales practices into the individual's aesthetic goals. The potter's signature or mark on each piece further identifies the work as an object made by an individual craftsmen and not a machine. Many customers will ask if the piece of pottery they are considering is signed. To further increase sales, it is always best to sign all the work and make a point of showing the customer the signature.

Some Things Not to Do with Sets

The first and most important rule when making a set is *always, always* turn out more than will ever be needed. If a set of four lunch plates is required, it's best to make at least six or seven. Why? By making additional pieces it ensures that at least some will come through the process of trimming, drying, bisque firing, glazing, and glaze firing without defects. It also allows for choosing the best pieces to form a set if all or most come through intact. The extra time and effort required to produce the work is nothing compared with the disappointment of not being able to assemble a complete set because some pots were lost in the process. Never be in a position of just making the exact number of pots for a set. One of the most common situations a potter can encounter is when a customer wants a replacement piece of pottery for a set that was bought in the past. If you are exceptional at planning ahead, you'll have additional plates from the original set. This will mean a perfect match and a satisfied customer. However, the effort of keeping track and stocking extra plates from every set might not be worth the occasional profitable end result. The real problem occurs when the potter tries to duplicate his or her own work from the past. It can be done, but keep in mind that pottery is made up of countless variables. The kiln atmosphere can change, glaze materials can change, or your own aesthetic could have gone through a transformation. It is often a disappointing task to try to reproduce old work; frequently the potter and the customer are never satisfied with the result. It is always a better selling strategy when making a set to include extra pieces. When the customer purchases the set, suggest buying the extra pieces at that time, telling him or her that they will not be available in the future. Most times the customer will see the logic in this statement and buy the extras. Not only will the potter be spared the time and effort to possibly make replacements in the future, he will increase his sales in the present.

Don't Do This!

Never try to make replacements for a set that someone else has produced. Customers will often bring a cup, bowl, or plate from a set that another potter or—in some cases—a machine produced. Sometimes they don't have the pot and will try to describe what it looks like, after which they will ask if you can match the glaze color, the pottery form, or the style. *Do not do this!* You will find yourself trying to duplicate someone else's work, and invariably the results will not delight you or the customer. The next words out of the customer's mouth are "That's a nice cup, but can you make it bigger, smaller, less heavy, taller?. . ." At that point you have achieved the "*Titanic* effect": you are on a ship that is going down. Good luck.

Satisfy yourself first when making individual pots or sets,

then find people who appreciate your work. This is simple advice, but it's the most valuable way to use your time and labor. In the end, creating pots you enjoy is always the best recommendation.

31. HAND INJURIES IN POTTERS

We use our hands with little knowledge of their physiological structure, and our education often begins when they are damaged. Making pottery is a labor-intensive activity, and like other physically demanding pursuits, it takes a toll on the body, subjecting it to a variety of stresses. The outcome depends on the individual potter's physical condition and the intensity and duration of the activities.

There are twenty-seven bones in the human hand, surrounded by synovia fluid, which lubricates the tendons and joints, allowing for extreme degrees of flexibility and strength. The synovia fluid is maintained between cartilage surfaces and acts as a shock absorber. It also performs other functions such as reducing friction,

Lifting 25 lbs. of compact, dense, moist clay can cause back pain and can strain hands and fingers.

🔵 Wedging clay can stress wrists, fingers, and palms.

🔵 Pressure is applied to fingers when a clay cylinder is pulled up.

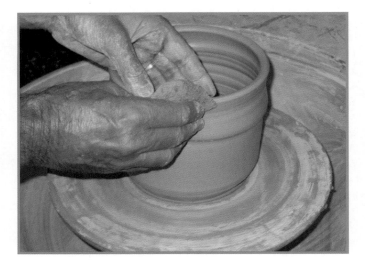

🔵 Pressure is applied to the hands as the moist clay is centered on the wheel.

supplying nutrients, and removing waste material. The human hand is such a small area but has great potential for things to go wrong. It may be a single injury or small stress events accumulating over time. Anyone who uses their hands and arms strenuously or repetitively for extended periods of time is susceptible to hand injury. This group includes musicians, carpenters, and data entry personnel and can also encompass furniture movers, surgeons, and dentists.

Repetitive-Stress Injuries

The potter's first tool and the one that is always used is often the most easily damaged. Handmade pottery: the name itself describes the central part played by the hand in forming pottery. While the potter does have other tools such as sponges, ribs, and throwing sticks, the human hand is often the best tool to smooth a moist clay surface or repair a raw-glaze blemish. The hand is also sensitive in the application of the correct degree of pressure in the forming and finishing operations. Imagine trying to pull up a cylinder on the potter's wheel while wearing thick gloves. The hand can replace many tools, but no tool can replace the hand in its sensitivity and precision.

The most-prevalent types of hand problems occur when lifting bags of clay, handling bulk glazes, or moving equipment around the studio; all are heavy and unwieldy, placing stress on the hands. Wedging also introduces pressure on the wrists and palms as the potter is repeatedly rolling and compressing dense layers of clay into each other. Throwing pottery on the wheel and pulling up a cylinder can cumulatively place excessive pressure on the fingers. During these activities, stiff fingers are an indication of more serious damage if the appropriate steps are not taken.

Pottery-making activities create forces in nerves, tendons, ligaments, and muscles in the confined area of the hands. The potter's hands are like the moving parts of a machine. Eventually these moving parts begin to wear out. These repetitious and strenuous motions during normal studio activities can cause repetitive-stress injuries (RSI).

One of the most common hand problems in the general population and specifically potters is RSI causing tendonitis, which results in an inflamed tendon, the thick cord that attaches bone to muscle and allows a joint to flex or extend. Symptoms can include pain at the site of the tendon and surrounding area. Pain may increase gradually or be sudden and severe; swelling is also common with this type of injury. Wedging as little as 2 to 5 lbs. of clay for long periods can induce inflammation and pain in the wrists.

In the general population, 10% of women over twenty-five years of age will develop tendonitis or carpal tunnel syndrome at some point, and statistics indicate that women are eight to ten times more likely to suffer from carpal tunnel syndrome than men. The causes are anatomical, physiological, and neurological differences. Women's

tendons are not as strong, having less tendon growth and less strength following habitual exercise. There is a slower recovery rate for tendon collagen following acute exercise, and overall lower mechanical strength. Additionally, women's tendons have a lower rate of formation of new connective tissue and respond less to mechanical loading, thus leaving them more susceptible to injury.

Carpal tunnel syndrome is prevalent in painters, typists, computer entry personnel, and potters, among many other occupations. The median nerve is compressed against the carpal tunnel bone in the wrist. If the tunnel is tight or there is swelling in the nerve and accompanying tendons, the results can be numbness in the first three fingers and weakness in the thenar muscles in the thumb and palm. Numbness, tingling, and weakness can also be present due to pressure on the median nerve.

DeQuervains Disease

DeQuervains disease is one of the most common tendinopathies seen in potters. Women are ten times more likely to get DeQuervains disease than men. Potters can perform a simple test (Finkelstein test) to see if they might have this injury. Place your thumb inside the closed fist (of the same hand), and bend the wrist toward the pinky side of the hand. A positive test is noted by a sudden excruciating pain. Additionally, the inability to make an OK sign with the fingers can indicate a positive result.

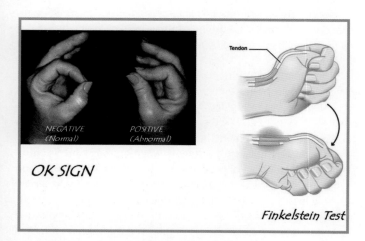

"OK" sign reveals DeQuervains tendonitis.

Trigger Finger (Stenosing Tenosynovitis)

Trigger finger is another aliment caused by repetitive and vigorous use of the fingers and thumb. Women forty to sixty years of age are more susceptible than men to trigger finger. The most common symptoms are soreness at the base of the finger or thumb and a snapping sound when straightening the finger. In some instances the finger or thumb can lock in place. Repeatedly carving moist clay or long sessions of trimming pots can bring on trigger finger. Injury to the fingers can also be caused by applying too much compression when pulling up a cylinder on the potter's wheel. Working with stiff clay can exacerbate any repetitive finger pressure when forming clay objects.

Repetitive hand injuries that included carpal tunnel syndrome, DeQuervains tendonitis, and trigger finger were major health-related issues reported by potters (statistics documented in the Potter's Health and Safety Questionnaire 2000, sponsored by the National Council on Education for the Ceramics Arts [NCECA]). Back pain, burns, and cuts were cited as the three other health problems most likely encountered by potters at all levels of experience.

Arthritis is another problem that can affect the potter's abilities. Chronic wear and tear of the joints results in joint surfaces losing their cartilage, which acts as a "shock absorber." When the protective cartilage thins or wears out, bone-on-bone contact results, causing pain, swelling, and stiffness of the joint. As with other types of hand injury, older potters are more susceptible; as tendons and cartilage age, they tolerate less stress and are less elastic, causing tearing. Bone problems such as osteopenia and arthritis have higher incidence rates in women, especially those with calcium deficiency, which is a leading factor in loss of bone strength.

Individual Cases

Michael McCarthy, a potter for over fourteen years, noticed pain and sensitivity in his thumb, extending to his index finger, after repeatedly wedging clay. Luckily, he stopped this type of activity and started to wedge clay for shorter periods of time, and the problem stopped. In many instances, recognizing a symptom early is the best technique for solving the problem and preventing further injury. Unfortunately, some potters decide to "work through" the pain, and the injury gets worse.

Many potters report that their fingertips crack in cold weather; this is just a function of working with this moist, dense, plastic material. Working with clay constantly subjects the hands to cycles of moisture and cold, causing skin openings in the sensitive fingertips. While the cracks do not bleed, they are painful when throwing or performing other studio operations. Tom White, a potter with over thirty-five years experience, uses superglue to hold the separated skin together until healing takes place. Keep in mind that this practice has not been medically approved.

Potters face a number of physical challenges when engaged in this labor-intensive, repetitive, physically hard activity. To a much lesser degree, some instances of hand injuries are not self-inflicted but are due to genetic factors. One such potter is afflicted with Dupuytren's contracture, which is a thickening of the tissue under the skin in the palms of the hands, resulting in a progressive

⊘ Incisions were made on the ring finger and small finger to remove scar tissue.

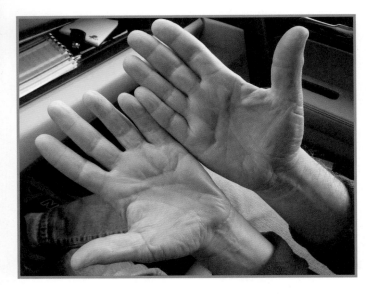

⊘ Healing after five months of physical therapy.

pulling of the fingers inward toward the palm. This potentially disabling symptom can be mitigated, but eventually it will return. As a potter, using your hands to shape and pull up clay on the wheel, this type of disability can hinder or stop a career. The ring finger and pinky are most often affected by Dupuytren's, which develops mostly in men age forty or older with northern European backgrounds. Two in-office procedures are available; if symptoms persist, surgery is recommended. After the operation and five months of physical therapy, the potter is back in the studio making pots.

Preventive Measures

There are several techniques that reduce the effects of carpal tunnel syndrome before resorting to surgery. Keep in mind that surgical correction involves decompression of the tunnel in the wrist, releasing the tight ligament from its roof. If this procedure sounds time consuming, expensive and painful it is. The goal of surgery is the reduction or elimination of anatomical defects caused by carpal tunnel syndrome, trigger finger, or DeQuervains disease. Surgery can repair the injured structures or replace injured structures, as in joint replacement. The first thing to do before seeking surgical intervention is to recognize the symptoms early and make corrections in your pottery-making activities. Adjustments in how you use your hands are a most effective strategy if employed at the onset of discomfort. A preventive exercise to increase blood flow in the joint and to reduce aches is to make a fist and then release your grip several times. This allows normal gliding mechanisms of tendons and joints, diminishing swelling and tenderness. In fact, this might be a good exercise to use every time before entering the pottery studio.

Frequently changing your hand location when wedging, centering, and forming, either on the wheel or in handbuilding, can also alleviate past injury sites. Try to keep your hands in a neutral position when at rest. If the procedure allows, it is best to switch hands often when repeating movements. When possible, use your whole hand and not just the fingers when holding objects. If an acute injury occurs, cool packs can reduce edema (fluid collection in injured tissues), after which local heat can increase blood supply which helps absorb toxins that accumulate at the injury site. Anti-inflammatory medications such as ibuprofen or more-aggressive methods such as steroid injections followed by rest may improve the condition and promote healing. Steroid injections decrease inflammation and diminish the activity of the immune system, reducing chemicals in the body that cause inflammation, keeping tissue damage to a minimum.

Making pottery involves lifting bags of clay and chemicals, moving buckets of glaze, and other labor-intensive activities. Reducing stress on any point of the body will also help minimize damage. For example, when gripping a bag of clay, body leverage works better than trying to "muscle" the clay out of the shipping box with just the fingers. Leverage also plays an important part in other studio activities, such as setting the height of the wedging

table so you can lean down with your upper body when working the clay. This will enable the weight of your body to move through your arms and onto your hands. During any wedging procedure, take several breaks, which will place less stress on the hands and wrists. When centering the clay on the wheel, keep the seat height level with the wheel head, since this will allow your upper body weight and leverage to help center the clay rather than relying only on the strength of your hands. Additionally, keeping elbows close to the body when centering allows the use of your whole body to help move the clay onto center.

Hand problems can lead to other more serious difficulties, making it hard to mix glazes, load kilns, or lift 50 lb. bags of clay. Back injuries from lifting heavy boxes of clay or loading shelves into a kiln can also result in additional strains when throwing on the wheel or bending over the wedging table. Essentially, acute hand problems if untreated can give way to persistent problems elsewhere in the body. Whenever an area of the body is compromised, the neighboring regions can suffer when trying to compensate. Potters should note any of the following symptoms. A stiff, painful, tender finger may result in adjoining digits being affected by attempting to compensate. Hand and finger ailments can compromise wrist dynamics. Elbow pain can accompany hand and wrist problems. Shoulder pain can result in arm problems, and neck strain can lead to poor body mechanics. Many potters fifty years or older report they are simply "wearing out" from years of labor-intensive activity. At some point, working harder is not the solution, but working smarter is the first step in improving hand injuries.

Most injuries start with a mild indication of stress or pain. It is at this initial stage that the problem has to be addressed before irreversible changes occur. A visit to the doctor will be of great help. Just think, if a piece of studio equipment started to break, would you keep using it until it failed? Those who ignore early signs of hand stress often seek medical attention too late. Don't let your ego overrule common sense. A few simple preventive measures will go a long way to make working in the pottery studio less demanding on the hands.

Proper diet with essential vitamins and nutrients is important for bone and tendon health, as well as promoting healing when ailments do occur. The effects of cigarette smoking (nicotine vasoconstricts and diminishes blood flow, and carbon monoxide diminishes oxygen-carrying capacity) are well documented to promote premature aging of tissues. Obesity places additional strain on tissues as well as increases the incidence of type 2 diabetes, which compromises microcirculation to tendons and fingertips. Something as simple as drinking fluids helps maintain healthier hand tissues. The best methods to avoid hand problems are to start with proper body mechanics. The positioning of hands, wrists, elbows, and shoulders when lifting and wedging clay, loading kiln shelves, and working on the potter's wheel or any activity that involves repetitive prolonged motions requires the correct use of leverage, which moves the force through the body and not just the hands.

With increasing age and working long hours in the studio, hand problems are more likely to occur. Clay is a dense material that can be shaped in many ways, but it offers resistance when handled in the forming and firing stages. Many potters at the beginning of their ceramics experience do not realize the forces needed on a repeated basis to move clay. However, at some point this fact becomes apparent when an injury occurs. Potters who prevented or minimized hand injuries took precautionary action in their pottery-making techniques or recognized hand stress at its onset. Prevention is the best course of action, since anything else involves pain, medical expense, and varying degrees of inability to make pots.

32. SELLING POTS

Making pottery can lead to several technical difficulties in forming, glazing, and firing the ware. Selling pottery can involve a completely different set of problems that the potter must recognize and solve. The ability to sell what you make is seductive, and most potters will at some point face the question of when and how to sell their work. If you are dedicating much of your time to making cups, bowls, teapots, etc., at some point after giving away gifts, the actual quantity of work necessitates some method for moving it out of the studio. Many functional potters eventually sell through various wholesale and retail outlets.

There is a truism that states that business people who become potters make money; potters who do not acquire business skills lose money. The primary difference between both groups is the level of business training. To compound this, in many instances individual potters do not share their own experiences in setting up and maintaining a pottery business. By communicating, we can profit from the mistakes and successes of others to fashion a business plan that works for our own individual needs.

On a fundamental level, selling pottery requires a minimum amount of repetition to stock ware or fulfill orders. If the potter publishes a catalog or makes samples of their production ware, there is an implied commitment to reproduce the line of pottery for sale. Selling at wholesale or retail shows can generate orders based on customers viewing the pottery on display. Soon, potters find themselves chasing money and producing repetitive objects, and as the scenario is repeated there is less enjoyment in the task. In the beginning, an exciting artistic endeavor—which also produces money—turns into just a job making pots with a questionable monetary return. Aside from the monetary issues, any money earned from the sale of pottery can often freeze the evolution of new forms and glazes, retarding the artistic growth of the potter. At some point, future ideas for pottery shapes are put aside to concentrate on daily business obligations. The potter is stuck making current forms and glazes that will, it is hoped, sell in the marketplace. An indication of a problem occurs when potters are questioning themselves on what color glaze will sell this season. At this point, artistic growth and new pottery forms do not take shape or are put aside for the immediate monetary gain.

As a ceramics consultant for the past thirty years, I frequently encounter potters who think they have a technical problem. They

describe a favorite glaze that has run off their pot or a raw material that has been discontinued. Many relay similar stories, which start with them trying to get into a big show in the next few days, but a technical problem has left them stumped and time is running out. They need help fast or they will lose money. The central question is why they are in this unfortunate position, which is most likely compounded by a lack of planning. While specific technical problems are often the most immediate and dramatic production-stopping events, upon further investigation they are not the underlying problem. The technical problem is frequently the most visible sign of an impediment in the production cycle of forming, glazing, and firing, but it can also indicate a lack of planning in other critical areas of the business. Like the tip of an iceberg, the hidden defects of the business are not readily apparent, but just like the *Titanic*, the underlying unstable business structure can sink any company.

At first it's easy to sell functional pottery. The problems start when the potter's relatives and close friends have exhausted their need for pottery. Up till this point the potter might think that selling more pots to greater numbers of people will grow the business and increase the profits. A false sense of security based on early sales to a select group of admirers can often lead to an unsound business expansion program that will eventually fail. Unfortunately, the initial positive reinforcement for selling pots isn't placed into perspective by the inexperienced potter. The pottery market has low barriers to entry, expenses for starting the business are modest, and potters sell their work with little initial effort. With income earned from even-reasonable sales, the purchase of pottery equipment, supplies, and raw materials can be paid off in a very short time but does not always mean real profits for the expanding business. Growing the business beyond this point requires more knowledge of business and less of pottery making.

Many people mistakenly believe they can make a living selling pottery while attending craft centers or obtaining a college degree in ceramics. To a great extent, educational institutions subsidize the actual cost of making pottery, and the true costs of production cannot be calculated from this model. Students falsely assume that the next step after graduation involves starting their own studio that can then generate an income from the sale of their work. This misconception is further perpetuated by the lack of any practical, in-depth business courses offered at the educational institution. It is a rare occasion when professional potters are asked to come into the institutional setting and lecture on the business aspects of their trade. Many colleges and craft centers are in a sense closed loops where the course of study prepares graduates to teach on their own or in educational institutions. To counter this trend, students should seek out individual workshops and seminars that do offer training in business techniques to help them operate profitable potteries. It is unusual for a potter to achieve a well-rounded, complete education in pottery and business from a single location.

At some level, producing greater numbers of pots won't necessarily translate into making more money. After the easy entry phase, the next stage of selling involves efficiently operating a small business. What started as an enjoyable pastime soon turns into an actual business competing in the real market place. The effort required to achieve profitability is based on developing skills necessary to run a business that coincidentally just happens to make pots. The potter has to have an extensive knowledge of the market in which he or she hopes to sell. Selling handmade pottery in the United States at best appeals to a marginal niche market of potential buyers. Handmade functional pottery has to contend in many instances with commercial pottery, which can be produced and marketed on a large scale. The result of mass production is an economy of scale, which simply means that the unit cost of each pot is lower due to increased production. This factor alone produces a significant price difference compared to what the potter can offer. The central equation the potter has to solve is how many people will actually buy a relatively expensive, handmade coffee cup sold in a limited geographic market, compared to an inexpensive machine-made cup available at many retail locations nationally.

Learn about Business

Statistically, the majority of all small businesses fail within the first five years of operation; however, there are several steps that will ensure a greater degree of success for the potter. As in other areas of endeavor, a little prior investigation can pay big dividends when deciding whether to start a pottery business or to pursue other interests. A critical piece of advice is to search for people who have traveled the same path. Begin by researching how other potters are selling their ware before starting to sell your own. At this point you can learn from the mistakes they have encountered, and incorporate the good points they have learned through experience. It is easy to be overly concerned with the technical aspects of making pottery; however, if you want to sell pottery, the business aspects can be the deciding factor in success. Ask other potters about the financial component of their business. If possible, inquire as to their other sources of income. Surveys have revealed that many potters do not rely exclusively on sales for their primary income. Having a supplemental income can allow potters a greater array of options on where and when to sell their work. It can also help the business survive periods of slow sales or pass on selling opportunities that offer a marginal return.

The answer to outside income will place their operation in a clearer perspective as to its stand-alone business viability. Comparing their business model with your intended business might not be accurate if they have other sources of income and you do not. Also inquire about what they had to sacrifice artistically to achieve their business goals. Operating a business can be a full-time job, conflicting with family or personal obligations. Will competing forces on your time and energy affect the business? While such direct questions are hard to ask, obtaining the answers can be invaluable to your business plans. After asking a number of potters, an informed perspective might indicate that the personal cost of selling pots is too high. Since every potter will have to weigh the positive and negative issues, there is no single answer that will fit

all situations. If, however, after investigation, selling pottery is still an attractive enterprise, an education in standard business practices is an essential tool.

Many community colleges and adult education centers offer accounting, marketing, economics, and other basic business-related courses. While sitting in a classroom isn't the first thought that comes to mind when wanting to make pottery, it's the way to acquire the skills needed so the business does not fail. Other sources of information include the many books published in recent years for craftspeople wanting to start their own business.[1] Craft magazines and ceramics journals can also offer articles on selling pottery. The articles are written by potters who can pass along strategies that have helped them develop their own business. After reading and talking with others, the potter can then acquire a sense of what kind of pottery is being produced, and can plan to compete in the marketplace.

As with any business that's successful, many individual elements contribute to the total profit margin. Business skills, which include product development, marketing, advertising, accounting, and sales, all have to be mastered to sustain any selling operation. Any time spent learning about other small businesses will be worth the effort later, when your own business is in operation. To obtain a more directed education, search out a profitable pottery operation and consider working for them as an apprentice or part-time help. While this might not fit into everyone's lifestyle, it is not an uncommon strategy in other kinds of business training. In fact, apprenticeships were the traditional method by which craftspeople learned their trade in the past. Potters often apprenticed to a master potter for years before they had reached a level of competence. In this way they learned the tricks of the trade and were able to eventually open their own pottery, where they could hire and train the next generation of potters. While working for another potter for this length of time might be impractical, any time spent in the daily operation of a pottery is a valuable education that can be applied at a later date to your own business. If there is not the possibility of an apprenticeship, a part-time job working for another potter can often reveal everyday business procedures that potters would have to discover by trial and error in their own start-up operation. For example, firing a kiln is best learned by observation and guidance from an experienced potter. This particular skill is very difficult to learn by reading books and can be achieved faster with professional help in the studio. Keep in mind when working for others that the potter can learn from the profitable and unprofitable business practices of the operation. It is always less expensive to obtain this type of information from others as opposed to experiencing it yourself.

Developing a Business Plan

A business plan summarizes your vision for the company and lays out a blueprint for its operation. The first thing to decide is who is going to read the plan. Is it for external use, as in applying for a bank loan, outside financing, or grant, or is it for internal use as a self-guideline for developing the business? If you are the reader of the business plan or showing it to a few advisors, it can offer a step-by-step, clear-cut informal model that can help spot potential problems before they affect the business. Sometimes just reading the plan will cause a revision on the basis of new information or a different perspective. The best changes in the business plan are those that come from feedback and the review of others. It is always easier and less expensive to alter the plan rather than make changes once there is an ongoing daily business operation.

If the business plan is for external use, the financial and projected sales components become more important, since you are asking other individuals or institutions for money. The supplied information should be accurate, comprehensive, and pertaining to your individual pottery business. Loan officers or anyone considering a loan wants to be assured of a low-risk investment. One way to alleviate the perception of risk is by supplying information and market research on your product. Specifically, loan-originating institutions are looking for a "generally accepted accounting principle" (GAAP) format for profit-and-loss statements, cash flow charts, balance sheets, and projected future earnings statements. The GAAP format is an internationally recognized preparation of accounting documentation. For example, in a cash flow statement, the bank wants to know if you purchased clay on a certain date and how long it will take to make pottery and collect revenues from the sale. Obviously, if the turnaround time is excessively long, the risks are higher on a return on investment. At this point, supplying detailed information on pottery production will help inform the lending institution. They want to be assured that you can manage money, control expenses, and manage revenues. Often the most difficult part is forecasting pottery sales, since by definition they have not occurred when the plan is written. Future sales can be estimated from market research, sales by potteries of similar size, and other methods. There is a wealth of information detailing ways of projecting sales on the US Small Business Administration's website www.SBA.gov.

One of the major causes of all small-business failures is undercapitalization. The lack of money can severely reduce the potter's options in choosing rental space, purchasing equipment and supplies, and limiting advertising. Why would anyone start a business and expect immediate revenues? There can be a long delay in terms of setting up the business and the eventual steady income from the sale of pottery. Not allowing for unforeseen problems in production can often delay the infusion of cash to the business. Delays can also be caused by many reasons, such as community zoning restrictions or a sudden sickness causing incapacitation. Having a working reserve of capital can allow the time and expertise necessary to solve problems and continue pottery production. Developing a plan on how to obtain start-up and working capital will greatly remove a significant impediment to failure.

If you are unsure how to write a business plan, there are many resources available, such as software programs, college business programs, local business development offices, accountants, professional planning consultants, and more. Independent companies and consultants can write plans, but be sure to inquire

if they can supply statistical market information pertaining to selling handmade pottery.

Searching online for business plans will yield many companies that specialize in writing them. They often list sample plans that the potter can adapt to his own requirements. One company that has proven very helpful to potters, supplying information on business plans, can be found on the Internet at www.businessandmarketingplans.com. If the potter wants to write a plan, any library will reveal several books on the topic, one of the best being *Writing a Convincing Business Plan*. A series of books on marketing by Jay Conrad Levinson, called *Guerrilla Marketing*, offers several inexpensive and innovative techniques in marketing and selling. The goal, whether buying the services of a business-planning company or writing your own plan, is to make it as specific as possible to your own requirements so that it will achieve your objective of obtaining financing or improving your operations.

A Pottery Business Plan

A comprehensive business plan should include the following topics:

Description of the product. What kind of pottery will be produced?

Marketing of the product. How will the company promote, distribute, and sell the pottery?

Financing of the company. Will personal savings provide start-up costs and operating expenses or will outside financing be available?

Management of the company. Will the business be staffed by a sole proprietor or employees?

What exactly is the market? Who will buy my pottery? What is their income range, education, history of buying pottery, and reasons for pottery buying?

Where are the customers? Do they live in state or out of state and are they from the city or the country?

What are the customers' buying patterns? Do they buy pottery every week, month, or year? Do they buy at craft shows, galleries, online sales, catalog, or direct from the potter?

Why should they buy pottery from my company? List specific value-added features such as unique glaze colors, durability, ease of use, and wide assortments of functional pottery.

Should I concentrate on the whole market or a segment? Should I try to sell pottery to everyone, or to potential customers who are craft oriented?

What is the competition? Are other potters making similar pottery? Are pottery imports a larger part of the market?

What are the competition's strengths and weaknesses? The competition produces pottery of equal or superior quality. The competition does not make customer pottery.

How can I improve my product over the competition? Should I use unique glazes? Should I specialize in making sets? Should I customize the pottery with slogans or names?

Is the market stable, growing, or shrinking? Are people buying more pots this year than in the past five, ten, or fifteen years? What is the projected growth of the handmade pottery market?

What is my plan for growing the business? I plan to advertise in a local newspaper. I plan on hiring studio help to increase production. I intend to send literature to past customers, notifying them of future sales.

It is amazing to think that many potters do not have a business plan or any cogent ideas on how to operate and grow their business. Some potters' long-range plans consist of packing the car for the next craft show. Whether the expense of going to the show will justify the anticipated revenues is often overlooked. At one time, every potter has brought pots to a show that featured other participants with unrelated items for sale such as garden supplies. Obviously, people attending the show came to see and buy garden equipment, seeds, and plant materials and were not drawn to the event with the idea of buying pottery. Being at the wrong show can be a major setback. It is important to develop real plans for marketing and advertising on the basis of research. They should include an evaluation of prospective craft shows, a timetable to reach short- and long-term goals, and a listing of primary and secondary markets for the sale of your pots. The plan should also provide a complete financial breakdown of direct and indirect costs of production, hourly wages for yourself, and profit margins.

The breaking down of information into strategic plans allows for two important benefits. First, committing ideas to paper assures they won't be forgotten, and allows them to be structured in terms of their importance. However, the most important thing is that it begins setting up a system of feedback and control. It allows the potter the ability to benchmark oneself. For example, projecting revenues for particular shows allows the potter to establish goals. If these goals are exceeded, then you can replan for the future. If the goals aren't met, then you know you need to analyze what you did and didn't do, so the next time it can be done better. If you don't have those plans, you're benchmarking against nothing and have no measure of success or failure.

When applying for a commercial bank loan, a business plan and an explanation of your products and their sales potential are required. The simple act of drawing up a plan will focus the potter on investigating alternative strategies for selling. If you're not borrowing money, the plan still should help with a blueprint for your own course of action. Be sure to review the plan at regular intervals to decide if your objectives are being met. The potter should have the flexibility to change a plan depending on current market information or internal business factors. Specifically, any preparations for future marketing or advertising operations will be a valuable tool in growing the business.

Keep Records

If your business is filing tax returns, records of income and expenses are required, with accurate information supplied to the government. For potters with minimum business experience, there are many books detailing simple record-keeping procedures designed to help the non-business-oriented craftsperson. Additionally, community colleges or adult educations programs frequently offer classes in beginning bookkeeping. Recently there have been many computer software programs that allow easy entry of and access to transactions. Record keeping also serves an important function in tracking raw-material shipments. If moist clay or raw materials are defective, the date of purchase and lot numbers are important pieces of documentation that will help in any credit adjustments.

By keeping accurate, up-to-date financial records, the potter can often spot the first indicators of business difficulty. Potters have lost money by not realizing the nature and extent of their problems until it was too late for corrective measures. In such cases, the potters were focused on the day-to-day requirements of making pots and didn't consider the everyday business decisions necessary for survival. For example, one potter was pleasantly surprised to be accepted to a large crafts show, which was held a few hundred miles from his studio. He felt this would be an opportunity for selling a greater amount of pottery. The potter packed up his pots and spent money on gas, tolls, hotels, and entry fees, and he did not consider these costs versus the potential sales. Besides losing four days of work, he did not sell enough pots to cover expenses. By doing a little research, the potter could have found out from others that this particular show was never well organized, resulting in low public attendance. Try to keep records of past experiences, which will be a benchmark to future opportunities when selling. In this case it would have been wiser for the potter to stay in his studio working and to look for a future lower-cost venue with a better sales history.

Calculating fixed and variable costs is an essential element in determining a wholesale and retail pricing structure. Fixed costs include studio insurance, rent or mortgage payments, heating and lighting, or any recurring costs to do business. A fixed cost becomes progressively smaller on a per-unit basis as the *driver cost* factor (cost determinant) increases. For example, the fixed cost for rent will decrease as more pots (cost determinant) are produced, since the fixed cost for each pot decreases as more pots are created. Variable costs change in total proportion to changes in the *driver cost*. For example, if a potter makes covered jars and needs corks, they are calculated as a variable cost due to the fact that this cost will change in relation to the amount of pots produced. Variable costs also include materials and supplies to produce pots, which include supplies for advertising materials or studio cleanup materials. Keep in mind that there are several different accounting methods to determine fixed and variable costs. The central idea is to choose a bookkeeping system that will yield accurate and reliable quarterly or monthly financial statements that reflect the true cost of producing a pot. If an accurate assessment of fixed and variable costs is not made, potters can find themselves in a situation where they are able to generate a lot of sales but discover they are not making enough profit or are losing money due to the fact that their costs of production are greater than their profit margins. This situation is typically encountered when a potter goes to a wholesale craft show (lower profit margins as compared to retail sales) and obtains many orders for pots, only to discover that sales volume does not always equate to profits.

Not only are financial and inventory records important to file and keep, but the records of glaze testing and kiln firings are critical in duplicating a good result or plotting a bad result and obtaining a correction. Glaze testing can generate many small test tiles with various number and letter designations. Before starting a glaze test series, formulate a plan on how to label the tiles for accurate and easy access in the future. Many times a potter will change a numbering system only to be confused later in the testing series. Often the potter is faced with many small, fired glaze test pieces for which the glaze formulas are lost. In such instances it can be very frustrating and time consuming to retrace past results. The major objective in record keeping is devising an accurate system that fits your individual needs and allows for the recording of additional test results. The information from glaze testing must be easily accessible for future reference. Do not rely on memory, since the number and diversity of glaze test pieces can multiply after just a few kiln firings.

Legal Issues

We live in a litigious society (see chapter 25, "A Problem with Cobalt"). Simply stated, today more people are likely to sue and be sued. Preparing to avoid or counter a legal suit is sound business insurance. Are legal problems prevalent when producing pottery? No; statistically a small percentage of potters will require the services of a lawyer or find themselves in court. However, if it happens to you, statistically it's 100%. So it is always less expensive to prepare now or possibly pay more later. Many communities have lawyers who specialize in working with artists and craftspeople. Often, another artist who has used the services of a lawyer can make an appropriate recommendation. Before starting any commercial activity, contact a lawyer and find out what specific documents are needed to conduct business.

A central part of working in ceramics is firing the kiln. At some point the installation of certain types of kilns might necessitate a permit from the local fire department. An indoor or outdoor kiln requires that before installation. The local town hall will have information through their various departments. Also, contact other potters in the area and ask what documentation was required for the authority to sign off on any type of studio installation. In fact, it might be best to confer with other potters before contacting any official agency, since they can be a valuable resource when dealing with officials in your town. When meeting with officials, be prepared to supply more than enough material on your kiln or equipment to make the process as understandable as possible to non-potters. Remember, in most instances they are not familiar with pottery equipment and can be hesitant to issue permits. They do not want to sign off on anything that might have a mishap and focus blame on themselves. The lack of permits can void any fire, liability, or theft insurance claims. Electric kilns installed in the house or basement studios might not require a local fire department permit, but potters should check with their insurance companies to ensure that their coverage is still intact.

If you are selling pottery (see chapter 32, "Selling Pots"), the glazes should be tested for any possible release of heavy metals when in contact with food or liquids. The chances of a person eating or drinking from a cup or plate and getting sick are minimal. However, if such a situation occurs and they seek legal redress, you will be named on the lawsuit along with the ceramics supplier and any other person or organization in the chain of events. Keep in mind that your pottery does not have to be the actual cause of the problem, but now documentation and proof will be required by your lawyer to counter the suit. If your glazes are tested and pass, this action will greatly reduce legal expenses or remove your name from a lawsuit. Again, this course of events is rare, but the trend for such actions is increasing. The cost for testing glazes is minimal and offers excellent insurance. While the test is simple and effective, it is important to use the appropriate laboratory that specializes in testing ceramic glazes.[2]

Potters renting space should have a clearly defined legal lease with all terms and conditions simply stated. If you do not understand any or all of the lease requirements, visit a lawyer who can state the conditions in understandable terms. For potters sharing studio space, a document stating each person's responsibilities should be signed by all parties. The record should also state the conditions and procedures for the termination of the arrangement. Any verbal agreement can lead to expensive misunderstandings at a later date. When starting a business, potters frequently help defray expenses by taking in other potters. The general rule on studio cooperatives is the more people in the studio, the more problems. Potters will have to balance their start-up capital versus their ability to work well with others in determining if a cooperative situation will be of benefit and truly reduce costs.

Insurance

Insurance protects you and your property from loss. In a sense, when making an insurance payment you are actually betting against yourself, expecting that a future accident will be mitigated by compensation. The need for insurance presents itself fully when a mishap occurs. However, the time to take advantage of insurance is before an accident takes place. Relatively small insurance premiums can counter a large financial loss suffered by an accident. Basically, the potter will have to determine how much risk he is willing to assume, as opposed to how much money he can afford to cover any possible loss. In some situations, insurance is mandatory, as in auto insurance or homeowners insurance if the home has a mortgage. Furthermore, standard homeowners coverage might not extend to employees working in a basement studio, cover loss due to a fire caused by a defective kiln, or extend to an event where a customer cuts her lip on a defective cup. Statistically, many potters are covered by health insurance through other resources. If they are not, the potter will have to determine if health insurance is affordable; if not, are they willing to carry the risk? Will an illness or injury affect the business? The potter should look into workers' compensation insurance if workers are hired. The requirements for this type of insurance differ from state to state.

Traditionally, selling handmade pottery has low profit margins under the best of conditions. There is little leeway for error when calculating the total cost associated with doing business. At some point, carrying increased amounts of insurance to cover every potential event will drive up costs to the point of reducing or eliminating any profits. Since every potter's requirements and resources will be different, the best advice is to seek out an independent insurance agent who has access to several companies. The agent can then offer recommendations as to the type of insurance, costs, and limitations of the coverage to your business. As an alternative, some crafts groups and organizations also offer insurance; however, it might not be as comprehensive as products offered through an independent agent.[3]

Make Pots You Like

Under the best of conditions, making pottery is a demanding, labor-intensive, and repetitive activity. It can be doubly harsh if you don't like the pots you are making. Working long hours in the studio must in some sense be a reward in itself. The best advice is to design pots that are fun to turn out while expressing your own aesthetics, and *then* search for the suitable market. Chasing the market with a popular glaze color might produce short-term results, but succumbing to this impulse will eventually make potting just another dull job. The potter will be making objects devoid of real imagination or meaning. Initially it might be more difficult and time consuming to find the appropriate market for the ware you love to make, but in the long run it will result in energized production.

Many potters do make a compromise and produce objects they know will sell even though the pottery might be less than interesting to produce. Once the guaranteed-income pots are finished, they go on to create the work they enjoy. If you choose this path, maintain a balance between the "paycheck pots" and those that express your aesthetic statement and beliefs. It is also best to review this balance at regular intervals, making adjustments according to income and your interest in creating a particular series of pots. One potter shifts gears when he feels that the pots are just "widgets" on the production line. He then sets aside a few days and refers to a notebook in which he keeps ideas for pots he'd like to make. Often this line of pots sells at higher prices than his standard production ware. If you are considering making pottery for any length of time, it is just too hard a craft to not enjoy your work.

Set Limits

Making pottery involves many small tasks that often have to be timed correctly to achieve the desired result. For example, wedging the clay, forming the pot, waiting for it to dry to a leather-hard state, and trimming the pot are carefully organized steps that can occur daily in the studio. The initial kiln loading and bisque firing prepares the ware for the glazing operation, followed by the eventual glaze firing. All of these actions require planning, execution, and evaluation. The reality is that a potter has only a finite amount of time and energy to make pots. Time is the most important commodity and also the largest cost in the pottery business. One potter periodically stops her activity in the studio and evaluates how much time is left in the day and then decides what else has to be accomplished. Making a list of daily, weekly, or monthly goals such as throwing cups, trimming plates, stacking the bisque kiln, etc., is a device that will increase efficiency and focus attention. Almost every successful pottery has a calendar in the studio or office indicating important production deadlines.

Along with monitoring the time required for all aspects of production, it is also possible to produce too many different pottery forms. Limiting the line to a select range of well-thought-out functional pots makes production less complicated and diminishes the potential for forming, glazing, and firing problems. Reliable technique in all forming operations is easier to achieve if varied and diverse forms do not have to be executed on a regular basis. Making five different-sized casseroles (1 qt., 2 qt., 3 qt., 5 qt., 6 qt.) can complicate production and overstock inventory, while three different sizes (1 qt., 3 qt., 6 qt.) might sell just as well. In wholesale situations where many similar-sized pots are made, potters can find themselves in a time-consuming situation just filling the various orders in a efficient manner.

A small production line with a wide price range ensures a balanced opportunity for sales. Every pot in the line should stand on its own and produce a profit. One question the potter should ask: Is the time spent making a coffee cup equivalent to the time required to make a large bowl? If it takes just as long to make a bowl, the potter might want to produce more bowls than cups. If an expansion of the line is needed, consider making sets of bowls, cups, plates, goblets, etc., since the number of pieces sold will increase along with profits. Many times, prospective customers will be specifically looking for a set of cups or bowls and not individual pieces. By offering a combination of both individual pots and sets, there is a greater possibility of attracting customers. In fact, the production of dinnerware sets, which can consist of a dinner plate, lunch plate, soup/salad bowl, and cup, can greatly increase sales. Most importantly, the prices should reflect the extra time and effort required to produce any set of functional pottery.

Don't make custom pots to order. Turning down a request for a personalized plate or bowl is often difficult, but almost every potter has been put in this situation by family, friends, and customers. It is a great ego boost to have someone offer to pay for pottery, but it can very easily turn into a time-and-cost trap and leave everyone frustrated with the results. It can be an arduous and uncertain task to produce a pot based on a customer's direction as to color, shape, and design. Letting the customer design the work and then evaluate the finished piece is always a risk. The potter is sacrificing his own aesthetic and time to please customers who might not like or want the finished pot. If the piece doesn't meet the customer's requirements, making a replacement usually eliminates any potential profit along with taking up the potter's time, which could have been used to make other pots. If custom work is needed, first show samples of what the customer can expect, and don't stray from the sample options in fulfilling the order.

Also included under situations that do not produce profits and do waste time is the enticing method of selling on consignment. In essence you are giving a store free inventory with the hope they will sell your pots and give you a percentage of the selling price. While it is always ego building to have your work in demand, it should be immediately followed by payment, and delayed payment for any reason increases the possibility of default. It is a high-risk situation to assume that every store will carefully handle the pottery and be competent in its bookkeeping. If the store cannot afford inventory, they might

be undercapitalized, resulting in a higher-than-normal failure rate. On the basis of many potters' experiences with consignment selling, there are more-profitable methods of selling pottery that will yield better results.

Keep It Simple

Keep clay body and glaze formulas simple by using as few raw materials as possible to obtain the desired results. Many basic versions of clay body and glaze formulas produce the same fired effect as formulas containing numerous raw materials, resulting in reduced material inventories that can translate into paper work, record keeping, and reordering. If there are fewer raw materials in the studio, there will be easier and faster weigh-outs of glaze or clay body formulas, which will save time and labor. It will also simplify ordering, which translates into less money being tied up in stocking inventories of raw materials. At some point a raw material might change in chemical consistency or particle size; by using fewer raw materials in clay and glaze formulas, there will be less time expended in tracking down a defective material.

To keep the mixing procedure simple and to save time, the actual amounts of raw materials used in a glaze or a clay formula can also be rounded off to the nearest whole number. For example, in a glaze formula requiring 45.2% of flint, use 45%. Glaze formulas containing coloring oxides, stains, opacifiers, dyes, binders, or suspension agents are the exception, and the exact amount should be used. If the glaze formula requires cobalt oxide 2.3%, that exact percentage should be used in the glaze for the precise intensity of fired color. In clay body formulas, additions of grog, silica sand, nylon fibers, bentonite, metallic coloring oxides, stains, or plasticity agents should be used exactly as specified in the original formula.

Keeping things simple in the pottery studio also applies to the layout of supplies and equipment placement. Just as good kitchen design depends on the layout of appliances when saving steps in food preparing, efficient design principles should reflect the placement of equipment in the pottery studio. For example, moist clay should be placed near the wedging table, which should be close to the pottery wheel or handbuilding table. In this way the potter will not have to double back on his steps and waste time. Often, time-consuming and labor-intensive techniques are unnoticed in the daily production of pottery. Upon careful evaluation of all phases of production, some elements can be eliminated without affecting the end product. The greatest expense in the whole system is time. There is a saying among potters, "the more you touch the pots, the more costly they are to produce." The overall goal should be geared toward developing a system to make pots in the most efficient, low-cost, direct method while still exhibiting the handmade imprint.

Choose Reputable Suppliers

Choose ceramics suppliers on the basis of their reputation and history of reliable customer service. Ask other potters what their experience has been with specific suppliers. A ceramics supplier will not treat you any better than others. Don't waste time trying to fix or work around a consistent problem caused by a supplier; the fastest, least expensive fix is to use another supplier and get on with the process of making pots. Many potters through lack of experience or misguided customer loyalty stay with nonperforming suppliers for too long. Unfortunately, such customer inaction only allows substandard companies to proceed with their actions and remain in business.

While shipping costs and the potential for long supply line problems are always present with distant suppliers, the real concern is buying from a ceramics supplier who doesn't offer good service and reliable products. Late clay deliveries, low raw-material inventories, and incorrectly mixed clay body formulas are the supplier's concern and priorities—not yours. Choosing a lower-cost ceramics supplier who offers substandard services is not a cost-savings strategy. Your focus should be on producing saleable pots; any problems caused by the supplier should be corrected by them and not you. At some point even the most reliable supplier can deliver a defective batch of clay or glaze. Pay close attention to how they handle such events. If you are not satisfied with the result, talk with the supplier and outline your complaint along with any appropriate documentation to support your claim. At that point, if the matter is not resolved equitably, look for a new supplier. In the final analysis a ceramics supplier's mistakes can cost you money.

Buy or Build the Appropriate Kiln

When purchasing any studio equipment, learning from the mistakes and knowledge of others is an inexpensive education that can return considerable benefits. Seeking the advice of others who make similar pottery at approximately the same volume will offer valuable information on the selection of a kiln. The quality of the kiln and the frequency of repair are critical factors in determining what kiln to buy. The potter should consider visiting a college or other educational institution that has a ceramics department. Often the ceramics instructors will be able to suggest what type of kiln has worked best for their program. Under teaching conditions, kilns are exposed to many firing cycles, with various instances of abuse by students and poorly trained instructors. Some manufacturers' kilns will hold up better under these conditions, and they should be considered for purchase in your studio. After deciding on the kiln with the lowest incidence of repair, choose the size that is easiest to fire accurately and consistently for the line of pottery you're producing.

As a cost-saving measure and learning experience, some potters choose to build their own kiln, saving approximately one-third the price of a manufactured kiln. However, it can also lead to several construction and firing difficulties if not done properly. If the potter is a first-time kiln builder, it is best to take a course in kiln building. One of the best methods for practical instruction is to help other potters build their kilns. Obtaining this type of experience reduces the time and effort required to build your own kiln. You do not want to be in a position of experimenting when building a kiln. It is best to use a design that other potters have built, since most if not all of the design problems will have been resolved by them. If you know of others who built this type of kiln, they can be a valuable source of information on construction techniques and offer recommendations on firing. However, if the kiln is poorly designed, a further ongoing problem results when firing the pottery during a production cycle. What starts as a cost-cutting measure of building your own kiln can soon turn into an expensive endeavor that does not produce consistent acceptable results. There can be nothing more time consuming than trying to fire a badly designed and poorly built kiln.

If the pots are fired in kilns fueled by hydrocarbons (gas, propane, oil, coal, or wood), the potter must understand the theory and practice of creating a reliable reduction, oxidation, or neutral atmosphere, since these kilns provide countless variables in atmosphere that can produce variations in clays and glazes. While the major reason for choosing fossil-fueled kilns is to alter the metallic coloring oxides in clays and glazes, incorrect firing can contribute to inconsistent results. Unreliable results offer no benefit for customers waiting for specific orders that can't be produced. If, however, your pots sell with inconsistent glaze and clay body results, changing the firing methods or type of kiln used in production won't have to be considered.

Electric kilns have a better chance of producing reliable clay and glaze textures and colors compared to hydrocarbon-fueled kilns. Electricity is clean burning, producing an oxidation atmosphere within the kiln. One benefit of electric kilns is their ability to produce consistent glaze and clay body results with minimum input from the potter. However, with experimentation, electric kilns can produce unique clay body and glaze results that in some instances duplicate clay and glazes fired in hydrocarbon-fueled kilns. The primary concern for the potter is determining what type of kiln will produce pottery that is saleable.

Whatever type of kiln is chosen and whether it's used in bisque or glaze firings, it should be fully loaded every time. Completely utilizing the stacking space will help in heat retention, creating greater thermal mass during the firing and cooling phases. A fully loaded kiln will also equalize heat distribution during the firing. The kiln shelves, posts, and pottery will radiate heat during the firing and after the kiln is turned off. In the initial bisque firing, bone-dry pottery can be placed on or within each other, size and shape permitting. The stacking technique allows for the elimination of some kiln shelves, further increasing space for pottery. In a glaze firing, pottery can be placed ⅛" apart, but not touching, to provide for increased pots per firing and greater thermal mass within the kiln. Aside from the technical considerations, there will be a cost savings with greater utilization of kiln space, thus reducing unit cost per pot.

False Economies

There are several areas where potters lose their way in determining the best methods to save money. Often, such mistakes come about through a lack of perspective in viewing the entire pottery production operation. Focusing on a single item can be short sighted, while not considering how other parts of the operation can negate any one cost reduction. Without careful thought, research, and planning, there are more ways to lose money when making pottery than there are ways to increase profits. Another area concerns the inefficient use of time and labor when potters overestimate their non-pottery skills in studio construction or equipment fabrication. Any time spent building equipment takes time away from making pottery. If the potter is skillful and has the right tools and raw materials, the process can be efficient; however, if the potter takes an inordinate amount of time in construction or the project is poorly designed, problems will multiply and continue affecting pottery making. In such instances, a self-evaluation of the skill level and time required to complete the project will have to be balanced against the time not used making pottery. While the listing of false economies does not include every mistake made, it will give the reader some insight into the missteps of others, one hopes preventing future problems.

Lower-Cost Fuel

One of the most prevalent false economic ideas concerns the cost of fuel to fire kilns. Whether it's electricity- or hydrocarbon-based fuel, the significant cost is the time and labor required to make pottery. A common misconception involves the building of a wood-fired kiln because wood is inexpensive. While the fuel source might be cheap, the labor needed to fire a wood kiln, with the need for consistent stoking of the firebox and the preparation of the wood, would clearly cut into any potential profit from the sale of pottery. If the actual wood-fired pots produce an extra margin of profit due to the aesthetic qualities, that's another issue that will have to be evaluated. Unless the pots require the effects of wood firing, using gas or electricity saves more in labor than the high costs of these fuels.

Lowering the Firing Temperature

Lowering the kiln-firing temperature to save on fuel is an endeavor that should be carefully considered. Aside from less wear on the kiln and shorter firing and cooling cycles, the fuel saved might

not be worth the time and effort to recalculate clay body and glaze formulas to the lower temperature range. Potters can recalculate their glazes, but in some instances the same clay body cannot be used at the lower temperature range due to less vitrification in the fired ware. The clay might feel dense and ring when hit, but it can leak if not mature. Keep in mind that a glaze only provides a smooth surface for cleaning and offers aesthetic factors. It can never be considered as a sealant. Lowering the firing temperature might be attempted when there is a slow period in fulfilling orders or when the need for regular production is not critical in the operation of the business.

Adding Value to Pottery

Adding features to the ware may not return the investment in time and labor. For example, one potter has been making coffee cups for years that mainly consisted of a cylinder with a pulled handle. He then made a few cups with sprigging (additional clay designs added to the body of the pot) on the sides. While the extra steps required additional time, he was not able to charge a higher price for the cups. At some point, even though the new cups looked very good, they sold only at the old cup prices. The time spent in adding sprigging could have been spent making more cups that did not require additions. There is a fine balance between carrying out an aesthetic concept and justifying the extra time required.

Cheap Equipment / I Can Build Anything

Another false economy involves the purchase of less expensive equipment at the cost of high-quality construction and efficient design. If the equipment constantly breaks down or does not perform well, the initial savings are soon lost and can become more costly as production continues. Used equipment such as kilns, pug mills, clay mixers, or spray booths should be carefully inspected by a trained professional before purchase. For potters with the ability to build their own equipment, there is always the question of the time required to complete the project as opposed to time spent making pots. One of the most nonproductive events occurs when the potter constructs a badly designed and marginally functioning piece of equipment such as a potter's wheel. Not only did it take time and labor to construct the wheel, but it does not function efficiently. Interestingly, potters have built their own gas-fired kilns with a comprehensive set of plans and kiln-building experience. The ability to organize, execute, and assemble bricks, burners, and metal support details is critical to the success of any kiln-building project. Aside from electrical, plumbing, or structural building repairs, which have to be inspected as to specifications and safety, is it worth the time required to build shelving, tables, or work benches? In some instances, yes, if the potter has completed

such projects with skill and expedience in the past. But the answer is "no" if the potter takes excessive time and labor to arrive at shelving that is unstable. Again, the potter's self-evaluation of his or her skills and time requirements will dictate what projects and repairs are attempted in the studio.

Cheap Clay

Cheap clay can be very expensive. The cost of moist clay purchased from a ceramics supplier is insignificant when deciding which clay to use. What is important is the amount of defects any given clay body formula generates over a sustained history of use by other potters. Some clay body formulas generate a greater amount of problems due to factors such as raw-material irregularities, narrow temperature maturation range, fired color inconsistencies, kiln atmosphere sensitivity, or forming-quality limitations. Other clay body formulas have wide parameters that enable potters to achieve a higher success rate. Before purchasing any moist clay, try a few different formulas within the temperature range and fired color you will be using, and note the differences in forming qualities and fired results in your kiln. Additionally, ask your ceramics supplier for the names of potters using the clay body formula you are considering, and inquire of their experience before committing to purchasing a large batch. Does it make sense to buy clay that is two, three, or ten cents less per pound than another clay and have it produce dollars worth of defective pottery?

Mixing and Reprocessing Clay

Potters frequently mix their own clay. While this labor-intensive task is educational and interesting, it is not actually a cost-saving strategy. In fact, so many potters are mixing clay that it assumes a value not indicated by the economic realities of production. While car manufacturers are not related to pottery production, they do share a similar raw-material objective; namely, they do not make the steel for their cars, since they purchase this raw material from the steel production plant. Potters should follow the same example and purchase moist clay from the ceramics supplier. Simply stated, the time and effort required to mix your own clay could be better used to make more pottery. Often, potters make the mistake of taking their own labor for granted and not utilizing their time in more-productive activities. The extra cost for dry-clay storage, mixing machines, and related clay-mixing activities all add to the cost of production. The same principle applies to the reprocessing of clay scraps. The time required for this low return on time investment activity could be better used in making pottery, which generates a profit. If you want to make money selling pottery, buy premixed clay and do not reprocess clay.

Ceramics Suppliers

Do not jump from one ceramics supplier to the next looking for the lowest-cost raw materials. Most suppliers price their goods and services on the basis of the competition. When price differences do arise, they are hardly worth going to another supplier for a short-term gain. The reason for this strategy is simple: at some point there will be a problem with goods, raw-material supplies, or product defects. If you are a valued, steady customer, it counts a lot when it's time to resolve disputes. In some instances when purchasing large items such as equipment or kilns, price shopping is required, but always ask your primary supplier if they can meet the bargain price or do better. It is perfectly acceptable to find the lowest price on equipment and then try to negotiate a better deal with your primary ceramics supplier. Always compare the price of the equipment along with shipping, packaging, and any possible setup costs. Many ceramics suppliers have their own service departments and can repair or replace defective parts on equipment, while an online discount supplier will not be able to supply this service. The potter will then be directly contacting the equipment manufacturer, which can be time consuming and expensive.

Maintain Quality

Closely monitor quality control. Defect rates from any cause should always be noted. A total defect rate should average less than 8%. Higher defect rates indicate a problem either in the technical or production area that needs to be addressed immediately. Monitoring defects and their causes helps in identifying early warning signs. Identify the problem, find the cause, correct the problem, and get on with the work. High defect rates result in major production delays and losses. Often, potters think they can still profit from selling defective pots, and while they do sell, profits are reduced. The ability to sell seconds is often used as an excuse not to investigate the primary causes of failures. Any pot that fails and has to be made or fired again takes up time and increases labor in loading and unloading the pot from the kiln. The replacement also uses space in the kiln that a new pot should have occupied. Replacing a failed pot causes multiple losses in time and labor.

Set Reasonable Prices

While buying handmade objects has an appeal for a distinctive market segment, the actual number of people who value handmade pottery is very small. The potential pottery-buying market in the United States as compared to Japan, where pottery is regarded as a high art, is limited. On some level, potters are faced with competing with commercially produced coffee mugs sold for $1.79 each. Aside from the mass production, there is also a major marketing effort to sell the pottery through a large network of stores. An individual potter cannot hope to compete on this level. A more productive strategy would be to find the market that is interested in handmade pottery and to direct sales efforts to this group of people. Potters can operate profitable businesses; however, it takes extra effort to search out the niche market in order to sell pottery with an acceptable profit margin.

It is important to understand all production costs before setting wholesale and retail prices. An hourly wage and a profit margin on each pot must be included in the total selling price. Many potters include a profit margin in the selling price only after all the hidden costs take effect. At that point they can be actually working for a few cents per hour. Calculate the time and labor required at every stage of production. Cut costs where possible, but think how a cost reduction can affect the whole system. One potter decided to eliminate the bisque-firing process, thus saving time and fuel costs. However, he did not adjust the glaze formulas for raw glazing and single firing. Several glazes applied to the green ware peeled off during the glaze firing, causing the loss of many pots. Another loss occurred when he tried to refire some of the ware, which subsequently cracked due to thermal shock. This potter through his lack of technical knowledge did not realize that the original fired pottery was dense and could not withstand a fast initial increase in temperature during the second firing. Such major adjustments should not be attempted as a sideline to regular production or while trying to fill existing orders.

Unfortunately, there is no single policy for pricing pottery. Potters usually arrive at a formula through trial and error, eventually finding a price point on each item that is competitive while still generating a profit. Calculating the wholesale or retail price on the basis of other potters' prices can often be misleading, since you do not know their true cost of production. If potters are selling coffee cups at $6.00 retail, a very low price, you do not know if they have an independent means of income to offset their pottery "hobby." Such extremely low pricing at craft fairs or in the immediate area of other potters selling their work depresses the entire market. However, if at the craft shows there are many potters selling coffee mugs within a narrow range of pricing, it might be a starting point to use in your own calculations. Obviously, pricing too low might increase sales but limit profits or produce loss if you do not know your true cost of production. If the pricing is too high, competition from other potters will inhibit your sales.

Selling Pottery

Pottery is different than other merchandise in that once it is fired it does not degrade—except for breakage. With planning, the potter can choose the time and place in which to optimize sales income. Building a reserve of pottery can allow the potter to select the market segment that will return the most income for his efforts. For example, it might be more profitable to sell semiannually from the studio as

opposed to entering craft fairs, with all the additional expenses they would entail. The ability to choose appropriate sales venues cannot be overlooked, since pottery appeals to a market segment that can be difficult to locate. Unlike some general-use products, pottery is dependent on a market segment that is aesthetically attuned and has discretionary income. A flea market might not be the best location for pottery sales, while a gallery or craft show will attract buyers specifically looking to purchase pottery.

Use Several Markets

After the pots are completed, the next step is deciding where pottery will be sold. Often, potters starting out in business choose markets that have worked well for fellow potters. In fact, a good starting point is to survey potters as to what craft shows, stores, galleries, and other outlets they have found successful. Their cost structure, location, personal contacts, individual style of pottery, and supplemental income might be the deciding factors in their choice of selling options. Regard their experience as a starting point for your own marketing decisions. Even though a majority of potters use several common selling outlets, do not let that restrict your exploration of new markets. One potter traveled to several local nurseries that sell bonsai trees, and sold planters to them. Diversification of sales outlets will ensure the best chance of future sales. This does not mean that any random sales opportunity should be pursued, since several marginal venues can lead to loss of product or no income for the effort of shipping, stocking, and maintaining a sales outlet.

Selling from the Studio

For potters who are capable of letting customers visit their studios, and where local zoning regulations or rental agreements permit, selling directly from the studio offers several benefits, giving the potter the most control with the least amount of additional expense. Whether or not you like people roaming through the studio and touching pots, tools, and equipment, these negatives can be diminished by listing a set time for the sale and marking off areas that are not accessible to the public. Additional marketing strategies involve building a mailing list of former customers and sending a postcard notifying them when there is a kiln opening. People who have purchased in the past are more likely to purchase again in the future. Notices in the local newspaper or signs posted in appropriate locations will also let the general public know of any kiln openings or events. In some instances, customers will ask for a discount, since they are buying directly from the source. It is up to the individual potter to make this type of judgment call, but cutting your profits is a slippery slope and not recommended. By offering a discount for direct sales, you are to some extent negating the main reason for selling from the studio. If the customer does

not buy pottery (most do when they make the commitment to visit the studio), the next customer will.

There are few things more cost effective than having people travel at their own expense to the studio and buy pots warm from the kiln. All that is needed is packing material and boxes. The central idea is for the potter to touch the pots as little as possible at every stage of forming, firing, unloading, packaging, and transporting. Eliminating transportation costs will surely increase profit margins. Often, transportation costs involve packing supplies, postage, insurance, and the time required to wrap the pots for mailing. Transportation costs could also involve packing pots, loading them in your car, and then unloading them for a craft show or gallery sale. Any time spent away from making more pots while transporting pottery is also a cost of transportation.

Selling at Craft Shows

Craft shows are the most widely employed markets for selling pottery; however, there are several expenses that must be considered before starting on this type of selling venue. Entry fees, displays, and travel and hotel expenses all reduce profit margins before one pot is sold. The time spent preparing, sitting at the show, and packing for the return trip has to be balanced against the time lost in making more pots. These additional costs of doing business are often overlooked initially but show up in the final balance sheet. Potters can become extremely focused on the competitive nature of some craft shows. The process of sending slides or digital images, judges' evaluations, and the prestige of a particular show can often override the true objective, which is to sell pottery and earn a profit.

Craft shows that require great travel distances deserve careful consideration. Often the cost of a hotel room for two or three days plus food can severely diminish profits from the sale of pottery. Local craft shows might produce greater net profits, since travel expenses will be reduced with less potential for unforeseen costs. Often the craft show close to home returns greater profits than a show hundreds of miles away. However, one or two low-income shows, no matter the location, can severely affect profits. Structuring the business around two or three big selling opportunities, no matter what form they may take, can be a high-risk strategy. Do not assume that just because a craft show has returned large sales every year it will continue to do so in the future. Craft show management can change, affecting the publicity, and organization of the show or the economy can take a turn for the worse, leaving people with less income or inclination to buy pottery.

Craft shows do offer an excellent opportunity to meet the public and use their sometimes constructive comments for future reference. Often the public's comments about size, shape, or handle placement will be useful in future pottery designs. One person commented that the handle on a casserole was too small, since she would not be able to grip it with oven mitts. Another commented that dinner plates were too large to fit in a standard-size kitchen

cabinet. In some instances the best-looking glaze on a plate scratches easily from a knife blade. The potter should discover functional defects before placing his or her work for sale. Aside from potters actually using their prototypes before committing to full-scale production, friends and neighbors can also be utilized to sample new pottery forms and glazes, noting positive and negative aspects in design.

Aside from a well-lighted, clean, uncluttered booth, the best selling point at any craft show is the potter. It seems only natural, since pots are made by hand, that the general public or wholesale buyers might want to see and talk with the potter. Many sales are aided not so much by the technical or artistic quality of the pottery but by the personal relationship developing as the potter talks about his work. Wholesale buyers often come back year after year to specific potters because of familiarity and confidence in the potter. The general public is often reticent to engage in conversation when entering a booth. If the potter can engage them in dialogue, there is a much better chance of a sale. Sitting in the back of the booth, reading a book, and not looking at the public does not set the right atmosphere for a profitable day at the show. While these commonsense recommendations are obvious, often the stress of setting up the show and keeping track of the many details causes inattention to the human factors involved in selling.

Craft shows can generate fast income compared to other selling methods, such as waiting for customers to buy pots from a gallery or retail store. Some craft shows are structured to sell both wholesale and retail. Buyers from stores and galleries are invited to the show the first day or two, after which the general public is admitted. Wholesale selling presents a different set of challenges and should be carefully investigated before committing any work to this type of market. Whatever price structure the pots are sold at, an inviting booth will increase sales. The potter should have business cards and postcard photos of her work easily available for distribution. Many times, people will not buy at the show but will contact the potter at a later date to make purchases. Often this is an opportunity to show them new pieces or items that were not on exhibit at the show. Due to the high volume of people attending craft shows, a book in which customers can give their name and contact information is a valuable marketing tool. People who take the time to sign up are a self-selected group who are more likely to purchase pots at a later date. Sending a postcard or e-mail announcing a kiln opening is an excellent marketing tool to generate sales. It is always advisable to cultivate previous customers, since many will collect your work over time.

Selling Wholesale

Selling pottery at wholesale pricing can be a very difficult situation, since the potter is accepting less profit for a given pot compared to selling directly to the customer. Wholesale selling can be accomplished through galleries, stores, craft shows, or catalog sales. The reputation of the seller is of utmost importance and should be investigated before signing any contract. The first sale of pottery should be prepaid or cash on delivery. Because the profit margins are much lower than in selling directly to the customer, the precautions when selling wholesale are critical to an eventual payment. Try to build relationships with stores and galleries that sell your work on the basis of their payment history and your timely delivery of orders.

In the past five years, imported pottery has taken a larger share of the once exclusively domestic pottery market. Potters have begun to send prototypes to China for mass production, and exact copies are shipped back to the United States. The cost of manufacturing and importing is lower than the potters producing the items themselves. The reproduction values of the pottery are outstanding. However, long delays and shifting market demands can occasionally leave the potter with container loads of product that does not sell. To counter this trend, one potter sends free small samples of his pottery, showcasing new designs to promote future orders. However, the samples are sent only to stores that have a consistent history of sales. The success of this strategy depends almost entirely on choosing the appropriate stores and knowing the individual who is responsible for buying pottery in the organization.

Always look for new markets and be prepared for change in old markets. A key ingredient in any type of selling is developing a relationship with buyers. This applies to one-time retail sales, wholesale selling, or pottery exhibited in galleries. Having a buyer like you and enjoy your work can be an important element in current and future sales. If your personality does not meet the requirement of the people-friendly potter, think about having someone else presenting this public face to potential customers. There is so much competition that a buyer can afford to look elsewhere rather than deal with a problematic potter. At some point a buyer will change jobs or market forces will require another type of pottery. Do not get caught not looking for new markets, and start the search while still having good buying relationships with your current customers.

Before committing to any sales venue, make sure you can meet any eventual demand. There can be problems and losses incurred by not enough orders, but there can also be losses encountered by orders that the workplace or personnel are not prepared to meet. One potter was very pleased when his work was highlighted in a catalog; however, he was ill equipped when a high volume of orders were generated. The extra personnel required for completing the order and the delay in shipment to the catalog company caused a major setback in his business plans. In this case, too much of a good thing and his lack of production capability caused the loss of the catalog account. Another potter anticipated a large number of orders from initial sales at a gallery. He hired several people to help with production. Unfortunately, the gallery closed and he was left with a payroll expense and no pottery orders. Before committing to any selling situation, do the research necessary to ensure that you do not under- or overplan for production.

If variable and fixed costs of production are not correctly calculated, potters can find themselves taking orders for many pots but generating very little profit or even incurring losses.

Generally, the wholesale price of pottery is one-half the retail price, but this percentage can vary depending on the individual pricing structure of the business. Often the potter will have to decide on some ratio of wholesale to retail sales to assure a consistent revenue source. A potter who sells both wholesale and retail proudly stated, "I grossed over $100,000 last year in sales." When asked how much profit did he net, the answer was $15,000. Clearly, this potter had to review the business structure that led to a low net profit after generating a large volume of pottery. In fact, the same potter was overly concerned with a technical problem he was encountering with his firings. Unfortunately, he was unaware of the significant financial crisis that had to be solved.

Selling on the Internet

The Internet has become the latest vehicle in selling everything; market research indicates online revenues of one trillion to two trillion in sales for the year 2017. The Yahoo search engine generates seventy-five million visitors a month. While these numbers are truly impressive, selling pottery through the Internet has limitations. In the past few years, potters have placed web pages on the Internet, advertising their pottery. The most productive websites feature professionally photographed clear images and descriptive text. If sales originate from the studio, a detailed map listing hours of operation and directions will lead customers easily to the pottery shop. Retail store and gallery locations can also be listed along with testimonials from satisfied customers. While many people have the technical ability to create a web page, a professional design is recommended. When potential customers are looking at various web pages and contemplating purchasing pottery, an amateurish, hard-to-read web page does not inspire confidence. Current pricing for web page design is approximately $800 to $1500 or greater, depending on the individual website requirements. An Internet hosting for the web page can cost $80 per year, or no charge if the potter assumes this task. Many website-building companies will supply templates for those interested in designing their own website. It is a good idea to have several people look at the proposed site and offer comments as to its readability and clear representation of the pottery.

Pottery is a hands-on medium in its forming, glazing, and firing. It is also a tactile, three-dimensional object that has to be held and observed. Looking at the sharpest, most detailed web page image cannot compete with walking into a studio or shop and actually touching the pot and observing the intricacies of form and variations of glaze color and texture. Traditionally, Internet sales of pottery have not produced a high level of income for potters, but this situation has steadily improved as customers have become familiar with purchasing other items by using this method. To date, one of the best uses of the Internet web page has been to lead people to the studio or store where the pottery is being sold. Aside from shipping costs, which are usually not prohibitive, people still like to handle the pots before committing to a purchase.

Packaging/Shipping Pots

For those potters packaging pottery for shipment, it is very important to invest in the correct materials and containers. Often, newspapers and used cardboard boxes will prove useful, but be aware of breakage, which can negate any potential cost savings in low-grade shipping materials. Many potters provide custom shrink-wrapped plastic and cardboard backing for their ware. Why invest labor and time in a piece of pottery only to have it break in transit? Pottery breaks; this is no surprise to potters or customers.

When shipping, wrap pots carefully in plastic bubble wrap, newspapers, or Styrofoam peanuts. It is always better to use extra packing material, since the additional cost is minimal compared to potential breakage. Double-cardboard boxing with at least 1–2" of filled space between containers is best to prevent damage. The objective in packing is having the pot arrive unbroken, so that an insurance claim does not have to be pursued and a replacement pot does not have to be sent. A shipping-and-packing charge should be included in the total price of all pottery shipped through commercial carriers.

The goal, whether shipping ware to another state or simply placing the pots in boxes at a craft fair, is to ensure that the objects do not break. The shipping package is also an excellent place to include any promotional literature, which will help sell pottery in the future. Postcards or flyers about the next kiln opening or sale are inexpensive advertising and can prove effective since they will be in the hands of customers who already have purchased pottery.

Advertising Media

There are a number of techniques and advertising mediums that can be used to promote the pottery business. At a certain point, some type of advertising will have to be considered to increase sales. Functional pottery and, to some extent, ceramic sculpture require the buying public to be educated to the unique qualities of the materials and glazes. The more informed the potential customers, the greater chance they will want to buy and collect pottery.

Educational literature can take the form of small informative cards enclosed with every pot, stating the pottery name, address, web address, and phone number. It can also recommend whether the pottery should be used in the oven, as well as cleaning instructions. The general public is influenced by mass-production pottery, where all the dimensions and glaze colors are identical. Often, a card explaining the nature and irregularities of handmade objects will go a long way to answer questions on why there are variations in the pottery. People want to buy handmade objects, but the imprint of machine-made uniformity often has to be countered with an alternative aesthetic.

The uniform design and logo of stationery, business cards, postcards, posters, flyers, and invoices offers the public a professional, consistent image of the pottery business. It often pays to work with a graphic designer and have him or her supply several different designs. The potter can then choose the one who works best for the business. The first image the public sees often creates interest and may determine if it leads to a sale. If the potter chooses to have a web page, the address should be listed on all printed literature, since this will further present the ware to the public.

Having images of the pottery will be important for postcards, mailings, and show applications. They can be a useful advertising tool if they represent the pottery in a professional format. Whether the potter takes color slides of his work (many craft shows and galleries have dropped this format for entry evaluation) or uses a digital format, it is important to have clear, sharp images. Try to place one pot in the full frame of the picture against a neutral background, which is important to eliminate any noncritical details. If you cannot bring professional-quality standards to photographing your pottery, building a web page, or designing stationary, choose people specializing in these advertising mediums. Have a group of impartial people look over the advertising literature for readability and appeal before committing to any pottery images or promotional literature.

Watch Your Time

Time is the one element in making pottery that cannot be replaced if lost. Remember, *the more you touch the pots, the greater the cost*. Forming, decorating, firing, finished-pot handling, and packaging all are labor intensive and must be as efficient as possible. Potters should use clay bodies, glazes, firing atmospheres, temperatures, and decorative techniques with wide tolerances. Reliability and consistency should be the basis for choosing equipment, materials, and techniques.

Clay bodies and glazes with narrow tolerances in terms of firing temperatures or kiln atmosphere conditions will not produce pottery of consistent quality. Glazes with short maturing ranges, which can easily be underfired or overfired, will not be reliable or profitable. If a favorite glaze or clay body depends on firing exactly to a specific pyrometric cone and does not do well one cone lower or higher, the glaze or clay body should be dropped from the production line. For potters firing with hydrocarbon-based fuels, a kiln atmosphere that is not consistent can hinder production.

Many potters face a situation where they publish a catalog of their work or send out actual samples and cannot reproduce the pottery in subsequent firings. Much time and labor is lost in trying to correct inconsistent kiln firings. Careful planning and organization of production, marketing, advertising, and distribution will yield an efficient production pottery.

Professional potter Angela Fina in her booth, with functional pottery on display. An interesting display at craft shows is an important factor in selling pottery. The display should be clean and well lighted, with a varied price range of pottery. Potters are assigned booths at craft shows, while the public walks around looking at the displays. Good booth design should attract people with an open, inviting atmosphere, which will encourage sales.

A busy booth attracts more people. Try to arrange the pots for maximum viewing from any angle. Potters who do well at craft shows talk with prospective customers and have an open, informative attitude about their work. If the potter is reading a book or is not present in the booth at all times, such lack of interest does not induce sales.

⊗ Michael Cohen Pottery booth.

⊙ Michael Cohen Pottery; close-up view of pottery display. Good lighting with additions such as pencils and flowers help place the pottery in a functional context. By showing the potential customer how the pots can be used, a sale in more likely.

33. CUPCAKES AND POTTERY

What does the sale of custom-made cupcakes have in common with selling pottery? Both businesses depend on profits to continue to exist, of course. They also have other similarities in terms of product, production, and marketing. Many times, both enterprises are focused on technical details without considering the long-term financial essentials. Frequently, the true costs of production and low profit margins are not noticed until the business is failing.

In some situations the lack of technical ability in producing functional pottery does not inhibit sales when a superior marketing plan is in place.

Quality Not Quantity

I love cupcakes for their proportioned size and great taste. I could easily finish a whole seven-layer cake at one sitting, but cupcakes limit my intake because after you've finished three and can see the paper cup liners spread before you, it occurs to you that it might be time to stop. I can eat commercially prepared cupcakes and do, but they never seem to completely satisfy the last pleasure spot in my brain. It's the difference between eating a fine meal in Sorrento, Italy, and dining at the local Olive Garden; both serve Italian-inspired food, but there is a qualitative difference in the tasting experience.

Custom-made cupcakes do taste significantly better than the mass-produced supermarket varieties. Whether it's their small-batch formulation or the extra care taken with a handmade object, it's something you might not be able to articulate, but instinctively you just know there is a noteworthy distinction. Handcrafted cupcakes and pottery are not necessities; lesser-quality substitutes can be easily found commercially. You could buy cupcakes at the local supermarket or purchase pottery from commercial factories, but these are mass produced, not handmade. Locating people who recognize the value of a handmade object is essential to continued sales of both specialty products.

Farmer's markets are very popular right now. Aside from the fresh quality of the vegetables, they also offer a venue for many items such as peanut butter, honey, organic meats, toys, and other items that are produced by one- or two-person enterprises. On a recent visit to the local farmers market, I met Valerie Hansen, owner of Frosted Swirl Cupcakes. While purchasing several excellent cupcakes, I asked Valerie questions about her business and found it very similar to making and selling pottery, since both produce a handmade object requiring a well-developed skill set. Additionally, both cupcakes and pottery production have similar business structures and marketing goals.

Making Cupcakes / Making Pottery

Two of Valerie's reasons for starting the business were the love of making cupcakes and the joy of producing a distinctive handmade product. Finding your passion can fuel the energy for any business but can also produce serious blind spots when actually trying to run the operation. Significant to her success, Valerie came from a management position in a large food-service company and wanted a more personal work experience where she could use her business knowledge and baking skills.

Similarly, many potters report a genuine love of making pots and a desire to use their skills while being their own boss. This is evident when talking with Michael Cohen, who has been making exceptional handmade ceramic tiles for years. Both Valerie and Michael like the independence of planning and operating a small business, coming from traditional jobs at larger organizations. They greatly enjoy the creative process and have incorporated it into their lifestyles. Such qualities are good motivating factors for competing in the marketplace. In their stories it seems like profit is carefully calculated into operating the business.

Both businesses have low barriers to entry. Ovens, baking supplies, and utensils are not costly to purchase; the same situation applies to kilns, clay, raw materials, and tools. Essentially, a kitchen for making cupcakes or a ceramics studio for creating pottery can often be set up in basements or other parts of a house, all of which make both operations low overhead and modest risk. Conversely, high barriers to entry are found in other traditional businesses such as food stores, which involve rent, office supplies, inventory, insurance, permits, and salaries. The preliminary capital expenditures and ongoing expenses in such businesses leave many prospective entrepreneurs out of consideration.

Valerie Hansen displaying one of her cupcakes.

Fast Initial Sales

Often, initial sales both of cupcakes and pottery are encouraging, but after selling to friends and family and at craft fairs, the next stage involves not working harder but smarter. At this plateau it is often misleading to think the business will keep growing of its own momentum. Baking and pottery skills at some point have to be complemented by business skill sets. After a relatively early success, enterprises that do not have adequate business structures often fail or, more insidiously, meet a slow financial death over months or years. Often, both types of entrepreneurs do not realize they are working for "McDonald's" wages until they are well into the process.

While selling out of cupcakes or pottery can be very encouraging, it might also indicate areas of concern if the true costs of production and profit margins are not calculated. For example, if the cost of production such as labor is not calculated accurately, profits can be reduced or eliminated as actual sales volume increases. A common mistake made by potters is thinking that they are doing well when just looking at gross sales and not calculating their net profit margins. It's like building a many-storied house with a bad foundation: the higher you go, the more unstable the enterprise. Surprisingly, many potters and bakers do not realize that selling more could be causing their financial difficulties.

Sales can also cause undue pressure on production if there is only one person turning out the product. Many potters work alone in their studios, as Valerie does in her kitchen. However, if injury or illness occurs, production can be slowed or stopped. Often the profits generated from such operations do not justify hiring a worker to help. Unlike in larger companies, technical help to solve production problems can be difficult to access. Many small businesses are undercapitalized,

Michael Cohen making ceramic tiles.

🔽 Custom-made cupcake.

🔽 Custom-made pottery.

Baking cupcakes (350°F).

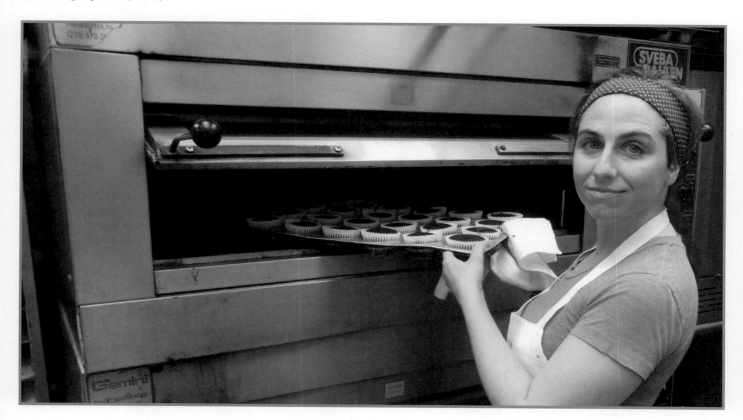

Kiln-fired pottery (2300°F).

🔽 Finished cupcakes.

🔽 Finished ceramic tiles.

and if an unexpected expense occurs such as a kiln or oven failure, production is affected since there are no financial reserves to permit repairs or replacements.

Similar Tools and Production Methods / Variable Factors in Production

In baking, mixing tools, spoons, and flour sifters are equivalent in many respects to trim tools, sponges, and sieves used in making pottery. In some instances, mixing machines for bread dough are used by potters mixing clay. Making cupcakes and pottery is labor intensive and subject to raw-material variations that can cause the final product to fail. Atmospheric conditions in kitchens and studios can influence dough and clay in the forming process.

Cupcakes bake at 350°F, while pottery is fired to 2300°F, vastly different temperatures, but both dough and clay go through significant changes when heated and cannot revert to their original condition. Ovens when not filled completely can affect the density of the final product. The same dynamic applies when less thermal mass is present in a partly loaded kiln, causing porous, less dense pottery. In both instances, less thermal mass results in lower levels of radiant heat, altering the cupcakes and pottery. When cupcakes are taken out of the hot oven too soon, they can sink; pottery when removed too soon from a hot kiln can crack due to thermal shock. Both endeavors require specialized knowledge of materials and heating to arrive at a saleable consistent product.

One significant difference in producing cupcakes is their limited shelf life, while pottery can be stockpiled and sold anytime, allowing for greater flexibility in production and inventory building.

Strategies for Success

There is no "magic bullet" that will solve a failing business; usually they fail for a number of reasons. A combination of strategies should be considered, starting with education. Many community colleges offer courses in bookkeeping, product development, and advertising. Students can learn how to test-market their products and devise surveys to yield information on the subset of the market most likely to buy their items. The tuition is a small investment that will offer a large return. Ideally, this education strategy should be employed before any business is contemplated.

A more direct method is to apprentice to a skilled individual who is already running a profitable business. By participating in the daily running of the operation, one can learn valuable tricks of the trade about ordering raw materials, forming pottery or cupcakes, and firing (baking) skills. You can learn the basics of controlling production costs as well as discovering potential markets. If hiring yourself out to a business is not likely, consider working for free, since this type of information is vital and priceless.

I spoke with a potter who exemplified the underlying problems most potters face when trying to make a living from their craft. The potter received a BFA degree in ceramics from a well-known college but was ill served since the institution did not offer any courses in business. This omission proved to be the greatest obstacle to his success—not the quality or quantity of the pots produced. The reasons for this lack of training are many, but it does not prepare the student for a profitable pottery operation upon graduation. However, in recent years, several colleges and crafts centers are addressing this issue and have added business courses to their curriculum.

After reviewing the potter's work—which was technically proficient—he said, "I can't keep up with the demand on several items." Looking into the pricing structure of these items should be the next step in any evaluation of sales. In a sense, he did not know where he was on the supply-and-demand curve. Increasing the price on fast-selling items by 5% or 10% might have generated more profits and still kept demand up. Taken to an extreme, raising the price too high would place them on the negative side of the supply-and-demand curve, resulting in fewer sales. This calculation was not evident to the potter.

A complicating factor—aside from the lack of business training—was the potter's spouse supplying additional income to the business. There was no incentive for examining pricing or other financial issues, since the enterprise was subsidized. The business deficits were constantly being glossed over by an outside source of income. In this instance the pottery was sold below its value and unfairly affected other potters whose businesses were not subsidized. Such subsidies do not allow the potter to address the true costs of operation. At this point, is this a business or a hobby?

Another issue that illustrated an economic fallacy was the reprocessing of clay scraps. Why engage in a labor-intensive activity to save pennies when the labor and time could be used in making more pots, which have a higher rate of return. The potter could not offer a direct response to this question but revealed several potential problems concerning the future of the business. He enjoyed using his pug mill and was trained by a potter who always reprocessed clay trimmings. While it is easy to say "the blind leading the blind," this faulty economic reasoning is not uncommon to other potters who claim to run a business. Similar lapses in judgment occur when potters buy less expensive clay and it produces defects in the pottery. In this instance, paying a few cents more to a supplier who institutes quality-control procedures in their clay-mixing operations is worth the price.

Use these skills as a model for your own business, and adjust what you've learned depending on the circumstances. However, a central question to ask when trying to sell cupcakes or pottery is, "I know how to make the product, but do I know how to sell it?"

Valerie Hanson, of Frosted Swirl Cupcakes, is still in business after several years, and her cupcakes are delicious.

CONCLUSION

The Dead, Burned-Up Alfred Dog Myth

I love this story because it has all the "hooks" to capture the listener's attention. Let's follow the sequence that brings us to the point of accepting this myth as fact. As you can already figure out, this story does not have a happy ending, which is in itself a manipulative device relying on our fascination with appalling events. One of the most compelling and strange pottery myths was reported on the Clayart network, a ceramic information bulletin board that is a vast source of rumor interspersed with facts and glaze formulas that always seem to be incomplete (I heard it on the grapevine). This believable/unbelievable story—depending on the depth of your ceramic knowledge—takes place at Alfred University, College of Ceramics, in New York Sate. As told, it happened to a friend of a friend. Most potters know that in the past, Alfred was one of the best institutions in the United States for ceramics education (legitimate sources). This knowledge contributes to and makes possible the remaining part of the myth; namely, that a potter's dog who always stayed in the pot shop died. The body of the dog was then cremated in a kiln (mixed truth) and upon opening the kiln the outline of the dog's silica-encrusted lungs remained intact (it could be possible, but is it probable?) (bizarre and strange tales). This horrific condition was caused by all the silica dust the creature inhaled while in the pottery studio (watch out or else). Here we have a classic myth that encompasses some elements that can be true; namely, that there is an Alfred University, College of Ceramics. After this, it is reasonable to assume that there was a dog that spent a great amount of time in a ceramics studio, and it's not too inconceivable that at some point the dog died. We could even stretch things and concede that the dog was cremated in the kiln. The outline of the silica-coated lungs is when the story artfully slides over the line of reason, logic, and ceramic knowledge, but, like being on a speeding train, it is sometimes hard to get off in time to prevent the story from taking over and playing on our thoughts and fears.

Did This Really Happen?

The story contains the characteristics of any potent myth. The mental image of a cremated dog's lungs, rigid and white as stone, is indeed ghastly. The image stays with me even though I know the facts. Since we all have wondered about the dust present in even the cleanest workplaces, it takes listeners one step further in their imagination. This is a true cautionary tale offering a drastic example that appeals to our need for self-preservation while relying on our ignorance of ceramic toxicology and human anatomy. Many potters will trouble themselves visualizing their own lungs hardening from the inhalation of silica. It is the equivalent of someone telling you about a car accident where a body is decapitated. How do you get rid of that mental image? In the interest of those readers who cling to the idea that maybe this really did happen, I feel it is my duty to help separate fact from fiction, all the while realizing there is a magic quality to good stories and powerful myths. However, when enough facts are known, myths lose their power to enthrall. Were you let down when you found out there was no Tooth Fairy? As a graduate student at Alfred University, I never heard this myth but was able to make inquiries of the staff as to the facts of the story. Yes, there were dogs over the years that belonged to the students, and yes, it is possible that some of them stayed in the studios for long periods of time. Whether any dogs died at the school was not known, and if they did, there were no reports of cremations in the kilns. That would leave open the gruesome possibility of a dog meeting its end, resulting in calcified, silica-impregnated lungs. At this point I researched two sources: one medical; the other, my own experience. The veterinarian stated that the amount of silica inhaled over an extended period of time could cause silicosis and eventual death, but the residual silica would not be sufficient to form or maintain perfectly calcified lungs after cremation. The other source relied on experience with my own dog, named Friday. Several years ago my black Labrador retriever, a pot shop dog, died. I can report that after cremation there was no outline of his lungs; only a handful of bone ash (calcium phosphate), a white/gray powder. However, I did use his ashes to make a very attractive glaze.

What Does All This Mean?

In short, do not take anything at face value. Test independently and do your own research. Question experts and realize that they can and do disagree; at that point, further investigation is required. Increase your knowledge of ceramic materials and kiln-firing techniques. Every potter has blank spots. Recognizing how much you don't know is the first step in any education. Pottery has romantic traditions that pull on our spirit and inspire us to form objects from clay. How many people would sit with a kiln all day and night, have an awful firing, and repeat the whole process after pulling out so many bad pots? How many people would bother to make a coffee mug when they could go to the corner store and buy a machine-made cup in any color, size, or style? We should not discard the vision and energy that drive us by believing misinformation and toxic myths.

⌃ Friday, pot shop dog.

⌃ Black cup fired to 2300°F with bone ash glaze.

GLAZE FORMULAS

C/06 (1828°F) — C/04 (1945°F) Base Glazes

Zam #1 Clear, Gloss

Frit CC-250*	95
EPK	5

Zam #2 Clear, Gloss

Frit CC-279*	95
EPK	5

Zam #7 Clear, Gloss

Ferro frit #3195	57
Wollastonite	19
EPK	8
Flint 325x	8
Barium carbonate	8

Zam #8 Clear, Gloss

Ferro frit #3124	78
EPK	9
Nepheline syenite 270x	13
Bentonite	2%

Zam #9 Clear, Gloss

Ferro frit #3195	65
Wollastonite	21
EPK	8
Flint 325x	6

Zam #13 Clear, Gloss

Ferro frit FB276-P2**	98
EPK	2
Bentonite	2%

Zam #3 Satin

Ferro frit #3134	60
EPK	20
Nepheline syenite 270x	15
Flint 325x	5

Zam #4 Satin

Ferro frit #3124	80
EPK	20

Zam #5 Satin

Ferro frit #3134	90
EPK	10

Zam #10 Satin

Ferro frit #3124	35
Ferro frit #3110	37
Talc	8
EPK	10
Zinc oxide	4
Flint 325x	6

Zam #11 Satin

Ferro frit #3124	40
Ferro frit #3110	35
Talc	8
EPK	9
Superpax	3
Zinc oxide	5

Zam #14 Satin

Ferro frit #3124	60
Kentucky Ball OM#4	20
Nepheline syenite 270x	15
Flint 325x	5

* CC-250 and CC-279 can be purchased from Laguna Clay Company, 800-452-4862.

** Ferro frit FB276-P2 can produce clear, transparent glossy, noncrazed surfaces in many glaze formulas. It can be purchased from Sheffield Pottery, Inc., 413-229-7700.

All base glazes take a wide range of coloring oxides and stains.

Glaze suspension agents, VeeGum T (Macaloid), bentonite, or gums VeeGum CER or CMC can be added to any glaze.

Directions: VeeGum T and VeeGum CER. Measure out VeeGum, place in hot water, and mix; use all of this mixture in glaze batch. VeeGum T can be used to keep any glaze in suspension (⅛% to 2%, on the basis of the dry weight of the glaze). VeeGum CER can be used to prevent a dusty raw glaze surface (⅛% to 2%, on the basis of the dry weight of glaze).

Bentonite, a very plastic clay, can be used to keep a glaze in suspension (⅛% to 2%, on the basis of the dry weight of the glaze).

With the addition of any glaze suspension agents or gums, the liquid glaze should be placed through an 80 mesh sieve three times to ensure that all materials are mixed.

C/6 (2232°F) Glazes

Zam #1 Clear, Gloss

Ferro frit #3195	50
Custer feldspar	21
Flint 325x	16
EPK	8
Whiting	5
Bentonite	2%

Zam #2 Clear, Gloss

Whiting	13
Dolomite	6
Nepheline syenite 270x	36
Flint 325x	33
EPK	6
Zinc oxide	6

Zam #3 Clear, Gloss

Whiting	18
Dolomite	6
Nepheline syenite 270x	37
Flint 325x	30
EPK	4
Zinc oxide	5

Zam #4 Clear, Gloss

Nepheline syenite 270x	20
Whiting	20
EPK	20
Flint 325x	20
Ferro frit #3124	20

Zam #5 Clear, Gloss

Ferro frit #3195	60
Flint 325x	22
EPK	12
Whiting	6
Bentonite	2%

Zam #6 Clear, Gloss

Nepheline syenite 270x	41
Zinc oxide	6
Whiting	16
Barium carbonate	7
Flint 325x	30

Zam #7 Clear, Gloss

Nepheline syenite 270x	31
Zinc oxide	6
Whiting	16
Barium carbonate	7
Flint 325x	40

Zam #8 Satin

Whiting	15
Nepheline syenite 270x	40
Flint 325x	38
EPK	7

Zam #9 Satin

Custer feldspar	37
Whiting	12
Zinc oxide	25
EPK	4
Flint 325x	22
Bentonite	2%

Zam #10 Satin

Nepheline syenite 270x	29
Magnesium carbonate	11
Zinc oxide	3
Gerstley borate	14
EPK	8
Flint 325x	35

Zam #11 Satin

Nepheline syenite 270x	31
Zinc oxide	6
Whiting	16
Flint 325x	40
Barium carbonate	7
Superpax	10

Zam #12 Satin

Custer feldspar	25
Dolomite	16
Whiting	3
Zinc oxide	3
EPK	18
Flint 325x	35

Zam #13 Matte

Nepheline syenite 270x	60
Dolomite	15
EPK	10
Gerstley borate	14
Flint 325x	15

Zam #14 Matte

Nepheline syenite 270x	60
Dolomite	15
Kentucky Ball OM #4	10
Flint 325x	15

Zam #15 Matte

Nepheline syenite 270x	45
Whiting	18
EPK	20
Zinc oxide	3
Flint 325x	5
Zinc oxide	12

C/9 (2300°F)–C/10 (2345°F) Glazes

Zam #1 Clear, Gloss

Custer feldspar	23
Tenn. #1 ball clay	22
Whiting	21
Flint 325x	34
Bentonite	1%

Zam #2 Clear, Gloss

Nepheline syenite 270x	55
Flint 325x	27
Whiting	9
Magnesium carbonate	5
Gerstley borate	4
Bentonite	2%

Zam #3 Clear, Gloss

EPK	10
Whiting	20
Custer feldspar	40
Flint 325x	20
Nepheline syenite270x	10

Zam #4 Clear, Gloss

Custer feldspar	55
Whiting	20
Tenn. #1 ball clay	15
Flint 325x	10

Zam #5 Clear, Gloss

Tenn. #1 ball clay	17
F-4 feldspar	34
Flint 325x	27
Whiting	22

Zam #6 Clear, Gloss

Dolomite	5
Whiting	16
Custer feldspar	34
EPK	14
Flint 325x	31
Bentonite	2%

Zam #7 Clear, Gloss

Whiting	18
Dolomite	6
Nepheline syenite 270x	36
Flint 325x	30
EPK	4
Zinc oxide	6

Zam #8 Clear, Gloss

Custer feldspar	60
Whiting	15
EPK	10
Flint 325x	15
Bentonite	2%

Zam #9 Clear, Gloss

Ferro frit #3195	35
Custer feldspar	42
Flint 325x	13
EPK	6
Whiting	4
Bentonite	2%

Zam #10 Satin

Petalite	76
Talc	14
Whiting	3
EPK	7

Zam #11 Matte

G-200 EU feldspar	45
Flint 325x	5
EPK	25
Dolomite	22
Whiting	3

Zam #12 Matte

Custer feldspar	45
Flint 325x	5
Tenn. #1 ball clay	25
Dolomite	22
Whiting	3

NOTES

Chapter 1

1. Lawrence, W. G. *Ceramic Science for the Potter*. New York: Chilton Book Company, 1972, 171, 172.
2. Lawrence, W. G. *Ceramic Science for the Potter*. New York: Chilton Book Company, 1972, 117.
3. Lawrence, W. G. *Ceramic Science for the Potter*. New York: Chilton Book Company, 1972, 117.

Chapter 2

1. Lawrence, W. G. *Ceramic Science for the Potter*. New York: Chilton Book Company, 1972, 116, 117, 118.

Chapter 3

1. Information on clay mining operations and photographs supplied by J. Russell Fish, Director of Technical Services, Old Hickory Clay Company.
2. Fina, Angela. "Improving Plasticity," *Ceramics Monthly*, January 1984.
3. Dodd, A. E. *Dictionary of Ceramics*. Littlefield, Adams & Co., 1967, 169.

Chapter 4

1. Lawrence, W. G. *Ceramic Science for the Potter*. New York: Chilton, 1972, 117.
2. Bishop, C. C. and R. H. Chapman, "Ione Basin Tested."

Acknowledgments:

Shane Bower of Christy Minerals LLC supplied information on the mining and processing of fireclays.
Jon Pacini, Clay Manager at Laguna Clay Company, was very helpful in contributing information on West Coast fireclays.
Eric Struck, Technical Service Director at Industrial Minerals Company, supplied detailed information on West Coast fireclays and processing operations.
Dave Jenkins, President of Ione Minerals, Inc., supplied technical information on the mining of Greenstripe fireclay.
Mort Gensberg, Seaway Shipping & Trading, directed my research into West Coast fireclay mines.
John Cowen, President of Sheffield Pottery, supplied images and descriptions of the clay screening process.
John Benedict, Clay Manager at Sheffield Pottery, screened samples of fireclay for the chapter.
Jim Keating, Technical manager of Gladding McBean, supplied information on Lincoln fireclays.
Jim Kassebaum, General Manager of Laguna Clay Company, supplied samples of fireclays for evaluation.
Jon Brooks, Clay Manager of Laguna Clay Company, was most informative and helpful with information on West Coast fireclays.

Chapter 5

1. Powell, Patrick. "Ball Clay Basics," Old Hickory Clay Company.
2. Typical data sheet obtained from Old Hickory Clay Company.
3. Lawrence, W. G. *Ceramic Science for the Potter*. New York: Chilton, 1972, 35.
4. Darvan No. 7, produced by R. T. Vanderbilt Company, Inc., 203-853-1400.
5. Lawrence, W. G. *Ceramic Science for the Potter*. New York: Chilton, 1972, 123.
6. The manganese content of ball clay is not listed in the chemical analysis because the amounts are in the parts per million range if found at all. However, manganese does reveal itself as brown/blackspecks in the fired clay.
7. Pyrometric cones used for testing, The Edward Orton Jr., Ceramic Foundation, P. O. Box 2760, Westerville, OH 43086-2760.
8. American Society for Testing and Materials, 610-832-9693. Founded in 1898, a non-profit, voluntary organization which sets standards for materials, products, systems, and services used in industry.

Acknowledgments:

Chris Lombardo, Technical Sales Representative, Old Hickory Clay Company, was extremely professional and timely with information on ball clays and casting slip formulas. Information in this chapter was obtained from interviews conducted in 1999.
Konrad C. Rieger, Ceramic Engineer, Research & Development Division, R.T. Vanderbilt Company, Inc.supplied information on Darvan No. 7.
Patrick S. Powell, Vice President Sales and Marketing, Old Hickory Clay Company, oldhickoryclay.com/ball_clay_basics.htm
Jim Fineman, professional potter and technical editor, was instrumental in the format of the chapter.

Chapter 6

1. Clay bodies are composed of clay(s), fluxes, and fillers such as sand, grog, wollastonite, etc., to achieve a precise handling characteristic, firing range, texture, shrinkage, absorption, color, and glaze compatibility in a specific kiln atmosphere.
2. Lawrence, W. G. *Ceramic Science for the Potter,* New York: Chilton, 1972, 38-39.
3. Finkelnburg, Dave and Matthew Katz. "Sexy Bodies – In The Mix." *NCECA Journal,* 2010, Vol. 31, 95.
4. Katz, Matthew. "Clay Selection and Performance, or Performance Art." *NCECA Journal,* 2007, Vol. 28, 38.
5. Finkelnburg, Dave and Matthew Katz. "Sexy Bodies – In The Mix." *NCECA Journal,* 2010, Vol. 31, 95.
6. Katz, Matthew. "Clay Selection and Performance, or Performance Art" *NCECA Journal,* 2007, Vol. 28, 38.
7. Matt and Dave's Clays Porcelain produced by Matt and Dave's Clays, LLC.
8. Finkelnburg, Dave and Matthew Katz. "Sexy Bodies – In The Mix." *NCECA Journal,* 2010, Vol. 31, 96.

Acknowledgments:

I would like to thank Matt Katz and Dave Finkelnburg of Matt and Dave's Clays who contributed technical content and images used in this chapter.
John (Benny) Benedict supplied images of clay mixing machines and pug mills.
Frank Tucker, President of Tucker's Pottery Supplies, Inc., www.tuckerspottery.com, was helpful in supplying information about filter pressing of clay bodies.
John Britt, professional potter, supplied information on filter press clay mixing operations.

Chapter 7

Acknowledgments:

John Cowen, President, Sheffield Pottery, Inc., www.sheffield-pottery.com, was helpful in supplying information on market demands on pre-mixed clays. Sheffield Pottery also provided clay mixing photographs.
John Benedict, Production Manager, Sheffield Pottery, Inc. supplied information on quality control procedures used in mixing clays.
Jim Turnbull, President of Standard Ceramic Supply Co., www.standardceramic.com, contributed information on the marketing and distribution of moist clays.
Julie Hregdovic, Standard Ceramic Supply Co. contributed information on raw materials used in the production of pre-mixed clays.
Frank Tucker, President of Tucker's Pottery Supplies, Inc. and Cone Art Kilns, Inc., www.tuckerspottery.com, supplied technical information on clay mixing quality control procedures used in the industry.
Jim Fineman, professional potter and technical editor for *Ceramics Consulting Services*, reviewed and corrected the chapter.

Chapter 8

1. Zamek, Jeff. *The Potter's Studio Clay & Glaze Handbook.* Beverly, MA: Quarry Books, 2009, 109.
2. Fraser, Harry. *Ceramic Faults and Their Remedies,* 2nd ed. Oviedo, FL: Gentle Breeze Publishing, 2005, 45.
3. Fraser, Harry. *Ceramic Faults and Their Remedies,* 2nd ed. Oviedo, FL: Gentle Breeze Publishing, 2005, 45.
4. Digital Fire http://difitalfire.com/4sight/tests/ceramic_test_soluble_salts.html
5. Parmelee, C. W., *Ceramic Glazes,* 3rd ed. Boston: CBI Publishing Company, Inc., 1951, 585.
6. Britt, John. *The Complete Guide to High-Fire Glazes.* New York: Lark Books, Division of Sterling Publishing Co., Inc., 82.
7. Digital Fire http://difitalfire.com/4sight/tests/ceramic_test_soluble_salts.html
8. Additive A produced by LignoTech USA, Inc., 100 Grand Avenue, Rothschild, Wisconsin 54474-1198, 715-355-3603.
9. Zamek, Jeff. *What Every Potter Should Know.* Iola, WI: Krause Publications, 1999, 86.
10. Digital Fire http://difitalfire.com/4sight/tests/ceramic_test_soluble_salts.html

Bibliography:

Chappell, James, *The Potter's Compete Book of Clay and Glazes.* New York: Watson-Guptill Publications, 1977.
Hamer, Frank and Janet, *The Potter's Dictionary of Materials and Techniques*, 4th Edition, Philadelphia: University of Pennsylvania Press, 1997.
Parmelee, C.W. (1922), "Soluble Salts And Clay Wares." Journal of the America Ceramic Society, 5:538-553. doi: 10.1111/j.1151-2916.1922.tb17439.x
Simon & Schuster's Guide to Rocks & Minerals. New York: Simon and Schuster, 1978.

Acknowledgments:

Ken Bougher, Technical Director, Old Hickory Clay Company, supplied information on clay mining operations and testing procedures for soluble salts.
Amy Waller provided images of her Egyptian paste pendants. Amy Waller Pottery, www.amywallerpottery.com
Jim Cutright, Technical Director, Spinks Clay Company, offered information on overburden and soil pH levels as well as commercial considerations in mining clay.
Mike Schoenherr, Area Business Manager, LignoTech USA, Inc., 908-429-6660, ceramics@borregaard.com, www.lignotech.

com, supplied information on Additive A.
Jim Fineman, professional potter and technical editor.

Chapter 10

1. Zamek, Jeff. *What Every Potter Should Know*. Iola, WI: Krause Publications, 1999, 97.
2. Fina, Angela. "Porcelain Plasticity Update." *Ceramics Monthly,* June/July/Aug. 1985.
3. Lawrence, W. G. *Ceramic Science for the Potter*. New York: Chilton, 1972, 44.
4. Lawrence, W. G. *Ceramic Science for the Potter*. New York: Chilton, 1972, 115.

Chapter 11

1. The American Talc Company, 432-283-2330, mines Texas talc which many ceramics suppliers stock.
2. Chemical analysis supplied by The American Talc Company, P.O. Box 1048, Van Horn, Texas 79855.
3. Ciullo, Peter A. and Janis Anderson. "Industrial Talc." *Technology Forum*. R. T. Vanderbilt Co., Inc.

Acknowledgments:

Steve Harms, President of American Talc Company, supplied information on talc mining practices and quality control procedures used in the industry.
Mort Gensberg, West Coast sales agent for Texas talc, supplied the history of talc use by ceramics supply companies.
Jon Pacini, clay manager, Laguna Clay Company, was very helpful in explaining the different types of talcs available to potters.
John Cowen, President of Sheffield Pottery, Inc., www.sheffield-pottery.com, supplied samples of Texas talc and NYTALC HR 100.

Chapter 12

1. Isaacs, Richard P. "Albany Slip Clay—50 Years Later." Ceramic Bulletin.
2. Isaacs, Richard P. "Albany Slip Clay—50 Years Later." Ceramic Bulletin.
3. Information on the exact locations of Albany slip provided by Barbara Reeley of River Street Pottery, 621 River Street, Troy, NY 12180.
4. Kechum, William C. Jr. *Early Potters and Potteries of New York State*. New York: Funk & Wagnalls, 1970, 87.
5. Hansen, Tony. "Ceramic Materials Database." Insight glaze calculation software, http://digitalfire.com
6. Guilland, Harold F. *Early American Folk Pottery*. New York: Chilton, 1971, 85.
7. Hamer, Frank and Janet. *The Potter's Dictionary of Materials and Techniques*, 4th ed. Philadelphia: University of Pennsylvania Press, 1997, 226.
8. Hamer, Frank and Janet. *The Potter's Dictionary of Materials and Techniques,* 4th ed. Philadelphia: University of Pennsylvania Press, 1997, 335.
9. Analyses supplied by Hammill & Gillespie, Inc., 154 South Livingston Avenue, P.O. Box 104, Livingston, NJ 07039.
10. Analyses supplied by Hammill & Gillespie, Inc., 154 South Livingston Avenue, P.O. Box 104, Livingston, NJ 07039.

Acknowledgments:

I would like to thank Dorna Isaacs for her help in supplying technical information and the histories of Albany slip clay and Barnard/Blackbird clays. I have relied in part on the articles and notes of Richard P. Isaacs, past president of Hammill & Gillespie.
Dr. Richard L. Lehman, Technical Director, Hammill & Gillespie, Inc. supplied information on Albany slip and Barnard/Blackbird clays.
Barbara Reeley and her husband Dennis of River Street Pottery, 621 River St., Troy, NY 12180 contributed photographs of the Albany slip clay site in 2005 and information on the location of Albany slip clay.
Black and white photos of the Barnard/Blackbird mine site and Albany Slip mine in operation are from the Hammill & Gillespie archives.
Photographs of pottery are from the author's collection.

Chapter 13

1. Hamer, Frank and Janet. *The Potter's Dictionary of Materials and Techniques*. A&C Black Publishers, 1997, 126.
2. Custer feldspar information supplied by http://www.pacerminerals.com/products/ceramic-grade-feldspar
3. Zamek, Jeff. "A New Feldspar." *Ceramics Technical,* Oct. 2009.

Acknowledgments:

Bill Rogers, sources for historical information and the froth flotation process of G-200 production.
Tony Hanson, Digitalfire http://digitalfire.com Calculation/Database Software for Ceramic Industry, website supplied information and a description of G-200 feldspar.
Jim Fineman, technical editor and professional potter, has contributed his expertise and experience to this chapter.
John Bennedict, Production Manager, Sheffield Pottery, Inc. contributed samples of G-200, G-200 HP and G-200 EU feldspar.

Chapter 14

1. Hamer, Frank and Janet. The Potter's *Dictionary of Materials and Techniques*, 4th ed. Philadelphia: University of Pennsylvania Press, 1997, 126.
2. Muscovite is a common mica or potash mica containing aluminum and potassium. Biotite is a phyllosicate mineral within the mica group containing iron, aluminum, silicon, oxygen and hydrogen bound by potassium ions. Wikipedia source.
3. Lamar Long, Gary Nelson, and Linda A. Koep, Market Developing Manager, supplied information on processing of I-Minerals feldspar.
4. X-ray fluorescence (XRF) measures the relative strength of the reflection of an x-ray beam from the material being tested. In an x-ray fluorescence goniometer (the machine that measures x-ray fluorescence), x-rays emitted from an x-ray tube are directed at the surface of a sample (usually a pressed powder disc of the sample, but it can also be a fused glassy disc of the sample) at a predetermined angle, and the machine measures the strength of the rays as they bounce off the surface. Different elements exhibit different reflection strengths, and these can be compared to standards to generate an analysis for the particular sample. The number of elements that can be measured at one time vary depending on the size of the goniometer. In the case of G-200 Feldspar, we measured SiO_2, Al_2O_3, Fe_2O_3, CaO, K_2O and Na_2O. Total time to prepare and analyze a sample was about an hour. (Most of that time was preparing the sample disc; the actual analysis took about 8 minutes.) The key to accuracy is calibration of the machine.
Wet methods chemical analysis for feldspar is a lot more complicated. To run all of the analyses above would take days. There is an individual test for each of the oxides that required digestion of the feldspar sample, precipitation of the oxide being quantified, measurement by titration and weighing of filtered residue. Needless to say, wet methods chemistry is far more labor intensive and time consuming, and accuracy is dependent on the skill of the chemist or lab technician. Also, the quality of the various chemical reagents used in the analysis process is very important to accuracy.
G-200 Feldspar was quality tested using wet methods chemistry at the Monticello, GA plant. We monitored in-process quality by running shift composite analyses after each shift, and "grab" samples during the shift, as necessary. We ran a shipment composite sample for the certificate of analysis for each shipment. Back-up confirmation testing of G-200 composites using x-ray fluorescence was performed periodically at our main lab in Spruce Pine, NC. This helped ensure that our two labs and the two methods of analysis correlated well, and maintained our confidence level in our analytical methods and procedures.
5. Zamek, Jeff. "A New Feldspar" Ceramics Technical, No. 29, 2009

Acknowledgments:

I would like to thank Jim Fineman, excellent potter and technical editor.
Digital Fire glaze information software was used to calculate raw materials. http://digitalfire.com/
Sheffield Pottery, Inc. donated raw materials for the test series.
Feldspar testing information supplied by William Z. Rogers

Chapter 15

1. The exact chemical composition of Gillespie borate is proprietary to Hammill & Gillespie. Gillespie borate is a mixture of ulexite ($Na_2O.2CaO.5B_2O_3.16H_2O$) with various clay minerals (aluminum silicates), alkaline earth carbonates and silicates. This material contains approximately 25% B_2O_3, 23% CaO, 4% total alkali and 31% loss on ignition.
2. Richard Lehman, Technical Advisor to Hammill & Gillespie

Bibliography:

Zamek, Jeff. "Substitutions for Gerstley Borate." Ceramics Monthly, October, 2001.
Zamek, Jeff. "No More Gerstley Borate." Ceramics Monthly, March, 2000.
Zamek, Jeff. "Gerstley Borate and Colemanite." Ceramics Monthly, June, 1998.
http://digitalfire.com/4sight/education/variegating_glazes_25.html

Acknowledgments:

Thank you Jim Fineman, professional potter and technical editor.
Hyperglaze Ceramic Software for Artists by Richard Burkett, www.hyperglaze.com
Insight Glaze Software, Tony Hansen, Digitalfire.com

Chapter 16

1. Obstler, Mimi, "Out of the Earth into the Fire," The American Ceramic Society, 1996. Original Source: Presidential Address of C.V. Smale, 1977. Letters to Mimi Obstler, C.V. Smale, June, July 1989, March 1993.
2. Hamer, Frank and Janet. *The Potter's Dictionary,* 4th ed. A&C Black, University of Pennsylvania Press, 1997, 77.
3. Source: http://digitalfire.com/4sight/material/cornwall_stone_240.html
4. Hamer, Frank & Janet. *The Potter's Dictionary,* 4th ed. A&C Black, University of Pennsylvania, Press, 1997, 78.
5. Source: http://www.potters.org/subject02304.htm/
6. Obstler, Mimi. "Out of the Earth Into the Fire" The American Ceramic Society, 1996, 21.

7. Hamer, Frank and Janet. *The Potter's Dictionary,* 4th ed. A&C Black, University of Pennsylvania Press, 1997, 77.
8. Typical Chemical Analysis of Cornwall Stone.

Acknowledgments:

Jim Fineman, professional potter and technical editor
Ben Evans, Director of Ceramics at I.S.183 Craft School, contributed cone 6 comparative glaze testing series.

Chapter 18

1. Zamek, Jeff. *What Every Potter Should Know.* Iola, WI: Krause Publications, 1999, 154-155.
2. Zamek, Jeff. *What Every Potter Should Know.* Iola, WI: Krause Publications, 1999, 113.
3. Zamek, Jeff. "Substitutions for Gerstley Borate." Ceramics Monthly, October 2001; "No More Gerstley Borate." Ceramics Monthly, March 2000; "Gerstley Borate and Colemanite." Ceramics Monthly, June 1998.
4. Pinnell, Pete "That's a Very Good Question…" Clay Times, Vol. 9, No.6, November/December 2003.
5. Hesselberth, John and Ron Roy. *Mastering Cone 6 Glazes.* Brighton, Ontario, Canada: Glaze Master Press, May 2002. The authors have assembled an excellent text with accompanying photos illustrating many stable glaze formulas.

Chapter 19

1. Eppler, Richard A. *Understanding Glazes.* The American Ceramics Society, 2005, 242.
2. Eppler, Richard A. *Understanding Glazes.* The American Ceramics Society, 2005, 231.
3. Eppler, Richard A. *Understanding Glazes.* The American Ceramics Society, 2005, 231.
4. Hesselberth, John & Ron Roy. *Mastering Cone 6 Glazes.* Brighton, Ontario, Canada: Glaze Master Press, 2002, 59.
5. Hansen, Tony. I.M.C. "Glaze Marks or Scratches." Ceramic Materials Information.
6. Hesselberth, John & Ron Roy. *Mastering Cone 6 Glazes.* Brighton, Ontario, Canada: Glaze Master Press, 2002, 21.

Before using any glaze formula it is always best to have the glaze tested.
Testing Services:
Brandywine Science Center, Inc., Kennett Square, PA, 610-444-9850.
New York State College of Ceramics at Alfred University, Alfred, NY, 607-871-2486.

Acknowledgments:

White liner glaze pottery produced by Dennis Bern, BernWell Pottery, 828-883-8300.
I would like to thank John Hesselberth for his contribution to this chapter. His book along with co- author Ron Roy, *Mastering Cone 6 Glazes,* is a valuable study of stability in glazes.
Additional information on glaze marks or scratches can be found on *http://digitalfire.com* along with the Insight glaze calculation program.

Chapter 20

1. Dover Pottery web page *www.doverpots.com/maiolica/maiolica.html*
2. Attard, Robert & Romina Azzopardi. *Mediterranean Maiolica.* Atglen, PA: Schiffer Publiching Ltd., 2011, 5.
3. Source: Ceramicadirect.com
4. Drury C. E. Fortnum (1892) *Maiolica.* London: Chapman & Hall. Quoted in E.A. Barber, (1915), *Hispano Moresque Pottery.* New York: The Hispanic Society of America, 25-26.
5. Source: *Maiolica in the Renaissance* – Heilbrunn Timeline of Art History, *www.metmuseum.org/toah/hd/maio/hd_maio.htm*
6. Source: *Maiolica in the Renaissance* – Heilbrunn Timeline of Art History, *www.metmuseum.org/toah/hd/maio/hd_maio.htm*
7. Wikipedia – http://en.wikipedia.org/wiki/Cipriano_Piccolpasso
8. Attard, Robert & Romina Azzopardi. *Mediterranean Maiolica.* Atglen, PA: Schiffer Publishing Ltd., 2011, 43-44.
9. Carnegy, Daphne. *Tin-glazed Earthenware.* Radnor, PA: Chilton, 88.
10. Lawrence, W. G. *Ceramic Science for the Potter.* New York: Chilton, 1972, 116.
11. Attard, Robert & Romina Azzopardi. *Mediterranean Maiolica.* Atglen, PA:Schiffer Publiching Ltd., 2011, 7.
12. Carnegy, Daphne. *Tin-glazed Earthenware From Maiolica, Faience and Delftware to the Contemporary.* Radnor, PA: Chilton, 1993, 78-79.

Bibliography:

Attard, Robert and Romina Azzopardi. *Mediterranean Maiolica* Atglen, PA: Schiffer Publiching Ltd.
Carnegy, Daphne. *Tin-glazed Earthenware From Maiolica, Faience and Delftware to the Contemporary.* Radnor, PA: Chilton, 1993
Wilson, Timothy. *Maiolica – Italian Renasissance Ceramics in the Ashmolean Museum,* 2nd ed. Ashmolean Museum Oxford University, 2003.
William Brouillard, Prof. of Ceramics, Cleveland Institute of Art
http://clevelandartsprize.org/awardees/William_Brouillard.html has several recommendations for firing Maiolica with no white spots:

Bisque hot in a well vented kiln.

Use pre-reacted materials in your glazes - frits as opposed to Gerstley Borate.

Thinner rather than thicker application of glaze.

Slower rather than faster firing curve after the glaze sinters.

Apply white slip to leather hard pot, then low bisque fire after which apply overglaze colors, followed by a thin coat of clear and refire.

Acknowledgments:

Damariscotta Pottery, damapots@tidewater.net. Rhonda Friedman who works in Maiolica ware supplied information on firing cycles to prevent white spots.
L&L Kiln MFG, Inc., 877-468-5456.

These professional potters contributed images and content to the chapter:
Jonathan Kaplan has been involved in the ceramics field as a potter, ceramic designer and manufacturer, author, educator, and gallery curator for over 40 years. He has authored numerous articles for *Ceramics Monthly*, *Pottery Making Illustrated*, *Studio Potter*, and *Ceramics Technical*. A review of his recent ceramic work appeared in *Ceramics: Art and Perception #85*. Jonathan is a board member of *Studio Potter* and curates Plinth Gallery in Denver Colorado. He can be reached at *jonathan@plinthgallery.com*.
John Britt has been a potter and teacher for over 26 years. He is the author of the *The Complete Guide to High-Fire Glaze: Glazing & Firing at Cone 10* which was published by Lark Books in 2004. He has written numerous articles for publications including *Ceramics Monthly*, *Ceramic Review*, *Studio Potter*, *Clay Times*, *Ceramic Technical*, *New Ceramics* and *The Log Book*. He is currently a studio potter in Bakersville, North Carolina and teaches glaze chemistry, throwing, kiln building, glazing and firing workshops. He can be reached at: johnbrittpottery@gmail.com.

Chapter 21

1. McColm, Ian J. *Dictionary of Ceramic Science and Engineering*. New York and London: Plenum Press, 1984.

Chapter 23

1. Hesselberth, John and Roy, Ron. *Mastering Cone 6 Glazes,* Brighton, Ontario, Canada: Glaze Master Press, May 2002, 62.
2. Hamer, Frank and Janet, *The Potter's Dictionary of Materials and Techniques,* 4th edition University of Pennsylvania Press, 1997, 89.
3. Lawrence, W. G. *Ceramic Science for the Potter.* New York: Chilton, 1972, 155.
4. Lawrence, W. G. *Ceramic Science for the Potter.* New York: Chilton, 1972 159.
5. Information on feldspar additions to correct shivering supplied by Tony Hansen, Digitalfire Corporation, 406-662-0136.
6. Lawrence, W. G. *Ceramic Science for the Potter.* New York: Chilton, 1972, 158-159.
7. Lawrence, W. G. *Ceramic Science for the Potter.* New York: Chilton, New York, 1972, 122, 126.
8. Additive A is produced by Ligno Tech USA, 908-429-6660.
9. Vee Gum CER and C.M.C. are both glaze binder additives; either can be used from 1/8% to 2% based on the dry weight of the glaze. They can be purchased through a local ceramics supplier. Some testing will be required to learn the correct amount of glaze binder for a glaze. All glazes should be mixed wet through an 80x mesh sieve to ensure complete blending of raw materials and binders.
10. All temperature references to cones are based on large Orton pyrometric cones heated at 270° F. per/hr.
11. Additive-A Type 1, Type 3, and Type 4, also improve plastic and green strength properties of moist clay without changing shrinkage, fired color, or fired clay absorption. Produced by Lignotech U.S.A., Box 582, Lavonia, GA 30553, 706-356-1288.
12. pH is calculated from 0 to 14. 7 is neutral. Less than 7 is increasing acidity. More than 7 is increasing alkalinity.

References:

Hamer, Frank. *The Potter's Dictionary of Materials and Techniques*. New York: Watson-Guptill Publications, 1975.
Rhodes, Daniel and Robin Hopper, *Clay and Glazes for the Potter*,

3rd ed. Iola, WI: Krause Publications, 2000.

Chapter 24

1. Parmelee, Cullen W. *Ceramic Glazes*, 3rd ed. Boston: Cahners Books, 1973, 580.

2. Parmelee, Cullen W. *Ceramic Glazes*, 3rd ed. Boston: Cahners Books, 1973, 580.
3. Lawrence, W. G. *Ceramic Science for the Potter*. New York: Chilton, 1972, 116.
4. Frank and Janet. *The Potter's Dictionary of Materials and Techniques,* 4th ed. London: A&C Black/University of Pennsylvania Press, 1997, 27.
5. Eppler, Richard A. *Understanding Glazes*. Westerville, OH: The American Ceramics Society, 2005, 250.
6. Eppler, Richard A. *Understanding Glazes*. Westerville, OH: The American Ceramics Society, 2005, 250.
7. Lawrence, W. G. *Ceramic Science for the Potter*. New York: Chilton, 1972, 114.

Chapter 25

1. Hamer, Frank and Janet. *The Potter's Dictionary of Materials and Techniques,* 4th ed. A&C Black Publishers Limited, 1997, 64-65.
2. Myerson, S. Ross, MD, MPH, Myerson Occupational & Environmental Medicine, P.C.
3. Zamek, Jeff. *Safety in the Ceramics Studio*. Iola, WI: Krause Publications, 2002, 141.
4. Stopford, Woodhall, MD, MSPH, Assistant Clinical Professor at Duke University Medical Center.
5. Kriss JP, Carnes WH, Gross RT. "Hypothyroidism And Thyroid Hyperplasia In Patients Treated With Cobalt". JAMA, 157(2): 117-121, 1955.
6. Barceloux, D. "Cobalt". Clinical Toxicology 37(2), 301-216, 1999.

Chapter 27

1. Regular self-supporting Orton pyrometric cones heated at 108° F. per/hr.

Chapter 29

1. Lawrence, W. G. *Ceramic Science for the Potter*. New York:: Chilton, 1972, 38.
2. Information on feldspars supplied by Tom Landon, Technical Services Leader, Imerys North America Ceramics.
3. Information on flint supplied by Keryn Geho, Technical Services Representative, U.S. Silica.
4. Information on nepheline syenite supplied by Unimin Corporation.
5. Two respirators NIOSH (National Institute for Occupational Safety and Health) approved to meet OSHA (Occupational Safety and Health) requirements and C.D.C. (Centers for Disease Control) guidelines, 3M 8210 N95 Particulate Respirator or 6000 Series Low Maintenance Respirator with replacement cartridge filters.
6. High Efficiency Particulate Air filters can remove 99.97% of airborne particles 0.3 microns in diameter. Particles of this size are the most difficult to filter and are the most penetrating particle size (MPPS). Particles larger or smaller are filtered with even higher efficiency. Source: World Health Organization document WHO/SDE/OEH/99.14, "Hazard Prevention and Control in the Work Environment: Airborne Dust", page 95
7. IQAir, www.iqair.com

Chapter 31

Acknowledgments:

Dr. Gary Branfman, hand surgeon, supplied technical details and medical descriptions relating to hand injuries.
Michael McCarthy, professional potter, contributed his experiences when working with clay.
Tom White, professional potter, supplied information on his technique for healing finger skin cracking.

Chapter 32

1. Hopper, Robin. *Staying Alive, Survivals Tactics for the Visual Artist*. Iola, WI, Krause Publications, 2003.
2. Brandywine Science Center, Inc., 204 Line Rd., Kennett Square, PA 19348, 610-444-9850.
3. Branfman, Steven. *The Potter's Professional Handbook*. Iola, WI: Krause Publications, 1999, 144.

Acknowledgments:

I would like to thank Angela Fina and Michael Cohen, professional potters in Massachusetts, for their suggestions on booth display.
Professional potter Steven Branfman contributed suggestions from his own pottery selling experience. His help was invaluable to the content of this chapter.

Chapter 33

Acknowledgments:

Jim Fineman, professional potter and technical editor, contributed his skills to this chapter.
Valerie Hansen, president of Frosted Swirl Cupcakes, contributed information about her company for the chapter. Twitter @ FrostedSwirl.
Small Oven Bakery supplied technical details on custom made cupcakes and images. informsmallovenbakers.com.
Michael Cohen, professional potter, shared his time and invited me to tour his studio to discuss selling pottery. mcohentiles@comcast.net.

GLOSSARY

absorption: The amount of moisture taken into a clay body in the fired state.

Additive A: A blend of lignosulfonates and organic and inorganic chemicals used to increase plasticity and green strength in clay body formulas.

Albany slip: A low-temperature, high-iron-content clay mined in the Albany, New York, region of the United States. Commonly used as a glaze in stoneware and salt-glazed pottery.

aluminosilicate: A processed compound containing aluminum oxide and silicon oxide combined chemically.

aluminosis: Lung disease caused from exposure to aluminum-bearing dust.

APG Missouri fireclay: A coarse refractory clay formed against seams of coal, lignite, and other impurities. Used in clay bodies for its "tooth" or stand-up ability in the moist clay's forming operations.

ball clay: A secondary clay transported by water from its forming site. Its fine-grained particle size results in a very plastic clay.

barium carbonate: An alkaline earth raw material that can be used in glazes to create opacity and influence the color of metallic coloring oxides.

bentonite: A clay formed from volcanic ash. Often used in clay body formulas for its plastic properties. Used in glaze formulas for its suspension properties.

bisque firing: A preliminary firing to remove organic material and mechanical and chemical water from the clay in preparation for the glaze firing.

blister: A gas inclusion in the clay body. In glazes, it is a disruption of the glaze surface with sharp crater edges.

bloat: The swelling or bulging of ceramic objects when subjected to heat in a kiln.

bone ash: Calcium phosphate that provides a flux in china bodies. In glazes, it contributes to an opalescent luster.

bone dry: A stage in drying when most of the mechanical water is removed from the clay. Clay at this stage can be very fragile.

brushing: A method of transferring glaze, engobe, or underglaze to a ceramic form by using a brush.

calcining: The process by which a material is purified by heating, when mechanical and chemical water is removed.

caramelization: Browning of sugar in cooking that produces a sweet, nutty flavor.

carbonaceous: Carbon-containing materials found in varying amounts in some clays.

carpal tunnel syndrome: A wrist, arm, or hand injury caused by repetitive motion; can cause pain, tingling of the hand, and numbness.

casting slip: A clay body that is very fluid and can be poured into plaster molds.

C&C ball clay: A small platelet-size clay that can be used in a clay body for its plastic properties. In glazes, it contributes suspension properties and alumina and silica.

Cedar Heights bonding clay 50x: A high-temperature plastic stoneware clay used in clay body formulas. A coarser grind of Goldart stoneware clay.

chelation: Chemical process used to remove heavy metals from the body.

chemical water: Water that is combined with clay and not driven off until 842°F to 1112°F (450°C to 600°C).

clay: Igneous rock that has weathered down, having a platelet structure. When moist it is plastic, and when fired it achieves a hard, vitreous quality.

clay body: A combination of clay(s), fluxes, and other materials designed to achieve a specific fired color, temperature range, and forming ability.

clay mixer: A machine that mixes dry clay with water to achieve a plastic consistent mass.

clay platelet: The microscopic hexagonal shape of clay. The ratio of length to thickness is approximately 10:1.

clay shrinkage: A reduction in the dimension of clay in the drying or firing stages.

clay slip for casting: A mixture of clays, fluxes, fillers, and deflocculant, enabling a liquid clay to pour into molds.

cobalt carbonate: One of the most potent ceramic colorants that can produce blue in glazes.

concave: A structure with a recessed area. The inside of a bowl is an arched curve.

conduction: The transfer of heat through solids.

cone: A cone formulated from ceramic raw materials that will deform at a given temperature over a specific rate of heat increase.

coning up: A procedure that brings the moist clay into a cone shape on the potter's wheel to prevent "S" cracking.

convection: The transfer of heat through the movement of air.

convex: Curved or rounded, as in the exterior of a sphere.

copper carbonate: A coloring agent used in glazes that can produce blues and greens.

copper oxide (red): A coloring agent used in glazes that can produce blues and greens. A stronger concentration than copper carbonate.

Cornwall stone: A naturally occurring mineral containing sodium, potassium, magnesium, silica, alumina, and other trace materials. Can be used in high-temperature glazes as a flux or glass former in conjunction with other materials in the glaze.

crazing: A network of fine lines in the fired glaze when it cools under tension in comparison to the underlying clay body.

cristobalite: A crystalline solid material formed in the conversion of silica.

Custer feldspar: A potassium feldspar used in clay body formulas for its high-temperature fluxing ability. In glazes it is a primary high-temperature flux, bringing other glaze materials into a melt.

damper: A device in the kiln stack that regulates exhaust emissions.

Darvan #7: A polyelectrolyte deflocculant used to make casting slip bodies pourable.

deflocculant: A compound, usually sodium based, that disperses the clay platelets in a water system, yielding a fluid clay slip.

dipping: A method of applying glaze to a ceramic form by submersion into a glaze container.

dolomite: A sedimentary mineral containing equal parts of calcium and magnesium.

dry shrinkage: The percentage of shrinkage from moist to bone-dry clay.

earthenware clay: Commonly found clays that when fired to low temperatures (1657°F to 1945°F) are nonvitreous and porous.

electric kiln: A kiln heated by electric coils and firing in an oxidation atmosphere.

end point: The highest temperature reached in a kiln firing.

engobe: Another term for a decorative slip applied to the ware. However, a technical description of an engobe is a liquid suspension of clay or clays with additional flux and other materials.

EPK: Edgar plastic kaolin, a refractory, primary, white firing clay used in clay body and glaze formulas.

Epsom salts: Magnesium sulfate, used in glazes for its suspension properties.

ergonomic: Designed to minimize physical effort and discomfort and, hence, maximize efficiency.

eutectic: A combination of two or more materials resulting in a lower melting point than any of the raw materials.

F-4: A sodium-based feldspar used in clay body formulas for its high-temperature fluxing ability. In glazes it is a primary high-temperature flux, bringing other glaze materials into a melt.

feldspar: Materials formed by the weathering of granite; forms an alkaline flux in clay bodies and glazes.

feldspathoids: A group of aluminosilicates containing various alkaline oxides and having qualities similar to feldspars.

Ferro frit #3110: A low-temperature flux combination of potassium, sodium, calcium, alumina, boron, and silica that can be used in low- to medium-temperature glazes.

Ferro frit #3124: A low-temperature combination flux combination of potassium, sodium, calcium, alumina, boron, and silica used in low- to medium-temperature glazes.

Ferro frit #3134: A low-temperature flux combination of sodium, calcium, boron, and silica that has been calcined. Used in low- to medium-temperature glazes.

Ferro frit #3195: A low-temperature flux combination of sodium, calcium, boron, alumina, and silica that has been calcined. Used in low- to medium-temperature glazes.

Ferro frit #3269: A low-temperature flux combination of potassium, sodium, calcium, zinc, alumina, boron, and silica that can be used in low- to medium-temperature glazes.

filter press: A method of mixing clay and water in which the liquid clay is squeezed between cloth bags to remove excess water.

fireclay: Refractory clay having high amounts of alumina and silica.

fired shrinkage: The total percent of shrinkage from moist clay to fired clay.

firing: The process of heating pottery in a kiln.

flameware: Clay bodies and glazes designed to withstand direct-flame impingement.

flint: Commonly called silica. Used in clay body formulas to promote vitrification with other materials and reduce shrinkage and warping. In glazes, flint combines with fluxes to promote glaze melting.

flocking: Small colored fibers sprayed on an adhesive-coated ceramic surface.

flux: A material that promotes melting.

free silica: Chemically uncombined silica found in clays and glaze materials.

frit: A combination of alumina, silica, calcium, sodium, or other oxides that have been mixed in specific amounts, fired to a glass, fast-cooled, and ground into a powder. Frits are frequently used in low-temperature glazes as a melting agent.

G-200: Potassium-based feldspar used in a clay body formula for its high-temperature fluxing ability. In glazes it is a primary high-temperature flux bringing other glaze materials into a melt.

Gerstley borate: An unprocessed soluble ore containing calcium and boron, used as a flux in low- to medium-temperature glazes (no longer mined, and stocks are being depleted).

glaze: A glass coating on pottery formulated for color, opacity, surface texture, or transparency.

glaze maturity range: The temperature range within which a glaze forms into a stable configuration.

Goldart stoneware clay: A medium-platelet-size, plastic clay frequently used in clay body formulas for its particle size.

grog: A calcined high-temperature alumina silicate that is inert and reduces shrinkage and warping in a clay body. High percentages of grog in a clay body can reduce plasticity.

Grolleg kaolin: A primary, high-temperature white clay used in clay bodies for its color and particle size. In glazes it contributes alumina and silica and can increase suspension properties.

handbuilding: The forming process that uses slabs, coils, extrusions, or pinching to manipulate clay.

Hawthorn Bond fireclay: A coarse refractory clay formed against seams of coal, lignite, and other impurities. Used in clay bodies for its "tooth," the ability to stand up in moist-clay-forming operations.

Helmer kaolin: A white-firing, high-temperature clay formed on-site, used in clay bodies for its refractory qualities and color. Can be used in slip applications for its ability to flash with brown highlights.

high coefficient of expansion: Ceramic materials that when heated have a high degree of contraction.

hydrocarbon-based fuels: Oil, propane, natural gas, wood, sawdust, coal, or any combustible material.

jelly roll lamination: The circular pattern of moist clay when it is extruded from the pug mill.

jigger/jollying: A machine using a template and spinning wheel to form moist clay.

kaolinite: The idealized pure clay mineral containing alumina, silica, and water.

Kentucky ball clay OM #4: A small-platelet-size clay used in clay bodies for its plasticity and strength. Used in glazes for its alumina and silica content and its ability to keep glazes in suspension.

Kentucky ball clay #9: A slightly darker-firing ball clay than Kentucky ball clay OM #4, but having the same plastic and glaze suspension properties.

kiln: An insulated, heated container for the firing of ceramic objects.

leather hard: A stage in drying when the clay is cold to the touch, damp, and slightly pliable.

lime pop: Nodules of lime that expand due to hydration, causing a clay body defect.

Lizella stoneware: A high-iron-content clay that can supply brown to tan colors to clay bodies.

LOI: Loss on ignition, the weight lost when heating ceramic materials to high temperature.

low coefficient of expansion: Ceramic materials when heated have a low degree of contraction.

luster glaze: A thin metallic film such as gold, silver, or platinum coating a ceramic surface.

M 44 ball clay: A plastic clay used in clay body formulas and glazes; it aids in suspension and supplies alumina and silica.

manganese dioxide: An active flux that will produce weak browns, violets, purples, or red tints in glazes.

marcasite: A type of white iron ore containing sulfide.

Mason stain #6003 Crimson: A calcined mixture of chromium oxide and zinc used to color glazes.

Mason stain #6242 Bermuda Green: A calcined mixture of silica, praseodymium oxide, zinc oxide, and vanadium pentoxide used to color glazes.

Mason stain #6405 Naples Yellow: A calcined mixture of iron, silica praseodymium oxide, and zinc oxide used to color glazes.

Mason stain #6600 Black: A calcined mixture of cobalt oxide, chromium oxide, iron, and nickel oxide used to color glazes.

mechanical water: Uncombined water found in ceramic materials such as clays, which is removed in the first stages of firing. Also called free water.

mesh size: A number indicating the open spaces in a sieve. The larger the mesh size, the finer the particle size.

metallic coloring oxide: cobalt, chrome, iron, rutile, nickel, manganese, copper, oxides, or their carbonate equivalents used to impart color to glazes.

micron: Unit of measurement; 1 micron equals 1/24,500 of an inch.

Mohs scale: The measurement of a mineral's hardness.

mullite: An aluminosilicate formed in a fired clay body that contributes strength.

nepheline syenite: A sodium-based feldspar used as a flux in clay bodies and glazes.

neutral atmosphere: Can occur in any hydrocarbon-fueled kiln when equal amounts of air and fuel are introduced into the firing chamber.

Newman Red: A high-iron-content stoneware clay that imparts color to clay bodies.

nickel carbonate green: A refractory metallic coloring carbonate that produces a variety of subtle colors depending on the base glaze formula, firing temperature, and kiln atmosphere. It is often used to modify and tone down other coloring oxides.

nodule: A rounded or irregularly shaped particle.

Ocmulgee stoneware clay: A high-iron-content clay used in low-, medium-, and high-temperature clay bodies for orange/red colors.

orange peel: A dimpled pattern that appears on salt- or soda-glazed pottery, resulting from sodium vapors reacting with the alumina and silica in the unglazed clay body.

overburden: Soil, decomposed rock, and organic matter that cover a seam of clay.

overglaze: One glaze applied over another, either at the time of the first glaze firing or on subsequent firings.

oxidation atmosphere: Combustion in hydrocarbon-fueled kilns with a higher air-to-fuel ratio.

pH: A measure of alkalinity and acidity, based on a scale. The number 7 indicates neutrality, with lower numbers indicating increased acidity and higher numbers indicating alkalinity.

Pine Lake fireclay: A plastic fireclay used in clay bodies, which is no longer available.

pinhole: A small, round hole with a smooth edge found in an unfired or fired glaze.

Pioneer kaolin: A primary, high-temperature white clay used in clay bodies for its color and particle size. In glazes it contributes alumina and silica and can increase the suspension properties of glaze.

pit firing: Pottery fired in a hole in the ground, enclosed and covered by a combustible material.

platelet: A flat structure observable when clay is placed under magnification.

porcelain: A white clay body, translucent when thin.

primary clay: Clay formed by weathering and not transported from the site of origin.

pug mill: A machine with auger blades that compresses clay into an extruded form.

pyrite: Iron sulfide having a yellow metallic glow.

pyrometric cone: Small, triangular cones that are formed from different raw materials; when placed into a kiln, they bend at specific temperatures.

pyrophyllite: A hydrated aluminum silicate used in clay body formulas to reduce shrinkage and warping.

pyroplastic deformation: Irreversible deformation of ceramic materials when stressed at high temperature.

radiation: Transfer of heat by energy waves.

raku: A fast-firing procedure in which the ware is heated, taken out of the kiln while still hot, and placed in a reduction medium or left to cool in an oxidation condition. Either atmosphere can alter the color and texture of the glaze and clay body.

Ram press: A hydraulic press in which air is injected into the plaster mold to release the ceramic form.

Redart: A high-iron-content earthenware clay used in clay bodies.

red heat: Visible heat in the kiln, around 1000°F.

red iron oxide: One of the most versatile coloring oxides used in glaze formulas and occasionally in clay bodies.

reduction atmosphere: Combustion in hydrocarbon-fueled kilns with a higher fuel-to-air ratio that creates carbon monoxide.

refractory: Capable of resisting high temperature.

rib: A shape made of wood, metal, or any material that is used in clay-forming operations.

Roseville stoneware clay: A medium-platelet-size, plastic clay frequently used in clay body formulas.

rutile, powdered light: An ore containing iron and titanium, used in glazes to produce weak tans, blues, and mottled surface textures.

S crack: A crack in bone-dry, bisque, or fired ware on the bottom of the pots. Found in wheel-thrown forms that have not been correctly "coned" up during the centering process.

sagger: A heat-resistant box protecting pottery from direct-flame impingement or kiln atmosphere.

salt firing: Sodium chloride is placed into a firing kiln, creating sodium, hydrochloric acid, and chlorine vapor. The sodium vapor reacts with alumina and silica in the clay body, forming a sodium-alumina-silicate glaze.

secondary clay: Clay that has been moved by wind, rain, or water from its point of origin.

Sheffield clay: A high-iron-content earthenware clay that produces brown tones in clay bodies.

shivering: Sheetlike plates of fired glaze that peel off the clay body, caused by the glaze cooling under extreme compression.

shrapnel effect: Small pieces of clay that explode in the first stage of bisque firing due to the fast release of steam trapped in the clay body.

silica: Silicon dioxide, also referred to as flint, is found in all clay bodies and glazes. By itself it is very refractory and does not melt below 3110°F.

silica sand F-65 48x: A coarse mesh size of silica used to cut shrinkage and warping in clay body formulas. Also used to promote an "orange peel" effect in soda/salt-firing bodies.

silicosis: A lung aliment caused by exposure to crystalline silica dust.

slip: Liquid clay that can be colored with metallic oxides or stains that can be applied to the ware in the leather-hard, bone-dry, or bisque stages. Traditionally, a slip contained only clay and water, but the term now encompasses any combination of materials in a liquid form that can be applied to clay.

slip casting: The process of pouring liquid clay into a mold.

slump: Deformation of a wet, dry, or fired ceramic form.

soda ash: Sodium carbonate used in vapor kiln firings. In glazes it acts as a low-temperature flux and is soluble.

soda firing: Sodium carbonate or sodium bicarbonate is placed into a firing kiln, creating sodium vapors and carbon dioxide. The sodium vapor reacts with alumina and silica in the clay body, forming a sodium-alumina-silicate glaze.

soluble salts (scumming): Raw material of chlorides, sulfates, silicates of lime, soda, potash, or magnesia, which can migrate to the surface of a glaze or clay body and cause efflorescence.

spinel: A mineral composed of $RO\ R_2O\ O_3$, containing alkaline oxide and amphoteric oxide.

spray booth: An enclosed structure that traps and safely captures any surplus glaze deposited on the ware from a spray gun.

spraying: A method of glaze application in which atomized glaze is deposited onto a ceramic form by a stream of compressed air.

stains: Commercially prepared metallic coloring oxides and stabilizers that have been calcined.

stoneware clay: A secondary clay (moved from its site of origin) that is semiplastic and refractory.

strontium carbonate: Comparable to other alkaline earth materials such as calcium and barium, it causes opacity in glazes.

Superpax: A zirconium silicate used in glaze for opacity.

super sacks: Bulk shipping containers that hold 2000 lbs. of material.

Taylor ball clay: A light-firing clay used in clay bodies for its plasticity. In glazes it contributes alumina and silica while aiding in glaze suspension.

Tennessee ball clay #1: A light-firing, coarse-grained clay used in clay bodies for its plasticity. In glazes it contributes alumina and silica while aiding in glaze suspension.

Tennessee ball clay #9: A ball clay used in clay bodies for its plasticity. In glazes it contributes alumina and silica while aiding in glaze suspension.

Tennessee ball clay #10: Low-organic, medium-grained, white-firing ball clay used in clay bodies for its plasticity. In glazes it contributes alumina and silica while aiding in glaze suspension.

terra sigillata: Fine particles of clay that are applied to low-temperature pottery, producing a smooth burnished or rough surface in the fired state.

Texas talc: Used in glazes in which magnesia and silica are needed. In high-temperature clay bodies, talc can be an aggressive flux. In low-temperature clay bodies, it can promote glaze fit.

thermal mass: Solid objects that capture and retain heat, such as kiln shelves, pots, posts, and kiln walls. Upon cooling, these objects will radiate heat to the surrounding area.

thermal shock: Drastic change in temperature in a ceramic body.

thixotropy: The ability of casting slips to change fluidity when not agitated.

Thomas ball clay: Small-platelet-size clay that can be used in a clay body for its plastic properties. In glazes it contributes suspension properties and alumina and silica.

throwing: The process of forming moist clay on the potter's wheel.

Tile #6 kaolin: A plastic, white-firing, refractory, high-temperature clay used in clay bodies. In glazes it supplies silica and alumina and aids in glaze suspension.

tin oxide: An opacity-producing oxide used in glazes.

titanium dioxide: A material that can cause opacity in glazes and, in some instances (depending on the cooling cycle in the kiln), produce crystals.

tooth: The ability of moist clay to maintain its vertical position in any forming process due to the combination of clay platelet sizes and grog particles.

VeeGum T (VGT): A hydrated magnesium aluminosilicate used to increase plasticity.

viscosity: The resistance of a fluid such as casting slip to flowing freely.

vitreous: Glass structure in a clay body due to heating.

wedging: The process of hand-kneading clay to distribute moisture and remove air pockets.

wedging table: An absorbent surface on which moist clay is mixed before it is formed.

wheel: Refers to forms made on the potter's wheel.

whiting: Calcium carbonate, ground fine and used as a source of calcium in glazes.

XX sagger: A type of ball clay that contributes plastic properties to clay bodies. In glazes it supplies alumina and silica along with suspension properties.

zinc oxide: A flux in medium- to high-temperature glazes. Contributes to fired-glaze hardness and promotes intense blues from cobalt oxide.

REFERENCES

These other books by Jeff Zamek are available at
www.jeffzamek.com:

What Every Potter Should Know. Iola, WI: Krause, 1999.

*Safety in the Ceramics Studio: How to Handle Ceramic Materials
Safely*. Iola, WI: Krause, 2002.

*The Potter's Studio Clay and Glaze Handbook: An Essential Guide
to Choosing, Working, and Designing with Clay and Glaze
in the Ceramic Studio*. Beverly, MA: Quarry Books, 2009.

ABOUT THE AUTHOR

Photo credit: Trae Von Morrison

Jeff Zamek walked into a pottery studio over 50 years ago and started his career as an amateur potter. After completing a degree in business from Monmouth University, West Long Branch, New Jersey, he obtained BFA and MFA degrees in ceramics from Alfred University's College of Ceramics in New York. While there, he developed the soda-firing system used at Alfred, and went on to teach at Simon's Rock College and Keane College.

During this time he earned his living as a professional potter. In 1980 Zamek founded Ceramics Consulting Services, a consulting firm developing clay body and glaze formulas for ceramics supply companies throughout the United States.

He works with individual potters, ceramics companies, and industry, offering technical advice on clays, glazes, kilns, raw materials, ceramic toxicology, and product development. He is a regular contributor to *Ceramics Monthly, Pottery Making Illustrated, Pottery Production Practices, Clay Times, Studio Potter, Ceramics Technical*, and *Craft Horizons*.

He is the author of *The Potter's Studio Clay and Glaze Handbook; What Every Potter Should Know*; and *Safety in the Ceramics Studio*, as well as "The Potter's Health & Safety Questionnaire," all available at www.jeffzamek.com.

Zamek is currently working on several ceramics research projects and is making pots as an amateur potter. For technical information, call 413-527-7337 or visit www.jeffzamek.com.